A CITY AND ITS STORIES

slake
LOS ANGELES

STILL LIFE
EDITED BY JOE DONNELLY AND LAURIE OCHOA

Summer 2010

Issue 1

A NEW VOICE TAKES ROOT IN LOS ANGELES

Slake is published by Slake Media LLC.
Subscriptions: A one-year subscription (4 issues) is $60; a two-year (8 issues) is $110.
To subscribe, please make check payable to:
Slake
PO Box 385
2658 Griffith Park Blvd., Los Angeles, CA, 90039-2520
Or visit us online to order by credit card at slakemedia.com.
E-mail us at slake@slakepublishing.com.

Slake is a trademark of Slake Media LLC
slakemedia.com

Distributed to the trade by SCB Distributors
scbdistributors.com
Production in the United States of America. Design by Alex Bacon and Dan Peterka of GAMA Function.
Printed in South Korea by Four Colour Print Group, USA.

CPSIA
Tara TPS Co., LTD, Kyunggi-Do, South Korea
4/13/2010
040710CC / Batch 1

Library of Congress Control Number: 2010927753
The following is for reference only:
Slake: *Still Life* / edited by Laurie Ochoa and Joseph Donnelly
 Los Angeles / Laurie Ochoa and Joseph Donnelly
 p.cm.
 ISBN: 9780984563500
1. Los Angeles (Calif.) – Journalism/Essay. 2. Los Angeles (Calif.) – Fiction/Poetry. 3. Los Angeles (Calif.) – Photography.

εuropane

BAKERY + CAFE

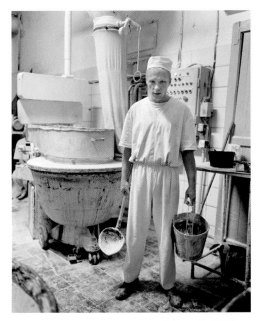
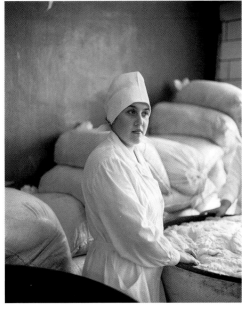

*"The center
of civilized life in Pasadena."*
—Jonathan Gold

345 E. Colorado Blvd., Pasadena, California 91101 and 950 E. Colorado Blvd., Pasadena, California 91106
(626) 844-8804 (626) 577-1828

SPECIAL THANKS

SLAKE SPONSORS

Hammer Museum
10899 Wilshire Blvd., Los Angeles, (310) 443-7000 www.hammer.ucla.edu

Europane Bakery
950 E. Colorado Blvd., Pasadena, (626) 577-1828

Sandra Donnelly

Ken Donnelly

Cathy Bishop

Neal Oku

FRIENDS OF SLAKE

213 Group
www.213downtown.la

Broadway Bar, 830 Broadway, downtown L.A., (213) 614-9909

Cole's, 118 E. Sixth St., downtown L.A., (213) 622-4090

Seven Grand, 515 W. Seventh St., Second Floor, downtown L.A., (213) 614-0737

Golden Gopher, 417 W. Eighth St., downtown L.A., (213) 614-8001

Las Perlas, 107 E. Sixth St., downtown L.A., (213) 988-8355

The Varnish, 118 E. Sixth St., downtown L.A., (213) 622-9999

Casey's Irish Pub, 613 S. Grand Ave., downtown L.A., (213) 629-2353

Caña Rum Bar, 718 W. Olympic Blvd., downtown L.A., (213) 745-7090

Tony's Saloon, 2017 E. Seventh St., downtown L.A., (213) 622-5523

Spice Station
3819 W. Sunset Blvd., Los Angeles, (323) 660-2565, and 2305 Main St., Santa Monica www.spicestationsilverlake.com

Caryl Kim
Noodle Stories, 8323 W. Third St., Los Angeles, (323) 651-1782 www.noodlestories.com

Lou Amdur
Lou: A Wine Bar, 724 Vine St., Los Angeles, (323) 962-6369 www.louonvine.com

Skylight Books
1818 N. Vermont Ave., Los Angeles, (323) 660-1175 www.skylightbooks.com

Joe and Laurie would like to thank the artists and writers who put passion ahead of their usual pay rates to contribute to Slake. We would also like to acknowledge the following for their support: Rob Hill; Jonathan Gold; Michael Sigman; Arty Nelson; John Albert; Steven Kotler; Robert Sobul; Madhu Sharma; Marena Barron; Ruth Reichl; Margy Rochlin; Nancy Silverton; John Powers; Jervey Tervalon; Robin Green; Dorothy, Sean, and Shannon Donnelly; Sara Salter; Isabel and Leon Gold; Mark Gold and Lisette Bauersachs; Evelyn Ochoa; Tom Gilmore; Michelle Huneven; Polly Geller; Arlie Carstens; Tamarra Younis; Conor Kawesch; Tom Christie; Mark Z. Danielewski; Pandora Young; Erica Zora Wrightson; Veronique de Turenne; Simone Kredo; Trish Carpico; Cynthia Lapporte; Joanna Yas; Laura Kim; Christine Spines; David Kipen; Anne Fishbein; Tom Lutz and Laurie Winer; Candy Olsen; Tracy Bacon; Leslie Roberts; Alison Morgan; and, of course, Willa.

Thanks, also, to Vince Donnelly, who insisted, "This ain't no dress rehearsal."

slake
LOS ANGELES

Founding Editors
LAURIE OCHOA and JOE DONNELLY

Art Direction and Design by
ALEX BACON and DAN PETERKA / GAMA FUNCTION

Copy Editor and Man of Style
CRAIG GAINES

Editorial Assistant and Voice of Reason
SIMONE KREDO

Production Consultant
SHARAN STREET

Bullpen Copy Editor
ELEANOR TEMPLETON

Publishing Consultant
COLLEEN DUNN BATES

Legal Consultant
ALONZO WICKERS / DAVIS WRIGHT TREMAINE

Sponsorship Director
SUSAN UHRLASS

Founding Publisher
JOE DONNELLY

slake
CONTENTS

(Cover+endpage photographs by Shannon Donnelly)

slake
A NEW VOICE TAKES ROOT IN LOS ANGELES
Summer 2010

EDITORS' LETTER

There is still life
 ... in print
 ... in art
 ... in storytelling
 ... in L.A.
 ... all around you

Welcome to *Slake*, a handcrafted selection of deeply reported journalism, essay, memoir, poetry, fiction, painting and photography from an embarrassment of talented contributors. We expect you'll find a lot of your city and yourself in these pages.

Joe and Laurie

Photograph by Dan Peterka

Average American
(60 Hot Dogs and 60 Sticks of Butter a Year)
2005
by **Sandow Birk**

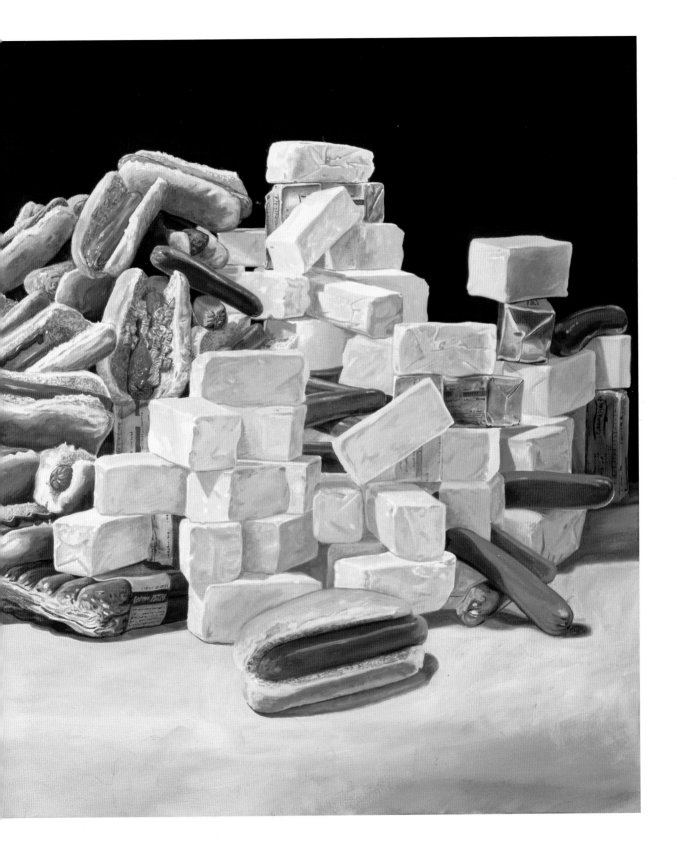

Average American
(32 Donuts, 17 Bars of Soap, 1 Book)
2005
by **Sandow Birk**

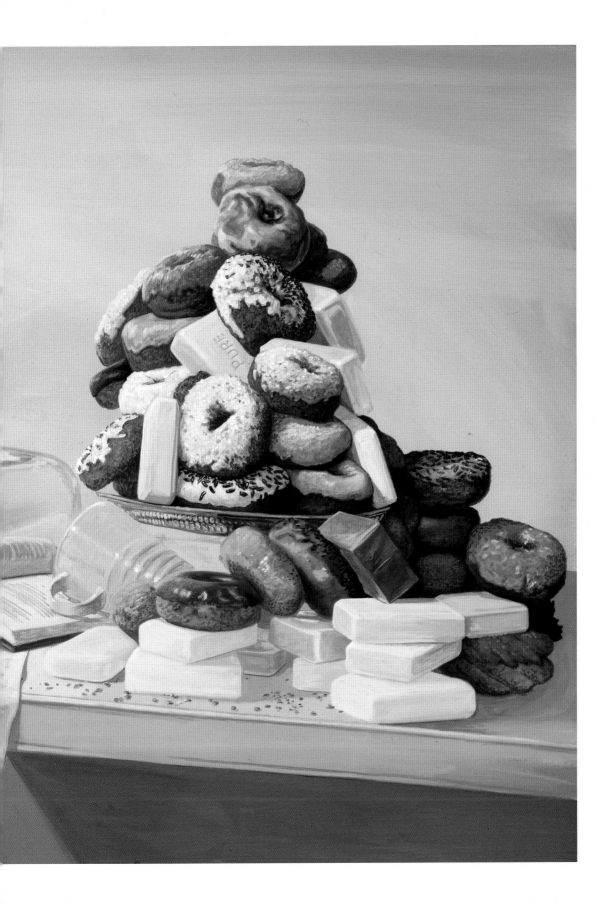

Mark Z. Danielewski's

The Promise of Meaning

1. Writers who do not read poetry cannot be taken seriously.

Which goes (self-evidently) for poets, (just as evidently) for novelists, philosophers, historians and (perhaps less evidently) for jotters of laws, judgments, appraisals, prescriptions, blogs, tweets, text messages, menus, directions and grocery lists.

Without a slow and careful consideration of how words move, form, diminish, connect, enact, deceive, sway, detach, destroy, allude, reattach, imply, fail, obscure, seduce, reveal, relax, undo, hold, tease, estrange and clash, achieved through the patient sounding out of meter and sense, the watchful measuring of what inheres and what escapes, writers can no more know what they mean than what they intend. They will not understand how in what they are writing they are already written and therefore have as yet written nothing at all.

Words are just words. Poetry is something else.

Because poetry is at the heart of the matter.

Because poetry is the heart of the matter.

Because poetry depends on what we cannot do without.

Because poetry defines what we are without.

Because poetry defends why without still matters when we're no longer around.

2. **QUESTION:** How is it possible to write something and not write anything at all?

ANSWER: The same way it is possible to say "Let there be peace" or "I love you" over and over and not convey a thing.

QUESTION: Are you serious about devaluing writers who don't read poetry?

ANSWER: What might indicate any answer to the contrary?

QUESTION: Grocery lists?

ANSWER: Without knowing how to read closely we cannot say adequately and therefore can never heed accurately what we need.

QUESTION: So people who read poetry eat better?

ANSWER: Suddenly the possibility is there.

QUESTION: And lawmakers?

ANSWER: They will write better grocery lists too. Not to mention laws. After all, how can anyone conceive a directive on behavior without a thorough understanding of the material that comprises the very design of that directive? Furthermore how can the consequences of such a man-date even be effectively assessed? Can the great enterprise of justice on behalf of the living succeed if the potentials and limitations of its own construction go unrecognized?

QUESTION: Is poetry then merely the particle physics of expression?

ANSWER: That is the matter. But not the heart of.

3. "I cannot imagine having written *House of Leaves* without Rilke (*You must change your life* – ***Archaic Torso of Apollo***) or *Only Revolutions* without Dickinson (*For I have but the power to kill, / Without – the power to die* – ***My Life had stood***) and Stevens (*It is cold to be forever young, / To come to tragic shores and flow* – ***Variations on a Summer Day***).

"I may have loved but would I have understood love's consequences without Vergil (*omnis et una / dilapsus calor atque in ventos vita recessit* – ***Aeneid IV***) or love's hope without Apollinaire (*Comme la vie est lente / Et comme l'Espérance est violente* – ***Le Pont Mirabeau***) or love's denial without Donne (*For thou art not so* – ***Holy Sonnet X***)?

"I would have fallen for her anyway but doubt I would remember her so eidetically without Crane (*And so it was I entered the broken world / To trace the visionary company of love* – ***The Broken Tower***) or know her still so intimately without Graham (*They're flowers because they stop where they do* – ***The Strangers***).

"I cannot see sustaining the reckless engagement with life's infinite propositions without Milton (*in the lowest deep a lower deep / Still* – ***Paradise Lost IV***) or endure its dereliction without Whitman (*I too am but a trail of drift and debris* – ***As I Ebb'd***) or greet its vicissitudes with anything close to a smile without Chaucer (*and in he throng* – ***The Merchant's Tale***) let alone suffer its misreadings without Keats (*forget / What thou among the leaves hast never known* – ***Ode to a Nightingale***).

"To experience the intense requires a language confident in its calmness. While to live without language is to forfeit life's gift. As to live without awareness is to forfeit life's meaning.

"Meaning, after all, is what survives but what survives only offers the promise of meaning if it can perish.

"Or fail.

"Or at least fall.

"During that blur of time before I turned eight, when the outdoors increasingly offered the chance of unrestricted investigation, my father's recitations of Shakespeare still intrigued me most (*for in the very torrent, tempest, and, as I may say, whirlwind of your passion, you must acquire and beget a temperance that may give it smoothness.* – ***Hamlet III 2***).

"During my freshman year when music blared loud it was Eliot in a black-lipstick scrawl on a dorm-room wall who proved loudest (*I will show you fear in a handful of dust* – ***The Waste Land***).

"And of those days between desks and debt, requirement and request, whether at a bus station or park or coffee shop or encampment on a friend's sofa, Hollander (*Are you done with my shadow* – ***Kitty***), Bishop (*This is the house of Bedlam* – ***Visits to St. Elizabeths***), Merrill (*A new voice now?* – ***The Changing Light at Sandover***), Rimbaud (*Je me suis armé contre le justice.* – ***Une Saison en Enfer***), Tennyson (*'The Gods themselves cannot recall their gifts'* – ***Tithonus***),

Blake (*immediately Go out* – **Auguries of Innocence**), Auden (*dismantle the sun* – **Stop all the clocks**) and Wordsworth (*Was it for this* – **The Prelude**) gave voice to what thirst and hunger nightly threatened to digest.

"And now in years more recently traversed when political challenges increasingly demand the philosophical and the pedestrian scheduling of taxes and travels encounters the unanticipated shocks of death and solitude, Hill (*To have lost dignity is not the same / as to be humble* – **The Triumph of Love**), Szymborska (*The panther wouldn't know what scruples mean* – **In Praise of Feeling Bad about Yourself**), Stanford (*Blood come out like hot soda* – **The Singing Knives**), Oliver (*hurrying / day after day, year after year / through the cage of the world* – **Mountain Lion on East Hill Road, Austerlitz, N.Y.**) and Telford (*What bores an angel more – violence or beauty?* – **At the Theatre**) grant prominence to that miracle limit where even the expected conclusion is unended by a rarer and revitalized retelling."

4. What was that all about?

5. Scene: Lucques. Time: After closing. Cast: Your usual strangers.

GUSTAV: Writers who don't read poetry can't be taken seriously. That goes for poets, novelists, jotters of laws, grocery lists and –
IVAN: Text messages?
OCTAVIO: Menus?
LORRAINE: Eviction notices?
VANESSA: Dear Gustav, what about love letters?

Vanessa and Gustav are falling in love but they will never get together in a play or a novel. If only they could live in a poem.

But who will write it?
Not I.

A fast rattle of dialogue ensues defending and denouncing the value of various poets ranging from Plath, Lowell, Byron, Frost, Millay, Baudelaire, Pound, Cummings, Milosz, Paz, Williams,

Yang and Mallarmé to Hughes, Shelley, Nash, Wilbur, Sappho, Hix, Neruda, Herrera, Yeats, Basho, Perillo, Ashbery and Kees along with splashes of lines like: – If truth is beauty what of an ugly truth? – I will show you love in a handful of dust. – I will show you an allergen!

MAN AT THE BAR: Who are you people?
VANESSA: Good question.

Finally –

IVAN: And what of writers who don't read poetry at all but still manage to produce volumes of verse? Should they be taken seriously?
GUSTAV: They should be shot.

Man at the Bar runs away. Lorraine takes advantage and finishes his drink. She is drunk again.

LORRAINE: Is serious even so important?
GUSTAV: Without it levity also departs.
IVAN: Always so clever.
LORRAINE: Clever isn't funny. I'm not smiling, Gustav. I'm leaving and I'm not smiling. And I haven't laughed once. Seriously.

But Lorraine doesn't leave. Gustav and Vanessa do. Lorraine gulps down their unfinished drinks. Octavio laughs and falls off his stool. He's drunk as well. Lorraine's laughter turns to snorts. They both end up on the floor.

Lorraine and Octavio are not in love but they get together all the time. They don't need to live in a poem. They are happy. Tomorrow morning they won't remember a thing. Well that's not true. They will remember things but only vaguely. Meanwhile Ivan's fast asleep dreaming of Russian faces.

VANESSA: And how will we say good night this time?
GUSTAV: As we always do.
VANESSA: But will they be the same words?
GUSTAV: Never.
VANESSA: Promise me.

GUSTAV: I promise you.

MY DAYS
AND STR
A TAPEST
SPREAD T
WITH AG
FAR BELO
TUMBLE WE
THAT FA

Stilled Life

By John Tottenham

ARE SHORT
NUOUSLY IDLE;
OF VAGUENESS
AND FRAYED
TION. WHILE THE CARPET
RESEMBLES A DESERT LANDSCAPE
S OF HAIR, AND DUST
S LIKE RAIN

FALLEN FRUIT

BY JONATHAN GOLD

Visitors to the Norton Simon Museum, the collections jimmied into the corpse of the former Pasadena Art Museum, come to admire the handsome Frank Gehry garden, the shimmering tiles by Edith Heath, and what is probably the most impressive group of Rembrandt paintings on the West Coast. There are Degas ballerinas by the bushel, Rubens by the acre, and Venetian cityscapes sufficient to decorate the parlor of any 18th-century earl. Simon, or his consultants, had a decent eye—his Cranach looks like a Cranach, and the Ingres portrait is really fine. There may not be much competition, but the Simon is probably the best small art museum in California, and as much as one personally might mourn the superb contemporary-art museum that was vaporized to accommodate the catsup millionaire's dream, as a fact on the ground the Simon is admirable.

But a casual visitor, someone there because her guidebook tells her that she should come have a peek at the Van Gogh, might be puzzled by the institution's apparent emphasis on *Still Life with Lemons, Oranges and a Rose* by Francesco de Zurbarán, a 17th-century Spanish painter who was unlikely to have come up in the Renaissance art survey course she took as an elective sophomore year. The museum's gallery map features the Zurbarán on its cover, and the gift shop is stocked with replicas of the painting in every possible size and form. It was the star of the small Norton Simon exhibition in New York's Frick last year. More to the point, the Norton Simon's galleries are laid out in a way that makes *Still Life* almost impossible to avoid, a flash of yellow in a room just off the most glamorous corridor, a magnetic yellow positioned to distract you as you rush toward the Botticelli.

When Simon bought the painting in the early '70s, it was the third-most-expensive Old Master ever sold, a stand-in for the Velázquezes that would never hit the auction block, and the $2,725,000 cost figured into the allure of what is, after all, a picture of some fruit. Zurbarán, the painting's author, was a friend of Velázquez and an admirer of Caravaggio; his work, chiefly pious religious scenes painted for his court patrons in Seville, is often compared favorably with them both. If you are an aficionado of the way a saint's loose, white robe puddles around his holy ankles, Zurbarán is the Baroque-era painter for you.

But *Still Life* is charismatic for a picture of fruit, a three-part composition of nipply lemons, oranges, and an untouched porcelain cup of water on a silver tray. An oddly specific light illuminates the composition, early morning sun perhaps, streaming through a window above and to the viewer's left, sharply focused enough to render the left face of the oranges bright and washed out, although the shadows are almost black. The wooden table on which they sit appears to receive barely enough light to do a crossword puzzle by. To the right of the oranges, the sunlight glints from the rim of the porcelain drinking cup; a white rose stained pink at its edge glows softly as if illuminated from within. On the left are four lemons: some

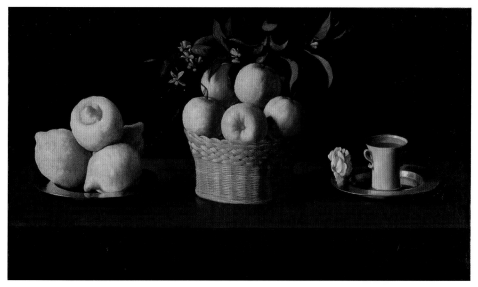

Still Life with Lemons, Oranges and a Rose, Francesco de Zurbarán, 1633, in the Norton Simon Museum

are as defined by their sunken areoles and proud nipples as a vintage *Playboy* centerfold; another, in the foreground, appears to have the outline of a face with a jutting, crooked nose. If you squint, it is almost a match for the head of the leathery crone who cradles the newborn Virgin in another Zurbarán painting mounted a few feet to one side. The rough-skinned oranges, heaped in a finely woven basket, are wreathed with an arrangement of dark leaves and virginal white blossoms that seem less to grow from the fruit than to have descended from heaven.

The museum abounds in other fruit-filled still lifes of the era, and they thrum with life, the yellowing edges of leaves signifying decay, the lumps and hollows hinting at sweet temporality, even the turnips and loamy potatoes that look like tomorrow's dinner. Ants, butterflies, worms, beetles skitter along the edges of the displays, nibbling, sucking out juice.

Fruits are pure sex, the naked reproductive organs of a tree: juicy, plump with fertility, cleft with alluring, syrup-crusted fissures. When we look at Chardin's cherries or a Cézanne peach, what we see is possibility. Zurbarán's citrus may be the opposite of that—unviolated ornamental fruit meant to be admired rather than eaten. There are no crumbs. Not a bite is missing. The lemons are actually citrons, whose rind is fragrant but whose flesh is all but inedible; the oranges, like most in Seville at the time, are almost certainly bitter. These will never be eaten.

In fact, Zurburán mostly hides the naughty bits as completely as Raphael does the genitals on his half-robed saints—except for a solitary, lovingly rendered crater, the stem end of the forwardmost of the oranges, at the mathematical center of the painting and thrust out quite directly at the viewer, the pucker at the center of the world. Centered between the virginal chalice on the one hand and the voluptuous citrons on the other, the dark, bottomless pucker invites what is sometimes known as the male gaze.

The saintly glow of the fruit is indistinguishable from the one on the face of Zurbarán's St. Francis on the painting next to this, or rather to that on the skull before which the saint kneels. There are no glints of light on the oranges themselves, no shine; just brilliantly rough surface. The fruit has no physical presence—it is impossible to imagine plucking it from its basket, to smell it, to feel the heaviness of its juice in your palm—but you want to, you ache for sensation, driven by its sheer, pornographic unavailability. It is no wonder Zurbarán's oranges enraptured a millionaire.

You don't want to eat this fruit. You want to fuck it. And it's going to hurt.

THE HOLLYWOOD PEDESTRIAN

BY GEOFF NICHOLSON

I swear this really happened. I was walking north on Wilton Place where it crosses the 101, right before Sunset Boulevard, in sight of The Home Depot. The day was hot, I wasn't moving very fast, and I'd slowed even more to look at the traffic on the freeway below when a car pulled up and the driver got out and ran round the car to face me. Now I've been in situations similar to this before and generally it hasn't been the prelude to anything good, but this guy looked benign enough. He said he needed directions. He pointed at his wife, who was sitting in the car, and said she had some crazy idea that there was a place in Los Angeles where you could walk along and see the names of Hollywood stars set in concrete in the sidewalk. Was there really such a place? He himself seriously doubted it.

I still felt this might turn out to be a setup for something more dubious, but I took him at his word and explained how to get to the Hollywood Walk of Fame. We talked a little more and I decided he was on the level. He had an accent I didn't recognize so I asked where he was from, and he said Spain. By then he'd worked out that I had a non-American accent too, and I explained I was originally from England.

"Ah," he said, "mad dogs and Englishmen go out in the midday sun."

It's not every day that you're walking in L.A. and somebody quotes Noel Coward at you. Then again, if you believe the legend, it's not every day that anybody walks in L.A., period. As is the way with all legends, this one has an army of debunkers, and when I arrived in L.A. about seven years ago I decided to join them, determined to maintain the serious walking habit I'd developed in London and New York.

Since I ended up living on the lower slopes of the Hollywood Hills, my first, not-very-well-thought-out plan was to walk every Hollywood street in a systematic, regimented way. The gridded layout appealed to the minimalist-slash-conceptualist in me. But problems presented themselves immediately. For one thing, the exact boundaries of Hollywood are a matter of some debate: the tour guides, the cops, the onetime secessionists all have competing beliefs about where Hollywood begins and ends. One popular notion is that Mulholland Drive is the northern boundary, and although I've walked sections of Mulholland, the idea of walking its entire length, with its blind bends and nonexistent sidewalks, strikes me as simple insanity.

Another problem was the 101, the Hollywood Freeway. Since it snakes diagonally across the grid, northwest to southeast, the Hollywood walker encounters it all over the place. You have to go under it or over it, and in the beginning both struck me as equally daunting. I'm no agoraphobe, but certain bridges can make me feel quite wobbly. That place on Wilton where I gave directions to the Spanish tourist used to have an incredibly low railing, not more than waist high, and you could have easily vaulted over it, to certain and unheroic death. They've now built Helen Bernstein High School on that street, and a tall section of chain link has been added, so that the kids can't throw themselves, or more likely each other, over it. The bridge over the 101 at Western still offers agoraphobic thrills, however.

Walking under the freeway is no picnic either. The underpasses are usually what Rem Koolhaas has called junk spaces. You know that somebody must have designed, or at least engineered, them, but essentially they seem to be off-cuts of architecture, the bits and pieces that happen to be left over when more urgent structural concerns have been met. And even though there are sidewalks in the underpasses, they're chiefly made for automobile traffic, and it doesn't seem that anybody ever considered what it might feel like to walk along them: generally unpleasant and sometimes downright scary. I'm aware of just one pedestrian-only underpass, connecting two sections of North Kingsley Drive, in the area between Santa Monica Boulevard and Melrose Avenue. It's about as pedestrian friendly as a snake pit: narrow, low-ceilinged, walls thick with textured paint and floor-to-ceiling graffiti. There's light at the end of the tunnel but you wouldn't get halfway there before the pursuing zombies had ripped your legs off.

When I initially encountered the 101, I was determined not to engage with it, or even see it. The areas around the freeway became blank spaces on my mental map of the city, and blank parts of my walking experience. But after a while I realized that simply wouldn't do. I was enough of an urban explorer, and a contrarian, to think that confronting the very thing you don't want to confront was what the L.A. walking experience might ultimately be all about. I decided to embrace the freeway.

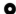

The first thing to notice is that intense life of one kind or another thrives around the freeway: all those houses and apartment blocks, even motels, that snuggle up to the freeway and have balconies with panoramic views of the traffic. Meanwhile, down at ground level, the offramp seems a place to do business, not just for the guys selling bags of oranges, but for others chilling out, playing guitar, holding up cardboard signs saying they just want to get a little money for a motel room. There's also vigorous plant life; vines that creep up the concrete pillars and parapets and threaten to make the freeway look like a jungle ruin, even while it's still in use.

In fact the intersection of straight streets and diagonal freeway creates strange little pockets of unused land, many of them roughly triangular, and greenery thrives there, too. Some of them would allow you access to the freeway, but this access is denied by high fences and locked gates, and although not strictly impenetrable, these things deter the casual trespasser, which is probably no bad thing. In general it's best not to let pedestrians wander onto the freeways.

On the other hand, certain areas are completely accessible. On Van Ness, someone has adopted a patch of ground between the offramp and the parking lot of Tommy's and turned it into a flowerbed, complete with euphorbia and variegated agaves.

Other, larger areas are put to more or less decorative purposes. There's a large, thin slice of downward-sloping land on the south side of Sunset next to a Saab garage that anybody can walk onto, and obviously many have, me included. In the daytime you'll usually find nobody home, but there's always plenty of evidence of habitation: blankets, old clothes, the occasional mattress, even pages torn from a bible, tarot cards, the odd battered teddy bear. The prop department has been busy if not especially inventive.

I sometimes talk to homeless people, much the way that I'd talk to anyone else walking on the street. I try not to condescend, try not to use them as writerly material, but occasionally I encounter someone who looks so compelling and dramatic that I can't help wondering about, maybe even constructing, his or her backstory. A few weeks ago I saw two homeless guys lurking in the fenced-off area under the freeway bridge at Franklin and Argyle, one of them stripped to the waist, with a tattoo of a leafless tree covering the whole of his back. I stopped for a moment, hung about, wondered if I could naturally fall into conversation with them, but it was kind of hard to know where to start. They were some distance away: the tattooed guy seemed to be washing his armpits. Yelling out, "Hey, man, nice tattoo, man. How do you *feel* about living under a freeway bridge?" sounded just a little bogus to me. I had a feeling no good could come of it. Simultaneously I realized that William T. Vollman would have no such inhibition.

There used to be a nice painting of a robot or space alien up on the stanchion where the two guys were hanging out, but it didn't last long. It soon got painted over, which I suppose is a good thing, though I'd have thought there were more pressing acts of public beautification you might want to perform around L.A. Of course the real eyesores, the tags way high up on the parapets, stay where they are, presumably because it's too difficult to get up and obliterate them.

I'll leave it to somebody else to define at what point graffiti become a mural, but right there at that crossing of Franklin and Argyle you have some of my very favorite L.A. murals adorning the walls of the wonderfully named Hollywood Bowl Self-Storage. There in the gloom under the freeway are giant depictions of, among others, James Dean, Liz Taylor, Clark Gable, and Vivien Leigh in *Gone With the Wind*, and there's also John Wayne and Crazy Horse. The artwork, originally by Dan Collins, is a little clumsy. The likenesses are recognizable but the eyes and the facial proportions are significantly off, though I'm not complaining. The paint has recently been refurbished, the colors made brighter and more intense, and there have been one or two changes. There used to be a speech bubble coming out of John Wayne's mouth that said, "The chief up there wants to be president." That's gone now, and I can't decide if it's been done in the name of political correctness or because the painter is convinced we're living in Obama's postracial America.

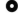

I'm not really in the business of recommending walking routes, but I have been known to take people on walks to show them the "other" Hollywood. And if that's what you want we could start right there by those murals and head up Vine Street on the north side of Franklin. Most peo-

ple don't even realize it is Vine at that point, because it's a steep, narrow, curving street that for a short while runs more or less parallel with the freeway. If you walk up and look back across the lanes of traffic you'll see the towers of downtown, and if the light is right it looks a lot like a golden city to me.

As Vine flattens out we might take a left onto Vedanta Terrace, home of the onion-domed Vedanta Temple, which according to the guidebooks is sometimes called the "little Taj," though I'm not sure by whom. The temple looks a fine and spiritual place, but even so it's jammed up against the freeway, with only a concrete wall (though one free of graffiti) to protect it.

From Vedanta we could make another left down Ivar, Nathanael West's old street, which he called Lysol Alley, though he was referring to the section below Franklin, and he certainly had no freeway to contend with. Walking down our part of Ivar takes us through one of those junk spaces I talked about, a curious, lightless, claustrophobic underpass, only slightly brightened by its lining of white tiles that come up to about head height. At least it's short.

Make a right on Dix Street, and if you're in the mood we could take another right on Holly Drive, which would bring us back under the freeway again, through a much longer, far more gloomy underpass, though one that's shaggy with overhanging greenery that almost covers up the sprayed words "bullets and octane," which for a while (call me a fool) I thought was someone's urgent street poetry but of course turns out to be the name of an angry punk-metal band.

If you didn't want to head up Holly I'd understand, and I'd understand even more if you did want to head

up North Cahuenga Boulevard, but I'd say wait, we're saving that for later. I'd recommend we go all the way along Franklin to Highland, turn right and walk as if we were going to the Hollywood Bowl. But before we get there we'd hang a right on Odin Street. Odin, top deity of Norse paganism, father of Thor, god of war and death, poetry and wisdom: it's worth walking there just for the name, but in fact it's one of those underpasses where the necessities of road construction have created a surprisingly attractive, curving space.

There's something cinematic and widescreen about it, its mouth surrounded by palm trees that tower over the freeway, in some cases seeming to grow out of it. Its walls also bear a mural, hard to see because it's so dark in there, called *Blue Moon Trilogy* by Russell John Carlton for AIDS Project Los Angeles. According to a serious-looking metal plaque on the wall, the work's a triptych, "Eve of Conception," "Dawning of a New Age," and "A Glorious Revelation." This frankly seems a bit grandiose for what are three very modest murals with blue, green, and red stripes, triangular pine trees, and blue moons that look like stuffed cocktail olives.

When we emerge from the underpass we'll be on Cahuenga Boulevard, which veers ahead of us toward the 101 and the Cahuenga Pass. But I don't think we want to go walking up there alongside twelve or sixteen lanes of traffic: even I'm not that nuts. Instead we should follow the road around to the right and eventually we'll be heading downhill to the North Cahuenga Boulevard underpass, which is journey's end (of a kind).

If you drive through that underpass the experience is nothing at all, but on foot it's definitely something.

The bridge supporting the freeway is broad and gently arched, and when you stand under it you see overhead that the freeway is divided into separate northbound and southbound lanes, with a gap between them, and filling that gap is a long, narrow skylight. This isn't in the usual sense "stained glass," though there's certainly plenty of staining: inky blues and earth browns caused by who knows what—oil, carbon, decomposing vegetation, road gunk, maybe road kill. Even so, the light that filters down is eerily appealing. It's not exactly like being in a cathedral but you're definitely standing in a strange, compelling architectural space. People on foot just don't belong there, which is a large part of the attraction. I can stand there for long periods of time, looking up at the light, hearing the noise of the traffic, basking in the weird, brutal, accidental elegance of it.

I'm not one of those people who revel in Los Angeles's capacity for apocalypse, and my understanding (I mean, I found it online) is that there's been some "seismic upgrading" of the concrete in the bridge to increase its "flexural capacity," but even so this is the kind of place you really wouldn't want to be when the earthquake hits. It's all too easy to imagine the fragmented glass, the pulverized concrete, the falling cars coming down, and there we are below, defenseless, out of place, a couple of pedestrians who wouldn't stand a chance.

I'm sure one or two people must have seen me standing there from time to time, gazing up, taking photographs, and they've probably thought I was a weirdo, but as yet nobody's ever stopped their car to talk to me. Nobody there has ever accused me of being a mad dog or an Englishman.

Sammy talks Frank

By Jerry Stahl

"Sinatra? Sinatra was like a guy raping your wife who stops for five minutes to buy your kids toys."

Sammy leaned forward on the white leather couch, alligator shoes barely touching the white shag carpet, and dipped his sterling-silver coke spoon into its matching bowl. He snorted, then stretched the chain taut around his neck, raising the spoon to eye level, like he needed to see the *SDJ* engraved on the back to remind him who he was. Sammy Davis Junior. It's almost like it was *reassuring*.

"Was Frank a pal? Sure. I mean, me and Frank … baby, there's shit I make sure I can't remember, cause if I did, I'd have to arrest *myself*!"

Sammy cracked up, whipped his head from side to side and stomped his feet. Then, like *that*, he got serious.

"Listen, baby, I dug the man. But—and I say this with love—he was management. And he never let you forget it. Fuck you 90 cents on the dollar seven nights a week, but soon as your Grandma Jehoogivesashit dies, Frank baby's right there slappin' five grand down on her funeral. Meanwhile, Grandson Sammy's still walkin' around owing big, and if he don't march his ass into the vice president of the Who Let a Coon in the Hood wing of the First Bank of Beverly Hills it's gonna be his skinny Jew tush in a box. And I'm talkin' about while it's still alive.

"Course, Frank was too classy to talk about that stuff. He had a press agent for that. That man bought coffins for a lotta folks you never heard. Matter of fact, I made a joke once, at the Sands, how the Mob's gotta have their hooks in the mortuary biz, 'cause the way Sinatra's handin' out caskets, somebody's gotta be taking 20 percent off the top. That night, I'll never forget it, soon as we get offstage, Jilly—you know, Jilly Rizzo, the Super Wop who mopped the broads outta Frank's place before the family came by?—Jilly comes up and says, 'Keep talkin', Cyclops, maybe you'll find out sooner than you think.'"

Sammy picked some invisible lint off the leg of his jumpsuit and shivered. "Jilly, man, that cat could start washin' his hands on Tuesday afternoon and not get the sleaze off till Sunday morning. He was as lowdown as a soused, back-stabbin' Mob clown can be. I am serious, Jack."

I'll never forget it. Sammy sniffled, dabbed back a little tear, and I gotta tell you, son, I wanted to ask, *Hey, Sam, can you actually cry out of a glass eye?* But I held my mud. Wasn't the time.

Next thing I know he hops off the damn couch, breaks into this jump-and-split number, comes back up *outta* the split into a perfect twirl, then sits his ass back down and busts into this whole riff 'bout the photo he took with Nixon in Miami—the one where it looked like he was butt-fucking him onstage. That messed up his rep with his own people even worse than recordin' "The Candy Man" or lettin' Dino carry him around onstage like a lawn jockey.

Before we talked, I just figured Sammy for an Uncle Tom. But I was wrong. Matter of fact, I have never been more wrong about anything in my life. Sammy did more for the black man than Malcolm X, the Reverend King, and Jackie Robinson combined. He just did it on the sly. And that's that about that, Jack.

P.S. Don't talk to me about the Panthers, neither. Sammy Davis Junior made Bobby Seale look like a little bitch. And I just may be the only goddamn black man alive who knows the truth.

D WATER

By Jamie Brisick

Malibu was where the world cracked open for my two older brothers and me. On the stretch of sand between First and Third points, we encountered bums, Vietnam vets, leather-clad punks, and rakish surfers. Out in the sparkling waves, West Val stoners, East Val bongheads, Hollywood vampires, Santa Monica rich kids, Venice gypsies, Topanga hippies, Colony gazillionaires, and beer-swilling Wall knuckleheads all converged, creating a magical soup that not only entertained, but provided an education no school ever could.

Take Mickey Rat, a construction worker from Woodland Hills. Mickey was a nuggety goofyfoot with long, blond hair and a thick, blond moustache. He'd trot across the beach in high-cut Sundek trunks with a yellow Kennedy single fin under arm. At the shoreline, he'd drop his board and go through a series of tai chi exercises. Then he'd take off his shorts. He'd fasten them capelike around his neck and paddle out nude.

It was horrifying to watch Mickey duckdive under a set of waves, his white ass poking skyward. It was even more horrifying to have him nearly run you over, his pumped thighs, dangling dick, soggy balls, and spearlike board streaking past like a scene from a twisted porn film. But besides being a genius at crowd control (no one dared drop in on him), Mickey was also poetic. In this odd homage to the ocean's primal, amniotic lure, a mere Clark Kent on land turned into a naked, caped Superman in the surf.

Then there was that twenty-one-year-old punk-rock hell chick from Reseda. She had hot-pink spiky hair and wore raunchy black leather skirts with torn fishnets and stiletto heels. Her boyfriend, Dog, was a surfer, so even though she seemed like she'd be more at home in a dominatrix dungeon, she was forced to endure long, sunny hours on the sand.

To help pass the time while Dog was out on the water, she'd thrill us with graphic stories of her sex life, told with such zealous hand, mouth, and hip gestures that they became soft-porn soap operas. And either because she had some latent sense of propriety or just enjoyed toying with us as a cat would a ball of yarn, she'd bring her stories right to the edge and then leave us hanging.

"That's it for today, kids," she'd say, and then sashay off toward the pier, leaving us in whatever boner-concealing positions we'd assumed.

This was in the late seventies. Kevin, Steven, and I had only recently discovered surfing, and we were awe-struck and intimidated by Malibu's frenetic vibe. The lineup was packed, the surfers aggro. When sets came, six riders would be up at once and loose boards would fly over the backs of waves like corkscrew missiles.

We'd catch rides from parents, aunts, distant cousins, friends of friends' older sisters—anyone with a driver's license headed west. With butterflies in our stomachs but full of ambition, we'd pull our boards from the car, sling our backpacks over our shoulders, and cross the pearly-gate entrance to First Point. The hot sand under our feet felt like instant liberation; the water a kind of tonic in which our terrestrial problems washed away and our true selves emerged.

We came to Malibu at a turning point, both in our lives and the world around us. We came to Malibu when Mohawks and safety pins were replacing long hair and bell-bottoms, when my brother Kevin began to drift from surfing to punk.

☽ ☽

I was born in Hollywood in 1966, the youngest of three boys, and raised in Encino until 1973. Steven, the middle brother, is one year older than me,

Kevin two. My sister, Jennifer, was born in '73. She added a dose of feminine energy to our whirl of testosterone, but she also fell victim to endless farts to the head, hurled pillows, and *Jaws*-inspired attacks in our backyard pool.

We were a golden family in the seventies. My father worked as a publisher's rep, calling on campuses throughout Greater Los Angeles. He ran five miles a day, listened religiously to Nat King Cole, and showered us in books. My mother taught preschool, cooked elaborate feasts, and knew every word to every song on Supertramp's *Crime of the Century*. On weekends she carted us to skate parks or to the beach in our green Oldsmobile Vista Cruiser. On Sunday mornings we attended Catholic Mass as a family. Every night at 8:30 p.m. we gathered around my parents' bed and said prayers.

All seemed to be going well until we moved to Westlake Village. For senior citizens, young parents, or little kids, Westlake was ideal: spacious homes in models A, B, or C, tree-lined streets with names like Three Springs Drive and Walking Horse Lane, green belts and grassy parks with jungle gyms, a man-made lake with ducks and paddle boats. It exuded order, security—a kind of Southern Californian *Mister Rogers' Neighborhood*.

By moving us to Westlake, my parents thought they were getting us into a better school district; we thought they were sentencing us to prison. Our spiritual allegiance was with Dogtown—a derelict stretch on the Santa Monica–Venice border—and the band of raffish skateboarders who ruled it. My brothers and I had spent enough time hopping fences and skating empty pools with our streetwise cousins from West L.A. to know to never admit we lived "over the hill."

We begged our parents to move. I contacted real estate agents in Santa

Monica and Malibu. In denial, I drew Dogtown crosses on my Pee Chee folder and scrawled "Vals Go Home!" on the bottom of my Z-Flex skateboard. Skateboarding led us to surfing and surfing became a full-scale addiction during a family trip to Hawaii in '78. It wasn't just riding waves that did it, but the way the rides played back in my head as I fell asleep at night. The thrill of stroking, stroking, stroking, and then suddenly being raised up by some invisible hand; the precarious hop from prone to upright; the giddy buzz of assuming a Bruce Lee fighter stance as the wave propelled you forward—all of it returned in vivid detail. It was as if salt water had entered my veins.

After Hawaii, my brothers and I joined Bud Cravens Surf Camp, spending unforgettable days on the beach at La Conchita, a quiet, entry-level surf break a few miles north of Ventura. Though far tamer than Malibu, La Conchita gave us our first taste of the surfing life. The drill-sergeant-like Cravens insisted on ten "hop-ups" at water's edge before we could paddle out. He taught us never to grab the rails, to push from the center of the board, to stand "like a boxer."

Between surfs we scarfed down the salami sandwiches Mom packed for us, caught sand crabs and watched them scurry up and down our gleaming surfboards. Sometimes we bushwhacked through the tunnel that ran under Highway 10. My brothers and I were practically entwined. We'd slap five as we'd surf past each other in the shore break and later fall asleep on each other's shoulders on the ride back to Westlake in Cravens's immaculately clean twelve-passenger van.

 ↄ ↄ

Surfing all but consumed Steven and me, but after the initial rush Kevin started to lose interest. Of the three boys, he was the most intellectually curious, reading Hermann Hesse, Malcolm Lowry, Aldous Huxley, and playing Satie, Chopin, and Schubert on piano by the time he was fifteen. When my father read aloud passages from Jack London, Robert Frost, and C. S. Lewis, it was Kevin who came back with questions. When our grandpa told stories of bouncing from gig to gig as a big band musician, Kevin was all ears. And when we pulled into London at the tail end of a family trip through Europe in the summer of '79, Kevin understood that the punk rockers, with spiky hair, safety-pinned noses, and anarchy A's, were on to something more than just looking cool, that they were the beginnings of a cultural revolution.

Our lives were forever changed the night we saw Iggy and the Stooges play the Stardust Ballroom in '79. We'd been listening nonstop to Generation X, Buzzcocks, Dead Boys, and the Sex Pistols since we had gotten back from Europe, but this was our first live show.

Entering the roller-skating rink turned concert venue, I was stunned by the wall-to-wall punks and scared by how evil everyone looked. It was one thing to see this stuff on the inner sleeve of an album; it was quite another to be a thirteen-year-old pressed up against sweaty, pasty strangers in a dingy, smoky, smelly room off Sunset Boulevard with the music thumping at a deafening level. I didn't know that pogoing was such a spastic, violent dance, and though I'd heard of heroin, I had no idea you could accidentally step on nodded-out junkies in the darkness and they'd hardly budge. I remember thinking, *They're dead and no one even cares!*

The way Iggy darted on stage, ripped off his shirt, writhed and contorted, and then flung himself from the rafters somehow managed to evoke sex, violence, and death within the first few bars of the very first song. It became difficult for me to stay on my feet. The push and pull of slam dancing was like the surge and retreat of a powerful shore break, albeit one with elbows, spike bracelets, and the occasional steel-toe boot. A couple times I went down, but as soon as I hit the floor there were ten hands lifting me up. In the middle of the thrashing, I remember a pinch on my thigh and a punk girl reaching out to me through the strobe lights, and a green-haired kid in a ragged T-shirt with "Kill me I've never died before" scrawled on a ragged T-shirt.

Our curfews allowed us to stay for only three songs, but it was enough to create a seismic shift in our little lives. In Earth science class the following morning, I felt smug and superior, as if I'd been privy to a secret world my fellow eighth-graders knew nothing about. I couldn't stop thinking about Iggy's defiant performance and how slam dancing around a mosh pit was oddly comforting.

But for all its subversive allure, punk came at a time when Steven and I were deeply immersed in surfing, devoted to Malibu. Though we'd continue going to shows and would occasionally streak our hair green or blue, nothing was going to pull us away from the beach.

Kevin, on the other hand, was wide open. Puberty had not been kind to him. High school rewarded swagger and brawn, not intellect and sensitivity, particularly at cliquish, judgmental Agoura High. The ever-curious star son who reveled in our parents' praise of his straight-A report cards and exquisite piano recitals sunk into an apathetic torpor. The punk scene was Kevin's antidote.

So while Steven and I stayed home on Friday nights waxing our boards and psyching up for a weekend of surfing, Kevin went to places like the Starwood, the Hong Kong Café,

and Godzillas. And when Steven and I awoke at 6:30 a.m. for dawn patrol, Kevin was just returning from whatever debauchery he was getting up to on the streets of Hollywood.

⁘

Adolescence can sometimes seem like a constant search for a safe haven. Malibu became my refuge, the scene of my best and worst moments.

One of the best was when Larry Bertlemann, Dane Kealoha, and other members of Hawaii's flamboyant Town and Country surf team showed up at Third Point. It changed the way Steven and I thought about waves. No longer was it about posing elegantly in the trim line—now it was about slashing up and down the wave, throwing spray.

In 1980 I surfed my first contest and placed second. I was oblivious to strategy and wave selection, but the thrill was addictive. After that, I got sponsors—McCoy Surfboards and Rip Curl Wetsuits—and started collecting trophies. I discovered a bastard desire and focus I never knew before.

Malibu was also the scene of my bittersweet victory in the Western Surf Association Invitational, something I'll never forget. I'd been on the contest circuit for a couple years, and my bedroom had become a shrine to my pro-surfing dreams. In the corner was my five-foot-six McCoy Lazor Zap with a pink-and-yellow explosion sprayed on the deck. On my walls were posters: Tom Curren blasting out of the lip, Titus Kinimaka standing tall in a tube at Inside Sunset, Gary "Kong" Elkerton in a committed backside hack. On my desk was a stack of contest entry forms and a calendar with nearly every weekend spoken for. On my dresser were roughly twenty-five trophies, many of them for first place. I did sit-ups and push-ups and stretches before bedtime. I fell asleep imagining co-

lossal victories, champagne showers.

The WSA Invitational was an important event. Held in glassy, head-high waves at Third Point, it provided me both home-beach advantage and a chance to prove to my fellow Malibu surfers how far I'd come. To top it off, my sponsors would be there.

In the first ten minutes of the twenty-minute final heat, I racked up three high-scoring waves. The scores settled my nerves and let me get down to some serious wave riding. I outran shimmering, seemingly unmakeable sections, carved dramatic slashes out of dimpled, teal-blue walls, and whipped a dizzyingly quick 360. For the first time in competition, I tapped that dolphinlike, meld-with-the-ocean place that serious surfers aspire to. I won by a large margin. I felt euphoric.

I carried that feeling up to the parking lot, where about fifty sun-reddened surfers huddled around a yellow Vanagon for a makeshift trophy ceremony. David Lansdowne, the pioneering African American surfer, announced the results from sixth place to first. When my name was called to hoots and applause, someone patted me on the back and someone else yelled, "Yeah, Brisick!" I stepped up and received my two-foot-high trophy with a shiny, gold surfer on the top. I was buzzing.

But a few minutes later I saw Kevin, shuffling across the parking lot. He looked unmistakably high.

"You going home anytime soon, James?" he asked. "My asshole ride left me on the side of the road. I need a lift home."

"No," I told him, feeling self-conscious, worried about who was watching. "I'm going out for another surf."

He muttered something, we exchanged unceremonious goodbyes, and he went on his way. I was relieved to see him go. The illusion of sunny optimism I'd managed to project to my sponsors and fellow competitors,

who knew nothing of my home life, was safe for now.

But the facade was cracking.

I think of the day Kevin announced he was trying out for the Agoura High football team. How he pumped iron, drank protein shakes, and flexed in the mirror. It was, with hindsight, a sort of last-ditch effort to feel a sense of belonging. The football team turned him down.

Soon after, he shaved his head into a Travis Bickle Mohawk and fell in with a dodgy, itchy bunch. This crowd seemed less about punk rock defiance than a kind of nihilism. Kevin withdrew from the family. He, Steven, and I carpooled to and from school every day, but we said little to each other. Kevin's life became a mystery.

We got as good at keeping secrets from each other as we did from the outside world. We kids were shielded from how much our parents were struggling, going through what my father would later call "the ennui of twenty years of marriage." My mother remembers taking a long walk with my father on the manicured green belt behind our house, during which she tried to voice her unhappiness. She told my father that if things didn't improve, she would move out. In quintessential, Westlake Village fashion, my parents maintained the illusion of rock solidness. We kids were oblivious. We thought Mom and Dad were spending romantic time together when, in fact, they were discussing the logistics of separation.

There was also a creeping separation between Steven and me. Before surf contests entered the picture we were inseparable. We could stay up all night discussing Larry Bertlemann's iconic cutback or the ballet-like hand jive of Tom Curren's bottom turn. We communicated in codified surf speak that only we understood. "Two peas in a pod," my father said. But the contests changed things. I

did better, got sponsored, and made contacts with players in the surf industry. Steven resented me. It was nothing we talked about, but the rift between us was palpable.

Then there was Jennifer. Seemingly overnight she went from putting Rick Springfield posters on her bedroom wall and writing boys' names in lipstick on her dresser mirror to trying acid and getting hit on by a parade of doctors, actors, and pot dealers fifteen years her senior. She got kicked out of Agoura High and ended up at Indian Hills, a continuation school notorious for its degenerate students. She put the fear of god in Dad, Mom, Kevin, Steven, and me.

I ran for the water and didn't look back.

ᵕ ᵕ

We were blindsided. We knew he was dabbling and I'd heard he'd been seen at a party in the Valley shooting cocaine, but we had no idea how bad it had gotten.

I'm at the house of my friend, John Fiedler, playing Pong with his sister Julie in her pink bedroom when the phone rings. It's the day after my win at the West Coast Championships, an important victory on my road to professional surfing, and I'm full of myself, contemplating greatness. The Go-Go's "We Got the Beat" is playing on the stereo and Julie smells of grape Bubblicious.

Mrs. Fiedler comes in the room. "Jamie, phone for you."

It's my mother. Her voice is shaking. She tells me Kevin has slashed his wrists; he's in the hospital. I feel my stomach clench into a fist, but I try to not betray anything to the Fiedlers.

"I have to go help my dad," I lie.

Kevin looks horrible. His face has a sickly pallor; his lips are oddly purple and chapped. He seems to have shrunk. Kevin's bandaged wrists terrify me. It's taken something like sixty stitches to sew him up, and while the worst of it is buried under layers of gauze, the spray of cuts climbing his forearms make me wince. There is awkward silence, deflected eyes. I feel as if I've stepped into a movie scene, and that whatever comes out of my mouth will sound clichéd. We imagine ourselves as emotional action figures, rising to the moment and taking charge. But it doesn't always happen like that. We lose courage among the gurneys and hospital gowns, become tongue-tied under fluorescent lights.

Back at the house, a trail of blood stretches from the driveway to the foot of the stairs, where my mother had intercepted Kevin. He'd slashed himself with a razor in a nearby alley, driven home, and apparently planned to crawl into bed and never wake up. With a sixth sense that something was wrong, my mother waited up for him.

"Kevin," she called from the top of the stairs in total darkness. "You've cut yourself."

That afternoon, I ride my skateboard to the place where it happened. It looks like a crime scene. A flurry of scarlet shoe prints surrounds a pool of blood on the pavement—was he pacing in circles? Streaks of blood stain a nearby wall—did he try to stamp out the pain in his wrists the way one grinds out a cigarette? I feel squeamish and delicate, as if the slightest graze against even the bluntest object would tear a chunk out of me.

I have a horrific time trying to fall asleep that night. I shut my eyes and see razor blades gouging flesh, blood spurting. And then, in that dreamy state just before slumber, comes a recurring image: I'm riding along in the back seat of a moving car. I open the door, hang my bare foot out, and grind my heel into the pavement. Flesh, bone, cartilage, and blood splatter in a trail of red. It's cartoonish, but so real that when I shudder awake, I reach down to check my foot.

ᵕ ᵕ

Kevin went away to UC Berkeley in the mid-eighties. He fell in love and then swiftly had his heart broken when his girlfriend left him for a woman. Soon after, he OD'd and landed in the hospital again.

The next couple of years turned into a blur of overdoses, rehabs, and parole officers. His addiction trumped everything else in his life. The pattern became all too familiar: a few days or weeks of sobriety, a telephone call to one of his insalubrious friends, then a slip out the front door with a casual, "I'm goin' out for a bit." He'd come back home a few hours later, stoned. We tried an intervention, but all we accomplished was betraying Kevin's trust. After seventy-two hours in rehab he went straight back to using. He did a stint at Ventura County Jail when he was arrested for possession of heroin. Occasionally we'd see flickers of the old Kevin, flashes of the compassion, tenderness, and insight the drugs were burying.

Our relationship was spotty, reduced to brief exchanges in the den or kitchen. Once, Kevin tried to explain to me the lure of heroin. He told me of the time he was loaded, peddling a ten-speed at night. He ran into a curb and went over the handlebars and tore himself up pretty badly. But he was so blissfully high that he felt none of it. What's more, he'd forgotten that he'd been on a bike. He walked home and crawled into bed, oblivious. As he told me this story there was a zealous sparkle in his eyes, as if he'd glimpsed another world, one devoid of pain.

But even the bubble of heroin couldn't keep some things at bay. During a surreal family dinner one night, my parents announced their

divorce. My father broke into tears; my mother spoke clearly and articulately. She and Jennifer would move to a nearby condo; Dad, Kevin, Steven, and I stay put.

I joined the pro tour in '86 and traveled to Japan, South Africa, England, France, Spain, Brazil, Australia, and Hawaii. My surfing heroes were suddenly my peers, and we moved from coast to coast like some sunkissed traveling circus.

It was insanely exciting. I surfed Jeffrey's Bay, spiraling Burleigh Heads and terrifying ten-foot Pipeline. The fraternity of surfers lifted my spirits and ensured that a good chunk of the day was full of laughs. The contests, two a month with prize money for the taking, kept us constantly on the chase. On a Sunday we'd be in Biarritz competing in the Arena Surfmasters; on a Wednesday we'd be in Rio for the first rounds of the Hang Loose Pro.

I had a mediocre first year, scraping by on my meager sponsor wages and picking up the odd $300 for placing in the top half, but the gold-rush mentality was intoxicating. Never before had I felt such a heightened sense of purpose.

I felt safe abroad, where I had no history and could make myself up as I went. I imagined I was a sort of Ivan Lendl–Iggy Pop hybrid. I read *Tennis* magazine to inspire me as an athlete, and *Rolling Stone* to feed my inner rock star. And then I'd come home and be hit with reality.

Dad retreated to his office, where he read and wrote in solitude. Compared to my loud, starry-eyed life, he seemed like a recluse. He dressed sloppily. He had no interest in dating. Instead of the festive meals we once enjoyed as a family, we ate overcooked pasta with canned sauce. The dinner table was forever half empty. The house felt sad and lonely.

Mom and Jenny's condo was just the opposite. Spotless, warm, and potpourri scented, it oozed my moth-er's resolve to carve out a new life for herself. She got her real estate license and was making headway as a mortgage broker. She saw a therapist and read everything she could about drug addiction. Where my mother strived to stay upbeat and maintain a social life, my father delved inward. Where my mother stopped attending Sunday Mass, my father went every day.

Kevin continued to struggle. He worked temp jobs to earn money and talked about going back to school. Because his friends were mostly drug addicts, getting sober would mean solitude, starting over. On his bookshelf was Jimi Hendrix's *'Scuse Me While I Kiss the Sky* next to *Twelve Steps and Twelve Traditions*, on the nightstand a bottle of vitamin E oil. He would rub the ointment into the scars on his wrists as if trying to rub out his past.

Steven and I remained distant. I was sure my adventures on the road would only upset him, so I kept them to myself. Meanwhile, Jennifer was fourteen and raging. When I ran into her at Margarita Night in a Malibu bar, I ratted her out to Mom and Dad.

I spent endless hours in the water, took classes in tae kwon do, and followed the strict high-carb diet promoted in *Eat to Win*. I swam laps and put in daily ten-mile bike rides, peddling so furiously my thighs felt like they would explode. I was sure that the answer to the chaos at home was success on the pro tour. Win a contest, get a massive raise from Quiksilver, buy a modest condo in Malibu, and transform into a superstar athlete, complete with a sports car and long-legged woman.

And then on July 31, 1987, the thing I'd been chasing and the thing I'd been running from collided.

⌣ ⌣

My '87 season started off well, with solid results in Japan and South Af-rica. I was in Oceanside, an expansive beach break north of San Diego, for the Stubbies Pro on the day Dad, Kevin, and Jenny returned from Europe. They had visited Germany, Austria, Yugoslavia, France, Italy, and Switzerland. For the extent of the trip, anyway, they felt close again. Kevin had stayed clean and seemed inspired. He'd spoken of enrolling in German classes and finding a girlfriend.

The Stubbies was my chance to prove to my fellow Californians, sponsors, and the American surf media that I was a force to be reckoned with. And I finally felt like one, too.

While my dad, brother, and sister were clearing customs at LAX, I was beating Australian Bryce Ellis in the second round of heats. And while Kevin was having lunch with my mother in Westlake, a lunch at which she described seeing "the old Kevin, a Kevin full of optimism and clarity and sensitivity," I was surfing against Aussie Mark "Occy" Occhilupo, one of the most famous surfers in the world.

This was around 2 in the afternoon on a hot, cloudless Friday. The Stubbies was a major international pro event, and it seemed like half of Southern California had turned up to watch. The beach was a sea of spectators, and the concrete Oceanside Pier swayed under the weight of fans who cheered our every wave. A group of girls draped a sign over the pier: "We HEART Occy."

I'd never felt so fired up in my life. Every turn, every gesture—shoulders, arms, hands, even fingers—felt magnified. It seemed as though I was both out of my body, observing myself, and never more connected to it. I managed to fit in five off-the-tops on a wave that I'd normally barely manage three on. On another, after a late floater in which I cockily skittered my board to show who's boss, I heard my name shouted by people I did not know.

I lost to Occy, but put up a hell of a fight. It was my biggest result to date.

My mom was dropping off Kevin at my dad's house as I was exiting the water and being mobbed by autograph seekers. Kevin unpacked and made a couple phone calls. Around dinnertime he told my dad he was "goin' out for a bit," and left the house.

I went back to a friend's house where I was staying. A newspaper reporter I'd met earlier in the day called. He asked about my life as a pro surfer. Still glowing, I told him I planned to make the top thirty, then the top sixteen, then who knows? I remembered the profiles I'd read in *Tennis* and *Rolling Stone* and tried to be quotable.

Kevin met someone and scored. Sometime between 8 and 10 p.m., he went to a small lake near Chauncey's restaurant, about two miles from my father's house. Someone saw a body floating face down in shallow water and called the police.

⌣ ⌣

A knock on the door gets my father out of bed at 10:25 p.m.

"Who's there?" he calls from the upstairs window.

"Ventura County sheriffs."

My father greets the two cops in his pajamas. In the dining room, they hand Kevin's driver's license to my father.

"Is this your son?"

"Yes," my father says, staring into the photo.

"I'm sorry to inform you, sir. Your son's body was found in the Chauncey's lake."

"That's not a lake," my father responds, eyes fixed on the photo, "that's a pond."

He calls my mother. She and Jennifer race over, Steven arrives later, and the four of them gather in the living room for what will be the worst night of their lives. According to the autopsy report, Kevin had ingested a mixture of PCP and heroin. I'm asleep on a couch in Carlsbad, dreaming of imminent glory.

The following morning I catch a lift from Oceanside to Malibu, where I plan to surf till dark, then go home to catch up with the family. There is a WSA contest happening at Malibu that day and news of my exploits have already traveled north on the "coconut wireless." I'm treated like the hometown hero. I say "thanks" about fifty times. And it's in this puffed-up state that I run into Tom Maddox, my mother and sister's neighbor, a kid I hardly know.

"Have you talked to your mom?" he asks.

"No, I've been down in Oceanside."

"Well, um, you should call her. Your brother's dead."

His words cut from the inside out. My guts are shredded, but my face holds that stupid, proud smile. I actually thank him for telling me. And then I walk a few paces and think, *There's got to be some mistake. This fuckin' kid doesn't know what he's talking about!*

The stretch between Third Point and the payphones along PCH feels alien—I feel alien. My face is wooden, my ears ring, my legs are noodles. It takes extraordinary effort to walk. It's a blazing Saturday morning and a stream of friends and acquaintances salute me as they head out to Third Point to watch the contest.

Yeeeaaah, Brisick!

Right on, dude!

Good job!

I force smiles, nod greetings, and then put my head down and sprint for the phones.

"Mom, what happened?"

"*Jamieee honeyyy*," she says with that tenderness, that soothing, selfless, maternal stretch of the *eees*. "We've been waiting for your call."

I can hear in her voice that it's true.

"Tell me what happened."

"Where are you?" she asks.

"At Malibu. At the payphones."

"Don't move. Daddy and I are coming right now."

I hang up the phone, delicate, wobbly. I'm standing on a stretch of sidewalk where surfers gather to check the waves. The last thing I want is to run into someone I know.

Across PCH is a scrub-covered slope that overlooks the whole of Malibu. On big south swells, in-the-know photographers use this spot to shoot panoramas of the machine-like waves wrapping around the point. I climb the perch and sit on a rock, hugging my knees, trying to process the news of my brother's death, vacillating between my typical evasions and defenses, and then being bowled over by something like real emotion.

My face is heavy and I want desperately to cry, but instead my thoughts latch on to the OP Pro, which starts in three days. I wonder whether the funeral will interfere with my heat times. I envision my against-all-odds victory and the accompanying headlines: *Tragedy Turns to Triumph*. I hear Mr. Rhee, my former tae kwon do instructor, pushing me the way he did during sit-ups: *C'mon, James, you can do it! Go, James! Go, James!* I think about McEnroe and Lendl—how would they respond to something like this?

Some voice in my head chimes in and tells me that I'm not supposed to be thinking these thoughts. *This is not about you, you selfish fuck!* I try to picture Kevin, but I'm blocked. Then, a deluge of guilt, shame, hole-in-the-stomach, tears.

I look down at my red, patent-leather Adidas high-tops and Quiksilver-stenciled sweatpants and feel just plain disgust.

OUT STEALING PURSES
BY JOHN POWERS

*B*ack in the early 1990s, Spike Lee made a TV commercial as elegant as a koan. You may remember it. The ad is for Nike, and it's little more than Lee's alter ego, Mars Blackmon, asking Michael Jordan why he's the best basketball player in the universe. "Is it the shoes?" he asks over and over. "Is it the shoes?"

This commercial kept coming back to me as I tracked the unfolding saga of the so-called Bling Ring, a crew of five spoiled teenagers from the West Valley's prosperous suburbs—their original stomping ground appears to have been Indian Hills High School in Agoura Hills—who have been charged with committing a series of burglaries that might have been masterminded by a particularly witty professor of cultural studies.

Between the fall of 2008 and late summer of 2009, this enterprising coterie allegedly broke into the empty homes of Paris Hilton, Orlando Bloom, Audrina Patridge, and several other tabloidy celebrities, walking away with more than $3 million worth of jewelry—Rolexes, Louis Vuitton luggage, designer clothes and footwear from the likes of Chanel, Gucci, Prada, Burberry, and Yves Saint Laurent.

What makes their shenanigans unusual is that these kids didn't so much steal the stuff to sell it but to flaunt it; they wore it to Hollywood clubs and parties just as the original owners had. It let them act like they were famous. Although things didn't work out exactly as planned—if convicted, some face up to forty-two years in prison—the Bling Ring did succeed in becoming a popular touchstone with their own *Vanity Fair* coverage. Even as their members are compared to the Cullen family, the stylishly amoral vampire gang in *Twilight*, the thieves have achieved the supreme accolades of celebrity culture. Just like Paris, O. J., and many other great Angelenos, they're having their own tabloid-friendly trial in Los Angeles.

In some sense, the Burglar Bunch (as it was also known) *earned* its temporary fame or notoriety or whatever we now call it when you make headlines for doing something not worth doing. This was, after all, a groundbreaking Digital Age crime spree. Although the gap between rich and poor has grown over the last quarter century, cyber-tools like the Web and Twitter have diminished much of the old distance between celebrities and their followers. Not only did the alleged culprits use the Internet to locate their victims' homes and monitor when they were out—*Ah, Orlando is at a movie premiere!*—they were eventually caught thanks to the same cyber-technology. Once security cameras helped identify a couple of them, the police were able to connect the rest of the group by examining their friending records on Facebook.

If their MO was *au courant*, so was the spree itself, which was tailor-made for a *TMZ* era that oscillates between titillation and sanctimony. Even as the victims were the embodiment of vulgar celebrity (for once, you could fob off Hilton and Lohan as legitimate news), the alleged thieves allowed pundits to break into yet another chorus of, "Kids, what's the matter with kids today?" In fact, for those moralists who think America the new Rome, with reality TV standing in for the Coliseum, everything about this story was manna. Why, one of the arraigned was an *ex-pole dance instructor* who's on a reality show about being a Hollywood party girl! Why, the spiritual "sister" who sprung her from jail on the show (she may have also turned in the gang) has been a *Playboy* Cyber Girl of the Week. Why, even the pole dancer's mother was a former Playmate, who decorated the house with Buddhas from a failing Thai restaurant! In this one house alone, you had enough evidence of cultural collapse to keep David Brooks writing perplexed columns until the Palin presidency.

It didn't hurt that the story took place in Southern California, which has long been reckoned a laboratory—and bellwether—for everything from crackpot religion to crackpot tax policy. Although young people do dumb-ass things all over the globe, when they do them in Los Angeles their crimes take on a special metaphorical resonance. They're treated as emanations of the cultural moment. Thus, the '69 Tate-LaBianca

killings were treated as exposing the darkness in counterculture utopianism. The Billionaire Boys Club in '83 and the Spur Posse in '93 were seen as responses to Reaganism— by murderous rich kids in the first instance and by the raping sons of a fading blue-collar Lakewood in the latter. The Bling Ring slotted perfectly into this socio-narrative arc. Offering comic relief during the huge economic meltdown, their crimes embodied the values of a Bush-era America increasingly divided into winners and losers—if you're not living large, you're nothing.*

Of course, next to the Manson Family, these West Valley clothes-robbers seem so silly that it's hard not to think of Marx's old line about how history repeats itself, the first time as tragedy, the second as farce. Not that this is such a bad thing. Manson burned with hatred for the privileged—he wanted to kill them. The Bling Ring just wants to *be* them. Although I'm old enough to grumble about how shallow our culture has become, it's hard to imagine anyone being nostalgic for the good old days of Helter-Skelter: "Back in the sixties, m'boy, giants ruled the Earth. Our crooks were *visionaries*. They murdered pregnant women to start a race war. They wrote 'Pig' with their victims' blood on the front door. Now, *those* were criminals. Your young crooks today— they just steal purses."

Indeed, they do, and it's one measure of how far youth culture has traveled over the last forty-odd years that such a crime contains no hint of rebellion against a commercialized society hooked on commodities. "Imagine no possessions"—

you've got to be kidding. Far from being an act of *No Logo* anarchy, the Bling Ring members' crimes are a cannonball dive into Logo-centrism. Just like their heroes/victims, they want to wear big-name designer clothes and they want to be *seen* wearing them—even if such display gets them arrested. Better that than being invisible.

Here were crimes that all but announced their subtext. You don't have to be a ranting declinist to see how the profound social changes of the last few decades—in particular, unrestrained capitalism and 24/7 media—have transformed our psyches. We're not only given new things to want, but we're bombarded by manufactured images of manufactured celebrities who already possess manufactured objects of desire and *for that very reason* are treated as important. In such a world, actual achievement counts for less than its trappings, or, as Leo Braudy puts it in *The Frenzy of Renown*, "fame shades imperceptibly into fashion." These days, it *is* the shoes. While it's impossible to be another Michael Jordan—heck, even Kobe can't do it—wearing a new pair of Air Jordans confers instant status. You can be like Mike, and you don't even have to practice.

And, really, isn't that only fair? It's not like most of today's newfangled celebrities—Jon Gosselin or Heidi Montag or big-booty Kardashian—have ever done anything to legitimately claim our attention, let alone our respect. They have no visible talents. They're like yokels who won the lottery and have been pushed in our noses ever since. You could hardly blame the Bling Ring

*One reason L.A. crime stories are thought to be symbolically charged is that they often conform to decades-old cliches about Los Angeles—it's both a sunny Tinseltown *and* a noirish home of the apocalypse. These tiresome tropes have been reinforced by the likes of Joan Didion, whose writing reveals less about the city's actual life than her own inner disarray and detached disdain for ordinary people. Never was this clearer than in her essay "The White Album," which treats the Tate-

for believing that its targets are actually no more entitled to velvet-rope access than they are. I mean, they weren't stealing from Anne Hathaway or Leonardo DiCaprio. They were pillaging the homes of the fading, the chronically ungifted, and the unbelievably lucky: Orlando Bloom, who piggybacked to fame on two hit movie franchises, then proved leaden as a leading man; Lindsay Lohan, who went from bouncy young star to abject lesson in record time; Megan Fox's boyfriend, Brian Austin Green, who, though a longtime TV actor, is currently known as Megan Fox's boyfriend. Above all, there was Hilton, who, as the whole world knows, is even worse at oral sex than acting.

This isn't to say that the Bling Ring viewed its targets with the same dark glee displayed by Harvey "Fagin" Levin and his artless crew of dodgers, or local newscasters, who, getting off their high horses for once, seemed to find it amusing that teenage wannabes were robbing third-rate celebs. (Admit it: these *did* feel like victimless crimes.) True, the kids hit Hilton's place first because, as *Vanity Fair* reported, they thought she was "dumb"—she obliged by leaving her house key under the front doormat and apparently took months to realize she'd been robbed. Yet what's startling is that they genuinely *admired* their victims. Indeed, the gang's alleged ringleader, a Korean American girl named Rachel, stole from Lohan because she idolized her style even though Lohan possesses a reputation in the fashion world as a "brand damager."

While taking Hilton or Lohan as a role model is almost the definition of bad judgment, it can hardly be seen as aberrant in a culture where every new day seems to bring another example of somebody desperately whoring after fame—Balloon Boy's publicity-mad father, those beaming gate-crashers at the Obama White House, Snooki and The Situation from *Jersey Shore*. Things have gone so far that critic Neal Gabler has argued, cleverly if not altogether convincingly, that celebrity is the go-to art form of the 21st century. Talk about the medium being the message.

Nor is the Bling Ring's appetite for designer goods out of keeping with supposedly respectable culture. The craving for things *is* the American mainstream—remember George W. Bush's heady promotion of an "ownership society"?—and has been so since before Zelda and Scott let their ad-inspired dreams lead them to Paris.

Of course, it's all more naked now. Pick up *The New York Times* and you see article after article identifying the good life with luxury items. Open *Entertainment Weekly* and there's "Style Hunter," a whole page devoted to telling people where they can buy the clothes and accessories they've seen adorning their favorite celebrities. Not to mention all the magazines, from the tony *Architectural Digest* to the crass *Robb Report,* devoted almost exclusively to aspirational living.

I don't say any of this to justify the accused—what's to defend about stealing out of envy and a desire for attention?—or to suggest that their crimes are somehow normal.

Most teenagers are not starstruck and logo mad, and most starstruck, logo-mad teenagers manage not to be thieves. Moreover, there is something pathologically creepy about stealing other people's clothes in order to wear them—just ask that nice lady, Patricia Highsmith. I'm sure if I talked to the members of the Bling Ring, I'd want to smack these talented Mr. and Ms. Ripleys for their brain-dead apologetics—*Gee, I didn't realize stealing jewelry was serious*—and a sense of entitlement that would dwarf a stretch Hummer.

Still, I can't bring myself to demonize them, if only because there are so many others I'd rather smack first—paparazzi following reality stars out of nightclubs in hopes that they'll barf on-camera, bloggers snarking away about some brilliant actor's divorce on *Defamer*, local newscasters leading their broadcasts with yet another story about Michael Jackson's doctor, not to mention the moguls who get rich from covering every visible inch of America with the faces of celebrities, most with careers that won't outlast a mayfly. What was the name again of that porn star who bagged Tiger Woods? The Bling Ringers may be parasites, but lifting famous people's clothing strikes me as being a far more creative response to contemporary culture than simply trafficking in their images. More practical, too (unless you get caught). I mean, if you want to live like Paris Hilton, reading her Twitter feed won't help you at all. You're better off stealing her Louboutin heels.

THE SECRET LIVES OF STIFFS
A PHOTO ESSAY BY ANNE FISHBEIN

Mannequins can be headless or missing a limb, but we humans are undiscouraged by these limitations. We can't help seeing ourselves in their molded poses. And if they're doing their jobs, we'll buy the clothes off their backs. At times we walk past these working stiffs without a second glance—their presence is so familiar that we don't question their odd existence. But sometimes a mannequin's outstretched hand, its fingertips seemingly reaching for some kind of connection, give us pause. We search for signs of humanity behind their blank-vessel expressions. On occasion, we find ourselves aroused by their perfect bodies. And if you should ever find yourself in the middle of a gathering of mannequins—in the showroom, for example, at acme display in downtown los angeles, where the inventory that surrounds you includes "female euro-mannequins" with "your choice of wig among 11 styles and four colors," "male euro-mannequins with asian features," "voluptuous mannequins" with pinup bodies, "plus-size mannequins" to reassure our insecure selves, "economy adult mannequins," and especially the children ... The four-year-old girl, the six-year-old boy with arms akimbo and molded hair—you might start to wonder about a mannequin's soul.

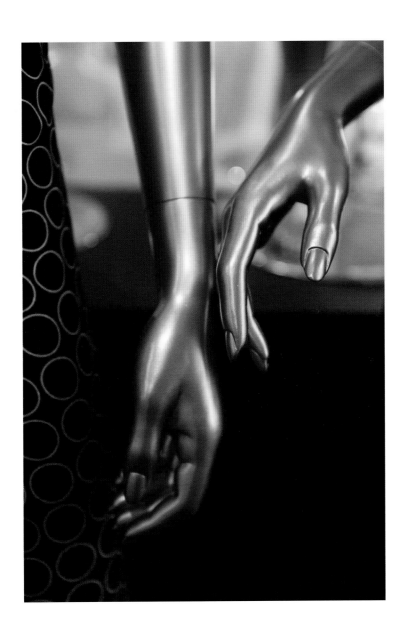

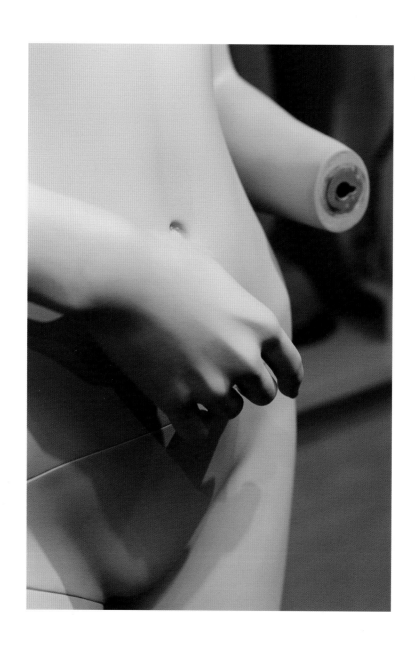

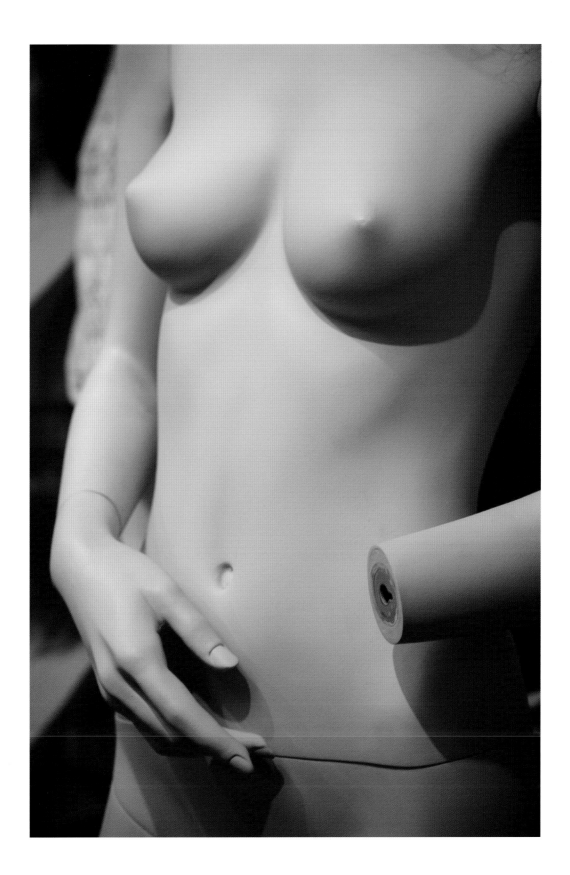

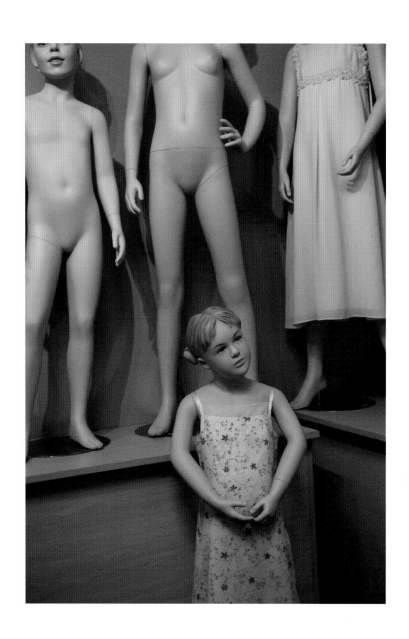

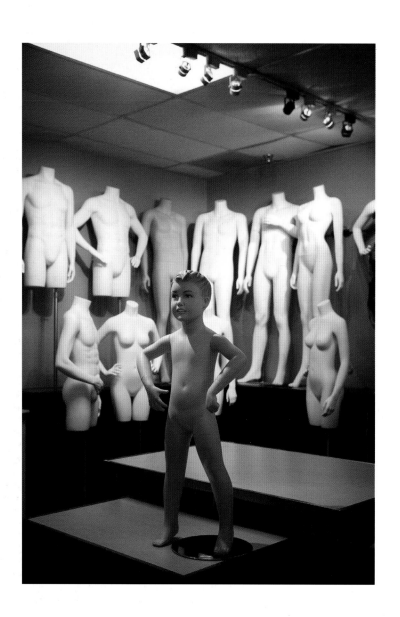

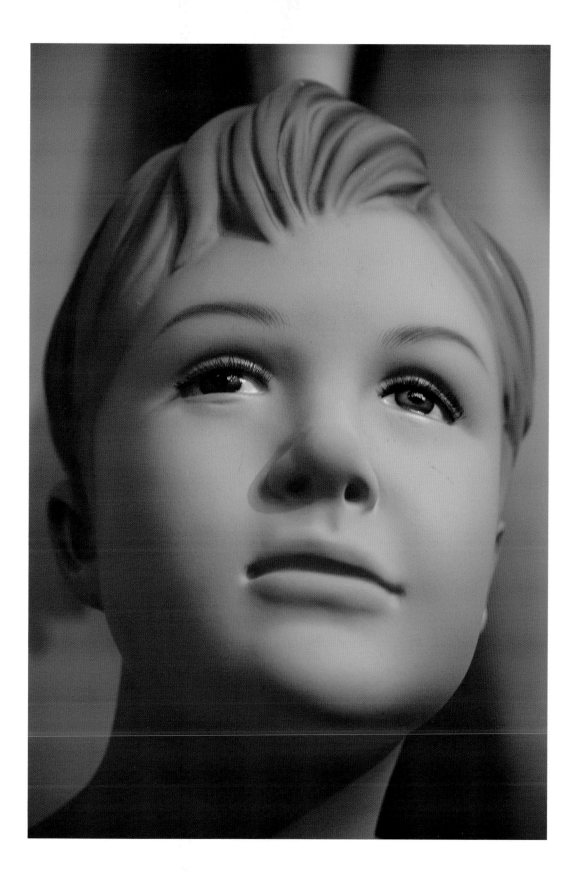

TRIPPING OUT IN NEZAYORK
By Daniel Hernandez

You're not supposed to go to Ciudad Nezahualcóytl, and certainly not alone. Ever since I moved from Los Angeles to Mexico City, people have been telling me that Neza is an out-of-control place. A no-man's-land. The scary "ghetto."

Sounds like an invitation to me.

I love going to Neza. Despite its image, I see why people who live there or were raised there are proud to represent their hood. Neza, just across the border of the Federal District (D.F.), in the state of Mexico, grew in the 1970s out of the arid plains of the former Lago de Texcoco, unplanned, organically, and, by most accounts, quite painfully. Immigrants who poured into the Valley of Mexico from outlying states—mostly Guerrero, Oaxaca, Veracruz, and Michoacan—settled in what would become Ciudad Nezahualcóytl, named after the Texcoco prince-poet whose florid Nahautl verses to this day adorn the walls of government buildings and cultural centers all over Mexico City. Overrun with rubbish, Neza was known for many years as a polluted and violent place. It would be one of the country's biggest cities were it not a part of the vast urban swamp of the Mexico City megalopolis. Today they call it "Neza York."

It's not just a nickname. So many Mexican migrants moved from Neza to New York in the late 1990s and early 2000s that the two cities are joined in many of the same ways that Los Angeles is connected to Oaxaca or Seoul. To live in New York as an immigrant from Mexico City is to live in Neza York, and to live in Ciudad Nezahualcóytl as a migrant returning from New York is to live in Neza York as well. At the same time, in a strange cross-continental cultural exchange, the dominant youth look in

Neza is the California cholo—shaved heads, crisply pressed Dickies slacks, white tees.

It didn't take long after I moved to Mexico City for me to make friends who were either from Neza or who were living there. One of them, Adonai, is a young engineering student at the national university, known as UNAM, and a generally mellow sort of guy with long, curly brown hair and skin the color of mature oak. Smart and observant, he wears beaded jewelry, listens to progressive techno, and sometimes helps out with his friends' band. I call Adonai one Saturday and say I'd like to come to Neza and see what's up.

"Come down," Adonai says. "We can go to a reggae club."

In the core of the D.F., I rarely get to ride in a car that isn't a taxi, but when I arrive on the Metro at Guelatao station, Adonai picks me up in an old Cutlass-like thing, blue with a vinyl top. It's one of his father's cars. I get in and lean back in the passenger seat. The engine barks. The sky is a flat gray. We enter the grid, block after block of wide, long avenues and narrow residential side streets, not a lot of pedestrians but plenty of zooming cars and rows of traffic lights as far as the eye allows. The endlessness reminds me of the San Fernando Valley. It occurs to me that whenever you see unflattering photographs of Mexico City—a vast urban landscape where the horizon is only hinted at beneath a colorless cloud of smog—you're actually looking at Ciudad Neza.

Neza may not be the country's most attractive cityscape, but to me it feels relatively quiet, peaceful, middle class, traditional in that tough barrio sense, where maintaining an atmosphere of "no problems" means

everyone minds their own business until making a "problem" is deemed necessary. Households are built up in post-slum improvisational style, with second- or third-floor appendages, maybe a car port, a workshop or shed built on as families improve their economic standing. The homes I've seen might have a garden, rooftop laundry rooms, large TV sets and stereo systems in the living room; there are altars to the Virgen de Guadalupe on alternating street corners. In Neza, because it sits on what was once a lake bed, the wind blows stronger than in the metropolitan center, and smells worse, too.

Maybe because of its prince-poet namesake, its history, or maybe something else entirely, there is palpable creative energy in Neza. This is where some of the city's best graffiti artists, rappers, and rockers are from. There is a strong sense of community here. In Neza there is an activist bent, a quality to the people and their values that reflect an awareness of a greater cause. In fact, I first met Adonai at an activist meeting at the university. He's a member of Grupo Accion Revolucionaria, a Trotskyist organization at the Faculty of Engineering, whose leaders I came to know. I often stop by their meetings, attend their fundraisers—house parties, reggae concerts—and marvel at how dedicated and earnest the members are. They are future programmers and electrical engineers, "nerds" to the untrained eye, working on achieving their version of justice in the world.

As we ride around Neza and catch up, Adonai stops at a bunch of auto supply shops. He's just bought a used Jetta, but he needs a plug for his Ford Escort. Without much public transit, the culture of the automobile in Neza is strong. Once we get to

Adonai's house, I count six cars in the lot, including a truck and a Mustang. What would Trotsky say? Maybe this: "The workers' state must become wealthier." And so, another vehicle is on the way. Adonai and his brother-in-law, Oscar, just put money down for a minivan to use as a *combi*, a homemade stop-and-go taxi. In Neza, people often have three or four cars per household. They pool money together, buy automobiles, fix them up, and that's just what you do in life.

When Adonai's parents come home, they arrive with bags of groceries, stories from the day. There are hugs, cheek kisses, strong handshakes. While coffee is prepared, I look at all the photos and religious decorations in the house and think that Adonai's home is cozier than most of the ones I've visited in the center of Mexico City, where sleek and modern are the operating principles of home design. Here, on the house's wall out front, facing the street, there is a Southern California-style cholo mural: Emiliano Zapata, an Aztec pyramid, a lowrider, the Wanderers, the words *Los Vagos* in old-school cholo block letters. Adonai's dad tells me that a neighborhood kid who'd spent time in California asked if he could use their home's wall to make it.

"So he brought that style with him," I say. "That cholo style."

"It's a social error," Dad remarks.

Dad asks all the usual questions: where am I from? What am I doing in Mexico City? I tell him that I'm from California, that I was born and raised around San Diego and Tijuana, and that I moved to Mexico City to write a book after living and working five years in Los Angeles. But the answers are more complicated than that. I don't tell Adonai's dad that back in 2002, the summer I was twenty-one,

I first traveled to D.F. to find myself, to figure out if I was really Mexican or really American. To find out where I'm really from. On that trip, I discovered that "finding oneself" is a fool's task.

And yet the Mexican capital did help me realize that if my identity remained unresolved, the possibility existed for me to walk in two worlds at once. And that if I could walk in two worlds at once, I could walk in three, four, forty. Or 400. This became something not to fear but to embrace. Doubt was not a downside, it was a window to more. And so Mexico City, teeming with millions and millions, as surreal as Los Angeles, as majestic as New York, became both my crossroads and my destination.

At the end of that first delirious summer in D.F. I returned to California a different person. In Mexico I learned to see the world with the widest kind of cultural lens, an idea I put into practice as a journalist in Los Angeles. With each new voice and set of experiences rooted and rising up from the streets, I saw cosmic bridges and digital chains being generated between San Diego, Los Angeles, San Francisco, Tijuana, New York, Mexico City, and beyond.

Everywhere I went I saw youth as the underground's agents and its glue. Mexico City beckoned me back. And so I quit my job in Los Angeles, gave up my Echo Park apartment, sold my Honda, skipped out on a steep cellphone bill, and took a one-way flight to the Distrito Federal. I wanted to return and deliver myself completely to the rhythm of the Mexican capital, to *really* figure it out. And I wanted to do it now, while I was still able to insert myself into the tribes of the young, the greasy engine of any national culture.

Outside Adonai's house, the boys are working under the hood of the Escort. I'd nearly forgotten about the intense concentration that is required to work on the insides of an automobile. I remember watching my father and my brothers work on the cars we had—always three or four in the driveway. I see now how much of an art it is. The game, the puzzle you are trying to solve, connecting the dots. The bare-knuckled work.

"I want a car," I say absently to Adonai's dad as we watch. "It's been more than a year since I've had one. I miss having a car."

Ordinarily such a statement wouldn't make sense to the typical Mexico City *chilango*. Cars are more trouble than they're worth. Not to Adonai's dad here in Neza. He is pleased to hear that I long to drive a car.

"Yes," he says. "It's a necessity. It's no longer a luxury."

Finally someone who doesn't think I'm crazy for wanting to drive here.

The plug is in the Escort at last and we go inside for coffee. Classic Mexican homestyle coffee—boiling water and instant Nescafé, with loads of cream and sugar. We chat, we laugh, we hang out.

Here, the slang for hanging out is *cotoreando*, the verb, or *el coto*, the abstract noun version of what you do when you get together, go out, drink, smoke, talk. In Mexico, the young practice *el coto* with absolute devotion and dedication. So it goes almost without saying that I answer "yes" and "yes" when Adonai and Oscar, in his long, unruly dreadlocks, ask if I want to go visit their friend Cesar's tattoo and graffiti shop, and then a reggae-dub club they like called African Star.

Dioselina, Adonai's older sister and Oscar's girlfriend, is the woman in the circle, and therefore must ask her parents if she is allowed to go out. It's a custom that I didn't think was practiced anymore, what they call *buena educación*—"good education." No one seems to mind a bit of formality before starting the night. Dad and Mom say yes and ask that Dioselina return home before it gets too late. It's already dark out. After long deliberation over which automobile to use, or whether to go get Oscar's beat-up VW van, we pile into the Cutlass-like thing again and head out. A listless black dog trails us a bit as we pull out of the yard. Adonai's parents wave cheerily.

In the daytime, Neza feels a bit dreary. All you see, it seems, are auto supply shops. But at night, Neza is alive, animated, electric. People are out. Cops are out. Cars roar and race. One vehicle breaks down and strangers on the nearest sidewalk help the driver push his car where it needs to go. Lights on bars and clubs I hadn't noticed in the harsh, gray daylight glow bright against the Neza grid, coaxing in passersby.

At Cesar's store, we duck below a metal security gate and step into a long white room filled with posters, wristbands, CDs, T-shirts, spray-can caps, graffiti and tattoo magazines, lots of things in black. It's a one-stop shop for the alternative kid, I think to myself. In the middle of the room there is a foosball table. The crew is in the rear, throwing back beers and smoking cigarettes. Someone's kid, maybe nine years old, sleeps under a jacket on a couch.

"This guy is from *el gabacho* and wants to know about graffiti in Neza," Oscar says, introducing me to the others.

Cesar, also known as "Pato" ("Duck"), is a slight guy in a puffy black bomber jacket. His reversed baseball cap covers long, tight cyberpunk braids. Cesar and Oscar are in a band called La Julia. Cesar puts on one of their songs. It sounds just as I imagined it would—heavy metal with traditional Latin beats underneath. A graffiti writer named Shade is hanging out, and he and I chat it up for a while, talking about the history of graffiti in Neza, the major writers. Cesar and Shade tell me that when people come do documentary work on graffiti in Neza, they always talk to the same people, who say the same thing, over and over again.

"Of course," I say. "Because in graffiti the dopest, smartest writers are the ones who want to be as undercover as possible."

We all nod and drink and smoke. We talk about tattoos. We talk about reggae and Rasta. Cesar used to be into Rasta, but turned away, he says, because "ultimately it is a form of racism." Rastas say that for blacks to have glory, whites and mestizos can't exist, Cesar tells me. "This is why I can never understand how some Mexican dudes try to be Rasta." Reggae and Rasta are two very different things, Cesar emphasizes. "Rasta is a religion, reggae is a genre of music."

Midnight comes. It is time to head to the club. The guys close down the shop and we pile into the car and head farther east for the African Star. On Friday nights big names play and deejay, packing in kids from all over the D.F. On Saturday nights it's more relaxed, and mostly local Neza kids go. Adonai is at the wheel. When he sees a cop, everyone tells him, "Relax ... relax." Or, "*Esta* relax."

Police lights appear. Adonai moves to the left lane to avoid any trouble. Cops are a big deal in Mexico City suburbs. Suddenly I feel like I'm in the Valley again or some version of *American Graffiti*, Modesto in the 1960s, my father's day. We're bundled up and squeezed into the car. The windows are foggy. Everyone breathes in everyone else's breath. We coast through the city's grid, the tall street lights. We park near the club. Some girls walk past. Carlos and Ismael from the shop, who seem fairly polite and proper and traditional, hoot at them. "Check them out."

Two dudes walk up to the club wearing dark sunglasses, and our crew, led by Cesar, proceed to mock them. It is as though they are marking their territory. We stand around on the sidewalk and I wonder why we are still outside. When it's finally suitable—for whatever reason—we make our way in darkness up a few narrow stairs and walk into the club, a wide, tall warehouse-like space with exposed beams and several dance floors and balconies. The stage is set high above everything, teetering on a ledge-like industrial outcropping. The lazy bass beats feel good inside me. I catch my breath. I am already happy.

While the rest of the crew wanders about, getting a feel for the space, I head for the bar, which sells only beer and loose cigarettes. When I give the bartender 5 pesos extra for my large beer, she asks, "Do you want a cigarette or something?"

"No."

"This for me?"

"For you," I say.

"Oh. Thank you."

Onstage, a band plays classic, strong, root-down, soul-funk reggae. No Mexican twist. No need to dress it up or dress it down. People dance. A few dudes play aggressively on saxophones. The musicians wear dreadlocks, baggy jeans, white tank tops, sunglasses, and big hats. No one in the crowd is decked out in overdone Rasta gear. There are no Bob Marley T-shirts, no hemp, just regular kids from the hood who want to dance to some reggae on a Saturday night. Our crew makes a circle in the middle of the floor on the lowest level and dance. All of us.

Someone takes out a little wooden one-hitter and we have some more smoke, in front of everyone, in the middle of the club. No one bothers us, maybe because Cesar and Oscar are Neza OGs. And really, why the hell not? This is a reggae club in Neza fucking York. Cesar points out a big mural on the wall behind us—big aerosol portraits of Marcus Garvey, Martin Luther King Jr., the King of Ethiopia—and tells me it was done by Shade and one of his three crews, WAK. In Ciudad Nezahualcóytl, Mexico, the icons of black liberation are blessing our jam.

Dancing, free, I think about the sounds I was raised on, the beats my older siblings fed to me. Lisa and Sandra, cholas back in the day, surrounded me with Latin freestyle, early hip-hop, electro, and R&B. From San Francisco, the Central Valley, and New Orleans, Ernesto brought me ska, post-punk, and new funk. From Tijuana and the barrios of San Diego, Luis Gaston introduced me to Chicano hip-hop and subterranean reggae. Through Sergio, I absorbed classic rock and pure nineties hip-hop from both coasts. Then there were the sounds of Southern

California radio on the way to school, in our rooms, BET on blast every day after school. Now, as I explore the cultural underground of Mexico, these beats come back to me. They echo through the clubs, the parties, the outdoor punk moshing *toquines*. They belong to the archaeology of the moment, the fluidity that exists between North and South, the unifying thump.

What drives us, I realize in-between the African Star, are the in-between spaces, the ripples, and the intersections.

Man, I am so happy. I sit on my hind legs against the mural, and Adonai asks if I want to go lie down in the car. I think about this for a while, which makes Adonai a little uncomfortable.

"Can I?" I finally say.

"I'm only offering out of *educación*," he admits.

This makes me laugh. Here in Neza, if you see someone who seems tired, you offer him a place to rest. You just do it.

I drink more beer. More and more and more beer. More dancing, more beer, more dancing, more beer. More smoke. I am in a trance now. I am dancing with a girl and she is ready to go. We are all dancing. Oscar and Dioselina are in a corner making out lovingly.

When it is time to leave, Adonai, Oscar, and Dioselina decide to give me a ride all the way home to downtown D.F. I tell them I can just take a cab or pass out anywhere. But no. They are determined. "*Pero queremos dar la vuelta.*" They want to go for a ride.

I'm so drunk and delirious at this point that I don't resist. Still, I think to myself, *This could get ugly. What if we get pulled over?*

Dioselina drives. This is a mission. It's past 3 a.m. and we're about to take a journey that is like driving from downtown Los Angeles to Disneyland—without freeways.

As we leave the flatness of the outer suburbs and move into the madness of the city core, I can feel it. It even *smells* different. The city gradually becomes faster, bigger, flashier. Enormous blinking billboards. I think I might be sick.

Almost to Eje Central, the main north-south drag that runs down the very middle of Mexico City, right where I live, Dioselina has to pull over. Something's wrong with the car. They all spring into action, knowing their roles precisely. They must open the hood and do something to the engine! Or to the lighting system! I don't catch it all, I am so drunk. I step out of the car and the high-basin wind whips violently against my face. I muster all my will to avoid vomiting on the sidewalk. I sit down on the curb.

Dioselina, Adonai, and Oscar talk frantically, strategizing. Late-night Mexico City traffic channels alongside us. It seems that a car is not useful to Neza people if it doesn't break down every now and then. You need a car to be *alive*, to be a *thing*.

I want a car! I NEED A CAR.

It's cold. I feel fizzy. Success! The car is working again. We pull up on Eje Central, make a couple turns, and they leave me at my doorstep, Dioselina still at the steering wheel. I feel so grateful. I've never felt safer.

I go upstairs and promptly vomit, excessively. But who cares? It is the happiest, most well-earned vomit I have ejected from my system in a long time. From my balcony, I watch as Dioselina makes a wrong turn onto one-way Victoria Street. The adventure for my friends from Neza is only half complete.

S

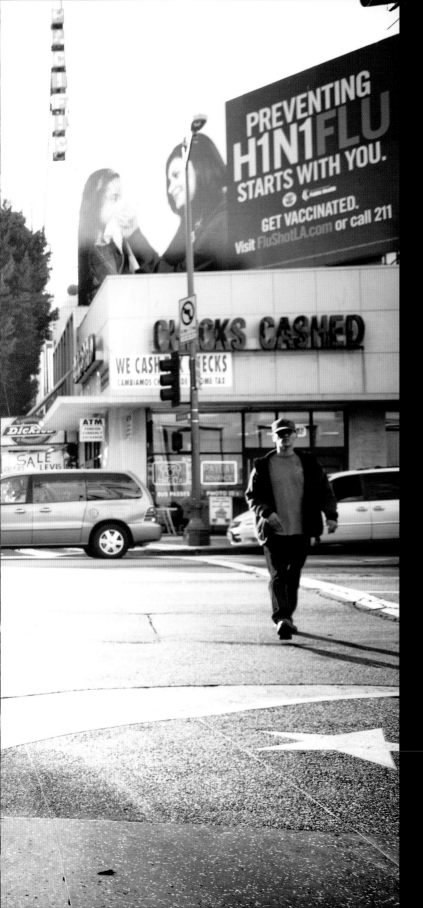

Binomial

By Polly Geller

B: You are very nice, but you are

M: Don't complete that thought

B: I'll try not to think of Mexico.

M: I've been told that before.

B: About the immigrant problem

M: Tea?

B: You forgot to count the stars.

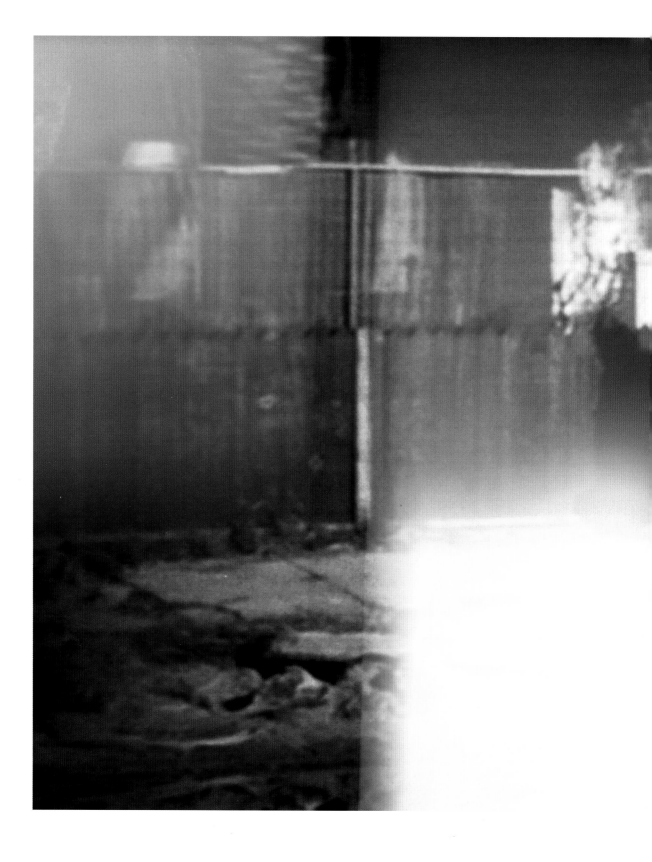

THE
CISCO KID

BY LUKE DAVIES

"How's the ol' universe?"

I am eight years old. I'm given a book of children's poetry. I hurry past the poems. It's the photos that I study, that I want to enter. There's a girl stamping in a puddle, and I feel a terrific yearning for her, so terrific as to be painful. It's that preadolescent anticipation of falling in love, and it's the foreknowledge of the mysteries of sex. In that single image, in that barefoot girl stomping so joyfully in a puddle, there lies the possibility of eternal contentment, possession, surrender, sublimation.

But what else about that photo? It's not the girl; it's not the foreground that matters so much. It's the house behind her that draws my attention, a house distinctly and completely American, the likes of which I've never seen in my own quiet neighborhood. It's a two-story gabled house with a deep front porch. The vernacular of American suburban architecture works as a great entrancing, hypnotic force in my life. I obsess for hours about all the perfection of form in my mother's *House and Gardens*.

An inconceivable mystery: from where I stood as a youngster, the people all around me appeared to be more or less satisfied with the notion that they were living in Australia. They seemed, in fact, to embrace the idea! For me, Australia was a pale simulacrum of what reality should surely have been offering. The thought never crossed my mind that a physical continent—a country, flesh and stone, citizens and states, events taking place with or, more extraordinarily, *without* me present—could in any way be disentangled from the imagination. It was all one world. It was all one country, and it was called America: this place I was living in, in every way except the physical. The way to this land, this America, was television.

I wasn't insane, not at all. I didn't think I *lived* inside television shows. But television stood for that which was even more real than that which was. Television *showed the way*. It was a *design for living*. It was an *aid to the imagination*. It was the bridge of metaphor, or the metaphor of the bridge. It led me to the promised land.

I could understand, at thirteen, understand in some abstract intellectual fashion, that something altogether BBC-ish like *Doctor Who* was a show worth following; these episodes were smart. They contained *story*, in a way that *Gilligan's Island* didn't, not really: *Gilligan's Island* was *situation*. Yet I couldn't stomach *Doctor Who*, whereas *Gilligan's Island* was like a nightly religious ritual. The *Doctor Who* sets were so cheap; sometimes you saw them shake. My imagination was no help here. I never wanted to be reminded of the stage machinery. Americans had budget! There was no stage machinery in America. It was the reality beyond artifice. *The Brady Bunch*, or better still *The Partridge Family*: now those interiors looked real, and solid. You could live somewhere like that and be happy.

"Real" life in Australia was messier. I felt I was on the wrong planet. Ceilings got moldy, and cupboard doors came loose. Something essential and perfect was missing from life. But the puddle girl: surely back in that house behind her, there would be a kitchen filled with all the wonders of the world, all the products in the advertisements in the American magazines. What on Earth was a Hershey's bar? Its unattainability was like a heavy weight on my soul.

"I'm a simple cat, man."

I'm twelve, thirteen. I've lost interest now in *Gilligan's Island* and *Lost in Space*.

I've come to recognize their locales as sets. I've become more spatially aware. Now, I need shows shot largely on location. Thus, reruns of *Room 222* or a new show called *Chico and the Man* are mostly only good for the opening credits. I watch *The Streets of San Francisco*. It's a bipolar viewing experience: whenever the action is inside, on a set, my attention wanders; outside, when the show is on location, I'm all eyes, devouring backgrounds, cars, shopfronts, extras. Where might I live? How will my life turn out? America becomes a slant of light.

I'm allowed to take the train to the cinema on Saturdays. With film, everything is different. With film, you can spend ninety minutes sinking into the "real" America as you might sink into a warm bath. I see *Jaws*, *Macon County Line*, *Dirty Mary Crazy Larry*. Now everything coalesces at once. I discover masturbation. I leapfrog from Steinbeck to *On the Road*. I seem to literally make a decision to become obsessed with drugs, and then I do. And a certain kind of drifting, American B-movie becomes my bible. For a while *Billy Jack* seems like the most important film ever made. *Little Fauss and Big Halsy* makes a kind of existential poetry of the motocross circuit in the Southwestern states. I decide I want to live in a trailer in Arizona after seeing *Electraglide in Blue*.

One summer holiday, I'm with my mother at a mall in Surfers Paradise on Queensland's Gold Coast, and I scan the movies and I know from the poster alone that *Alice Doesn't Live Here Anymore* is the one we need to see. I'm intrigued by Kris Kristofferson for the first time. More and more I am coming to like rootlessness, Arizona, New Mexico.

On the one hand there's this child still in me: I spend hours buried in the

final volume, *W-X-Y-Z-and-Atlas*, of the old set of encyclopedias my father has picked up from a school fete. It's a very American set, an American atlas: there are fifty beautiful, detailed double-page spreads for the fifty states, then about ten pages for the rest of the world. I continually invent the places where I will live. I invent entire networks of high schools, the team colors, team names. I work out obsessive methodologies of gathering quarterback statistics and game scores via a complex system of darts thrown at a target from three feet away. Every time I "move," every time I create a new life (a different double page, a different state), the fantasy begins again. New notebooks get filled with statistics. It's the OCD phase of my life: decisions within my imaginary world are made with obscure, rule-based alphabetical and numbering systems, and a 1970 pro football yearbook I find becomes, for many years, as talismanic as the I Ching.

When we travel north to the Gold Coast for those yearly family holidays, leaving Sydney behind us, the Pacific Ocean is always to the right. So I invert my world and imagine we are traveling south, from San Francisco, through Los Angeles (Brisbane) to warmer climes in San Diego (Surfers Paradise). The east coast of Australia replicates the west coast of America. The ocean remains on the right and, so long as I ignore the fact that we drive on the left-hand side of the road, a kind of plausibility is achieved.

On the other hand: there's the continually frustrating fact that I long to be an adult and yet I have no control over the glacial speed of the passage of time. I've leapfrogged again, now from Kerouac to Faulkner, then on to poetry, and everything has changed, and yet nothing at all. I see myself as a poet from now on.

I feel like an adult. I'm only thirteen. I want older friends. I desperately want to have sex.

The Partridge Family has long receded into the past. I discover Bob Dylan. Then, in *Pat Garrett and Billy the Kid* there's Kris Kristofferson again. I want to be handsome, and soulful, and laconic, like him. When girls take a mysterious liking to me or kiss me, or let me finger them, I don't feel lucky or blessed for all that long; I don't know how to take things in stride. Hovering behind my heightened yearning is the sense that this kissing or this fingering must surely only be some temporary malfunction in the workings of the universe, and that regular anguish will shortly resume. But if I were handsome and soulful and laconic like Kristofferson, then I would not be living in a world of malfunction. The future is waiting for me but not arriving fast enough.

Kristofferson is in *Pat Garrett and Billy the Kid* because Peckinpah cast him after seeing him in *Cisco Pike*, the 1971 B. L. Norton film about a dealer/ex-rock star who gets out of prison and tries to go straight. *Cisco Pike* is a B-film, sitting square in the middle of the hippie-era, outsider-versus-the-system movies that would wind up becoming the psychic sustenance of my adolescence. I don't know what it is that I'm attracted to—it's all instinct. Years later I will see the consistency of aesthetic in these B-movies—that pervasive atmosphere of a world waking all disillusioned and bewildered to a mean, sour hangover after the big party-gone-wrong that was, apparently, the sixties. Not that I would know, since in the sixties I was showered and pajama'ed by 6 p.m. every night.

Something clicks for me with *Cisco Pike*, and it seems to become, however

gradually, the ur-film of my imagined America. "I miss everything/I'll never be," the Smashing Pumpkins will sing years later. And I fall in love, around 1977, with a Venice Beach that B. L. Norton shot seven years earlier, which no doubt no longer exists even as I fall. Venice is the sun-drenched America of all my nostalgia, all my lost dreams.

"You know where the groove is at."

I'm hooked from the opening scenes, as Kristofferson ambles along the dilapidated Venice canals in the late sun, past slightly gone-to-seed houses that look like the kind of shared Sydney houses where I often find myself scoring pot. They are the kind of weatherboard houses I'd been wanting to live in: no longer *House and Garden*, to be sure, no longer that surreal perfection of *Leave It to Beaver*, but still, even in *Cisco Pike*, it's their Americanness that I want. The incidental background of films remains a dominant condition of my viewing them. But now my dreams are more sophisticated. I decide to be, if not handsome and soulful and laconic, then mysterious and aloof and slightly troubled. Hippie chicks like *Cisco Pike's* Joy Bang and just-plain-mad but sexy Viva will surely bed me in rollicking threesomes. One day I will be mysterious, and aloof, and slightly troubled.

I want to live in a world where people speak like the characters in *Cisco Pike*.

"What have you brought me?" asks the man in the guitar shop. "A little coke from Cuzco?"

"I ain't dealin' no more, man," answers Cisco, the first of a constant refrain.

"You mean you *isn't* dealin' no more," the guitar shop man chides. It's one of

those films that takes its languid, minimalist time, and it lets whole songs play out as it rambles. "He's a poet, he's a picker, he's a prophet, he's a pusher," sings Kristofferson. "He's a pilgrim and a preacher and a problem when he's stoned." I've found a model for living.

Cisco lives with flaky girlfriend Sue (Karen Black) in a small, bright apartment across the road from the beach. When we first see her, she's meditating on a table, in the lotus position. Cisco enters, comes up from behind. "How's the ol' universe?" he says into her ear. She remains immobile. He squeezes her breasts and nuzzles her. "Ommm, ommm," he teases, before segueing into, "Ommm, ommm on the range, where the deer and the antelope play" She giggles. Sue believes in astral projection and levitation and yogis who can "make it for twenty-four hours straight." When Dragon calls him, Cisco says, "I'm through. I quit dealing. Yeah, why don't you try Buffalo? I think he's got something. Dig you later, man." This is the territory. To this day I still have no clear idea how tongue-in-cheek it is.

"Are you sorry you quit?" asks Sue.

"No."

"No withdrawal pains?"

"Not on your nellie," says Cisco. "I'm gonna do this thing."

Then we're watching a police parade and funeral, and Officer Leo Holland (Gene Hackman) is among the mourners. Soon Holland steals a hundred kilos of marijuana from some Mexicans, and with threats and coercing and a promise of some help with an upcoming court case, forces Cisco back into business. Holland gives Cisco the weekend only in which to offload the hundred keys for $10,000. It seems an impossibly low price—$100 a kilo, wholesale—even for 1971. But what do I know? (Paja-mas, 6 p.m.) Perhaps Holland is simply in a hurry.

Thus the L.A. travelogue begins. We're with Cisco in his rental car, a guitar case filled with bricks of compressed pot in the back, from Venice to Los Feliz, from Hollywood to the Valley. Cisco presses Officer Holland as to why he's doing this, but Holland is evasive. "You do things and, er … one day you wonder why you're doing things," he muses. Hackman is excellent and sharp in *Cisco Pike*: all bitterness and paranoia. Later, we learn the real reason for his going feral. His medical is coming up, and he knows the tachycardia he's suffering from will have him stood down with less than two years to go before he qualifies for a full pension. Fuck the police, indeed.

There are moments of ludicrous dialogue, but the film's overall effect is not entirely ludicrous. There are moments that are unintentionally funny; I forgive them utterly at fifteen years old, and still do. Doug Sahm (of the Sir Douglas Quintet) is bizarre but hilarious: "You know me though, man, you know, I'm a simple cat, man, I like that simple stuff, man, I mean, you know, you know where the groove is at, that California thing don't get it, that far-out-in-space music, man, play the real thing, man. You know, man?"

Near everything is framed in clichés like this. Sahm's manager wears a suit, says to Cisco, "I saw you guys at the Forum in, what was it, '68?" "Shrine, '67," deadpans Cisco. "Oh, yeah," says the manager. "Big grosser, that show. You haven't done much since then, huh?" Viva (of Warhol's Factory fame), playing a spaced-out pregnant groupie, asks, "Will you sell me a pound?" "Of what?" asks Cisco. "Anything you've got," she says. "I'm not choosy."

But landscape, this celluloid geography, trumps clichéd dialogue any day. I've already lived entire lives in houses glimpsed for a second in the background of *The Streets of San Francisco*, so not much in *Cisco Pike* fazes me. I imagine I might live in a city like Los Angeles, the utterly exotic and the utterly familiar yoked together, the endless ugly sprawl of strip malls and neon.

Every now and again I might need to get my head together, so I'd probably go off to New Mexico for a while. (Doug Sahm to Cisco: "I saw Moss. He said he ran into Jesse in Taos." I'd need to live in a world where phrases like that flowed freely.) I know all about New Mexico from *Whole Earth Catalog* and *Domebook*. I might build a dome one day. There's a porn mag called *Gallery*, and I steal from the newsagent the *Gallery Girl Next Door Annual*, which is basically the pre-Internet version of the "amateur" category, 200 pages of home snapshots sent in by hot, lusty, American women (or their biker boyfriends, more likely). I might one day take my flaxen-tressed, hairy-bushed, cut-off-Levi'd girlfriend and head off to New Mexico to raise kids, grow pot, and live free. I am clueless, and near divine.

"I'm lucky like that!"

"You been using?" Cisco asks his old friend and band member Jesse (Harry Dean Stanton), who has turned up unannounced and doesn't look so great. "A little speed for the drive down here," admits Jesse. "Then I took an upper—no, I took a downer for the up. But I'm ready now, buddy, I'm ready now." They hit the town—Jesse will accompany Cisco in his attempts to offload the bricks. Jesse has a shot of speed before they take off,

and Stanton plays to a tee all the slightly-too-loud and slightly-too-fast, loopily extrapolating on the insurance money he has coming to him as a result of a car accident. "$10,000, just like that," he says. "I'm lucky like that!"

But Jesse frets about his looks. If they get the band back together, what will the crowd make of his wrinkles? "Aw, Jesse, man," says Cisco. "It ain't your goddamned body they're after, man. It's your soul." Jesse has just come from a failure-to-perform in the back seat of a car with groupie Joy Bang after meeting her at a gig at the Troubadour ("God-damned speed, man," he says, "that's why Virginia left"). The ravages of time are weighing heavily on his mind. He will die of a heroin overdose before the movie's end. Jesse makes me sad at sixteen, perhaps because at some un-conscious level I know certain ravages await me, or perhaps because the center of the film, the great art of it, is Kristof-ferson's immortality. Like Pacino in *Dog Day Afternoon*, Kristofferson attains—is granted by the gods—a moment of near-incandescent celluloid beauty. That moment is *Cisco Pike*.

Kristofferson is seventy-three now, and I am forty-eight, though very quickly this information too will be obsolete. For a long while, time stands still. In my twenties, completely be-holden to heroin by this time, I watch American football on TV—you can only see one game once a week at this time in Australia, on a free-to-air sta-tion, around eleven or midnight—and I still wonder if my fantasy might ever come true, that I might be the first Aus-tralian-born quarterback to lead a team to a Super Bowl victory.

I imagine a world in which it would be possible to be a quarterback who was also a good poet.

When I finally make it to America, of course, at thirty-five, everything is both utterly familiar and utterly foreign. It's exciting just being in a supermarket, in the corniest way, to get to touch the packaging at last. And there's that mo-ment of anticlimax, too: the realization that all those cereal boxes, all the shiny mass of commerce and consumerism, telling their stories of a perfect America, that these too are just stage machinery after all. After all that bother! (As when, at the end of *The Wizard of Oz*, the Wiz-ard is unmasked.) And that you are al-ways only wherever you are. And thus that some of Australia has been lost forever, frozen in those times when your head was in America.

In Los Angeles, the lostness of Amer-ica becomes most readily apparent. The signifier is omnipresent, but what it signifies is no longer so evident. The visual detritus of pure consumerism overwhelms the senses. The sameness stretches fractally, everything repeating to scale, to boundaries that are never quite clear; eventually, suddenly, you are simply in Las Vegas, pure money with no product, nothing manufactured there but yearning.

And yet, back west, here is Los An-geles, and here is the ocean. The same ocean that was to my east is now to my west. Not just time, which Einstein told us moves in curves, connects me there to here, but this endless ocean, too. It's been forever since that time when I lived so comprehensively in two-worlds-as-one. Was there a vacuum between me and my life, in which my real life lay unused? Possibly. It was the only life I knew.

One of the movie's posters announc-es: "Cisco Pike is a man of the west—west L.A.!" It seems inadvertently fun-ny now, like the tag line for a remake of *The Fresh Prince of Bel-Air*, but perhaps it meant something quite different for-ty years ago, when Venice was *frontier* as well as end of the road. In *Cisco Pike* there's nowhere farther west to go for Cisco; at the end he's heading east, out into the open space of the desert. I know that axis now: last year for two months I finally made it to New Mexico, looking after a cabin 9,000 feet up in the snows of the Sangre de Christo Mountains outside of Taos. There was no sense any more that life was awaiting me else-where. All that was long gone.

Not everything moves in circles, but all the ellipses and curves are uncan-ny. And the funny thing? There's still something dreamy and sun-drenched about Venice, something as trippy and marginal now as what you glimpse as background, as setting, as visual circum-stance, in *Cisco Pike*. "Algiers," wrote Camus, and he might just as much have been talking about Venice or my belov-ed Bondi Beach, "opens to the sky like a mouth or a wound. In Algiers one loves the commonplace: the sea at the end of every street, a certain volume of sun-light."

I miss everything I'll never be: that is the purest form of nostalgia, the ben-ediction and burden of the common-place. *Cisco Pike* as a dream of light. I haven't lived in Venice yet. I live in Hol-lywood for now, possibly because I want to experience shallowness at depth, pos-sibly because I want to live for a while in the last remaining nineteenth-century gold town on the planet. It will do. I can always take day trips to Venice.

S

LA

WORDS AND PHOTOS BY C.R. STECYK

Will the circle of containment be unbroken? It's jokers wild until the cards run cold. Be the bullet. Your ass is already bet, because you are dwelling on the center dot of the target. Tactically consider the reality of the Angeleno situation: no matter where you live, hide, or pass through in Greater Los Angeles you are in the shadow of military facilities, major defense contractors, and innumerable support personnel. California has 42.7 million acres of federally controlled land. That comprises 43.6 percent of the state. The terror that is already here might be more ominous than any that could be coming.

A line of demarcation across a dry lake bed.
At what height does this navigation marker resolve itself as a directional device?

Down range at Fort Hunter Liggett, a Julia Morgan hacienda once commissioned by the world's richest man is next to a Spanish mission. Over the hills from here, the National Reconnaissance Office commands advanced global investigation systems. The first use of satellites to gather intelligence was executed there. Any spot in California is just a button push away from multiple-phase interdiction.

It used to be easier to read the game board. Gun emplacements on Point Dume and Fort MacArthur, aerospace plants scattered amid think tanks like Rand and Systems Development Corporation, base camps on all the Channel Islands, armories with ceremonial cannons in every civic sector, an AF psyops film studio atop Lookout Mountain, and Nike nuclear missiles poised in Malibu, by Marineland, and on Van Nuys Boulevard. Today Los Angeles Air Force Base is still active in the heart of the megalopolis. And the Southern California Operations Area supports the largest concentration of naval forces in the world. Eyes in the sky overwatch all. And millions of contiguous acres are armored in the desert interior. Our contemporary sustainability strategy is to fire and forget.

God's cruel kingdom is a wilderness of weird populated by snake eaters, spooks, squids, high- and low-altitude jumpers, frogs, grunts, and company men. It is crowded in Indian country. These motivated individuals do not necessarily like you, but they will die for you. Their commitment is built on the understanding that their sacrifice allows you the luxury of hating what they stand for.

When it started I have no clue, but I can pinpoint the exact day I knew it was over. I never planned to take this group of photographs. They were each incidental views, which were indecipherably woven into the landscape tapestry of Los. October 14, 1997, dawn ... I stood on the Edwards AFB flight line. Brigadier General Chuck Yeager pulled up in a blue Cadillac with personalized BELL X1A license plates. We talked briefly during a majestic sunrise over the dry lake bed. That occasion was announced as being Yeager's last supersonic flight. I was certain that I was witnessing the end of the dominance of the military-industrial complex. It was doomed like the dinosaurs. But Chuck did indeed go on to break more sound barriers over the years. Eventually I learned that like all good systems, covert and overt actions reproduce their own kind in perpetuity.

The new minimalism? The wake from a surface-running submarine crosses the bow plank of an aircraft carrier.

B-2 Spirit stealth bombers have flown more than 14,000 sorties to date.

They have a range of 10,000 nautical miles on a single aerial refueling

and are capable of delivering twenty tons of nuclear ordinance.

They cost $2.1 billion apiece in 1997 dollars.

The bad news is that they are always there, everywhere.
The good news is that you need them and cannot escape their area of operations.

SEMPER EN OBSCURUS

The Crescent Tour
A declassified driving guide to Fortress L.A.

Start at the **Los Angeles Air Force Base** in El Segundo and drive north on Highway 1. Just over the Ventura County line, about sixty miles away, is the **Naval Air Weapons Station**, Point Mugu. From there it's just a handful of miles up the coast to the **Naval Construction Battalion Center (CBC)**, Port Hueneme. These bases occupy the coastal end of the Oxnard Plain, "the strawberry capital of the world," across which awaits Camarillo and Thousand Oaks, if you're so inclined. If you're enjoying the coastal vistas, though, you may want to continue north just past Santa Barbara to **Vandenberg Air Force Base**, which encompasses thirty-five miles of pristine coastland between Santa Barbara and Pismo Beach.

At this point, if for some reason you're tiring of the gorgeous Central Coast, head directly east over the coastal range and through the Los Padres National Forest, cross I-5, dodge Lancaster and Palmdale if you can, and arrive at **Edwards Air Force Base**. From there it's just a short hop north and east to the **Naval Air Weapons Station**, China Lake. If boots on the ground, heavy artillery, and sandstorms are more your style, continue east to the **National Training Center** at Fort Irwin, located in a giant swatch of the Mojave Desert just south of Death Valley and midway between Los Angeles and Las Vegas. From there it's just a quick jog south to the **Marine Corps Logistics Base**, Barstow, where you can witness the comings and goings of massive amounts of military matériel.

Logistics are fascinating, but maybe you're wanting to see how those Devil Dogs prepare for the challenges of post-9/11 warfare? Head south on Interstate 40, and just when you need that first bathroom break you'll have arrived at the **Marine Corps Air Ground Combat Center**, Twentynine Palms, gateway to Joshua Tree National Park, or the Morongo Casino Resort and Spa, depending upon your mood.

By now you've probably had enough of the desert's dull hues and relentless sun, but maybe not enough of the few and the proud. Take the blue highways to Palm Springs, pick up Interstate 10 going west for about thirty miles, grab I-215 South to I-15 South at Temecula. Pretty soon you'll be enjoying the cool, ocean breezes and seventeen miles of shoreline at **Marine Corps Base Camp Pendleton**, ideally situated in north San Diego County, between the lovely beach towns of Oceanside to the south and San Clemente to the north. When you're done watching the bombs drop, feel free to surf San Onofre and Trestles, two of Southern California's most-loved breaks.

Your tour of the military ops forming a crescent around Greater Los Angeles is now complete.

— Joe Donnelly

Fun Facts for Your Military-industrial Complex Tour

Compiled from: globalsecurity.org, wikipedia.org, usmilitary.about.com, yosemite.epa.gov

1. Los Angeles Air Force Base, California

Los Angeles Air Force Base, located within El Segundo city limits, is headquarters to the Space and Missile Systems Center (SMC), part of Air Force Space Command. The center is responsible for research, development, acquisition, on-orbit testing, and sustainment of military space and missile systems. In addition to managing Air Force space and missile programs, SMC participates in space programs conducted by other U.S. military services, government agencies, and North Atlantic Treaty Organization allies.

SMC traces its origins to the Western Development Division, created in July 1954. The organization's original mission was to develop intercontinental ballistic missiles, and the results are a proud legacy with the early Atlas, Thor, and Titan of the fifties through the Minuteman of the sixties to the Peacekeeper of the eighties. SMC has been the center of military satellite development since 1956. The center also operates programs such as early warning systems and meteorological, navigation, and communications satellites.

Approximate distance from downtown L.A.: 18 miles. Area: 112 acres.

2. Naval Air Weapons Station, Point Mugu

Point Mugu is part of the Naval Air Warfare Center Weapons Division, the Navy's full-spectrum research, development, test evaluation, and in-service engineering center for weapons systems associated with air warfare (except for antisubmarine warfare systems), missiles and missile subsystems, aircraft weapons integration, and assigned airborne electronic warfare systems. The Warfare Center also maintains and operates the air, land, and sea Naval Western Test Range Complex.

Approximate distance from downtown L.A.: 60 miles. Area: 4,500 acres.

3. Naval Construction Battalion Center, Port Hueneme

Port Hueneme's Surface Warfare Center Division provides testing and evaluation, in-service engineering, and logistics support services for surface combat, including naval mine warfare and weapons systems for nonsubmarine seacraft. Weapons systems include Point Defense, NATO Seasparrow, Harpoon, Tomahawk, and Aegis.

The Surface Warfare Engineering Facility (SWEF) is housed in a five-story, 50,000-square-foot building. The SWEF provides engineering, development, and integration of Navy shipboard offensive and defensive weapons systems. It gives the Navy the ability to safely conduct multiple simulations for the purposes of tactics development, operational evaluation, fault analysis, and training without the cost of taking the systems to sea.

Approximate distance from downtown L.A.: 65 miles. Area: 1,600 acres.

4. Vandenberg Air Force Base

Vandenberg is responsible for satellite launches by military and commercial organizations, as well as testing of intercontinental ballistic missiles, including the Minuteman III ICBMs. Vandenberg is assuming new roles with the creation of the Joint Functional Component Command for Space. The base's location on the Pacific along with its position relative to the jet stream make it easier to launch military and commercial satellites southward into polar orbit. (Polar orbits are rare from the Kennedy Space Center, where launches typically head east, away from major population centers to the north and south.) More than 1,700 launches have been conducted from VAFB since its first launch on December 16, 1958.

Approximate distance from downtown L.A.: 159 miles. Area: 98,000 acres.

5. Edwards Air Force Base

Almost every U.S. military aircraft since the 1950s has been at least partially tested at Edwards. The most recent projects are the F-35 Lightning II, F-22 Raptor, RQ-4 Global Hawk, YAL-1 Airborne Laser, and B-52 synthetic fuel program. The C-17 Globemaster III flight test program is another major project at Edwards AFB. And the Department of Defense's massive development on unmanned aerial vehicles (UAVs) has seen significant testing of prototypes at Edwards.

Approximate distance from downtown L.A.: 100 miles. Area: 301,000 acres.

6. Naval Air Weapons Station, China Lake

The Naval Air Weapons Station is where the Navy and Marine Corps have developed or tested nearly every significant airborne weapons system over the past five decades. China Lake carries out the complete weapon-development process—from basic and applied research through prototype hardware fabrication, test and evaluation, documentation, and fleet and production support. Missiles such as Sidewinder, Shrike, and Walleye are just a few of the many products that have been developed here.

Approximate distance from downtown L.A.: 150 miles. Area: 1.1 million acres.

7. National Training Center, Fort Irwin

As large as Rhode Island, the National Training Center (NTC) at Fort Irwin is the only instrumented training facility in the world that is suitable for force-on-force and live-fire training of heavy brigade-size military forces. The evolving sophistication of military equipment and advances in technology require a comprehensive battlefield that realistically simulates the tempo, range, and intensity of current and future conflicts. The NTC must provide all the necessary components to achieve world-class training.

The depth and width of the battle space gives brigade elements the unique opportunity to exercise all of its elements in a realistic environment. This is often a unit's only opportunity to test its combat service and support elements over a realistic combat distance. Teams must be able to communicate through up to eight communications corridors, evacuate casualties over forty kilometers, and navigate at night in treacherous terrain with few distinguishable roads. Other environmental conditions, such as a forty- to fifty-degree daily temperature range, winds over forty-five knots, and constant exposure to the sun stress every system and soldier to their limits

Approximate distance from downtown L.A.: 150 miles. Area: 642,000 acres.

8. Marine Corps Logistics Base, Barstow

The Marine Corps Logistics Base (MCLB) is within 150 miles of the ports of Los Angeles and San Diego, which are the primary storage and distribution facilities for Marine Corps forces west of the Mississippi and for the Pacific Fleet. MCLB Barstow, at a railroad hub between the ports, is ideally situated to accomplish its mission of supporting U.S. Marine Corps units along the West Coast and in the Pacific.

The city of Barstow functions as the western division point for Santa Fe's Transcontinental mainline and is also served by the Union Pacific's mainline to Los Angeles. MCLB Barstow possesses the largest Department of Defense railhead in the world. The rail and highway transportation network available to MCLB Barstow means that it is located within one day's travel time by road or rail of virtually all the Marine Corps units it serves.

Approximate distance from downtown L.A.: 134 miles. Area: 5,687 acres.

9. Marine Corps Air Ground Combat Center, Twentynine Palms

The base is home to the largest military training area in the nation (and the largest U.S. base in the world), and, consequently, the largest training program. The program known as Mojave Viper has become the model of pre-Operation Iraqi Freedom deployment training. The majority of Marine Corps units will undergo a month in Mojave Viper before deploying to Iraq or a mixed training venue using the Mountain Warfare Training Center for Afghanistan. Live fire, artillery, tank, and close air support exercises are used for training, as is the sprawling "Combat Town," a two-acre fabricated Middle Eastern village, complete with a mosque, native role players, an "IED Alley," and other immersive touches.

Approximate distance from downtown L.A.: 158 miles. Area: 596,000 acres, three-fourths the size of Rhode Island.

10. Marine Corps Base Camp Pendleton

The base's varied topography, combined with its amphibious training areas, inland training ranges and airspace, offers maximum flexibility for Marine Air Ground Task Forces and other service units that require a realistic combat training environment. Each year, more than 40,000 active-duty and 26,000 reserve military personnel from all services use Camp Pendleton's many ranges and training facilities to maintain and sharpen their combat skills. Camp Pendleton offers an array of training opportunities: firing ranges for everything from 9 mm pistols to 155 mm artillery, landing beaches, parachute drop zones, aircraft bombing and strafing ranges, three mock urban warfare towns, and large maneuver areas for training tactical units.

Of all the Marine Corps bases throughout the world, Camp Pendleton has one of the most intriguing pasts, filled with historical charm and vibrancy. Spanish explorers, colorful politicians, herds of thundering cattle, skillful vaqueros, and tough Marines have all contributed to the history of this land.

Approximate distance from downtown L.A.: 70 miles. Area: 125,000 acres.

GOLDEN

THE EDUCATION OF A YOUNG POOTBUTT

BY JERVEY TERVALON

I'm taking my own freedom ... Living my life like it's golden.
—Jill Scott

Wild haired, with an expansive Afro, comics in my back pocket and Arthur C. Clarke's *Childhood's End* in my shoulder bag, I was on the grand adventure of my young life: freshman year at the University of California, Santa Barbara. The moment I drove up from South L.A. and set eyes on San Nicolas dorm, I knew I'd arrived in California's promised land, where State Street was paved with gold and money grew on eucalyptus trees. Or at least it seemed that way when I made my way to the end of the financial-aid line and hit the jackpot: a student worker handed me a check for $500 and told me that all of my expenses were handled—Cal Grant B paid my fees and I would receive a check for $129 a month. I asked the stoner surfer dude what I needed to do with the money from the check, thinking maybe I had to pay some other bill. But he shook his head and said, "Do whatever you want with it. Buy beer."

I put the money in the bank. For one thing, I didn't like beer much. And I couldn't believe that this land-of-plenty stuff would last. Sad to say, I was proven right thirty years later. It's hard to imagine a young pootbutt like me getting a full ride at UC Santa Barbara today.

At that moment, though, on that sun-bathed campus surrounded by cooling breezes from the Pacific Ocean and Santa Ynez Mountains, I felt safe for the very first time. Not having to fear for my life on the increasingly brutal streets of South L.A. was worth more than gold to me. I will say here that those streets might have been brutal, but they were often pretty, jacaranda-lined streets with lemon-and-rosemary-scented air, and spectacular, smog-enhanced sunsets. But my arrival in Santa Barbara wasn't some lucky break—it's how California's public university system was supposed to work.

I've long suspected that I have some kind of reptile inside of me, not a superego or id, but a lizard so lazy that it responds only to the most desirable rewards, the juiciest flies. Somehow, my inner lizard settled on UC Santa Barbara as recompense for an education in the L.A. Unified School District, especially for what I had to go through at Foshay Junior High, where every day was a Kafkaesque institutional nightmare. Now, I fear, a lot more California schools are looking like Foshay misadventures. Who knew then that if you wanted to see the future of California public education that you'd look not to UC Santa Barbara but to Foshay Junior High?

"You want the money?" asked Lamont, the big kid sitting next to me in class.

I did. I wanted the money very much. Fifty cents in 1973 was a gang of change for me; I'd be able to get a cheese toast, a burrito, or one of those sugar-crusted coffee cakes at morning nutrition. But I had to pass.

"I ain't gonna ask you again, you want the money?"

"No," I said. "Thanks."

"You stupid. You could have had 50 cents for free."

Certain there was a trick, I was reluctant to take the money from Lamont because he was big and surly and taking the 50 cents probably meant he got to fire on me, or the money belonged to somebody else who would knock me out to get it back. Lamont lost interest, though, and I went back to reading my modern science textbook.

For a moment it was quiet, then from the corner of my eye I saw someone outside rushing toward our classroom windows. A sweaty-faced woman with a scarf on her head and a plaid shirt came right up to the room's broad, horizontal windows (the kind that don't open all the way) and yelled at us to leave school. Lamont smiled at her as though he were telling her, *Stupid lady, I ain't studying you!* Everybody in the class turned to look.

"Class, get to work. Don't waste time," Mr. Robbs, our big-headed teacher, shouted. But nobody paid any attention to him—more angry people were running toward us and soon they blocked almost the en-tire bank of windows. Just as Mr. Robbs started to close the blinds, Lamont spotted a flying object, popped up, and with his long legs stepped over the desk. I didn't see the brick until it crashed through the window, sending shards every-where. It landed neatly on the desk where Lamont had been sitting, right next to me. Dazed, I sat there, picking glass from my hair.

That was Foshay. We all knew why it happened: the speech a couple days before at one of those crazy-ass assemblies. I hated as-semblies—hundreds of kids in an overcrowded and noisy audito-rium—because you couldn't see somebody chucking an eraser in the dark. People would start throwing things and then a fight would break out and then kids would go really berserk. And I hated when kids went really berserk.

At the assembly two teachers were supposed to give us a talk about free lunch tickets and how we should use them. It seemed the new federal free-lunch program at Foshay wasn't going over too well. Nobody wanted to be seen with those tickets because they were afraid they'd get bagged on. The lunch tickets were left, unused, on homeroom desks, and the school was stuck with boxes and boxes of untouched submarine sandwiches and unopened cartons of chocolate milk.

After we were seated, Mr. Da-vis, a biology teacher with an Afro, and Ms. Harris, a gym teacher who always wore a dashiki, came to the microphone.

"Greetings, brothers and sis-ters," they both said. "Welcome to the black history assembly."

Mr. Davis stepped in front of Ms. Harris and gazed out at us with a profoundly serious look. He was a no-nonsense man who wore a leather jacket and tough-looking boots. Kids whispered he used to be a Black Panther.

"Today, we are going to see a film about the life of Martin Luther King."

Maybe Mr. Davis expected some interest, but everybody car-ried on, talking and laughing.

Ms. Harris stepped in front of the mike and took her shot. "We *were* going to see a film about the life of Martin Luther King, but now we want to discuss with you the importance of the free lunch program. We want to encourage you to use your free lunch tickets. People have worked real hard for you kids to get a good lunch. But those lunches aren't some handout. See, these lunches are owed you. It's nothing you should be embar-rassed about. You're entitled."

"That's right," Mr. Davis said. "When we were freed over a hun-dred years ago, they promised us something for making us slaves and we never got it. You know what they promised us way back then? They promised us forty acres and a mule. Now, y'all might not be too impressed with no mule, but forty acres—that's a whole lot of some-thing."

Now we listened intently, all 800 of us. It got a lot quieter in that huge auditorium. They said

the right thing—what we were supposed to get. That's what we wanted to hear, what we were interested in.

Ms. Harris took the lead now that we were sufficiently warmed up.

"You never gonna see that forty acres. That's just one more promise they broke. And that mule, just what would you do with a mule these days? Some of you might not know why we would be entitled to such things. The president a long time ago promised us land so we can get a start in this country," she said with ever-increasing anger. "We were slaves, we didn't have a pot to pee in and they said they would give us a start. But what we got are these free lunch tickets."

"Y'all shouldn't be ashamed," Mr. Davis said.

"Eat the lunches before they take that away!" they shouted in unison.

That did it. We were hanging on their words. Usually assemblies weren't worth listening to, but this was different; the auditorium was under their total control.

"So come to school!" Ms. Harris and Mr. Davis shouted, and we roared our approval.

"And eat those lunches!"

We roared even more.

"It's your right!"

The auditorium rocked with cheers and claps. Some kids were jumping up and down like in church. A few girls near me were even crying.

The assembly ended too soon.

After Mr. Davis and Ms. Har-ris left the stage and the lights came on, there was Mr. Oak, the principal, telling our teachers to take us back to class. After students did their booing and cursing, the teachers managed to move us out.

At noon, we all lined up to get our forefathers' reparations: a submarine sandwich, an apple, and a four-pack of Oreos. I wanted the lunch, but I couldn't get a ticket—both my parents worked and made too much. That pissed me off because it was the same thing I was paying 50 cents for.

Then Ms. Harris and Mr. Davis were fired.

Those first-period students who had a look at the replacement teachers for Ms. Harris and Mr. Davis got the word out fast. "They got rid of them," I heard somebody say in the crowded, dimly lit hallway, "'cause of those lunches." By noon it was stale news. In my biology class, Mrs. Green, a very uptight black woman who didn't seem to know much about or have much interest in biology, brought up the firing as soon as we were seated.

"You know they fired those teachers because of what they said, because they wanted y'all not to be embarrassed about eating those free lunches."

Some kid raised his hand and said, "They fired them 'cause they black."

Mrs. Green didn't need to answer. All over the school the same opinion was being shared among the black faculty and students. At this junior high school, political action wasn't something the student body was about. We just wanted to get home without getting jacked or stomped. This situation of fearful coexistence changed overnight.

The next school day was tense, like something had to happen. Teachers kept their doors locked and shut, no matter how stuffy the classrooms got—and with all those kids not showering after gym it was especially funky. Some students, the hard-looking ones with the big Afros and the bomber jackets and shiny Levis, stiff from too much starch, and with red or black handkerchiefs dangling from their back pockets, hung outside the gates of the school ready to get into some shit. All of us pootbutt scrubs made wide, cautious detours around them. Sometimes the principal or one of those gym teachers, the true enforcers of authority with their walkie-talkies and coach shirts and shorts, would come up and try to scatter them, but it didn't work. They stayed cohesive, defying the gym teachers.

Nothing happened yet, no rocks were thrown, though soon enough the gangsters started drawing others out of class, even some of us pootbutts. Girls started ditching, too; fine ones, not just the Criplets, chicken-headed mugwug girls who remade themselves into gangster molls. Administrators attempted to gain control, but they had little effect. Finally, the police started roundups, forcing students into the school. But soon as they came in, they'd head around to the other side of the school and hop a fence. In desperation, the principal decid-

ed to chain and padlock the gates of the school so that no one could get in or out. By then, though, parents had gotten wind of the controversy at Foshay and started showing up, trying to get their kids. The locked gates confused and angered them; soon all kinds of people were coming up to the school, even some militant types, including the one who chucked the brick that landed on Lamont's desk.

We were locked in the school, maybe 800 kids and sixty or so teachers, a whole lot of people who didn't feel safe. That's when the fire marshal showed up with a crew of firemen, who spent an hour with big metal shears cutting all the chains and confiscating them.

"Listen," the fire marshal said to the principal, "if you chain these doors again I'll close this school down and have you arrested."

The principal shrank from a big man to somebody knee high, less than a pootbutt scrub. He couldn't do anything about the students ditching class and raising hell on the gym field. He had to worry about nuts and fools getting onto campus or students ditching en masse, so gym teachers were sent to man the entrances, leaving us students on our own with minimal supervision. My desire was to stay out of the way of all this craziness, but we all had to go to the lunch area to get punch and coffee cake and those nasty burritos and submarine sandwiches.

I sat at my usual bench, near where one of the deans of boys usually planted himself to watch the lunch area. He was gone today to work at the hopeless task of keeping out the invaders. Still, lunch seemed pretty calm, no fights or anything. No bunch of boys trying to pull well-developed Mary May Flowers's dress up over her head. Most kids were eating and screaming at each other as always, when suddenly somebody yelled, "Look at this shit, a bug in my sandwich!"

Kids rushed to see, and the guy, a ninth-grader with a peanut head, showed off the sandwich as though it were a war wound. He smiled broadly, exulting in the bug crushed between two pieces of bread, squashed on top of lunch meat and lettuce. Soon he had to stand on a bench so the pressing crowd could see his good luck. Then, when unknowing kids were about to eat their own sandwiches, we screamed for them not to, that those were roach burgers.

"Hey!" someone yelled after getting hit in the head with a flying roach burger. Then they all started flying; a hail of sandwiches fell on us all, thug and pootbutt alike. The food fight got crazier with only a few adults around to make half-hearted attempts to end it.

The craziness spilled away from the lunch area and out to the gym field—a big expanse of asphalt in the center of the school. The pootbutts were the first to scatter at the sight of a wave of food fighters with rock-hard burritos, cocked and ready to fling. But some weren't cowering; the hurt ones, the ugly kids who hung out among themselves on the bleachers near the fence, came pounding down the steps, serious as heart attacks. Ugly guys and girls—fat and short haired, skinny and short haired, all with bad teeth, rushed in, throwing blows at the turf invaders, dead set on defending their precious isolation. All thoughts about the fired teachers dissipated into the free-floating rage that hung over Foshay.

The bell rang, but nobody responded. They stayed out there and fought until they got sick of busted heads and knuckles. Teachers were happy to see empty classes after the tardy bell rang, and hurried to shut doors and lock students out of classrooms.

I sat out there with Roy, a kid more shell shocked than I was, wondering when the fighting would slow down or when we would truly be in danger.

The principal finally just gave up. No one was in class. Fools were trying to sneak into the school, while we were trying to flee from food fights and riots. Coach Ken appeared with a megaphone and announced the retreat.

"School is canceled. Exit on Exposition. School is canceled. Leave immediately!"

That did it. Students stopped all that fighting nonsense; burritos dropped from clenched hands and were trampled as we deserted the school.

It wasn't over. The Exposition Street exit let out into a pretty rough neighborhood, blocks away from the path I usually took home. We moved like a herd, hoping for protection in numbers, but I lived

east so I broke off in that direction with some gangbangers I was on good terms with and a dozen or so other stragglers. We were about two blocks south of Western when we saw another bunch of kids running at us, or if not at us, away from something. We started running like spooked wildebeest, fleeing in all directions, racing for higher ground if it could be found. Finally I made it to Second Avenue, exhausted and bitter for having had to work so hard to travel such a short distance.

"What was all that up at Foshay?" my brother Jude asked as I came into the house. I ignored him, turned on the television, and settled onto the couch.

I was safe, at least until school tomorrow, but the school slowly became a ghost town. More and more kids stayed away until only a handful of us walked halls empty enough for tumbleweeds to roll through.

Mama heard about me sneaking off to school from Jude. She called from work to see if I was there and Jude said something like, "He ain't here. He went to school. He never does what you want him to."

"If you go back to that school, I'm gonna come up there and pull you by your hair all the way home," Mama said after she heard how dangerous Foshay had become.

And so I didn't go to school for a couple weeks. I stayed home, watched TV, and hung out in academic exile.

But soon enough I graduated to Dorsey High and continued on until I reached UCSB, where I

missed the start of the rock-cocaine epidemic in my old neighborhood and how it made a difficult world impossibly more so, culminating in the 1992 riot/uprising. Instead, I hung out with artists and scientists, dated women from affluent families, saw that I didn't need to be rich to live a rich life—unless I wanted to live really close to the beach. (And with a sufficient number of roommates, I could afford to get close enough to the beach to at least see the ocean.)

After I graduated I lingered in Santa Barbara for years, not wanting to return to Los Angeles, but eventually it seemed necessary, so I decided to teach. I was hired at Locke High School, where students lived in conditions that were far worse than what I had experienced at Foshay, where sudden, deadly violence was a constant threat. I talked to many of the students about seeing the world, about going to college, and some did. One former student studies computer science at UC Santa Barbara; another graduated from UC Berkeley and returned to teach at Locke.

Timing can be everything, and the California I knew when I first attended UCSB many years ago was still golden. Now it doesn't even seem shiny; it's more like unrecyclable plastic. In a post-Prop. 209 world, where affirmative action is now a historic anomaly, far fewer African Americans and non-Asian minorities attend UC schools. And it's only going to get

harder. Instead of rationally solving the state's budget problems, our politicians keep jacking up fees, putting us on the path to privatizing our best public universities.

Things aren't much better in the Cal State system, where I taught happily for years. The Cal States graduate most of our teachers, mechanical engineers, and nurses, but we're making those degrees ever more unaffordable at a time when we have more working-class students in need of a quality higher education. Now that California is a majority minority state, what worked to create prosperity for the majority white population in the twentieth century is now out of reach. The unfairness is a kind of educational apartheid.

Maybe it's only a coincidence that the minority coalition that opposes education funding increases in California is overwhelmingly white. It might be the first time in our history that an ethnic minority could help determine the economic fate of the majority of Californians. Tea baggers can bag all the tea they'd like, but they need to take their hands off of our education. I can't stand to think of all those kids who, because their families aren't rich or connected, won't have the experiences that I had, that meant so much to me and made my life infinitely better. It's time to start listening to the likes of Mr. Davis and Ms. Harris again. It's time to get militant about it: education through any means necessary.

S

SEPARATION

FICTION

BY MICHELLE HUNEVEN

was in bed with Herbie when the loud knocking started. It was the middle of the afternoon.

What the hell? Herbie said, pulling a pillow over his head.

We waited for it to stop. It didn't.

Maybe my car's blocking a garage, I said. Knotting my bathrobe, I answered the door. My mother stepped into the threshold.

I've had it with your father, she said.

Hang on just a second, Mom.

I mean it, she said, brushing past me and into the living room. A short and tanned woman with a cap of mink-brown hair showing just a few glistening threads of white, she pivoted and surveyed my one-bedroom, bungalow-court apartment. In her hand was a small plaid suitcase.

Stay right there, I said, and slipped into my bedroom, closing the door behind me.

My mom, I whispered. Herbie yanked on his jeans. There was no question of an introduction; Herbie was too new to my life and far too shy to meet my mother, especially under these circumstances. Go through the bathroom, I said. Shirtless, Herbie, all six-foot-two and 240 pounds of him, scuttled off.

Just getting dressed, Mom!

She opened my bedroom door a crack. I've had it up to here, she said.

I'll be right out! I unsnarled bedclothes, thumped pillows.

Is somebody in there with you? she asked.

No, Mom, I said, and opened the door wide to prove it.

What happened in China, Mom?

She and my dad had just come back from a twenty-one-day group tour.

We were in my dining room and sitting at the pine table I'd bought for $25 at an antique store, my first major furniture purchase. I was twenty-six, a poet, and still living like a student.

He wore the same filthy shirt for four days in a row, my mother said. It stank. He didn't change it even though I begged. And all he could talk about was when he hopped freight trains at seventeen. It was boxcars and switching yards at every meal. Thirty years ago those stories were stale! Of course, whenever I tried to say anything he

cut me off. And he criticized me nonstop. In front of everyone.

He's always been like that, I said.

I will never go anywhere or do anything with him again.

I felt a quick scorch of dread. My mother was sixty-one, which seemed very old to me, far too old to start a new life. Also, she had inoperable cancer, a rare kind of tumor in her liver that was so slow growing, the doctors said that something else would kill her first, probably. To be on the safe side, she went in for chemotherapy every four months.

When she was first diagnosed five years ago, she and my dad left Pasadena for a retirement community in Carpinteria. They bought one of the smaller apartments because they planned to travel ten months each year. Since then they had been to England and Scotland, all over Europe, to New Zealand and Australia, and now China. Turkey and Costa Rica were coming up.

What about Turkey and Costa Rica? I said.

Not going. My mother picked up her suitcase and took it into the bedroom.

That's fine, I said. You can sleep in there.

It's a big bed, my mother said. I don't mean to dispossess you.

The thought of sleeping with my mother filled me with physical revulsion. Her dry, spotty skin. Her yellowed toenails.

That's okay. I'll sleep in the living room, I said. I had a futon sofa, which I'd intercepted on its way to the dump.

She had done this before. Once, when my sister and I were teenagers, she stormed out of the house and hadn't come back for thirty-six hours. When I was away at college, she left my dad for a weekend. Both times she went to her cousin Ginger's house in Claremont. But Ginger had moved up to Puget Sound and my sister lived in London. That left me in Pasadena, at Braithway Court.

That first night, I cooked linguine with canned tuna and fresh lemon zest and made a green salad for our dinner. I poured us each a glass of bargain-bin Orvieto.

For three weeks I didn't have five minutes away from him, she said. He stuck to me like glue. And he never stopped talking for one minute.

My father did like to hold forth. His subjects included geology, the Marxist view of capitalism, and his life as a teenage hobo. Once he'd stopped by my apartment when I was giving a dinner party. He took a chair and, in the slow drawl of a school science film, said: 7 million years ago where we're now sitting was a trough in a deep sea.... He gave us the entire geological history of the Transverse Ranges as we ate. Nobody else got a word in edgewise. For dessert, he described the Army Corps of Engineers' flood control systems.

To this day, if there is an awkward silence, or a person is being particularly boring, one of my friends will drawl, seven million years ago....

My mother had been an energetic fifth-grade teacher. Now, when she wasn't traveling, she sewed *Vogue difficile* patterns and cooked complicated recipes from *Gourmet* magazine. She read five mystery novels a week, and every day she talked to her three best friends—Betty, Evelyn, and Alma—on the phone. Betty lived in the same retirement community. Evelyn and Alma were here in Pasadena.

She would probably stay forty-eight hours, I thought. At most.

I poured myself another glass of wine.

You drink too much, my mother said.

And you shouldn't drink at all, I said.

I know, I know. She held out her glass for more. Do you have a TV?

No. I read.

That's good, she said. I brought a book.

I didn't tell her that I hung out with friends at night. I didn't want to bring her along. I thought of our nightly courtyard gatherings as my true life, the life I was supposed to live, as opposed to the life I'd come from. As opposed to her.

I wanted a life of writing and publishing. I planned to make a name for myself. She didn't trust that my poetry would lead to anything: it was too abstract, she said, too oblique and formless. She'd been after me to follow in her footsteps and get my teaching certificate.

My mother took her book to the spot on the futon sofa by the reading lamp. I read in the battered wing chair, using light from the overhead fixture.

Braithway Court had been built early in the twentieth century for wintering Midwesterners. A guidebook called it "the city's best example of Japanese and Swiss-inspired Arts and Crafts bungalow architecture." My apartment had the original alabaster sconces and teak built-ins. When I first moved in, my mother came for a look-see. Oh, Iris, she'd said, as if exhausted. It's so dim. Maybe if you painted the woodwork white

My friends and I lived there amicably alongside the older residents. My friend Tillie was the manager, so whenever an old-timer died she made sure someone else we knew moved in. The neighborhood had gone downhill, so rents were affordable for people like us, who were trying to get started at what we meant to do: writing, painting, costume design, acting, or, in the case of Tillie's husband, atmospheric physics. Nobody else had a full-time job or much money. At night we wandered into each other's homes to eat and talk and drink cheap wine.

Around 8:30 I said, Aren't you going to call Dad and tell him where you are?

Why? she said.

We read in the living room until she began to yawn. I'm going to sleep, she said, and went into my bedroom, leaving the door ajar. Too lazy to unfold the futon, I spread out sheets and a quilt on its sofa seat. My mother began to snore. I closed her door. I could still hear her snoring. I went out on the front porch and stood looking out at dark bushes, the night sky. I could still hear her snoring. Down at the end of the courtyard, in Tillie's upstairs apartment, lights were on, humans were gathered, and white slivers of light glinted on wineglasses. I headed down, pausing every few yards to see if I could still hear my mother sawing logs. Not until I mounted the steps of the back building did the usual night noises—the distant hum of the city, cars going by, breezes and crickets—swallow her impressive racket.

Herbie met me at the door as I came in. He blocked my way so I had to mash against him to get inside. He clasped me around the waist. He was an actor. I was surprised how many bit parts a shy, aging ex-football player could get. I'd suggested he was talented and he said, actually, the great old

director George Cukor told him, You don't have talent, son, you have a gift.

We'd spent four nights together so far—not successive—all at my place. Herbie had a small one-bedroom unit and a roommate. They'd agreed not to have women over.

How long's she going to be here? he said into my hair.

A day or two, I said, and we went to join friends drinking wine by the fire.

When I came home, the message light winked on my phone machine. I turned down the volume and listened, my ear pressed to the grid of black holes.

Elsa? my father called my mother's name. Are you there? Elsa? Please pick up. Elsa, I know you're there. You have to talk to me sometime. Why not now? Okay. I'll call back tomorrow. I hope you're having fun.

In the morning I heard her in the bathroom so I got up and made coffee. She sat at the table drinking it. She wore my bathrobe.

Dad called last night, I said.

I heard, she said.

You weren't tempted to talk?

I've wasted enough time on him.

She began writing something down on my phone pad.

What's that? I said.

I like half and half in my coffee, she said, and rye bread. Tell me what else we need in the way of food. Don't worry. I'll pull my weight around here.

How long do you think you'll stay?

As long as you'll have me, she said. Don't worry. I'll keep out of your hair. She waved at my sparse living room. You could use some rent relief.

I cleared the table. My mother moved to the floor by the sofa and sat cross legged with her hands cupped upward on her knees. In addition to the chemo, she practiced visualization to combat her cancer. For half an hour, her eyes shut behind her glasses, she visualized healthy cells decimating cancer cells like Hannibal's elephants trampling Roman infantry.

I went to work, four hours a day at a nursery school where I was responsible for art, yard duty, story time, and snack. When I got home, my mother had Herbie lugging

in sacks from her car.

She had gone to Fedco and to Prebles Produce. She'd bought herself a firm pillow and one of those fat upholstered cushions with arms for sitting up in bed. She'd bought a brass floor lamp with a flexible gooseneck, and a matching table lamp. She liked new things, shiny, contemporary, and cheap.

I followed Herbie out to her car, ostensibly to help him carry in more stuff. He looked sulky, lips drawn down.

What's wrong? I said.

How are we ever going to see each other now?

It won't be that long, I said.

When Herbie left, my mother said, He follows you around like a puppy.

She'd bought rag rugs for the kitchen, a rubberized bath mat, cat food, kitty litter, and a litter box.

What's this? I said, nudging the cat stuff with my foot.

A kitten is better than television, she said.

My father was allergic, so we'd never had cats. No pets were allowed in Braithway Court, either, but I didn't expect my mother to know this because illegal cats sat on the walls like Egyptian figurines and lolled on the walkways, baring their fat bellies.

As my mother put away her purchases, I played phone messages loudly.

Iris, my father said. I know your mother's there. Where else would she go? Don't encourage her. She is not a healthy woman. No fair the two of you ganging up on me.

He hung up. Then he must have phoned right back. Elsa, if you need a few days off, that's okay. I can make do. Kick up your heels. Take Iris out to eat, put it on the card. Don't forget your appointment tomorrow.

You have an appointment tomorrow? I said. What time?

Never you mind, she said.

She set a new chrome napkin holder and new clear plastic salt and pepper grinders on the dining room table.

Mom, I said, this is actually my desk. Can we keep those in the kitchen?

Why carry them in and out each time we eat? Just push them back by the window. They won't bother you there. See? Now, shall we go?

Go where?

The kitten, she said.

At the Humane Society we picked out a friendly, slim, all-black kitten who had to be neutered before we could bring him home. We agreed to come back for him the following afternoon.

My mother insisted she could drive herself to her 8 a.m. chemotherapy appointment in Hollywood.

I'll stay there till I feel well enough to drive, she said. But when she went out to her car, the battery had been stolen.

I could've walked up the street and bought her battery back from the place that sold used hubcaps, tires, and batteries, but I didn't have the nerve. So I phoned the nursery school, explained what had happened, and drove her into Hollywood. While she was getting chemo, I went to a Pep Boys and bought a new battery. From a payphone outside the hospital I called Tillie and asked if my mother could rent a parking space back behind the court.

Tillie said, Of course. How long is she staying with you?

I don't know, I said. She's left my dad.

That's heavy.

I'm trying not to think too much about it, I said.

I didn't mention the pending cat to Tillie. She was management, and I didn't want to put her on the spot.

Back at the hospital, my father was sitting in a chair by the front desk in the lobby. At seventy-two, he was still a tall, fit man with an extremely handsome, craggy face. Thirty-five years ago that face had turned my mother's head. He jumped to his feet when he saw me.

You can go, he said. I've got it from here.

I better clear it with Mom.

She's not done yet.

Does she know you're here?

Don't you worry. This is between us.

I was tempted to leave them to each other, and perhaps I should have. But Mom deserved her options. Also, she'd promised to reimburse me for my lost day's work and

the new battery. And then there was the coming cat.

I sat beside my father. You should've changed your shirt in China, I said.

There was nothing wrong with my shirt.

Except Mom didn't like it. Isn't that reason enough?

Oh hell, he said. Hells bells. For crying in the bucket.

My mother came walking toward us. She looked wan and unsteady, precisely as if she'd just been infused with deadly chemicals. She carried a little plastic throw-up bag. Let's go, she said, coming up to me.

Elsa, my father said, I drove all the way in.

Nobody asked you to, she said.

Outside, my mother turned and whispered to me, Go get the car. I'll wait here.

She sat on a bench under the porte cochere. My father sat next to her. I crossed the street and went into the parking structure. By the time I drove up, my mother was by herself. In the car, she slouched down in the seat. Go! she said. Now!

How'd you get rid of Dad?

I gave you a good long lead time, then asked him to get me some water.

You tricked him! I cried.

He took my battery, she said. I'm sure of it.

The kitten galloped through the house like a little horse. At the sight of himself in the full-length mirror, he sprang straight into the air, a fluffed up, arched-back fraidy cat. He mastered the litter box instantly. He pounced on flies and dust bunnies, scaled the curtains and hung there, swaying. He was a traveling ink spot, a graphic pleasure. My mother bought him new toys daily: a feather on a springy wire, a terry-cloth snake, a hard plastic ball with chimes inside. We named him Wally.

Those shoes have seen better days, she said of my favorite loafers. Yet before I could protest, she added, Let's go get you some new shoes.

The next day, she said, You'd be such a pretty girl if you only got a decent haircut. Call your beautician, see if she can fit you in.

The shower curtain was replaced, as were my car tires. She bought black-out blinds for the bedroom. Towels. A stack of murder mysteries from Vroman's Bookstore grew on her nightstand. I gave her my spare key. She began to see her old friends. I came home to notes. At lunch with Evelyn. At movies with Alma.

Most nights, she was home for dinner. You are a good darn cook, she said to me. I'm getting spoiled. And fat.

Her arms and legs were terribly thin, but she did have a rounded belly.

We'd wash up together, then we'd make a fire, watch the kitten, and read. Around nine o'clock, my mother started nodding off and went to bed. As soon as she started to snore, I crept out of the house and went in search of my friends.

She's still here, said Herbie.

True.

It does put a crimp on things.

She has cancer, I said.

Your mother is having an affair.

Don't be ridiculous, Dad.

I thought, Who would ever have an affair with a sixty-one-year-old woman with cancer? I said, What makes you think so?

I ran into her at Vroman's and she was furious. She hissed at me. Told me to get lost! I'm sure she was meeting someone and didn't want him to see me.

You were in Pasadena? At Vroman's? How did you know she'd be there?

Never you mind, missy, he said.

You're stalking her! I cried. First the battery and now this. You better be careful, Dad, or she'll get a restraining order. I'm not kidding. She would.

Oh for god's sake, my father said.

Leave her alone, Dad. It's your only hope. Then maybe she'll forget what a jerk you are, and start missing you.

He was quiet, but only for a moment. Then he started shouting. Oh what the hell do you know about anything?

I came home from work to find her on the living room floor unsnarling some nylon straps and twanging metal springs that turned out to be some gizmo to tighten

abdominal muscles. We're both a little plump in the middle, she said.

Speak for yourself, I said. Then, eyeing her midriff, I had a bad thought. Mom, I said, did you see the doctor when you had your chemo?

Of course, she said.

And he says you're all right? I couldn't bring myself to ask if she'd actually shown him her belly, so I patted mine.

So far so good, she said. You know, you should at least wear colors. You look like a little gray bird. Come, let's go to Penneys.

No, Mom, I said. I won't go to Penneys. And you have to stop criticizing me. I can't take it.

Am I criticizing you? I thought I was being generous.

My father's calls and stalking stopped. Not another peep.

Herbie and I carried the futon sofa to the street—it was gone in an hour—and a boxy little gray sofa bed, brand new, sat in its place. I slept there, unfolding it every night to find my pillow flat as a record album. Ugly gingham potholders and sturdy stainless steel filled the kitchen drawers. Scratching posts appeared in the living room and bedroom. Herbie stacked a quarter cord of split firewood neatly on the front porch. A new electric kettle—red enamel—whistled on the counter. Little was to my taste, but all was superior to what I'd had. When a new fire screen replaced the antique one I picked up at the Pasadena swapper, I went and dug the old one from the trash.

Too far! I cried. You can't completely take over my life. I like antiques. I like old dark things. I *am* a little gray bird. You have to accept that.

If you don't want me here, Iris, I'll leave.

That's not what I'm saying. But you have to live with me, and my taste, at least a little.

I thought I was doing that! she said, and then she did what everyone else in my family did whenever I asked them to stop hurting my feelings: she burst into tears. You don't know what it's like, she sobbed, with the sword of Damocles hanging over

your head all the time.

I don't! I said, infuriated. And I'm sorry you do. But I didn't give you cancer, and I don't have to give up every shred of who I am because you're sick.

She suddenly seemed very pale and very small.

I'm going out, I said.

I went over to Herbie's. We have to have sex, I said. Right now.

But Justin's coming home any minute.

I don't care. Let's do it in the bathtub.

I'm too big, he said.

Tillie will let us use her guestroom, I said. Come on.

Herbie blushed and shook his head. I can't do that. I just can't.

My mother and I were careful around each other for a few days, and then she bought me a down comforter and a brand new Smith Corona typewriter. I preferred the touch and clatter of my old black Remington, but I feigned pleasure to keep the peace.

She lived with me for two more weeks, a month in all. One night she said, I hate to think of the mess your father has made in that condominium.

I came home from work to a note on the dining room table. *I will always treasure this time we had together. Love, Mom.*

The Remington came out of the closet, the Smith Corona went in.

She never did take another trip with my father. When he brought up Costa Rica or Turkey, she wouldn't discuss it. Then she got too sick. Her belly continued to swell, filled—as I'd suspected—with fluids produced by the tumor. Four months after she left my apartment, she was dead.

Wally, the cat, lived for sixteen years.

I never slept with Herbie again. By the time my mother left he'd already taken up with a script supervisor who had her own apartment. I see him on TV; he's a dad in a sitcom; a police officer or thug on a crime show.

I have written two books of poetry and teach English and poetry at a private girls school in Pasadena.

I went into Vroman's Bookstore on my lunch hour not too long ago and was standing in the gift section, letting my eyes adjust to the soft lighting within, when three women in coats brushed past me. One looked exactly like my mother. Her hair was grayer, her face more collapsed; uncharacteristically, she wore a dress under her coat, with hose and thick heels. Blinking among the wind chimes and small statuary, I was hit by crazy hope: she was not dead after all, but had been in Pasadena all these twenty years, living a life full of books and friends, without us.

The three women bustled into the book stacks. Ringing like a bell from shock, I started after them. They clustered around an end display in the biography section and pointed out titles, commenting: I read Mussolini wasn't very bright.... Oh, my sister went to school with Earl Warren.

A touch on one back—*excuse me!*— and they would've broken apart, turned to face me.

I let them be.

My father is alive and hale, but his memory is murky. He talks at length about his childhood, and occasionally can tick off all the countries he has visited. He remembers that I write and live in Pasadena, and recently he asked about some old friends there: Alma Markle? Randall and Evelyn Ellington?

Still kicking, I said, heartened that such small, coherent scraps of his life persisted.

And tell me, he said, with a familiar bright, sly look. Do you hear anything from Elsa?

Elsa? I said. My voice tensed. Elsa who?

My Elsa. He leaned closer. I made her mad, and she left. But not a day goes by that I don't wonder how she is. Tell me, do you ever run in to her?

His face was still craggy and handsome, his eyes sparkled. He nudged my knee.

I didn't have the heart to renew our old sorrow.

Funny you should ask. I saw her in Vroman's just the other day.

33.

By Ray DiPalma

Sitting in the portico of a derelict office building
lit by the mix of neon signs from the boulevard
as serene as the glow from an altar lamp
the handcuffed man was alert
his reflexes fixed in an immutable cycle
because of all the secrets he knew

Individual traits and external expedients, pauses and omissions—
the imaginary tracks of compulsive reality and fine detail,
an investment in contradictions
caught between layers of purple and scarlet light
amid the eerie scent of cold smoke

To see inside, past columns in every direction—
cardboard and fleece, what else is there?
without meaning—or resolution—
what resolve? exonerate what?
thought left—*emerging out of the moment*
falling backward in suspension without the charm of unexpectedness
having run out of the moment to which it had answered

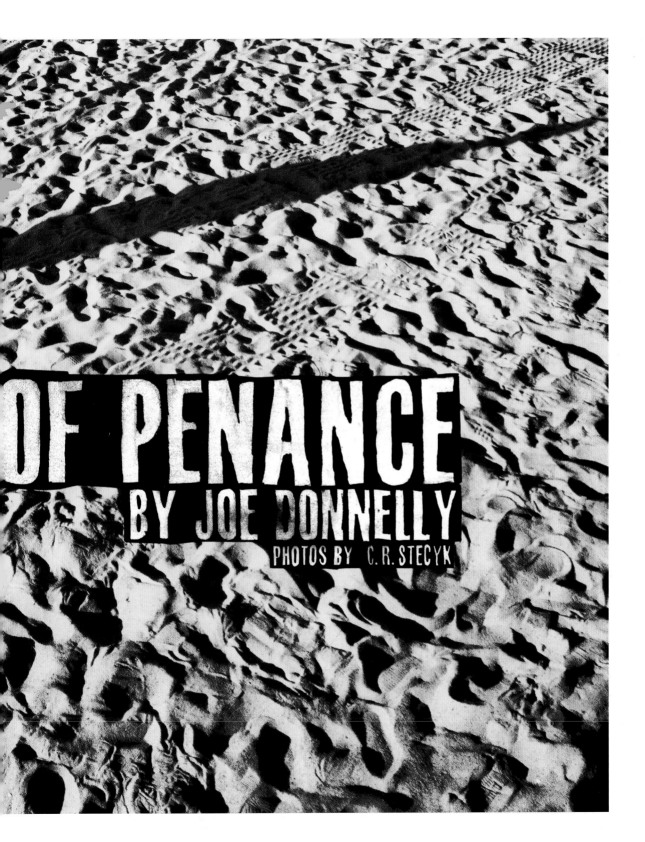

OF PENANCE

BY JOE DONNELLY

PHOTOS BY C.R. STECYK

Mystic Beginnings

When Lorey Smith was 12 years old, her father loaded her and her brother into his black 1965 Mustang and drove them down the Pacific Coast Highway to this cool little shop called Mystic Arts World. The store sold arts and crafts, organic food and clothing, books about Eastern philosophy, and other things, too. Lorey's father knew some of the guys who ran Mystic Arts and he thought the outing would be a nice diversion for the kids. It was a short drive from Huntington Beach but an exotic destination, at least for the girl in the back seat.

The year was 1969, and Laguna Beach, once the sleepy refuge of surfers, artists, and bohemians of little consequence, was a center of counterculture foment after a band of outlaws and outcasts went up a mountain with LSD and came down as messengers of love, peace and the transformational qualities of acid and hash. They called themselves the Brotherhood of Eternal Love, and Mystic Arts World was their public face, a hippie hangout where vegetarianism, Buddhism, meditation and all sorts of Aquarian ideals spread like gospel.

Lorey says she felt like Alice in Wonderland when she crossed the threshold and entered Mystic Arts. "It was like walking into a different world," she tells me 40 years later. "Everything from what was on the walls to the way people were dressed gave off this feeling of love, and, like, freedom."

Her father bought the kids some beads to keep them busy and Lorey fashioned a necklace. She walked up to a big, handsome guy with long hair and handed it to him.

"He opened up his hands, took the beads and had this big, beaming smile," she recalls, "and I just felt like, love, and I thought, *Someday I want to marry someone like that.*"

Into the Gran Azul

Security guards armed with machine guns patrol the grounds of the Gran Azul resort in Lima, Peru. It's the kind of place you have to know someone to even get close. But on an early winter day in 1975, Eddie Padilla, one of the founders of the Brotherhood of Eternal Love, has no trouble booking a room. He is a familiar face on a familiar errand.

Checking in with Padilla are Richard Brewer, a Brother from way back, and their friend James Thomason. "I chose Richard because he's a good guy," Padilla remembers. "He'll get your back. He's not going to run away. That played out in a way that I never, ever expected." Thomason is along for the ride—to party and taste some first-class Peruvian flake.

As the manager walks the men to their bungalow, he delivers a strange message. "Your friend is here," he says.

"Friend?" Padilla asks. "What friend?"

As soon as the manager says the name Fastie, Padilla curses. He's known the guy since high school where Fastie earned his nickname because he always knew the shortest distance to a quick buck. As far as Padilla is concerned, Fastie is a flashy, loud-mouthed whoremonger—the worst kind of smuggler. Padilla told him not to come to Lima while he was there. To make matters worse, Fastie's girlfriend is with him, and she has a crush on Padilla. When they run into her, she complains that Fastie has been taking off and leaving her at the hotel.

"She knows he's been going to see whores and coking out," Padilla says. "We're like, *Oh, god.*" Prostitutes and police are thick as thieves in places like Lima, Peru.

Still, there's no reason to be paranoid. "All I have to do is spend the night, pick up the coke, give it to a few people, and peel out in 24 hours," Padilla remembers thinking. Everything was set up ahead of time; the deal should be an in-and-out affair.

Though they had agreed to keep a low profile, Padilla, Brewer, and Thomason decide to go to the compound's bar that night. It's an upscale place and they get all dressed up. Fastie is there. Things are tense and Padilla knows better than to dance with Fastie's girlfriend. But when she asks, something won't let him say no. Maybe he just wants to rub Fastie's face in it. Maybe he's the guy who has to let everyone know he can have the girl. Whatever it is, when they get off the floor, Fastie isn't amused.

"All of a sudden, in a jealous rage, he gets up, scrapes everyone's drinks off the bar, and throws a drink on [his girlfriend]," Padilla says. "The bouncer, some Jamaican dude, kicks him out."

Fastie returns to his room and tosses his girlfriend's belongings out the window. She ends up spending the night in Padilla's bungalow.

The next morning, the girlfriend leaves to retrieve her belongings. She never comes back. Fastie isn't anywhere to be seen either.

If they'd been reading the signs, they might have waited until things settled down to pick up the coke. Instead, Padilla and Brewer stay on schedule and head to a nearby safe house for their load—25 kilos of cocaine worth nearly $200,000—and return to the bungalow without a hitch. Things seem to be back on track.

"It's so fresh, it's still damp," Padilla says. "So I've got it on these big, silver serving trays, sitting on a table. James is making a paper of coke [think to-go cup]. Bob Dylan's *Blood on the Tracks* is playing. Richard's doing something … I don't know what. And I'm writing down numbers. All of the sudden, the door opens. I look and all I see is a chrome-plated .32. *Oh, shit.* I just thought, wow, my life just ended."

The Making of Eddie Padilla

Thirty-four years later, Eddie Padilla emerges from Burbank's Bob Hope Airport into a balmy Los Angeles autumn night. He has a well-groomed goatee, a shiny, bald dome, and a nose that clearly hasn't dodged every punch. Wearing

a black jacket and tidy slacks, Padilla is muscular and sturdy at 64. He walks like a slightly wounded panther and offers a knuckle-crushing handshake. "Hey, man, thanks for coming to get me," he says with a lingering SoCal-hippie-surfer accent.

We grab a coffee. Padilla speaks softly, with an economy that could be taken for either circumspection or shyness. The circumspection would be mutual. I had been approached about Padilla through his literary agents; they'd been unsuccessfully shopping his memoir. Right away, I was skeptical. Padilla's story was epic, harrowing, and hard to believe. Aggravating my suspicions was the memoir's aggrandizing tone. Plus, I'm not a fan of hippies and their justifications for what often seems like plain irresponsibility or selfishness. Still, I have to admit, if even half of his story is true, Eddie Padilla would be the real-life Zelig of America's late 20th-century drug history. And, as is apparent from his first handshake, he has Clint Eastwood charisma to go with his tale.

I drop Padilla off at one of those high-gloss condo complexes in Woodland Hills that seem designed especially for mid-level rappers, porn stars, and athletes. His son, Eric, manages the place. Though Padilla lives a short flight away in Northern California, he has never been here before. Tonight marks the first time in nine years that he will see his son. For 20 years now, Padilla has been literally and figuratively working on reclaiming his narrative. Reuniting with his son is part of that effort. I may be too, and I'm not sure how I feel about it.

As we approach, Padilla falls silent, unsure of what to expect. Eric is waiting outside the lobby when we pull up. He looks like a younger, slightly smaller version of Padilla. They greet each other with wide smiles and nervous hugs. I leave them to it.

I pick Padilla up the next morning to go surfing. He's in good spirits. The reunion with his son went well. Plus,

he hasn't been in the water for a while and surfing is one of the few passions left from his earlier days.

Out at County Line, it's a crystalline day with offshore winds and a decent swell kicking in. For Padilla, I've brought my spare board, a big, fancy log that would be cumbersome for most on a head-high day at County Line. Padilla inspects the long board like it's a foreign object.

"I don't know about this," he says. "How about if I take your board and you use this one?" Worried about the danger I'd pose to others and myself, I refuse. "Okay, then," he smiles, and we paddle out.

Padilla's reservations disappear as soon as the first set rolls in. He digs for the first wave, a fat, beautifully shaped A-frame. He deftly drops in, stays high on the shoulder, slips into the pocket and makes his way down the line, chewing up every ounce of the wave. It's one of the best rides I see all day. But he's not done. Padilla catches wave after wave, surfing with a fluidity and grace that puts most of us out here to shame.

Exhausted after a couple hours, I get out of the water. When Padilla finally comes in, he is grinning ear to ear. "Who'd have thought I'd have to go from Santa Cruz to Los Angeles to find some good waves?" he jokes.

Buoyed by the return to his natural habitat, Padilla lets his guard down and begins to tell me about his life, over lunch at an upscale chain restaurant in Santa Monica. Though Padilla is forty years her senior, the attractive waitress is definitely flirting with him. Whatever it is that makes women melt, Padilla has it. He's magnetic and likeable. As for his story, it could stand as a metaphor for the past few turbulent decades—the naïve idealism of flower power, the hedonism of the 1970s and '80s, the psychosis and cynicism of the war on drugs, and the recovery culture of more recent times. It's a story that's hard to imagine beginning anywhere but in Southern California

Edward James Padilla was born in 1944 in the same Compton house where his father, Joe Padilla, was raised. Joe, a dashing Navy guy of Hispanic, Native American, and African-American ancestry, married Helen Ruth McClesky, a Scots-Irish beauty from a rough clan of Texas ranch hands who moved to Southern California, near Turlock, during the Dust Bowl.

Both family trees have their troubled histories. Joe's mother killed herself when Joe was 12. The family broke apart after that and Joe had to fend for himself through the Depression. "He had no idea what it was even like to have a mother," Padilla says.

Helen's father turned to moonshining and bootlegging in California. Padilla recalls how his grandfather liked to show off the hole in his leg. As the story goes, Federal agents shot him during a car chase. Padilla raises his leg and imitates his grandfather's crotchety voice: "That goddamn bullet went through this leg and into that one."

When his grandfather finally ended up in prison, the family moved down to South Los Angeles where work could be found in the nearby shipyards. Padilla says his mother and father met in high school, "fell desperately in love," and got married. This didn't please the old man, who didn't want his daughter mixing with "Mexicans and niggers." Helen found both in one.

As the son of a mixed-race couple before such things were in vogue, Padilla got it from all sides. He wasn't Mexican enough for the Mexicans, white enough for the whites, or black enough for the blacks. He was also a frail kid who spent nine months with polio in a children's ward.

Padilla would get beaten up at school, and for consolation his father would make him put on boxing gloves and head out to the garage for lessons with dad, a Golden Glove boxer and light heavyweight in the Navy.

"If I turned my back, he'd kick me," Padilla says about his father, who died

in 2001. "He was trying to teach me how to fight the world. My dad was a different kind of guy."

The family moved to Anaheim when Padilla was 12. There, he says, he became aware of the sort of prejudice that you can't solve with fists, the sort that keeps a kid from getting a job at Disneyland like the rest of his friends.

"That's when I started really getting ahold of the idea that, hey, I'm not being treated like everybody else. I'm sure I had a chip on my shoulder."

Padilla got into a lot of fights, got kicked out of schools and wound up in juvenile hall where he received an education in selling speed, downers, and pot. By the time he was 17, Padilla was making enough as a dealer to afford his own apartment and car. But it wasn't exactly the good life. He was doing a lot of speed, and one day he got arrested for what must have been an adolescent speed freak's idea of seduction.

"I started taking handfuls of speed and I got so crazy. I mean, I got arrested for exposing myself to older women because *just do that and we'll have sex.* That's how psychotic I was."

To make matters worse, he got in a fight with the arresting officer. The incident landed him 13 months at Atascadero State Hospital in San Luis Obispo. He came out feeling like he needed some stability in his life, or at least an 18-year-old's version of it.

"*I need to get married and settle down and be a pot dealer.* I remember clearly thinking that. So, I married my friend, Eileen."

Padilla and Eileen were 18 when they married on August 22, 1962. Marriage, though, didn't solve certain problems—like how to get a job, which was now even tougher with a stint in a psych ward added to his résumé.

"It would have been really cool if I could walk in somewhere and get a job that actually paid enough to pay rent and live, but from where I was coming from, I'd be lucky to get a job sweeping floors," he says. "I tried everything. So,

it was easy to start selling pot."

He turned out to be good at it.

Mountain High

Eddie Padilla turned 21 in 1965. Cultural historians wouldn't declare the arrival of the Summer of Love for a couple of years, but for Padilla and a group of trailblazing friends, it was already in full swing.

He figures he was already the biggest pot dealer in Anaheim by this time. For a kid who grew up watching *The Untouchables* and dreaming of being a mobster, this might be considered an achievement. But something else was going on, too. The drugs he was selling were getting harder and his lifestyle coarser.

He started sleeping with several women from the apartment complex where he and his wife lived. He spent a lot of time in a notorious tough-guy bar called The Stables. "That's where I started being comfortable," Padilla says. "This is where I belonged. Social outcasts for sure."

Eileen eventually had enough and took off for her mother's. But it wasn't just the philandering. Padilla also had an aura of escalating violence about him.

"I had a gun. I felt like I was going down the road to shooting someone, just like hitting someone is a big step for some people. So, that's kind of insane. I was going to shoot someone just to get it over with. It doesn't matter who, either."

Then, early on the morning of his 21st birthday, one of his friends picked him up and drove him to the top of Mount Palomar. Joining them was John Griggs, a Laguna Beach pot dealer and the leader of a biker gang whose introduction to LSD had come when his gang raided a Hollywood producer's party and took the acid. On the mountain with them were several others who would soon embark on one of the 1960s' most influential and least un-

derstood counterculture experiments, the Brotherhood of Eternal Love. They climbed to the mountaintop and dropped the acid. Padilla says he was changed immediately.

"I was completely convinced that I'd died on that mountain," he remembers. "It was crystal-clear air, perfect for taking acid. I came down a different person. It was what's called an ego death. I saw the light. I can't ever explain it."

A birthday party was already set with a lot of his old friends for later that night. Back home, in the middle of the celebration Padilla says he looked around at the guests, some of the hardest-partying, toughest folks around, and realized he didn't ever want to see those people again. He took the velvet painting of the devil off his wall and threw it in the dumpster. He dumped the bowls of reds and bennies laid out like chips and salsa down the toilet. He kept his pot.

"I went up the mountain with no morals or scruples, a very dangerous and violent person," he says, "and came down with morals and scruples."

From that day on, a core group of hustlers, dealers, bikers, and surfers, who at best could be said to have lived on the margins of polite society, started convening to take acid together.

"Every time we'd go and take LSD out in nature or out in the desert or up on the mountain, it would be just this incredible wonderful day," Padilla says. They were transformed, he claims, from tough cases, many of them doing hard drugs, to people with love in their hearts.

Things moved fast back then. The Vietnam War was raging; revolution was in the air, and the group that first started tripping on mountaintops wanted to be a part of it. Under the guidance of John Griggs, by most accounts the spiritual leader of the Brotherhood, they decided they needed to spread their acid-fueled revelations. In the foothills of the Santa Ana Mountains, they took

over a Modjeska Canyon house that used to be a church and started having meetings. Soon, they were talking about co-ops and organic living; they were worshipping nature and preaching the gospel of finding peace and love through LSD.

The Brotherhood of Eternal Love incorporated as a church in October 1966, ten days after California banned LSD. The Brothers petitioned the state for the legal use of pot, acid, psilocybin and mescaline as their sacraments. They started a vegan restaurant and gave away free meals. They opened Mystic Arts World, which quickly became the unofficial headquarters for the counterculture movement crystallizing among the surfers and artists of Laguna Beach.

The Brotherhood proved both industrious and ambitious. Soon, they were developing laboratories to cook up a new, better brand of LSD, and opening up unprecedented networks to smuggle tons of hash out of Afghanistan. They were also canny; they carved out the bellies of surfboards and loaded them with pot and hash. They made passport fraud an art form, and became adept at clearing border weigh stations loaded down with surf gear and other disposable weight, which they'd dump on the other side so they could return with the same weight in pot stuffed into hollowed-out VW panel trucks. In their own way, they were the underground rock stars of the psychedelic revolution.

Soon, their skills and chutzpah attracted the attention of another psychedelic revolutionary. By 1967, Timothy Leary was living up in the canyons around Laguna Beach carrying on a symbiotic, some would say parasitic, relationship with Griggs. Leary called Griggs "the holiest man in America," And more than anyone else, the Brothers implemented Leary's message to *turn on, tune in, drop out.*

"The Brotherhood were the folks who actually put that command into action and tried to carry it out," says Nick Schou, author of *Orange Sunshine: The Brotherhood of Eternal Love and Its Quest to Spread Peace, Love, and Acid to the World.* "Their home-grown acid, Orange Sunshine, was about three times more powerful than anything the hippies were using. They were responsible for distributing more acid than anyone in America. In the beginning, at least, they had the best of intentions."

The group, Schou says, was heavily influenced by the utopian ideals of Aldous Huxley's *Island.*

"There was a definite plan to move to an island," Padilla says. "We were going to grow pot on the island and we were going to import it. *We need a yacht and we need to learn how to grow food and farm, and we need to learn how to deliver babies…* We were just little kids from Anaheim. God, these were big thoughts, big thoughts."

The End of Eternal Love

Around the time Leary was setting up camp in Laguna Beach, the island ideal took on a new urgency for Padilla. No longer just a local dealer, he'd made serious connections in Mexico and was moving large quantities around the region. In one deal, Padilla drove to San Francisco in dense fog with 500 pounds of Mexican weed. But something didn't feel right. Padilla thought someone might have tipped off the cops. He was right: He was arrested the next day. It was the largest pot bust in San Francisco history to that point. In 1967, Padilla was sentenced to five to fifteen in San Quentin. With his son Eric on the way, Padilla was granted a 30-day stay of execution to get his affairs in order.

"On the thirtieth day, I just left and went to Mexico, went to work for some syndicate guys," he says. "I bailed."

Padilla's flight was also precipitated by a schism within the Brotherhood that some trace to its ultimate demise. Acting on Leary's advice, Griggs took the profits from a marijuana deal, funds that some Brothers thought should go toward the eventual island purchase, and bought a 400-acre ranch in Idyllwild near Palm Springs.

Padilla never cared much for Leary, nor for his influence over Griggs and the Brotherhood. "He was a glitter freak," Padilla says. "A guy named Richard Alpert, who became Ram Das, told us, 'You guys got a good thing going, don't get mixed up with Leary.'"

Padilla saw the Idyllwild incident as a turning point for the Brotherhood. "This is betrayal. This is incredibly stupid. You're going to move the Brotherhood to *a ranch in Idyllwild*? To me, it was like becoming a target."

The Brotherhood split over it. Many of those facing federal indictments or arrest warrants took off for Hawaii. Others moved up to the ranch with Griggs and Leary. As the Brotherhood's smuggling operations grew increasingly complex and international, revolution started looking increasingly like mercenary capitalism. Any chance the Brotherhood had to retain its cohesion and its gospel probably died in 1969 with John Griggs, who overdosed on psilocybin up at the Ranch.

"That was John," Padilla says, smiling, "take more than anybody else."

Not long after, Mystic Arts burned down under mysterious circumstances. It seemed to signal an end, though the Brotherhood would continue to leave its mark on the era. The group masterminded Timothy Leary's escape from minimum-security Lompoc state prison following his arrest for possession of two kilos of hash and marijuana. Funded by the Brotherhood, the Weather Underground sprung Leary and spirited him and his wife off to Algeria with fake passports.

To facilitate his escape to Mexico, Padilla raised funds from various Brothers and other associates to gain entree with a Mexican pot syndicate run by a kingpin called Papa. His Mexican escapades—busting partners from jail and other adventures—could make their own movie.

One time he drove his truck to the hospital to visit his newborn son, Eric, who was sick with dysentery. On the way, he noticed a woman with a toddler by the side of the road. The kid was foaming at the mouth, the victim of a scorpion bite. Padilla says he threw the boy in the back of his truck and rushed him to the hospital. The doctors told him the kid would have died in another five minutes. They gave him an ambulance sticker for his efforts.

"I put it on my window," he tells me. "I was driving thousands of pounds of marijuana around in that panel truck. When I'd come to an intersection there would be a cop directing traffic. He'd stop everybody—I'd have a thousand pounds of weed in the back and he'd wave me through because of that ambulance sticker."

In Mexico, Padilla ran a hacienda for Papa, overseeing the processing and distribution of the pot brought in by local farmers. For more than a year, he skimmed off the best bud and seeds. Meanwhile, he kept alive his dream of sailing to an island.

The dream came true when he and a few associates from the Brotherhood bought a 70-foot yacht in St. Thomas called the Jafje. The Jafje met Padilla in the summer of 1970 in the busy port of Manzanillo. From there, it set sail for Maui.

"It was five guys who had never sailed in their lives," says Padilla. On board was a ton of the Mexican weed.

The trip should have taken less than two weeks. A month into it, one of the guys onboard, a smuggler with Brotherhood roots named Joe Angeline, noticed the stars weren't right.

"He said, 'Eddie, Orion's belt should be right over our heads.' But Orion's belt was way, way south of us. We could barely make it out."

When confronted, the captain confessed he didn't know where the hell they were, but had been afraid to tell them. "There's a hoist that hoists you all the way up to the top of the main mast and we hauled him up there and made him sit there for a day," says Padilla. "That was funny."

Eventually, they flagged down a freighter and learned they were more than a 1000 miles off course, dangerously close to the Japanese current. The freighter gave them 300 gallons of fuel and put them back on track to Maui. He'd made it to his island with a load of the finest Mexican marijuana.

"The seeds of that," Padilla says, "became Maui Wowie."

Spiritual Warrior

Maui Wowie? The holy grail of my pot-smoking youth, one of the most famous strains of marijuana in history? When Padilla tells me he played a major role in its advent, my already-strained credulity nears the breaking point. I spend months looking into Padilla's stories, tracking down survivors, digging up what corroborative evidence I can. And, well, he basically checks out. But there are his stories and there is his narrative—how an acid trip on Mount Palomar transformed a 21-year-old borderline sociopath into a man with a purpose, a messenger of peace and love.That one's harder to swallow. While sitting over coffee at the dining room table in his son's apartment, Padilla finally tells me a couple stories that beg me to challenge him.

Back in the mid-'60s, he and John Griggs make a deal to purchase a few kilos of pot from a source in Pacoima. They drive out in a station wagon with 18 grand to make the buy. But the sellers burn them and take off with their money in a black Cadillac. The next day, Padilla and spiritual leader Griggs go back armed with a .38 and a .32. Padilla goes into the apartment where the deal was supposed to go down and finds one of the men sleeping on the couch. The guy wakes up and makes for a Winchester rifle sitting near the sink. Padilla runs up behind him and sticks the barrel of his gun in the guy's ear and says, "Dude, please don't make me fucking shoot you." Griggs and Padilla get their money back.

"So, that stuff went on. I've been shot at. People have tried to kill me. I've had bullets whizzing by my ear," he says. "But I've never had to shoot anybody."

Padilla tells me of similar episodes in Maui where the locals, understandably, see the influx of the hippie mafia as encroachment on their turf. They set about intimidating the haoles from Laguna, often violently. One newcomer is shot in the head while he sleeps next to his son.

At his house on the Haleakala Crater one night, Padilla opens the door to let in his barking puppy only to find "there's a guy standing there with a pillow case over his head and holes cut out and the guy behind him was taller and had a pager bag with the holes cut out."

One of the men has a handgun. Padilla manages to slam the gunman's hand in the door and chase off the invaders. "I'm going to kill both of you," he yells after them. "I'm going to find out who you are and kill you."

Padilla discovers the men work for a hood he knew back in Huntington Beach called Fast Eddie. Like a scene out of a gangster movie, Padilla and Fast Eddie have a showdown when Fast Eddie, in a car full of local muscle, tries to run Padilla and his passenger off the road. They all end up in Lahaina, where Fast Eddie's henchmen beat up Padilla pretty good before the cops break up the brawl.

"Hey, bra, you no run. Good man," Padilla recalls the Hawaiians saying to him. When Fast Eddie emerges from the chaos, Padilla points at him and tells the Hawaiians, "I want him. Let me have him.

"I worked him real good and that was that. People robbing and intimidating was over."

I tell him it doesn't seem like his life had changed very much since that day on Mount Palomar.

"You know, don't get the wrong idea," he laughs. "I'm still who I am. We're still kind of dangerous people. Just because we were hippies with long hair and preaching love and peace doesn't mean we became wusses."

"It doesn't sound like you had a spiritual awakening to me," I say.

"I was very spiritual," he replies. "I thought I was making a life for myself."

"As what?"

"A warrior. A spiritual warrior."

"What was your spiritual warring doing? What were you fighting for?"

He falls silent. "I never thought about it before....Remember, I grew up in South Central. I already had an attitude from a young age. So, by the time I got to Maui, it was like, here's your job, dealing with these people.

"The warrior part was, like, we want to live in Hawaii. We're not going to accept you guys running our lives. This is what we were trying to get away from. So, my job as a self-motivated warrior was pretty clear, but it's really difficult to explain."

"So, your job was protection?" I offer.

"I was never paid."

It occurs to me that Padilla really wanted to live beyond rules, institutions, and hierarchy, like some romaticized ideal of a pirate. "So why," I ask, "feel the need to color it with this patina of spirituality? Why not just call it what it was—living young and fast, making money, getting the girls, fucking off authority?"

"Uh, wow...I mean, you're right; it was about all that. It *was* living fast and really enjoying the lifestyle to the max."

"Why the need to justify it?"

"Well, it just seemed to me that was what was moving me."

"It seems that way to you now?"

"Now, yeah now. But then, I felt more, and this sounds really self-righteous, that we were the people who should be in charge, not the ones who were beating people up and taking their stuff and shooting them. So, spir-

itual warrior, maybe it doesn't look like that to anyone else, but it sure as hell looks like that to me now." His voice is soft and intense. "I didn't have a sign on my head that said *spiritual warrior* but I definitely felt that's what was going on....Nobody else was standing up to them. Nobody else would pick up a gun, but I sure as hell would."

"You have a massive ego," I suggest.

"Massive."

"And that's been your greatness and downfall all along?"

"Sure, yeah, I see that."

I ask again, amid all the chaos, how his life had improved since his supposed awakening on Mount Palomar.

"My life was incredibly better. I was surfing, sailing, living life. All this other stuff was just, you know...I'm not in San Quentin," he says. "That was the healthiest and clearest time of my life."

Then, he met Diane Pinnix.

Pinnix was a tall, beautiful girl from Beach Haven, New Jersey, who came of age when *Gidget* sparked a national surf-culture craze. It's not surprising that a headstrong girl from New Jersey would catch the bug, and she became one of the original East Coast surfer girls. Legend has it that when Pinnix decided she wanted to get away from New Jersey, she entered a beauty contest on a whim. First prize was a luggage set and a trip to Hawaii. Pinnix, then 18, won.

Pinnix's mother, Lois, still lives in Beach Haven. When I call her, she has a simple explanation for her daughter's flight to Hawaii, and her subsequent plight. "It was the times, it was the times. She wanted to spread her wings. Drugs were a part of the thing, but I was very naïve. I was a young mother and in the dark."

Padilla first ran into Pinnix when he went with a friend looking to score some coke from a local kingpin. Pinnix was the kingpin's girlfriend. "I looked at Diane and she looked at me and the attraction was so strong," Padilla recalls. "That was it."

He started making a point of showing up wherever Pinnix was.

"We're traveling in the same pack and we started talking and flirting," says Padilla. "It came to the point of ridiculousness...and my own friends were saying, 'Why don't you just fuck her and get it over with?' But that wasn't it, you know. I *wanted* her. It was an obsession. A massive ego trip, for sure, but at the same time there was an attraction unlike anything I'd ever experienced before."

By all accounts, Diane Pinnix, a stunning surfer girl/gun moll, with a nice cutback and blond hair to her ass, was the sort of woman who could make a man do things he hadn't bargained for.

"One day, we're getting ready to paddle out, waxing our boards, and I say, 'So, you want to be my old lady?' And she says, 'You have a wife and kids.' And I say, 'Okay.' I was willing to let it go right there and I start to paddle out and she says, 'But wait a minute.' And that was it. It was all over. And that's pretty much when I lost my mind."

Pinnix was a committed party girl, and Padilla started doing coke and drinking excessively to keep up. After getting iced out of a big deal by a new crew on Maui who claimed Brotherhood status, Padilla decided to go out on his own. He made connections in Colombia and was on his way to becoming a coke smuggler.

"There was no more spiritual warrior," he says. "This was a guy on his way to hell. I had gone against everything that was precious to me. I left my wife and kids. I wasn't living the spiritual life I was back when we had the church and it was the Brotherhood of Eternal Love."

"Why did you do it?" I ask.

"Money. For Diane and me. I probably knew deep inside that if I didn't have enough money and coke, that she wouldn't stay with me...whether that's true or not, I'll never know. The bottom line is I became a coke addict, plain and simple."

Paradise Lost

A few days before he's supposed to arrive at Peru's Gran Azul with Richard Brewer and James Thomason, Eddie Padilla is thousands of miles away on a beach in Tahiti. He sits and looks out at the ocean, contemplating how far things have degenerated, both for him and for the Brotherhood. He thinks about the messages of love, the utopian ideals, and the notion that they could change the world. All that is gone. What is left are the 1970s in all their nihilistic glory. The drugs, money, women, and warring, spiritual or otherwise, are taking their toll, and damn if he isn't feeling beat already at just 30.

In Tahiti, Padilla at last finds the island paradise that eluded him in Maui. And with Pinnix set up in style on the mainland, it's a rare moment of peace in his increasingly out-of-control life. He wants more of that.

"It was incredible," he says. "The best surfing and living, the best food on the planet. While I was in Tahiti, I really got sober and all of the sudden, I was looking at what I'd been doing and I didn't want to go back."

Smuggling coke isn't about peace and love; it's about money, greed, and power. He suddenly sees his life as a betrayal of his ideals, and he wants out. Feeling something like a premonition, Padilla decides that this next trip to Peru will be his last. Decades later, he remembers the conversation he had with a friend on that Tahitian beach.

"She says to me, 'What are you doing, how did you get into coke?' And I just look at her and say, 'I don't even know, but I know right now that I don't want to go back there.'" He's trapped, though. Too much money has already been invested in the deal. "I'm totally responsible and there's a whole bunch of people involved. But I'll be back,' I told her. That was the plan. 'I'll be back.'" He books a return flight to Tahiti. He never makes it.

Back at the Gran Azul, just hours before Padilla and his crew are scheduled to leave the country, quasi-military police agents storm the bungalow. One slams Padilla to the floor, another kicks Brewer in the stomach, and quickly Padilla, Brewer, and Thomason are all in cuffs.

"At least 10 or 12 of them come in through the door and they all have guns drawn. I didn't have a chance," says Padilla.

A man they will come to know as Sergeant Delgado takes a hollow-point bullet from his gun, starts tapping it against Thomason's chest, and says, "Tell me everything."

In some ways, Padilla is a victim of his own success. While he's been hopping between Hawaii, Tahiti, Colombia, and Peru building his résumé as a coke-smuggling pirate, Richard Nixon has been marshaling his forces for the soon-to-be declared War on Drugs. It's the beginning of the national hysteria that will see Nixon pronounce the fugitive Timothy Leary "the most dangerous man in America," and today has more than 2.3 million Americans in prison, a vast majority of them for drug offenses.

Nixon's strategy in the drug war is announced with his Reorganization Plan No. 2. It calls for the consolidation of the government's various drug-fighting bureaucracies into the Drug Enforcement Agency. The DEA is formed, at least in part, to do something with Nixon's boner for the Brotherhood's members and associates, dubbed "the hippie mafia" in a 1972 *Rolling Stone* article. Congress holds months of hearings on the need for this new agency in the spring and summer of 1973. One is titled "Hashish Smuggling and Passport Fraud, The Brotherhood of Eternal Love."

After the DEA starts putting too much heat on his Colombian connections, Padilla sets up shop in Peru. But the DEA's budget shoots up from $75 to $141 million between 1973 and 1975, and Peru, the world's largest cocaine-producing country at the time, quickly becomes a client state in the drug war. Some of that DEA money goes to fund and train the notorious Peruvian Investigative Police, or PIP (now called the Peruvian National Police). The PIP operates with near immunity and is expected to get results in the war on drugs.

Sergeant Delgado heads the force. A mean-spirited thug with dead, black eyes, he is one of the most powerful men in Peru. An Interpol agent known as Rubio is with Delgado.

Before the DEA put Peru in its crosshairs, Padilla would have been able to buy out of the arrest. Naturally, his first reaction is to offer up the $58,000 in cash he has with him.

"Don't worry," he remembers Rubio telling him. "Don't say anything about this and when we get to the police station, we'll work something out."

The three Americans are taken to the notorious PIP headquarters, known as the Pink Panther, a pink mansion that the police confiscated (they are rumored to have executed the owners). With no tradition of case building, Peruvian detective work at the time pretty much consists of coerced confessions and snitching.

The PIP is famously brutal. During the two weeks the guys are held at Pink Panther, Padilla says they're surrounded by the sounds of women being raped and men being tortured.

The country's shaky institutions are rife with corruption, and there is little to no history in Peruvian jurisprudence of due process or jury trials. Prisoners wait for years to have their cases heard before a three-judge tribunal, only to see their fates determined in a matter of minutes. Their arrest immediately throws Padilla, Brewer and Thomason into this Kafkaesque quagmire.

In a 1982 *Life* magazine story that details the horrors of the Peruvian prison system, and two men who tried to escape it, a survivor tells of his time in the Pink Panther.

"My god, I was in tears after they went at me," Robert B. Holland, a Special Forces Vietnam vet recounts. "I did a couple things in 'Nam I might go to hell for. But Peru was a whole new day."

When their escape attempt fails, the two primary subjects of the Life story commit suicide by overdosing on sleeping pills. In a final letter to his wife, one of the men, David Treacly, writes, "I have no confidence in either their concept of justice, their methods of interrogation and inconceivable brutality, or in the bumbling incompetence and indifference of our embassy....So, I'm going out tonight....John not only accepts and understands, but has decided he wants to go with me....Given the circumstances, I cannot think of anyone I'd rather go with."

In this atmosphere of brutality and corruption, Padilla and his friends strike a deal with Delgado. The deal is Delgado will keep the money and the cocaine, probably to resell, and Padilla, Brewer and Thomason will say nothing to the DEA about the drugs or cash—it's their only leverage. When they go to trial, Delgado is supposed to testify that he never saw the coke on display until he opened a black travel bag. The story will be that a jealous Fastie planted the bag as revenge for Padilla flirting with his girlfriend. With Delgado's testimony, they are assured, they will be home in six months. In the meantime, though they will have to go to San Juan de Lurigancho prison.

"'Don't worry,'" Padilla remembers being told. "'You'll be out in four to six months. And the prison is nice. There's basketball, soccer, a great pool.'"

La Casa del Diablo

There are, of course, no pools or athletic facilities at Lurigancho. There aren't even working toilets. Built in the 1960s to house 1,500 inmates, Lurigancho has more than 6,000 by the time Padilla is processed. (Today some estimates put the number of prisoners there at

more than 10,000.) Going in, though, Padilla still has an outlaw's cocky sense of exemption. Besides, he's paid off his captors.

"It's just like an adventure," he remembers thinking. "I'd been in prison. I'd been in jails."

That feeling doesn't last long. Padilla says the conditions are "like a dog kennel." Food is a bowl of rice a day—with beans on the lucky days. "People starved to death."

The running water, when it runs, comes from a community pump, which the prison often shuts down to clean rats out of the pipes. The water is full of worms and bacteria. Everybody has dysentery.

"If you got the runs, you better find a plug, because everybody's going to be real pissed if you shit in a cell," he says. "I had dysentery every day."

The toilet, a hole in the ground that prisoners line up to use, seems designed to make the most of this affliction. It constantly overflows with shit and piss so the prisoners resort to relieving themselves onto an ever-growing mound of feces.

"The whole place smells like shit," says Padilla.

The American prisoners and some other expats live together in the same cellblock, a more modern facility built off the big hall, which is a real-world incarnation of Dante's *Inferno*, where murderers, rapists and the destitute teem together in a bazaar of daily strife. There, Padilla says, you see people starving, drowning in tuberculosis, being beaten and stabbed to death.

Padilla's description of the prison is in keeping with interviews that a former human rights activist, who is familiar with Lurigancho, has conducted for this story with past and present volunteers in Lima. All have requested anonymity.

One volunteer says the guards have surrendered the place to the prisoners. Everything from cots to a spot in a cell must be purchased. Those with no re-

sources are left to wander the outskirts of the cellblocks, relying on handouts and picking through garbage like zombies.

Another volunteer, who worked at Lurigancho when Padilla was imprisoned there, says, "There were always ugly things....We felt very powerless against the mistreatment." She says there are constant fights between prison pavilions, wars between inmates and murders tacitly sanctioned by the guards, who are often paid off to look the other way.

As it becomes increasingly clear that his chances of getting out quickly are about as good as going for a swim in the pool, Padilla's days are given over to survival, often in a haze of *pasta*, a particularly toxic paste form of cocaine smuggled into the prison and sold by well-connected inmates. Nights are filled with the sounds of screaming and snoring, and the insane beating of drums from the big hall.

Padilla doesn't hesitate when asked to describe the worst thing he witnessed.

"Watching a whole cell block get killed," he says. "Watching a .50 caliber machine gun, at least a dozen rifles and a half dozen pistols...until no one is moving. And then, they open up the door and storm it. They shoot everybody."

The massacre comes, Padilla says, after a handful of prisoners take some guards hostage and demanded better conditions. The inmates release the guards when the prison warden agrees to their demands. The next day, the military comes in and shoots the place up. Padilla believes hundreds of inmates are killed in the attack.

On another occasion, Padilla says confused guards open fire on prisoners returning on a bus from court, killing dozens. "One of the [wounded] guys was in our cell block. He came up to the cell block just covered in blood."

The prison's atrocities mostly escape international attention until De-

cember 1983, when police shoot and kill a Chicago nun being held hostage by prisoners attempting to flee. Eight prisoners are also killed. Lurigancho gains further notoriety when, in July 1986, police kill anywhere from 124 to 280 (accounts vary) rioting members of the Sendero Luminosa, or Shining Path, Marxist guerillas incarcerated at Lurigancho.

Lurigancho's tableau of evils, both epic and banal, earn the prison the name La Casa del Diablo, the house of the devil. It remains a hellish place; the Associated Press reports that two people a day still die in Lurigancho from violence or illness.

Despite being imprisoned in the midst of this, Padilla doesn't slip into despair. Not immediately. It takes something more potent. It takes Diane Pinnix.

Femme Fatale

Quickly after the arrests, Diane Pinnix flies down to Lima, ostensibly to aid and abet Padilla's release. Before long, though, Peru's attractions prove irresistible and she starts partying. Padilla worries she'll get in trouble, the last thing he needs. He decides he has to get out of Lurigancho fast. His chance comes with a Colombian coke dealer named Jimmy, another inmate who's been supplying pasta for Padilla, Brewer, Thomason and other cellies to smoke.

During a delivery one day, Jimmy tells the guys how he plans to escape Lurigancho. Jimmy's lawyer will bribe clerks to get him called to court, but his name will be left off the judge's docket. At the end of the day, in the chaos of transferring prisoners, Jimmy's lawyers will hand the soldiers in charge counterfeit documents saying the judge has ordered his immediate release. If the plan works, it's decided that Pinnix will give Jimmy what's left of Padilla's money to set up the same deal.

But Jimmy takes Padilla's money and never returns to Lurigancho. Nor does Pinnix. Word filters back through the prison grapevine that Diane has been seen on the streets of Lima holding hands and kissing someone who fits the description of Jimmy.

Padilla spirals into a rage. He thinks only of revenge. To exact it, he seeks out a violent man known as Pelone, the boss of a neighboring prison cell. Through Pelone, Padilla orders a hit on Jimmy, an expensive proposition for which he has no money. Padilla promises to pay up when Pelone's *pistolero* cousin brings back Jimmy's finger, the traditional token of a successful hit. Padilla knows that with no money, it might be his life he pays with, but he wants Jimmy dead. In the meantime, he needs pasta to numb his pain. Pelone is more than happy to supply on credit.

Months go by with no success in the hit and Padilla falls deeper into despair. In the back of his mind is an inescapable fact: the pain he is feeling is the same pain he caused his wife, Eileen, and his kids, when he walked out on them for Pinnix. His spirit breaks.

"I gave up because of Diane. Not just because of Diane, but because I was betrayed and that brought on all the betrayal I gave Eileen, my kids. My dedication to God, you know it was just gone. I turned my back and betrayed all of it. Betrayed my soul."

Padilla rarely leaves his bunk. He interrupts his sleep and sobbing only to smoke pasta. When the pasta runs out, he turns to pills. In his bunk, he dreams of surfing, and of Tahiti and Maui. He gives up his battle with dysentery.

"That's how I got. I became absolutely disgusting. I stunk. I reeked," Padilla says. "Richard and James are pretty sure I'm going to die."

His death seems assured one night when Padilla turns over in his bunk and sees Pelone wearing a leather jacket zipped to the top. Padilla's cellmates aren't around and Pelone has seized the opportunity to come calling for his debts. Pelone pulls a long shank from under his jacket and comes at Padilla. Using his boxing skills, Padilla manages to dodge the first couple of stabs, but Pelone is skilled with a blade, and Padilla soon finds himself staring defenselessly at a shank aimed for his midsection. Just as Pelone is about to thrust, one of Padilla's cellies miraculously appears, and grabs Pelone's shoulder before he can stab. The opening gives Padilla enough time to throw a left cross into Pelone's nose, breaking it, he says. They tumble to the floor and by then a group of Padilla's cellmates storm in and disarm Pelone. The guy who has saved Padilla pays off the $400 debt to Pelone—a prison fortune—on the condition that Padilla gets his shit together.

In order to survive, Padilla realizes he needs to get back to some idea of God, to find a way to live beyond his fear. He quits doing drugs and starts meditating. He trains in boxing again. But his biggest challenge is still beyond him: the big hall. If he can master that, he thinks, he can master his fear. But he's not ready. He needs something more than God to hold onto. For Padilla, that could only be a woman.

One day during visitation, a young, indigenous woman named Zoila catches Padilla's eye. Padilla sees something in her that he hasn't seen in what seems like forever.

"She was the purest, most wonderful thing that could happen to me," he says. "She was like a gift from God."

The note Padilla throws down to Zoila from his cellblock feels like a life preserver. When someone hands her the note and points to Padilla, she smiles and waves. After that, she becomes Padilla's regular visitor and something like a love affair unfolds.

"She helped me heal so much in the prison. That was grace. I crack when I think about that experience." And he actually does crack when he tells this story, reinforcing my suspicion that beneath the surface of every tough guy is a heartbroken mama's boy.

With his dignity on the mend, Pa-

dilla knows there's something he must still do to be worthy of Zoila. After jumping rope one day, he decides it's time. He asks a prison guard to open the door protecting his cellblock from the big hall. The guard smiles contemptuously and opens the door.

Padilla walks through the maze. He sees men lifting a dead body out of the way. Blood from tuberculosis stains the floors like abstract art. His journey through the hall is quick, but he survives. Before long, he goes back again, this time under the guidance of a man named Chivo, a leader in this strange netherworld of Lurigancho. After a while, Padilla is allowed to pass the big hall with immunity. Something has changed.

Escape

More than three years after they were taken to Lurigancho, Padilla, Brewer, and Thomason finally have their day before the tribunal. As a matter of course, the Peruvian Supreme Court reviews cases after the tribunal renders its verdict—but guilty verdicts are rarely overturned. The tribunal will be the trio's biggest test. They have a couple of things working for them. First is Zoila, who packs the courtroom with family and friends. They also manage to secure the services of a sympathetic translator, without which they wouldn't stand a chance.

On the stand, all three stick to the story: Fastie planted the coke in their room and nobody saw it until Delgado opened the black travel bag. Thomason is just a friend who happened to be there. The key witness will be Delgado. Nobody knows whether he'll keep his bargain to back up the tale.

When Delgado walks into the courtroom, eyes as black and dead as ever, a visceral terror shoots through Padilla's body. But Delgado takes the stand and, to Padilla's surprise, gives a brief statement corroborating their account of the arrest. The tribunal has lit-

tle choice but to render *absuelto* in all three cases—absolved. It's the first good news in years.

That evening, Padilla and Brewer are taken to a hotel while Thomason is held back at a holding pen in the Lima neighborhood of Pueblo Libre. He has draft-dodging issues. Jimmy Carter had pardoned all draft dodgers while the men were in prison, but that means little to the Peruvian authorities. There's no telling how long or how much money it will take to sort this out. The longer it takes, the more likely it is that Padilla's decade-old San Francisco conviction will turn up like an albatross around his neck.

There are other complications. Padilla and Brewer have recently been implicated in the arrest of a former associate who Jimmy and Pinnix tricked into doing a coke deal with them by saying the proceeds would go to help spring the guys. If that case makes it to court before they're free, they are done for sure. Padilla and Brewer have to decide whether to make a break for it or wait for Thomason. They stay.

When Padilla and Brewer return to Pueblo Libre the next day, bad news awaits. The Supreme Court will be reviewing the case. Their lawyer mentions Padilla's "FBI problems." Freedom is near, they're told, but it'll take money. Padilla, Brewer and Thomason are put in a cell at the Pueblo Libre jail to await the Supreme Court's review.

Facing more than 20 years each should their verdicts be overturned, Padilla and Brewer know a return to Lurigancho is certain death. They start working on an escape plan. Thomason, facing just three years, wants no part of it.

Months go by in Pueblo Libre while Padilla and Brewer prepare for a moment that might never come. They ask an Episcopalian reverend, an Englishman who has started visiting them in Lurigancho, to bring them towels, maps of the city and the Amazon wilderness beyond it. He also brings them money. They scope out the jail and de-

termine they can get over a wall on the roof if given a chance. They make an effort to befriend their jailers, to show they pose no threat. Brewer swipes a serving spoon and hides it in his shoe.

In June of 1978, soccer-mad Peru makes an unlikely run through the first round of the World Cup being held in neighboring Argentina. During Peru's match against Scotland to advance to the second round, the atmosphere in Lima is ecstatic, even in the jail. The guards bring in beer and booze and good food, which they share with the Americans. They leave the jail cell open believing the only way out is past them since the steel door leading to the roof is spring-locked.

The partying gets more intense as the game plays. The guards are rapt. Brewer wakes up Padilla, who is sleeping off some whiskey. It's time to go, he says. Padilla says he's ready if Brewer can spring the lock to the steel door. They are worried about the loud noise the lock makes when it releases. Then, something incredible happens just as Richards jams the spoon into the lock and springs the steel door open: Peru scores! It's pandemonium in the jail. Nobody hears the door, or them as they scurry up the stairs and onto the roof.

On the roof, Padilla and Brewer scale the wall and look up at the barbed-wire-topped chain link fence. They throw towels over the barbs and hoist themselves up and over onto the freedom side of the two-story wall. They'll have to jump down onto another rooftop, scramble to the jail's outside wall and scale that to get to the street. Their plan is to split up and reconvene at the reverend's church in Miraflores.

At the outside wall, Brewer urges Padilla to jump. Padilla hesitates and in a flash, Brewer is hurtling down into a patch of light, landing hard on the ground below. Brewer grabs a ladder propped against a shack and hauls it over to the outer wall. Padilla finally jumps into the dark and lands with a thud on a pile of lumber. Pain immedi-

ately shoots through his body. He tries to stand but crumples. His ankle swells up immediately. His heel is broken. Padilla crawls and hops to the ladder and pulls himself up, the lower half of his body dead weight. He makes it to the top of the second wall and lets himself fall to the ground.

Out in the street, Brewer tries desperately to hail a cab. Padilla calls to him. Seconds go by like hours. Finally, Brewer sees him and comes racing back, asking what the fuck happened; how did he get so dirty? Padilla tells him he can't walk. Brewer races back and hoists Padilla over his shoulder, carrying him across the street into the shelter of an alley. He flags down a car and they make their way to the reverend's church in Miraflores.

Thirty-one years later, the same reverend answers a call at his home in the English countryside. Retired for 20 years, he asks that his name not be disclosed while he recalls for me the night the two men he'd been visiting in prison for months showed up at his door.

"It was unexpected. One of them had broken a bone in his heel and was having a tough time getting around. I think there was a lot of adrenaline going," the reverend says with typical English understatement. "We gave them some food and clothing and moved them onto a contact they had The police came around to find out what part I had in their escape and held my passport for awhile."

Padilla and Brewer next enlist the cousin of an inmate Padilla befriended in Lurigancho. He is a travel guide with the Peruvian tourism industry with access to an underground network of friends and relatives. The guide's family, like many others, has suffered at the hands of Delgado and the PIP as the war on drugs has conflated with political persecution and the other abuses you'd expect in a police state.

A domestic flight, arranged through a sympathetic airline worker, takes Padilla and Brewer to the Amazon River city of Iquitos. They stay for weeks at the lodge of a man who used be a PIP agent, but quit over the agency's brutal practices. There, the natural beauty of the Amazon and their first taste of real freedom bring Padilla and Brewer to tears. The hum of jungle birds and the roar of big cats at night almost drown out the sounds of snoring, screaming and drumming at Lurigancho, still echoing in their heads. Padilla thinks of Zoila. He feels she's out there in her village somewhere in the Amazon wilderness. It breaks his heart that he'll never be able to thank her enough.

After a close call with PIP agents in Iquitos, Padilla and Brewer acquire forged documents identifying the two as Peruvians going to visit family in Colombia. They fly to the Colombian border town of Leticia and reach a hotel owned by an expat. Padilla calls his ex-wife Eileen and she sends money on the next flight in. They pay off the Colombian equivalent of the PIP to write a temporary visa that gives them 72 hours to get out of the country or be arrested.

During their brief stay at the hotel, Padilla and Brewer befriend a group of college kids. One of them is a Colombian girl who rooms with Caroline Kennedy at Radcliffe. The friendship pays off in Bogota, the girl's hometown, when Padilla and Brewer can't get a hotel room there because they have no passports. They're terrified they've come all this way only to get picked up for being indigent. Then, Padilla remembers he has the girl's phone number. Their last night in South America is spent at the penthouse home of Caroline Kennedy's college roommate. The next day they get a flight to Mexico City and then it's on to LAX.

Home.

As they exit the airport through a stream of people, Padilla puts his hand on Brewer's shoulder and they stop for a minute. Padilla looks uncertainly at Brewer and his look is returned. Until now, they've known what they were running to. Now that they're here, they both realize the hardest part comes next.

Epilogue

Twelve years after she entered Mystic Arts World, Lorey Smith has grown into a woman already disappointed by marriage. She is cautious and jaded. To help get her out of her funk, Smith's sister suggests she come down to Corona del Mar for a party. A friend of her uncle's is going to be there and he can show her a good time. She hesitates, but when her sister tells her that the guy used to be in the Brotherhood, she softens.

"I had this thought, *okay, he's not anybody's who's going to harm me,*" Smith says. "I felt safe. So, I said, 'I'll come down.'"

The party is in full howl when Smith arrives. Every time she turns around, she bumps into her uncle's friend. His name is Eddie.

"He was following me all over the house. I thought, 'What is up with this guy?' My sister would say, 'Oh, he's fine. He's fine.' I didn't know everybody had been partying for the last three weeks. She left that part out."

Little by little, Smith settles in. She and Eddie start talking. They dance, despite Eddie's obvious limp. Two days turn into four. Smith is compelled by this guy, but unsure. He seems haunted, hunted even.

"I didn't know he was blasted on coke and had drank who knows how much by the time I got there—I just knew something was wrong. But once we actually started talking, and it did take a couple of days, then, I was like, 'Wow, what's his story? All this pain.'"

At some point during the partying, Smith loses track of Eddie. "All of a sudden, I heard this noise, like moaning, like pain and moaning. And I opened the front door and he's out on the lawn, by this bush…just in this really, really bad place.

"I tried to get him to talk a little

bit about it, and he did, and he shared enough with me sitting on the grass that one particular night that I was just…fascinated that he was even sitting there having been through what he'd been through."

Over time Eddie tells Smith more and more about what he's been through, about Lurigancho, a prison in Peru known as La Casa del Diablo. About how he escaped with his life, but wasn't sure about his soul.

"I was like, 'Whoa, you're kidding, you should write a book.'"

Smith tells this story at a small kitchen table in her small condo in Santa Rosa, California. It's the middle of December and a relentless, cold rain has been pounding for days. Smith serves up some sandwiches as she talks. The oven is on for heat.

Padilla comes in from the living room when he hears us talking about how he and Lorey met in Corona del Mar. "I wasn't fit for polite company," he jokes. Lucky for him, Smith wasn't *too* polite and they kept seeing each other. It didn't take them long to figure out they'd met before, when a wide-eyed 12-year-old handed a handsome man a handmade necklace and that man accepted it with a smile.

Eddie Padilla and Lorey Smith have been together since 1981. It's one of the few happy endings in this story.

Jimmy the dealer and Diane Pinnix stayed together until Jimmy beat her up badly, putting her in the hospital. Jimmy briefly went to to jail before he bailed out and fled to Columbia. He was eventually gunned down in the street.

Diane Pinnix died a junkie's death seven years ago in Jamaica. "The unfortunate thing is she died alone," says her mother. "She was beautiful when she was younger."

Drugs and alcohol continued to dictate the life of James Thomason, the man Padilla says did his time with more courage and grace than anyone else. I visit Thomason at the Rescue Mission in Tustin. His shoulder bears a tattoo that reads *Lurigancho 75-78*. His hard life has punched in his face.

When I ask about his time in prison, he says. "I don't know what hell is, but Lurigancho is as close as I can think of."

Thomason tells me of the dysentery, the filth, the flies, people getting stabbed, and Padilla's descent into despair after Pinnix betrayed him with Jimmy.

"That's when he really lost it," says James. "He was a lowly person in that Peruvian prison and nobody cared. He wasn't *Eddie Padilla* anymore. He was a prisoner."

When I ask about the massacre, Thomason's eyes go distant and his galloping speech slows to a near-halt. "They came in with rifles and the machine gun," he says.

These days Thomason dreams of being able to afford an apartment by the beach, watch TV, drink a few beers, and live out his days. Though he seems a poster boy for Post-Traumatic Stress Disorder, he admits to no lasting ill effects from his time in Lurigancho. It occurs to me that surviving Lurigancho is both the worst thing that ever happened to him and his greatest accomplishment.

Richard Brewer died a little more than two years ago. Upon his return from Peru, he quickly went back to his old ways. But he never lost his outlaw's code of honor. At Brewer's memorial, friends gathered to paddle his ashes out to sea. Afterward, they had a bonfire on the beach. Everybody had stories to tell, but Padilla had *the* story.

"I said, 'You guys know the story…but what you guys probably don't know is, he came back for me. We had agreed to go our different ways. He knew I wasn't going to be able to walk, and he came back for me.'"

We had just finished watching a documentary on Lurigancho and sifting through a kaleidoscope of memories—some better than others—when Padilla relates this. It's late in a long day and he starts sobbing.

"All those guys called themselves the Brotherhood for so long, but you know what? Richard was a real brother. He came back for me. He carried me…I always thought that if anybody came back for anybody, it would be me coming back for them."

As Padilla says this, embarrassed by his tears, it feels like a fresh revelation. In some ways, I think the simple fact that he wasn't the rescuer but the one who was rescued may have turned out to be the god Eddie Padilla was looking for his entire life—the ego break that neither acid, the Brotherhood or his misguided idea of freedom could provide. Perhaps this newfound humility allowed him to admit, where others didn't, that Lurigancho broke him. Maybe it gave him the strength to ask for help and to claw his way back after descending into a deadly alcoholism and drug addiction, fueled by his crippled leg and fractured psyche.

At death's door, and living on the streets, Padilla finally made it into rehab and set about on the long road back to recovery. He went to AA meetings and therapy for years. He managed to earn a degree in drug and alcohol counseling, and has made a career of working with juveniles and cons. He hopes his memoir will be useful in his work, both as a cautionary tale and a story of redemption. In the end, he just might have earned the narrative he seeks.

"You know when they first started telling me about the Brotherhood, that seems like what it was all about—it was people helping people," says Padilla's brother Dennis, who was instrumental in helping Padilla stay sober in those first crucial years of recovery. "It wasn't about money and things and I think that's where he's at today."

Sergeant Delgado was killed in a shootout when a friend of one of the doomed guys in the *Life* article tried to bust them out. According to the report, it took 11 rounds to bring him down.

S

ABSTRACT L.A.

One night a few years ago, on the way to an art opening, I panicked. If I had to face another painting of lost waif people meandering around a disheveled, semiurban landscape, I worried I'd do something drastic—maybe overeat in epic fashion, cut myself, spit on a midget—in short, some ill-advised, knee-jerk act of psuedo-rebellion that I'd surely regret by morning. Then came the sea change that acted as art-fan salvation: the tides of contemporary art took a turn back toward the abstract.

Here in Los Angeles, we're enjoying a significant migration of artists who are pushing the limits and even the definition of abstraction in contemporary art. Some of the work has its origins in figurative imagery; others draw liberally from previous movements such as minimalism, pop art, op art, and conceptualism. Coinciding with this diversity of influences and ideas, intriguing techniques have also been initiated, revived, or refined, including the deconstruction of the canvas, the use of stencils, even the exposure of treated surfaces to heat.

Of course, the new abstraction comes saddled with some of the old concerns that weighed down earlier, similar trends, including color-field and abstract expressionism. How does one sustain working in the abstract without it eventually feeling like an exercise in cathartic wanking or formalist tinkering? Can the artist square off against the blank canvas and meaningfully hurl pigment in a way that bares one's soul again and again, without eventually hitting a point where the action plays out like a hollow, therapeutic dance? More than one abstract expressionist (see Pollock's *The Deep* or Philip Guston) was clocked scrambling back toward more tangible object-based visual sources. Not too many years later, the color-field artists woke up to discover their ministrations careening out of fashion with not only critics but soon collectors as well.

I'm sure that sooner rather than later I'll yearn for something akin to a still life to remove the bittersweet taste of the inevitable non-representative glut. But until that time comes, let us take a moment to celebrate the innovations and sex appeal of this revival. What follows is just a taste in two dimensions, a small portal into what's being generated in Los Angeles studios by some of the artists who are helping shape this abstract moment.

Untitled, 2009

Dianna Molzan

What distinguished Dianna Molzan's first solo show last fall at Overduin & Kite from so many other first outings was that each of her eight pieces seemed to exist in its own universe. Drawing from an array of aesthetics, Molzan seems as adept at painterly abstraction as she is at stark, constructed minimalism. Molzan turns the medium into the message by slicing canvases, cutting out geometric shapes, exposing the frames, or even reversing the field so that the frame is in front and the canvas behind. These works made for an elegant and considered debut that managed the not-easy task of being notably diverse while simultaneously feeling tightly conceived. By plunging into the actual nuts and bolts and threads of her canvases and deconstructing those elements for a range of effects, Molzan's paintings create a compelling bridge between painting and sculpture.

Kaari Upson

Untitled, 2009

In her installation *The Grotto* at the Hammer last year, Kaari Upson continued her study of "Larry," an evolving portrait that melds details she's learned about the life of the man who used to live across the street from her parents' house with her own fantasies. More than just revealing aspects of Larry, the piece showed what happens when an artist allows herself to pursue a subject with utter abandon; it is a narrative of revelation. By using the specifics of her research as a kind of performance, Upson's original intent— "discovering Larry"—served as a catalyst to uncover what happens when one ventures to the furthest reaches of one's objective, even risking the possibility of becoming unhinged along the way (consider Paul McCarthy's early performance-based pieces). Adding yet another wrinkle to her work, Upson has produced a striking body of abstract pieces created by suspending meticulously prepared panels above handmade candles. Her intention is to "capture the smoke" on the surface of the pieces (Upson has also started making works with mirrored panels). The results are a gorgeous documentation of the artist's ritual, the imagery as harsh and as toxic as it is exquisite and fragile.

Articulation, 2009

Alex Olson

By varying the thickness and texture of the canvas, the brushes, and the paint, Alex Olson creates works with a high degree of specificity. She evokes a sense of nuance on her canvases that become not only a reflection of her original intention, but also a map of her process of discovery. Olson's paintings appear to change depending on any number of elements, such as light, time of day, and the distance from which the piece is taken in. The artist also places a premium on the careful act of mark-making. Her finished paintings are not a representation of or an allusion to something else, nor are they simply a record of an idea or a process. They are objects all their own.

A Reality of her own Particulars, 2009

Matthew Chambers

Like Kaari Upson, Matthew Chambers does not work exclusively in abstraction. The sources and references for his big, sprawling paintings are vast: the punk band Crass, Dickens, fast food, the sadly departed German artist Martin Kippenberger, and much, much more. For several years now, Chambers has also been hard at work creating an extensive body of abstract pieces that he assembles using ribbons of canvas from existing paintings that he shreds. The range of color and texture is dazzling, and by recontextualizing the strips salvaged from what were once other paintings, he evokes a sense of miles traveled and past lives lived in each and every band. The singular strips imply a history that is both unique to itself and, as part of the new piece, essential to yet another visual equation. The finished works are muscular, but have a handmade quality that convey a kind of intimacy.

Dragon Teeth, 2010

Tomory Dodge

Tomory Dodge's paintings have evolved rapidly since he first started showing in 2005, from lush inter-preted landscapes that revealed his exceptional painterly skills to works more in the realm of pure abstrac-tion. Given Dodge's obvious love of paint, and the generosity and confidence with which he handles it, the viewer is compelled to scan every inch of the surface. Each burst and smear, sometimes even a tube spurt of paint, offers itself up like a tasty, oil-based morsel. Most recently, Dodge did two shows of his collages, which sometimes act as studies for larger works and other times simply are what they are. Either way, the sensuality of Dodge's palette and the elegance of his compositions offer much to the senses.

Brendan Fowler

"Fall 2009..."

Brendan Fowler's most recent body of work rose from the ashes of his retirement—at least temporarily—from a significant body of performance-based musical work. By incorporating imagery from posters for canceled tours, Fowler started reclaiming his artistic identity. He then drew from other, more common visual sources—pictures of flowers, monochrome panels, even keyboards—to create the signature work of his current practice known as "crashes," in which the artist takes several framed visual elements and creates a real-life collision. The work that results from this highly personal process feels less like an assemblage than a controlled aftermath, which, even after it's mounted on the wall, has a formidable three-dimensional presence.

Untitled, 2009

Nate Hylden typically works in series, using hand-cut stencils and often employing the surfaces of multiple pieces, one on top of the other, to create edges and angles on several of the works simultaneously. The overlap documents the link between the given works, a visual cataloging of both process and relationship. Hylden makes collages and sculpture as well, and recently he's begun using aluminum panels. In many of these works, Hylden includes silk-screened images of canvases as a layer, then he builds subsequent layers and varies the sequence of his processes (stencils, hand-brushed areas), which add a sense of looseness and flow to the work.

MY ARM THE PORN STAR

BY DAVE WHITE

Maybe Anal-Eze is at Albertsons now; it didn't occur to me to look there. All I really know for sure is that I've been driving around the San Fernando Valley for ninety minutes, boldly marching into four different sex shops requesting the rectum-numbing cream by name and walking out of every single one of them empty handed. Still, I'm on a mission. I'm not to return without the product. Otherwise, the scene can't be shot. A double-penetration scene. If you don't know what that is, you could stop reading and Google it. It's a little explicit, so maybe you don't want to do that either. But I figure I might as well get the gnarliest bit of information out of the way first, so you can know that after this it doesn't get any freakier than what you just read. Any freakier for you, that is. For me, it's just beginning.

Being a writer is a great life. You work at home in your underwear. You set your own schedule. You bank, shop, and do laundry at nonpeak hours. You can see a movie on a Tuesday afternoon and have the whole theater to yourself. But you are not rich and probably never will be. So when a friend who also happens to be a gay porn director calls you and says, "I need a responsible person to be my production assistant for four days and I'll pay $600 cash," your first thought isn't, "No way, not working on a porn set," it's, "Sweet, that's tax-free income I can use to pay last year's taxes." Then, later, you think about how you can write about it someday. You tell your partner, Alonso, about the temp gig. "Money's money," he says. "Do it." Anal-Eze doesn't cross your mind.

The "movie" is being shot at a dark, overstuffed prop house, jammed into a low-rent residential area of the Valley about half a mile from the liquor store with the neon clown out front, the one where Alicia Silverstone gets robbed at gunpoint in *Clueless*. The action is set in a penitentiary, so two adjoining prison cells have been built inside the hollowed-out center of the space, the wooden doors and bars spray painted gun-metal gray to suggest something much sturdier. In the murky light it all looks authentic, but the walls can't be touched on camera or they wiggle. The back of the cell panels have stickers revealing that these same walls were used on the set of the Mary-Kate and Ashley Olsen sitcom *Two of a Kind*.

My job description:

1. Go to the grocery store. Buy food for snacks. Use best judgment but make sure there are at least bottles of water, Gatorade, Red Bull, bananas, and those terrible protein bars.
2. Pick up Reasonably Well-known Porn Star X at his hotel. Drive him to set.
3. Stock the food table. I know enough to avoid items like string cheese and Yoplait and sharp-edged, mouth-injuring tortilla chips. Instead I buy, in addition to the required snacks, Pepperidge Farm Milano cookies, oranges, oatmeal bars, and, because I'm going to be part of the eating team, doughnuts and my favorite crackers, Chicken in a Biskit.
4. Help the cameramen set up lights. Help the cameramen anytime they ask you to do anything. Get apple boxes for short performers, move cables, find the always-outside-smoking makeup guy.
5. Take lunch orders. Call in the orders. Pick up the order. Set up lunch. Clean up lunch.
6. Mop up … spills.
7. Run other errands, like to Starbucks or to the pharmacy for Viagra and condoms.

Yeah, they all take Viagra. All of them. They can be nineteen years old and non-stop, bonery jizz machines but they all take some form of erection insurance. Some guys use this thing called Caverject that you inject. It's even weirder. Sorry, I know I promised nothing freakier than DP. I won't go into it here.

And they all use Magnums. It's psychological. Everyone wants to feel like a gladiator. The director says, "Go to Walgreens and buy Magnums. Magnum XLs if they have them." And you're thinking to yourself that no one on that set needs Magnums. And they sure as hell don't need Magnum XLs. Well, okay, Reasonably Well-known Porn Star X needs Magnum XLs. He needs Magnum XXLs. But they don't make those. He just has to live with the knowledge that his forearm-size penis is a cash-generating freak of nature that's outstripped the consumer market for birth and STD control.

"What the fuck is Chicken in a Biskit?" asks the director as I set up the snack table.

"Those are mine. I didn't use set cash for those," I lie.

"That's disgusting. And why did you get doughnuts?"

"Everybody likes doughnuts."

"Yes, but I can't have my boys getting fat. It's all well and good for you, Mr. Bear. Pack it on all day. But my stars don't eat doughnuts."

The morning's three performers devour the three chocolate-iced raised I've just set on a plate.

Being called "Mr. Bear" is an endearment, but it's also a way of marking me on the set. Because to be fat in that environment is to be totally, perfectly (and to me, at least, very happily) invisible. To my director friend it's a way of setting himself and his stars apart as special creatures who are paid to take off their clothes for a living. And I'm not offended by that at all. Everyone has their job in life, and this is theirs. Mine is to write things sometimes and on this day, at least, to buy snacks for these gentlemen. I'm not there to be titillated or feel part of the special muscleman club. I'm there to get some paper. And some Anal-Eze.

The scene in question will be the day's most strenuous and demanding. It needs to happen early, when everyone is feeling their most energetic. For the man about to receive two visitors at once, however, nerves take over and he requests the numbing agent. I can't say that I blame him. Reasonably Well-known Porn Star X is about to make his morning a lot more difficult.

"So this is a for-real thing?" I ask the director. "It's an actual product?"

"Yes."

"Where do they sell it? And how do you spell it?"

"E-Z-E," he says, and hands me a list of Valley sex shops that might carry it. The photographer will take posed "glamour" shots while they wait for my return. I think about Eazy-E. What would he have made of a butt cream that sounds like his name? "Real Compton City Gs" and "Gimme Dat Nut" run through my head.

I get on the 101 Freeway. It's backed up. A warm December day. Friday-morning rush hour. I roll down the windows and just give in to fumes. On one of the NPR stations they're talking about a butcher shop over in Hollywood that sells ground beef blended with extra fat. I call Alonso at his office.

"You have to go to this butcher shop," I tell him. "Tonight we have to have meatloaf with this special ground beef fatting it up." He agrees without hesitation, which is just one of the Reasonably Well-known Porn Star X–length list of reasons I love him.

I wind up near Encino, then move down Ventura Boulevard, wondering how many other people are also driving to and from porn sets at 10:30 on a Friday morning. I imagine what would happen if I became a part of a *Boogie Nights*–like extended family of pornographers. Would there be awesome barbecues and potlucks? It's December now–are there Christmas parties? Maybe a Secret Santa thing where I could just give my randomly chosen porn star some pecan-pumpkin spread from Williams-Sonoma. "You put it on toast," I'd say. "It's delicious for breakfast."

As I enter and exit store after store, I realize that I've never gone into many actual sex shops. I tend to spend my disposable income not on custom-made leather dog masks, but on a really good cast-iron skillet, a great couch, and some limited-edition, import, vinyl-only releases by a select few Finnish metal bands. Important shit. No offense to people who enjoy custom-made leather dog masks, obviously. Still, I remember a curiosity-based visit to a sex shop in London. Then one in Munich a few weeks later. This was in 1989. You'd think, being a gay and all, that I'd be more savvy. But all the hip-hop AIDS public-service announcements back then were about making sure you had your "jimmy caps." And you could get those at the drugstore.

On this day, I learn that pretty much all sex-based brick-and-mortars–with the exception of those Portland, lesbian-run dildo boutiques where the staff is really nice to you and gives you cups of hot cinnamon tea–are exactly the same. DVDs, cheaply produced toys, various ointments, and sullen employees. Which is disappointing. You'd think they'd be more full of erotic life, up-selling their favorite products to regular customers: "Hey, buddy, have I got some nipple clamps for you! Check 'em out! They're from France! I tried 'em last night! I'm still sore!"

But what happens is I go in and say, "Do you carry Anal-Eze?" And the guy, chewing breakfast from Burger King and watching *The View*, says, "Nope," or "We're out," or "I don't know what that is." Each place is more chilly and depressing than the last.

Certain I'm going to be fired before I get my $600, I call the director. "No one carries this stuff."

"Go back into Hollywood. The Pleasure Chest will have it," he says, and hangs up.

The Pleasure Chest is a very big store. Clean. Bright. Enthusiastic employees like I'd hoped for in my earlier trips to lesser emporiums. *The Enquirer* runs photographs of celebrities going in and out. Leann Rimes, people like that. It's across the street from what may be the last remaining gay porn theater with a marquee out front. They used to put the titles on the marquee, so you could

drive past and see that *God, Was I Drunk* or *Dawson's Crack* was playing. And, thankfully, the Pleasure Chest is well stocked with Anal-Eze. Two hours of travel for a tube of something that does I don't even know what. Butt-hole erasure? These guys better celebrate me back on set like I'm a conquering Norse.

"That was a lot of coming and going," I say, handing over the Anal-Eze to the director.

"I'll reimburse you for the gas," he says.

Not quite the hero's welcome I was looking for.

"You know what else is really hard to find now?" I say. "Hostess Pudding Pies. It's like they just disappeared. I was thinking about that in the last shop over on Ventura."

"Most of the time I don't know what you're talking about," says the director. He's ready to get back to work.

The scene is efficiently shot. The camera guy moves around the action, cuts occasionally while the performers just keep going. Everyone's quiet off camera. At one point, the director asks me to hold a fill light about three feet away from the main event. I do what I'm told, making sure not to make eye contact with any of the performers—a big rule that I always obey. While holding the fill light I just keep my eyes on the floor or on the beam's point of focus. Which is balls.

Is it hot watching live sex? The answer is, sadly, not really. I mean, you *are* watching people do it. And there's definite entertainment value, like watching machines make crayons on those old *Sesame Street* clips about how things are created and packaged. You're mostly experiencing the excitement of peeking behind the Personnel Only door. But, truthfully, the only hot thing is the fill light. I'm sweating.

We break for lunch. I pick up a variety of pasta dishes from an Italian restaurant in the area. "Who's all this for?" asks the smiling, perky, sometimes-gets-a-callback-audition lady at the hostess podium.

"Porn stars!" I say, grinning.

"Nuh-uh …" she laughs.

"Seriously!" I respond, still grinning. "Gay ones!"

"Ha! Well … okay …"

The afternoon scene, the last one to be shot today, is between Reasonably Well-known Porn Star X and three fresh arrivals. I hand out bottles of water and paper towels to mop brow sweat. I hold another fill light. I hold a shaky prison cell wall in place. I think about subcultures and myths.

I'm not sure why the idea of prison conjures up gay sex. As a homosexual daydream, it's easy to explain: a captive room of really sexy, bad dudes. And they're bored. And probably straight. But it's more difficult to understand the single-minded fixation of heteros. Think of all the times you hear straight guys talk about dropping the soap in the joint. You can hear both excitement and ultimate horror in their voices. It's confusing but it's out there, all around you, waiting for a cultural anthropologist to write a paper. One probably already has.

"We're going to shoot the dialogue scenes now. It'll take maybe thirty more minutes," the director says.

"There's dialogue?" I ask.

"Yes. And I need you."

"I can run lines. Easy."

"No. I need you on camera."

"No, no, no. No. I can't be on camera. I'm the Anal-Eze guy."

"The scenario is that they've killed the warden and have taken over the prison and turned it into one big orgy," he says, ignoring me.

"Wouldn't they just escape, though? They have orgies outside prison, too."

"Why would they want to escape? They've got all the hottest men inside already!" he says, like I'm being stupider than anyone he's ever met.

"But … the beds … are softer? Outside?"

"No. So I need your arm. You won't be on camera. Just your arm. Your arm is going to stand in for the dead warden's arm on the floor. That's all the camera will see. You won't speak. You won't move. It's a nonsexual thing. So, I need you to lie down there."

"You're serious."

"Yes, I'm serious. And we've got to hurry

up." Then he stands there and stares at me until I lie down.

I agree because, you know, why not? It's my arm, not my face or my body. And the guys all around me have shown everything to anyone who'll pay to watch. This is extremely small stakes. And now, technically, even though no one touched it, my arm is a sex worker. I kind of think that's awesome.

I stare up at the ceiling of the prop house while men who are not actors stumble over dialogue about the proper methods for establishing a sex kingdom on their cellblock. In the finished DVD, my arm is never identified. But I do get a production assistant credit. They ask if I want a porn name like Chance Majors or Bolt Cruise. I choose Dave White, figuring it's so generic that it hardly matters.

The performers leave, except for Reasonably Well-known Porn Star X. I have to give him a ride back to his hotel. He waits on a couch while I help the cameraman put his gear into his SUV. The director gives me a bro hug and tells me that they start late tomorrow, Saturday, so be back on set at noon. I drive home over Laurel Canyon, chatting with X, asking him if he wants to have meatloaf with me and my partner. He can't. He's got plans. I don't ask what they are. But he loves meatloaf, he says. He doesn't make any silly double-entendre jokes about it. I appreciate that.

After dropping X at his hotel, I grab the uneaten Chicken in a Biskit and take the stairs to our second-floor apartment. I can smell dinner in the oven. I walk into the kitchen and say, "My arm is going to be famous. Touch it before I scrape off the porn."

I shower, put on pajamas. We eat the extra-flavorful meatloaf and I tell Alonso about my day of errands and driving and freaking out the Italian restaurant lady and standing in for the murdered warden of a man-on-man-on-man-on-man Alcatraz fantasia. He says, "When do they pay you?"

After dinner, I plug in the Christmas tree. We sit on the couch and watch *Rudolph the Red-nosed Reindeer*. I think about bringing leftover meatloaf tomorrow for my lunch. I do not plan to share.

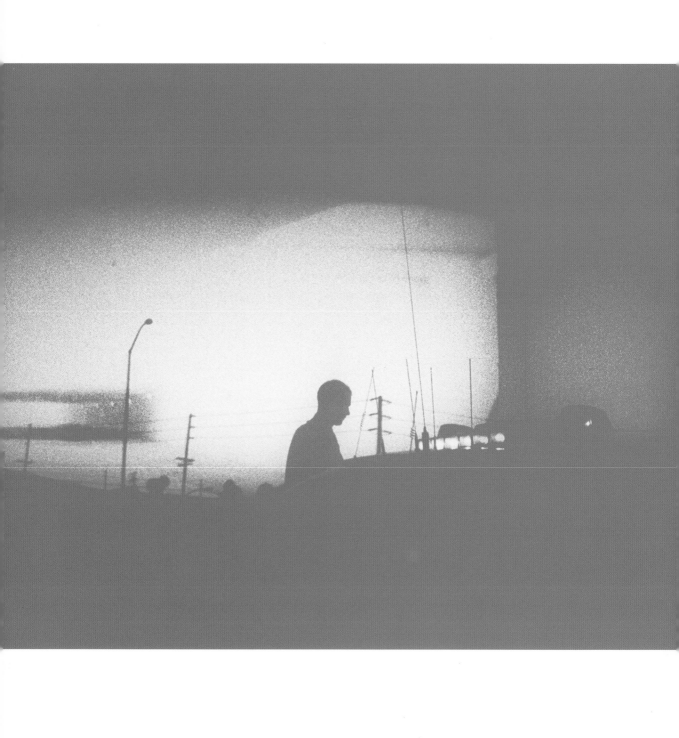

BALLAD OF THE TRUNK MONKEY BANDIT

BY DAVID SCHNEIDER

The Trunk Monkey commercial was filmed on what would have been Anton Chekov's 100th birthday, January 17, 2004. I had been performing in Chekov's *The Cherry Orchard* for several months for very little money. A good friend told me not to worry about the money—that Anton's spirit always protects those who choose to take on his work.

In the commercial, for Suburban Auto Group, I play a bandit who breaks into a car only to have the intrepid Trunk Monkey hit me over the head with a Maglite and throw me off a bridge. The commercial became a sensation during YouTube's infancy. It got tens of millions of hits, played on the JumboTron at Lakers games, and appeared multiple times on *America's Funniest Commercials*. Its notoriety helped me build a modest career as a commercial actor and make decent money while I continued my quest for a more "serious, artistic" career.

By the beginning of 2007, despite the fact that I had two national commercials running, $15,000 in the bank, and no debt, my desire for that "serious" career was all but a cross-faded memory in a smoke-filled room. Disillusionment was the order of the day. I'd been beat. Even though I was technically a working actor, it didn't feel as though I worked or acted. My days were mostly spent getting stoned, having coffee with friends, chasing girls. My friend Tom* would drop by every month or so and leave me quarter pounds of weed, gratis. I mean, not totally gratis—he always needed *something*, a friend to catch up with, someplace to sleep, a secure apartment to make six-figure transactions.

Tom and I met when we were both studying film and theater at the College of Marin. The first day of class he waltzed into Advanced Production an hour late and, rather than scold him, the teacher stopped class to hear about Tom's summer travels to Africa. It's the classic tale of the guy who walks into the room and, for better or worse, gets all the attention. Tom was about five-foot-six, 125, and at first I thought he was a little prick with a Napoleon complex who just knew how to work a room. But when we were assigned to be partners on the class's first project, we instantly connected. He understood exactly who I was and, more importantly, *where* I was.

I'd gone to the college to play on the basketball team and figured that film class was a good way to stock up on units without having to do too much. A career as a hoops coach of some kind made lots of sense, but as Tom and I got to know each other better he insisted that I pursue acting and film and drop the sports thing, which I did. He introduced me to some kids he'd worked with in the theater, and soon we were a family. I trusted him, thought him to be untouchable, and felt untouchable in his presence.

After two years of junior college, I studied acting at Circle in the Square Theatre School in New York and then came to Los Angeles. Tom dropped out, chose a life of psychedelics and counterculture, Burning Man, ganja farms, geodesic domes, and dysfunctional love. He tried Los Angeles twice and both times vanished with little more than a voice mail. I never knew if he gave up on his dreams or if they weren't ever his dreams in the first place. As he'd often say, I was on my path and he was on his.

Tom joined forces with some folks up north and, when this story begins, is doing what they do up there: farming. Los Angeles is a good place to bring his crop. Not only do I enjoy his visits, I cherish and look forward to them. But when my girlfriend Amy, finds out he's coming to town, she decides to spend the weekend with her parents in Ojai.

"I'm sorry, I just—I totally disapprove of him," she tells me. "He's a horrible influence on you."

I nod. "Go see your folks. It's the right thing to do."

Amy is moving to New York in less than a month. We'd been neighbors for a while before we started spending more intimate time together. She was getting out of a bad relationship and I was a neighbor with a good ear and just as much free time. At first I welcomed the closeness. But closeness quickly turned into expectations, expectations into rented films, dinner with her friends, claustrophobia. As her imminent move east grew closer, I began, once again, craving insanity.

A couple hours after Amy leaves, I go to her apartment to fetch a lamp I had lent her. The place is cold and empty, full of newly familiar smells, her personal effects and annoyingly wonderful memories of the time we've spent together. Prismatic bars of winter light are broken up by Jalousie windows. The whole scene gives me an ill and normal feeling. I rip the lamp cord out of the wall, go back to my place, smoke a blunt, and call Tom to see why in the hell he's late already.

Tom arrives about 10 p.m. Then, around twenty minutes later, a man called Particle—that's right, Particle—shows up in a white Volvo 240. He pops out of the car dressed in chic rags. His hair is shaved on the sides and the back, and long and wild on top. Tom and he embrace. I say hello; he notices the North Face logo on my vest and the Nike swoosh on my shoes, makes eyes at me, then at Tom.

"David and I been close friends for ten years. He's cool," Tom assures him.

"As long as he's on the conscious tip," Particle says casually. I chuckle. Tom collects these kinda guys.

They catch up a while; we all drink gynostemma tea.

*Some names changed to protect the not-so-innocent

"You wanted a five pack, right?" Tom finally says.

"That cool?" asks Particle.

"Of course."

They go out to Tom's car and come back, each wheeling a suitcase. They head to the bedroom, close the blinds and Tom opens one of the suitcases. Inside are fifteen vacuum-sealed, one-pound bags of Tom's homegrown, fitly manicured buds. Particle takes off his backpack, pulls out a brown paper bag of cash.

"Gracious host," Tom calls in my direction, "help me count?" My fingers are black by the time I am done: $17,500 in mostly small bills. Tom peels off five hundreds and gives 'em to me. Particle kicks me two more—location fees, standard.

After bagging on *Apocalypto* for an hour, Particle leaves and Tom and I smoke a spliff and cook some food. He tells me about business, that things are going really well for him. I'm thrilled.

I tell Tom about Amy leaving—that I'm sad, but not really; excited but, eh, not really. I tell him that along with Amy, I also have something with a girl who lives in New York. She's got a boyfriend and wants to move west, but I already know that she's a liar and a cheat and that she'll ruin me, which is, basically, exactly what I want. I tell him that my "Hungry Bruno" Taco Bell residuals are up more than $25,000, but despite that I feel old and lost; like it's the end of my life.

Tom listens intently, sitting in half lotus and wide awake despite being sleep deprived and completely stoned. When I'm done, he answers, all the while making circles with his thumbs.

"Bro, I see what tears at you. I know what you want and what you *really* want—it's good. But there is this thing, bro, your thing, and, sure, you get some pussy, your little commercials—your *fix*, and you're happy. You're Hungry Bruno, the cellphone guy, the fucking Trunk Monkey. ... You make some dough, people recognize you once in a blue moon and you're sort of 'ashamed, but you *more than sort of* love it, too. You land a film role, maybe sell a screenplay, whatever! You fuck a bunch of vampirical little whores from places like Denver and Phoenix and it all keeps a smile on your face until you realize at a certain point that the only one you're fooling is yourself. You go through a crisis, swear off nineteen-year-olds.

"Eventually, you fall in love, get married, get all caught up in *that* bullshit, and now you're chasing the perpetual dragon, you keep working to *become* something, but what the fuck are you going to become? All the things you swore you'd never become? Maybe not. What the hell do I know? And along the way, you make concessions; everyone does, it's part of fucking life and that's okay, because it means such different things to you now. ... 'It's not selling out,' you say. 'It's knowing how to pick your battles' or some goddamn buzz phrase like that. But all the while this unrest, this thing that is tearing you up inside right this very minute, that thing grows quietly inside you, it lives *off* you, feeds and grows from everything you covet and desire and fucking want, want, want ... to be envied and admired. ... You have a couple kids; your daughter wants her nose bobbed so she can look like Natasha Gregson-Wagner, then goes to Harvard or Stanford, or University of the Puget Sound, and you and your Botoxed apparition of a wife get to travel and go on wine tours in Temecula. Then one day your doctor tells you there's a tumor on your colon the size of a softball and you spend the rest of your life shitting in a bag taped to your inner thigh. It happens faster than you think, David. So nip that shit in the butt. ... Drink some ayahuasca, take a heroic dose of psilocybin, and check that fucking ego at the door. Figure out who you *really* are, what you really want."

Even though I'm not sure exactly *who* Tom is talking about, the warning is noted. It's always a funny thing between us, because we both know that a big part of him still wants to be an actor, and a big part of me wants to live off the grid. Our interludes fuel and fulfill both of our desires to live as two different people. We get our fix and go our separate ways.

But this visit feels different. Tom hasn't previously dealt this amount and at this frequency. Despite the fact that changes in California state laws work to his benefit, he walks a fine line, keeping details secret from everyone, including me. Tom isn't exactly paranoid, but I wonder if he's taken on more that he is comfortable with. We turn on the Criterion Collection of *Brazil* and both fall asleep in front of the screen. I never get a chance to call Amy.

The next morning, I'm drinking coffee at Groundworks, staring out the window on Cahuenga Boulevard. Tom is outside, talking on his phone. He comes in, turns his phone off, and takes the battery out. "GPS," he explains.

He orders a mocha, comes back to me after taking his time looking at photographs on the wall. "Here's the thing," he starts in, unusually pensive. "Some people down here were supposed to buy a twenty-five pack, but things are gonna fall through. *Soooo,* guy in Birmingham will take it off my hands, but this kinda trip ... not something I should really do alone. Only three kinda guys roll cross-country solo. The first is fucking Jack Nicholson from *About Schmidt*—slaves who just dropped their depleted 401(k)s on an RV, a George Foreman grill, and an economy-size bag of Lays Sour Cream and Onion. The second and

third are both drug dealers. One kind is the coiffed douche bag wearing Oakleys and a Tommy Bahama shirt who just graduated from UC Irvine and is selling Lipitor and Zoloft. I'm the other kind." The caffeine has Tom on a roll. I'm excited already.

"Also, I'm supposed to meet some people in Portland next week, so I wouldn't be able to drive back anyway." He leaves an opening, giving me an out, but I just wait for his plan.

"So I was wondering if you want to come with—make a mission out of it."

I hesitate. "I'll give you a thousand dollars," he says. I agree.

We head to Burbank airport to get a car. "Find something for me with out-of-state plates."

Nevada is the best I can do. I want to get a Cadillac. We decide on a Chevy Impala. Tom has no credit card, only a debit card, and the folks at National don't accept it. So we put the car on my card and under my name.

First night we get all the way to Flagstaff. Tom says to leave the weed in the car. It's not like your car gets broken into in motel parking lots in the first place, and even though it feels like having twenty-five pounds of weed in the trunk would increase the chances of theft, it actually does not.

Flagstaff has the last organic grocery store before Birmingham, so we stock up on kombucha, green tea, apples, oranges, bananas, blueberries, avocados, olive oil, lemons, greens, and sprouted grains. We hit the road in the late morning. Tom drives the whole way.

That evening, we get into Texas and Tom is drifting. He wants to get *through* into Oklahoma, so I take over the wheel and he gets pissed off at me for smoking a joint while he is asleep. I realize he's right, that we can't really be so careless; can't get *too* arrogant. We find another motel and crash out somewhere in Oklahoma. We make our only other

Oklahoman stop at an Indian casino right off the highway—a godforsaken place full of godforsaken folks. I remember it fondly.

The third day we drive all the way through. During the trip, I take loads of photographs and short videos. I'm relaxed and thoroughly enjoying talking about life, love, the war, the coming revolution, the government, the future, the heavens, the earth, the underworld, psychedelics, ancient cultures, the ocean, Woody Allen, our friends, our families, our unborn children, sex, why I keep playing this one Arcade Fire song over and over again, and basically just who we were, when we were, what we were here to do and how the fuck were we supposed to do it.

I only call Amy once or twice, and she isn't so much pissed as disappointed and worried. She decides to spend the entire week with her parents. The conversations are brief. Tom and I arrive in Birmingham at about 4 a.m., and Tom checks us into an Embassy Suites, a few blocks from the guy we're supposed to meet, a childhood acquaintance of Tom.

Next morning the exchange goes smoothly. We stuff $123,890—vacuum sealed in $5,000 increments—into the new backpack Tom suggested I get for this occasion. The three of us head out for a nice dinner and then to a strip club. It's my first time and I hate it. Tom's friend pays for me to have a lap dance with a nineteen-year-old I'd been staring at while she danced. She says her name is Angel.

After she finishes, Angel looks back at me and asks, "Aw, you didn't like that?"

"No, it was fine," I nod nervously. "Thank you."

Truth is, I just wanted to go to the movies that night and then to bed. Lack of sleep has finally caught up to me and I'm stressed out and exhausted from the drive. Not to mention that Tom overslept that morning and failed to take

me out for what he promised were the best biscuits in the South, something I'd been looking forward to the entire trip. By the time I drop him off at the airport I'm pleased to be on my own, looking forward to hitting the road, taking more photographs, checking out some towns. I plan on spending a night or two with friends in Santa Fe. Also, there's a girl there I'm thinking about looking up.

I leave Birmingham at 1 p.m. and around dinnertime in an Arkansas town I drive past the usual chain restaurants and find an elegant brick building. Folks are spilling out, talking in the street. I walk inside and discover the place is a private dinner club. Turns out I stopped in a dry county—only "private clubs" can serve alcohol. The host tells me to wait while he checks if anyone will sponsor me. Someone does, and I'm allowed to eat.

I sit at the bar, eat fried chicken and mashed potatoes, and strike up a conversation with a guy who sells preschool playground equipment. He's forty-six, divorced, curious about what someone like me is doing here in Bum Fuck, Arkansas, eating dinner alone at the bar of a private club with a huge backpack on his lap. I tell him I'm just driving across the country, taking photographs, seeking respite from my life. I like the guy so much that I almost tell him the truth.

I drive until about 3 a.m., stop just east of the Texas border in Elk City, Oklahoma, and check in to a Comfort Inn. As I get ready for bed, it begins weighing on me that neither of my parents knows where I am or what I am doing. I haven't called Amy, nor has she called me.

I have a horrible night of sleep, wake quickly, shower, put on my clothes, light a cigarette, and look out the window. It's dark and I can barely see the cars bustling down Interstate 40

in the hazy morning. I look around the room and make sure I have everything from the car: my clothes, laptop, some food, and the backpack full of money. I share the elevator with a group of guys in Halliburton work clothes. They are all dressed in red. I have to ask.

"Pipelines," they say. "We're laying pipelines." I nod, walk out, pack the car, and start driving.

I cross into Texas around 1 p.m. and about an hour later notice a K-9 Texas state trooper vehicle parked on the right side of the road. It seems like he notices me, but I continue driving, not thinking much of it. About a mile down the road, I see his SUV weave around a car to get closer to me. A Texaco station appears at the next exit, and I decide to pull off the highway at exit 113, in a town called Groom, for gas and coffee. The trooper follows me on to the exit, flashes his lights, and pulls me over. I stay in my car. He comes to the window.

"Howdy," he says.

"Hi, how are you?" I reply.

"I pulled you over because you made an illegal lane change." He's looking in the back of the car—it's full of garbage, stray clothes, empty bottles.

"Okay," I say.

"Do you have a license, registration, and proof of insurance?"

"Well, uh, it's a rental car, so I can give you the rental agreement. We took insurance."

I hand him the rental agreement, which has my name and Tom's on it. He studies it a moment.

"Where are you coming from today?" he asks.

"Uh, well, I was, um…. Last night, I stayed somewhere in Oklahoma, the Sleep Inn, I think."

"Sleep Inn, huh. Okay, how about before that?"

"Hmm, well, before that…the night before that? I was in Birmingham."

"What were you doing there?"

I don't answer.

"Where's your friend?" he asks, the brim of his cowboy hat resting on my car.

"He, uh, had to fly to Portland," I say.

"Your friend was smart," he nods, looks at my hands. "Why are you shaking?"

"I just…I don't know. I just haven't ever been asked this many questions before."

"You mind sitting in the passenger seat of my vehicle?" he asks nicely.

I get out of the Chevy Impala and take a seat in his SUV. His K-9, an elegant, black German shepard, starts barking the second I get into the car. The cop gets in, the dog calms down. I notice the name tags: the dog is Rex II, the cop, Ingle. He takes off his hat and throws it on the dash.

"You mind taking off your sunglasses," he asks. I take them off and stare off into the horizon. The sun burns my tired eyes.

"So," he looks at the rental agreement, "David, what were you and, uh, Tom … is that right? What were you guys doing in Birmingham?"

"Well, actually," and this is part true, "we're working on this documentary. Um, it's called *1977 at 30*. So I was—we were taking photographs of the country and interviewing people born in 1977 and just, you know, talking to them about their lives, what they think about the world, what they are doing and such, you know, as they turn thirty."

He looks at me and I repeat, "*1977 at 30….* Since that's when I was born, 1977."

He looks at my driver's license. It confirms my birth year; it also still has my father's address.

"So, you live in San Francisco?" he asks.

"Well, no, I live in Los Angeles."

"Uh huh, and where does your friend live?"

"He lives in San Francisco…and Los Angeles sometimes."

"What do you do for money in Los Angeles?" he asks as he runs my license on the computer.

"I am an actor, mostly," I say.

"Uh huh, and Tom, what does he do?"

"He's an actor, too…well, actually, he's a waiter." I figure that might sound legit, since everyone knows that all actors in Los Angeles are waiters.

"Actors, sure," he says. "Been in anything I seen?"

"Well, right now I am in these two Taco Bell commercials. I play a Russian eating champion called Hungry Bruno…." Ingle isn't responding.

"I lift my arms up like this and say, *I'm full!* You really haven't seen those?"

He laughs. "No."

He takes his time. "Did you know you are driving on a suspended license and that there is a warrant out for your arrest for a failure to appear on a jaywalking citation issued in Santa Monica, California?"

"No…I…wait, my license is suspended?"

He looks at me closer. "You been in anything else I might have seen?"

"Well, I was in this commercial a few years ago, called the Trunk Monkey. I break into a car and then this chimpanzee hits me over the head with a flashlight and throws me off of a bridge."

The trooper rips his sunglasses off and looks at me, and a big smile grows across his face.

"You kidding me?" he says.

He squints his eyes, tilts his head to the side, trying to see if he can recognize me.

"Holy shit, is it you? You know, that might be my favorite commercial in the world. I got it sent to me on e-mail and I loved it so much I sent it to all my friends. Everyone goes crazy for that Trunk Monkey. That's not really you, is it?"

"Yeah, it is … actually, it's funny because my agent—"

"How much you make for something like that?"

"Coupla grand." It's a lie. I only made $350.

"Not bad for a day's work. How long something like that take?"

"That one took a day."

"Well, shoot, that ain't bad." He shakes his head. "I can't believe this, what luck. The Trunk Monkey. This is amazing. … I just can't wait to tell all my friends, just no one is going to believe me."

I laugh and play along, hoping my casual approach to the whole ordeal will throw him off. It doesn't.

He takes a long time making notes, running backgrounds, doing whatever police officers do when you are waiting for them to be finished with you. All the while he keeps shaking his head, saying things to himself things like, "The Trunk Monkey … hot damn!"

I look out the window at the Texas panhandle. The landscape is rich with browns and light greens; there's clear, unpolluted sky as far as the eye can see. This is Texas, I think to myself. This is America.

"Okay," he finally says, "so I am going to write you a ticket for the illegal lane change and one for driving with a suspended license."

He hands me the tickets and I sign them both.

"Okay." I put my sunglasses back on. He adjusts himself in his seat.

"Oh, hey, by the way," he starts.

"Yes?"

"You don't, by chance, have any firearms in your vehicle, do you?"

"No, sir."

"What about any illegal drugs? You ain't got none of them?"

"Nooo."

"What about large sums of money?"

I contemplate giving myself up.

"Ummm … no."

"Great," he says, "So then—okay if I search your car?"

We all know the answer to this question is *no*. And I take a moment here to think this one out. Thing is, if I say no, I come off as suspicious. He takes the suspicion, runs with it, makes a phone call or two, gets a warrant to search the car, and finds the money anyway. My only chance is to bluff. Only an idiot would consent to a search while carrying illegal drugs or large sums of money. I gamble that he thinks I'm not an idiot.

"Yes, you can search my car."

"Okay, hand me your keys," he says.

"My keys? You want me to give you my keys?"

Suddenly, the trooper turns stern. "I told you to keep the sunglasses *off* of your face!"

My hands are sweating, shaking. I take off my sunglasses and try to pull the keys out of my pocket. I finally do and hand them to him. He puts them in his lap and continues doing paperwork. He opens his door.

"Okay," he begins, "now I want you to get out of the car … you are going to stand right there where I can see you." He goes right for my trunk. Before he opens it, he turns to me a final time. "Are you sure you don't have anything you want to tell me about that's in here?"

I think about it.

"If you talk to me about it now, things could be better for you."

I say nothing.

"Okay," he continues, "now, I am only going to ask you this once—if I find anything in this trunk, is it going to be yours?"

I'm fucked. I know it. He is going to find the money, no doubt about that, but I figure as long as I've gone this far, I can't just give myself away. I am actually more afraid of what might happen to Tom. I think, well, it's not my money, so how much trouble can I get into for it?

Tom is the one who could get in trouble, not me. Then, I think about my father, my mother, I think about Amy, I think about all the kids I grew up with who have become lawyers, doctors, teachers, husbands, fathers. I just say I am about to lose everything, which thankfully isn't much. I tell him, simply, "Sure, it'll be mine."

The trooper opens the trunk and looks around. Inside are two empty suitcases that reek of weed. Both are full of empty baggies, a vacuum sealer, rubber bands, pens, and other garbage. Then he gets to the backpack. Since Tom was paying, I'd bought a nice one that I could keep for myself once I got back to Los Angeles. It has lots of cool pockets, is made of some waterproof, meshy, Gortexy materials, even has a padded compartment in the center, perfect for a laptop.

I hear it unzip. I had covered the money with a pair of shorts—why, I'm not sure. I see the shorts go up in the air. Trooper Ingle says nothing, just reaches for his belt, pulls his handcuffs off, and walks right at me.

"Come here," he says motioning with is forefinger. "You're under arrest. You have the right to remain silent. Anything you say can and will be used against you; you have the right to an attorney." He puts the cuffs on, tight.

"Is this money yours?"

"No," I say, calm, numb.

"How come you said 'yes' before?"

I shrug my shoulders. "I don't know. I lied, I'm sorry."

He says nothing, just looks at me. I begin to panic.

"I'm so sorry, oh my God, I am so sorry for lying."

I start pacing in circles. In every direction are spectacular panoramas. The land is flat, the air so dry and clean and clear. I can't help but admire the vast and desolate beauty.

"Stop moving around!" he yells.

"You stay in one place, understand?"

But I can't stop. If I stopped for even a second, it would be real and I'd have to deal with it. I'm not ready for it to sink in. I still think I can run, still think it might be a joke, still pray it's all a bad dream. He walks at me. I fall to my knees and put my forehead on the ground. The wet bleeds through my jeans. He goes back to the car. I'm not crying but cursing myself, asking God for forgiveness for everything questionable that I've ever done or even thought in my entire life. After fourteen seconds of reprise, I look up and see that the trooper has emptied the contents of my car all over exit 113. He's having a blast. I get up and walk into the open field off the freeway.

"HEY! You!" This time he comes at me fast, full of anger and fear. "Didn't I tell you to stay put?"

He grabs my arm and moves me toward the passenger door of his car. I stumble and fall on the ground. He drags me a few feet until I regain my footing.

"Just please, can you, sir … can you just please tell me what's going to happen?"

"That'll be up to the judge," he says.

"Judge, what judge? Sir, the thing is, you have to understand—"

"Okay, listen, you need to stop talking. You are doing yourself a real disservice by acting like this. Now you need to let me do my work and just sit tight in my car. You got caught. It's over. Best thing you can do right now is just relax."

He puts me into the car, my hands cuffed behind my back.

Ingle goes back to my car and continues his search. I sit in the car. Rex II is behind me, his tongue hanging out, breathing in my face, swallowing.

"Hey, boy," I try. Rex II whimpers at me. "Who's the good boy, huh? Rex II, what a good boy you are."

The dog ignores me. I need to talk to someone. I need to talk to Trooper Ingle. I try to reach the window button with my hand or elbow, but I can't, so I use my tongue. The window goes down. "Sir," I call to him out the window.

"HEY! I thought I told you not to touch ANYTHING! Now, you better listen to what I say or your problems are going to get a lot bigger than they are right now. And right now they are big already!"

"What does that mean?" I laugh.

"HEY, nothing funny is happening here!" He then reaches inside the car and takes his shotgun.

"What!? You think I'm going to touch your gun?" I ask, smiling.

"This is SERIOUS. You are in serious trouble, are you not getting that? I have no idea what someone as stupid as you is capable of considering what you've already proven to be capable of."

Just then, another cop car pulls up to the scene. A tall, lanky guy steps out of his car, looks up at the sky and yells, "Yee ha!" He really did that.

The cop and Trooper Ingle talk. The new guy keeps looking at me in the car, his mouth agape. Ingle continues to search and the other guy comes to the car. He opens the driver's side door and talks to me.

"You really the Trunk Monkey?"

"Yessir."

"I like that commercial a lot. Given me a lot of laughs. My boys, too. It's a family favorite."

"Thank you," I say. "I really appreciate that."

"You're welcome. You're a funny actor. How you get a job that like?"

"Uh, well, I have an agent."

"Do you, now? So, how's that work, he gets you jobs?"

"She, yeah. I mean she sends me on auditions and, you know, if they want to use me, they call her and she negotiates the money or whatever."

"Interesting."

Ingle comes to the car, puts Rex II on a leash and takes him on a sniffing tour of my vehicle. Both cops are now "yee hawing" and "ooh mama-ing" their way around, doing all they can to get Rex II barking and worked up. I know that there is nothing left for them to find.

Ingle finishes the search and the other guy takes off without saying goodbye.

"Sir," I begin.

"Yes?" he says, not looking at me.

Jerome Ingle, Texas state trooper, is a conventional-looking Tex-Mex of sorts. He has thick arms, a stout figure, large, brown hands, and a crew cut.

"I don't under-, what did I do wrong exactly?" I play the moron card.

"You're under arrest for money laundering in the state of Texas."

"Oh, okay. So, does that mean I am going to jail?"

"Sure does."

"Okay. Uh, sir?"

"What?"

"How much time can I get for that?"

"Not less than a year, I don't think."

"A year, huh. … Okay." I ponder doing time.

"How much money you reckon is in there?" he asks.

"Uh, a little over a hundred grand."

"Where'd it come from?"

"It was the inheritance of a friend's and I'm taking it back to California for him."

"That's a good one," he laughs. "You expect me to believe that?"

"I don't."

"Why didn't your friend want to take his own *inheritance* home with him?"

"Well, he was—he had to be somewhere. He had a commitment and asked me to drive it for him."

"You're a good friend."

"Thanks, I like to think so. People trust me."

"We are going to wait for a tow truck to come. Shouldn't be long." He stares

off at the horizon. The silence is terrible.

"You from around here?" I ask.

"What?"

"I say, are you from around here?"

"Yes," he answers.

"Married?"

"Twenty-two years."

"Oh, that's great. I need to get married. I think. Yeah, I think that's what I need. Marriage. … It just seems like a great thing."

"Tough, but worth it."

"Did you play sports in high school?"

"I ran track and played JV football."

"Oh yeah! What events did you run?"

"Are you kidding me, kid? Do you understand the kind of trouble you are in?"

"I know, but please, just talk to me. I'll start freaking out again if we don't talk … please."

"I ran the 400 and the 800."

"Oh, yeah? What was your best time?"

We drive, miles and miles down a two-lane road. Trooper Ingle's phone rings. "This is Gee-rome. … Oh, hey. … No, I'm good, thanks. Uh huh, uh huh. … No, just some kid, hundred grand in his trunk. Oh, get this—you know the Trunk Monkey? Well, I caught the Trunk Monkey. … Yeah, I know."

I look out the side window. The sun is setting. It'll be dark soon. It's kinda neat that these guys all know me from the Trunk Monkey, I guess. I wonder if I'll get out of jail before Amy moves to New York.

"Hey, kid, will you take a picture with my friend if he comes meet us later?"

I nod yes. Ingle says goodbye and hangs up. We drive in silence for a few minutes.

"Actually, you're the monkey," I say finally.

"What's that?"

"Well, in the commercial I break into the car, the monkey hits me over the head and throws me off the bridge. So the monkey is the cop and that is you. You didn't catch the monkey, you are the monkey."

We follow the tow truck into a warehouse. There is no police station, no cars parked outside, no other guys, no jail. A garage door opens when we pull up and it closes behind us. Inside, Ingle takes me out of the car and cuffs me to a pipe on the wall. I sit on the ground. A crew of cowboy-boot-wearing, nonuniformed folks begins ripping the seats out of the rental car, shaking their heads, looking at me. I do the math: five of them, $125,000, one bullet in my head.

I take a photograph with one guy, sign an autograph for another. They all love the Trunk Monkey. My thoughts of pending doom are interrupted when the cavalry, headed by Special Agent Jimmie Perez, Immigration and Customs Enforcement, arrives. Perez, along with two state DEA agents, Donald Fleming and Brian Frick, takes me into a nice, warm office.

They read me my rights again. A tape recorder is turned on and the interview begins. Frick asks the questions. He is youngish, has a wedding ring, baseball cap and an unfortunate goatee.

"Did Trooper Ingle read you your rights?"

"Yes, sir."

"Do you have any questions?"

"No, sir."

"Okay, so where were you coming from?"

"Birmingham." I keep staring at the digital recorder.

"And what were you doing there?"

"Sir, do I get a phone call? I need to talk to my father. He's a lawyer and I need to talk to a lawyer."

"Okay, look … you can talk to a lawyer. That is one of your rights, but this is

your chance to help yourself. If you talk to us now, you can help yourself and we can help you. But if you talk to a lawyer, then all that's out the window. We can't do nothing for you once you talk to a lawyer, because once you talk to a lawyer all that you tell us is no good."

"Listen, I'd love to help you guys, I really would, and I still hope that you're gonna help me, but I just … I know I shouldn't be talking to you right now."

Frick ignores me and resumes the questioning.

"Now I am going to ask you about drugs and you answer truthfully."

I look at Special Agent Perez, who says nothing.

"Just … can I make a phone call maybe?"

"Have you smoked marijuana?" Frick asks.

"Yes."

"How often?"

"Every day."

"Cocaine?"

"No, not since I was young."

"Ecstasy?"

"I tried it twice."

"Heroin."

"I smoked it a few times with a friend, but honestly the taste was just, eh."

"Acid?"

"No."

"Pills?"

"No."

"Mushrooms?"

"Oh, sure."

"When was the most recent?"

"I don't know, a year ago. Why can't I make a phone call?"

"Are you involved in the cocaine trade?"

"What? No. Please, just let me call my father."

Suddenly a new voice chimes in, loud and fast. It's Special Agent Jimmie Perez. "How much weed did you and Tom bring out from California?"

"Not that much."

Special Agent Perez pulls off his glasses and looks me right in the eye.

"How much did you get paid?"

"I just did it for fun, to see the country. I got a thousand bucks, but that was just for my time. Oh, and I got some cash, you know for food and gas."

"Is this Tom's money, Tom's drug money?" Perez has the rental agreement.

"I can't say."

"This guy is not your friend, David. Now either you are going to go to prison or he is. You gonna protect someone who gave you a shit wage to take this type of a risk?"

"I told you I needed a lawyer. Why can't I talk to a lawyer?"

"Whose money is this, David?"

"I don't know. I don't know whose it is. … These guys, they grow weed. It's legal, it's legal to grow. I don't know who they are or where they are, but … and … I don't know. I don't have anything to do with it."

"So, then, explain why someone would trust you with this kind of money, when you have nothing to do with it." I think for a second and answer as simply and honestly as I can.

"Because I would never take anything that didn't belong to me."

They all look at each other. They know it's true.

"Are you part of a drug cartel?"

"I'm not part of anything. I was just doing a favor. I just … I just really wanted to see the frontier." My *Dances With Wolves* reference goes over their heads.

"David, will you tell us who you are going to be giving the money to?"

"I need a lawyer. I need a lawyer. WHY can't I make a phone call? I know my rights."

It's somewhere around there that the tape is turned off and Perez and I are left in the room alone.

"Son, do us a favor, stop talking right now." I nod.

Frick comes back into the room.

"State of Texas is not going to press charges. We're gonna keep your money, let you deal with this on your own."

I look at Perez. Perez looks at Frick. My smile is full of tears. I'm getting out of it.

They take me back to the warehouse and cuff me to the pipe again. Special Agent Perez makes a call on his cellphone. Ingle hovers; his cuffs are still on my wrists. The special agent's call goes on a long time and only once does he look over his shoulder at me. I see him nodding and scratching his head underneath his hat, then suddenly he snaps his phone closed and walks toward me, reaching into his pocket to pull out more handcuffs. There is a hint of sadness in his voice as he says, "You're under arrest for conspiracy to launder money. … You have the right to remain silent." As he reads me my rights, Ingle laughs. Frick's eyes open wide.

Ingle looks at me. "Lousy actor you are," he says, laughing.

Perez put his cuffs on me. Good ol' Gee-rome just can't help himself; as he removes his cuffs, he whispers in my ear, "Son, your life's about to change."

Ingle leaves and Special Agent Jimmie Perez takes me to a holding cell in another warehouse. There, I'm finally allowed to call my father, who at first laughs, thinking I'm joking with him. It isn't until the special agent starts talking that my Dad realizes this is for real.

"Sir, this is Special Agent Jimmie Perez. We picked up your son traveling west on I-40 with a large sum of what we believe to be the proceeds of—"

"David, listen to me. Listen to me right now! DO NOT TALK TO ANYONE! DO NOT TALK TO ANYONE ABOUT ANYTHING! DO YOU UNDERSTAND ME?"

"Yes. Dad, I'm so sorry, please. … I'm so sorry." I start to cry.

"Don't worry, just promise me that no matter what you've said already, that you are not to talk to ANYONE about ANYTHING from this point forward!"

"Listen to what your father is telling you," Perez says under his breath. He takes back the phone and says, "Sir, I need to hang up the phone now. He'll be at Randall County Jail. When I take him there, which should be in about an hour, he'll be able to call you, but only collect and you can't call cellphones."

"Okay, thank you. … David, I'll be at the house in an hour. I'll wait by the phone. Just be strong. I love you."

My father comes out the next morning. It's the weekend, so I'm left to watch the Colts win the Super Bowl. The heated debate that day in jail is whether Prince, who plays the halftime show, is a fag. After spending four days at Randall, I'm released on a personal recognizance bond (no money) and I return to Los Angeles. When I get my official indictment, it reads "The United States of America vs. David Henry Schneider, aka The Trunk Monkey Bandit." A few weeks later, Amy moves to New York and I move into my father's house in San Francisco.

I take a job teaching preschool—I'm not a convicted felon yet and, besides, it's my mother's school. I go to NA meetings, get letters from teachers and rabbis, do everything I can to appeal to the judge that this experience has been enough—that I am a changed man and don't need prison to get the point. My lawyer in Texas, one Selden B. Hale, begins to think I have a chance at getting probation, but during my sentencing Judge Mary Lou Robinson, the eighty-two-year-old federal judge from the Northern District of Texas, sentences me to six months in "custody." The feds are kind enough to let me serve my time in California at the Taft Correctional Institution. On August 28, 2007, I turn thirty doing time at Taft. It's one of the most memorable birthday parties I ever have.

S

Fine and Dandy

By Jacob Heilbrunn

It's always a little daunting for me to visit my brother-in-law, an art maven and television writer who seems to have the lowdown on everything and anything happening in Los Angeles. I'll invariably ask about some restaurant or gallery that's been touted in *The New York Times* and he'll just as invariably look at me with a mixture of despair and exasperation, as if to say, "That's not so yesterday, it's *so last year.*"

This has an unerring way of making me, a native of Washington, D.C., otherwise hard at work in the heart of the American Empire, feel like something of a rube. Still, on my most recent trip, I felt sure that I had a trump card. I knew a four-letter word that he didn't: Anto.

I stumbled upon Anto in January 2009 while strolling along Beverly Drive after lunch with a friend. From the outside it looked pretty nondescript, nothing fancy. But upon closer inspection … what's that line toward the beginning of Flaubert's *Sentimental Education* when Frederic first espies his beloved, Mme Arnoux? Ah, yes: "It was like a vision: She was sitting in the middle of the bench, all alone"

Suddenly lovestruck after years of longing and misadventures, Frederic knew what he'd been looking for, and that's pretty much how I felt when gazing upon the towering stacks of fabric, the cuffs, the collars, and lapels of the shirtmaker Anto of Beverly Hills.

My stay in L.A. was about to end, however, and I had to defer a proper visit until several months later. My brother-in-law accompanied me to Anto in the capacity of a skeptical wingman. His skepticism, though, didn't last long—upon crossing the threshold he went into a kind of reverential trance, as though he had discovered a rare objet d'art thought to have been lost to time.

In his—and my—defense, shirts can have that effect. How does Jay Gatsby impress his friends? "He took out a pile of shirts and began throwing them, one by one, before us, shirts of sheer linen and thick silk and fine flannel," writes F. Scott. "While we admired, he brought more and the soft rich heap mounted higher—shirts with stripes and scrolls and plaids in coral and apple-green and lavender and faint orange, with monograms of Indian blue." In a faintly parodic finale, Daisy bends her head into the shirts and sobs, "It makes me sad because I've never seen such—such beautiful shirts before."

Me neither. Granted, Anto didn't reduce us to blubbering wrecks, but it did bedazzle us with heaps and heaps of sumptuous and brilliantly colored bolts of fabric. It was a bit like entering a time machine that returns one to a period when it was just dandy to be a dandy. As we walked around in a minor state of stupefaction, the cordial and gracious Ken Septejian—whose father, Anto, handed the shop to his sons after building it up, partly by buying out the legendary Hollywood haberdasher Nate Wise—watched with barely suppressed amusement and pride.

A glance at the photos on the wall attests to Anto's rich, five-decade history. The shop has catered to the likes of Dean Martin, Frank Sinatra, Robert De Niro, Denzel Washington, and Samuel L. Jackson. Wardrobe coordinators have called on Anto to dress up the stars of *American Gangster*, *Gran Torino*, *A Serious Man*, *Benjamin Button*, *Leatherheads*, and more. Pick a movie star's style and Anto will reproduce it for you. Chances are the shop already has the pattern in its files.

Anto, in other words, represents something of a throwback to an older era in Los Angeles, one in which Harpo Marx could, among other things, parade around in a suit fashioned out of green. Pool-table felt.

Despite rigidly maintaining its lofty standards when so many pretenders thrive, Anto has a rather democratic feel. Customers can specify pretty much any collar size, any cuff permutation. High collar matched with a James Bond-style turn-back cuff? Not a problem. Resting on a large wooden table are several dozen collar and cuff styles, including some so outré that they had never occurred to me before—dou-

ble-V indentations on the side of a cuff or two buttons running parallel rather than perpendicular to it.

Anto, perhaps the world's finest shirtmaker, in many ways reflects the ethos of an earlier era, when the debonair Arrow Collar Man, designed by the legendary illustrator J. C. Leyendecker, became a Jazz Age byword for elegance, glamour, and sophistication. Leyendecker's biographers, Laurence S. Cutler and Judy Goffman Cutler, observe that he was instrumental in transforming the Arrow label into a potent brand. "By simply purchasing an Arrow Shirt for $1.50, or so Leyendecker made one believe, a man could buy into the world of civility and prominence. ... The future of the American male stepped onto the fashion scene with the birth of the Arrow Collar Man." Arrow quickly captured a whopping 96 percent of the market.

That was then. Now, with the proliferation of Gaps and Banana Republics, the emphasis is on cheap and casual clothing. Bespoke, by contrast, has earned the reputation of being the province of the aesthete, of dolled-up young swells. It's not hard to see why. An aristocratic hauteur has accompanied men's fashion ever since Beau Brummell, the arbiter

elegantiarum and pioneer of the modern suit and tie, reinvented it during Regency England.

Then there is Brummel's apostolic successor, Oscar Wilde, who maintained, "It is only shallow people who do not judge by appearances." More recently, the British dandy Sebastian Horsley landed at Newark Liberty International Airport in 2008 sporting a stovepipe hat and Savile Row three-piece suit. After being interrogated by the customs service, Horsley was refused entry for "moral turpitude," prompting him to lament that America may be the "home of the free, but sadly not of the depraved."

Of course, there has always been something a little suspect about dandyism in America. The studied bons mots, the eye for elegance, the devotion to small touches of frippery—is the pocket square a slightly lighter hue than the shirt? Does the suit coat feature working buttons?—can often seem at odds not only with democratic virtues, but also with the strapping masculinity to which American males have long aspired. In NASCAR Nation, Barack Obama is widely seen as an arrogant elitist—and this about a president who, unlike his predecessor, doesn't insist that men don a coat and tie

before entering the Oval Office.

The same symptoms can be detected in Hollywood, the epitome of glittering outfits in the 1920s and 1930s. The truth is that for all the films that Anto has supplied with custom shirts—and they number in the hundreds—Hollywood itself has at times had a rather uneasy relationship with high fashion.

Take *Sunset Boulevard.* Gloria Swanson's Norma Desmond progressively emasculates and fetters William Holden's hack screenwriter, Joe Gillis, partly by clothing him in the fancy garments of an earlier era, including a costly vicuña coat. Gillis's imprisonment becomes palpably clear when he shows up at a bar on New Year's Eve, wearing coat-and-tails, to fetch some cigarettes for her and bumps into his young, raucous friends. They stare in disbelief at his elegant attire before he obediently returns to Norma's vintage luxury car.

The circumspection with which Hollywood sometimes views high style goes beyond mere ambivalence. Dandyism is often associated with Hollywood criminals—in *Some Like It Hot*, the ludicrously foppish chief gangster is named Spats.

But perhaps the most portentous development has been the elevation of casual dressing into a generational credo. For all the status that the Baby Boom generation has attached to being able to afford to dress down, something of a backlash against hypercasualness seems to be taking place. After all, apart from his habiliments, how can a man express himself at a time when he may be headed for obsolescence? Gyms are unisex. So are clubs. The latest studies indicate that more women than men now hold down paying jobs and more are enrolled at the best colleges.

So it probably shouldn't be altogether surprising that blogs devoted to chronicling the latest and best men's wear are proliferating, whether it's the Sartorialist or Dandyism.net. Meanwhile, venerable Paul Stuart has introduced a new and slim-fitting Phineas Cole line. Brooks Brothers is trotting out waistcoats once more.

Indeed, *The New York Times* confirms that fancy duds now represent a form of cultural protest, an anthem for younger males who recoil at the slovenliness of their elders—"a kind of rift emerging between the generation of men in their 20s and 30s and those in their late 40s and 50s for whom a suit

was not merely square but cubed, and caring about how one looked was effeminate."

The charge of effeminacy need not detain us. The stronger accusation might be that dandyism reflects a kind of saccharine nostalgia for the past, when economic inequality was at its height in America. But given the difficulty of discerning class distinctions in dress today, when a business executive is probably wearing the same khaki Dockers as his employees, an establishment like Anto hardly seems to represent much of a threat to the American creed. Instead, Anto is where you can build castles in the air for a few hours.

When the shirts you've selected from Anto actually arrive—minimum initial order is six, at a not-insubstantial $325 a pop for 120s fabric and $425 for the even more sumptuous 170s thread count—it is a moment of heightened anticipation. How did the creations you helped design actually turn out?

It is also a moment for revelation. Ultimately, Anto doesn't offer a license for hedonism, but an opportunity to exercise personal autonomy and test your own judgment. Which, after all, is what it means to dress oneself, does it not?

TO CATCH A RAINDROP

BY JUDITH LEWIS MERNIT

A January storm sweeps across the northern Pacific on the jet stream and hits Southern California with prodigious amounts of rain. It brings wind, too: bursts up to eighty miles per hour lop the tops off palm trees, waterspouts swirl, and a small tornado lifts catamarans thirty feet in the air. Here in Sun Valley, in the northern reaches of the San Fernando Valley, hail clatters so loudly on the windshield of Mark Hanna's city-owned sedan that he has to shout over the din.

"Don't open your window!" A rooster-tail wake splashes high over the door handles as Hanna makes a hard right turn around a flooded street corner. We let out a *whoop*. With the flushed and wholesome look of a man who's spent half his life outdoors, Hanna, thirty-eight and a civil engineer at the Los Angeles Department of Water and Power, is the tall, blond, and super-capable guy you'd want piloting your raft on a wicked river trip.

"It's the perfect day to get out of the office," he says after I mention I'd worried the weather would bode ill for our tour of local watersheds. "This is the only way to understand the sheer magnitude of what's going on."

And so on we go, navigating roads where ancient streams now wildly reassert themselves, as the falling rain insists on taking historic paths out of the mountains, asphalt be damned. Only an inch of rain will fall today, but in drainage-challenged Sun Valley it's enough to turn several intersections into turbulent brown lakes by midafternoon.

"The water that you're looking at would all percolate into the ground if it weren't paved," Hanna says. "We wouldn't even have generated much runoff into the Los Angeles River yet." The river, when we passed it earlier, was running high, fast, and wild.

When the city paved Sun Valley's streets in the 1960s and 1970s, Los Angeles County's flood-control engineers had finished building the county's networks of storm drains; they had neither the money nor the will for more. So while the rest of the city's storm water flows swiftly into the ocean, Sun Valley floods.

"It's like we've had the whole place wrapped in cellophane," Hanna says, "and didn't poke any holes for the water to get through."

This phenomenon makes Sun Valley something of a storm-water laboratory, a place where environmentalists, forward-thinking engineers, and water managers have been able to experiment with what might happen if Southern Californians start looking at storm water as a dry-season resource, not a nuisance to rush out to sea. It also makes the working-class community and its rainfall-capture experiments newly, and urgently, important. "We're incrementally chipping away at the urban layer here," Hanna says, "because we really need the water."

There is always too much or too little water in Southern California, which might explain why it's always worked better to pretend we have no local sources of it. We can't deal with its fickleness. Southern California's history is one of water scarcity, to be sure, and of criminal water grabs—it's still Chinatown, Jake. But it's also a story of floods—of deluges that stretched from San Pedro to Compton and often determined where Southern Californians would live; of rivers that trickled along for years until a storm stalled over the mountains and sent a wall of water tumbling down, carrying boulders, tree limbs, and whatever property humans had left in its path.

After a month of rain in 1862, the Santa Ana River "rose up in billows 50-feet high," in the words of one firsthand account, and took out the whole town of Agua Mansa (literally, ironically, "gentle waters"). Tropical storms during the El Niño year of 1905 blew out man-made channels along the Colorado River and brought back a prehistoric inland lake as the Salton Sea. The often-feeble and sometimes-mighty Los Angeles River crested after four days of late-winter rain in 1938 and washed everything—bridges, cars—straight into the ocean. That was that, the U.S. Army Corps of Engineers decreed, and 10,000 men went to work boxing up what was left of the river into a trapezoidal concrete channel that would whisk water off the edge of the continent and no longer threaten lives and homes.

What happened to the Los Angeles River happened to nearly every other natural streambed in the region. (The rare survivor, such as the Santa Clara in northern Los Angeles County, remains under constant threat of channelization as developers eye its flood plain.) Which left few places for rainwater to linger after a major storm, and still fewer

sites where it could sink back into the aquifer so we could use it later.

The worn-out phrase "We need the rain" turns out to be crazy talk in Southern California when storm water goes straight to the sea. We need the snow that falls in the eastern Sierra Nevada mountains and melts each spring to fill our far-away reservoirs. The ocean does not need the rain.

Nor does it need the bacteria, viruses, and fertilizers of urban runoff. In a natural watershed, water spreads out and moves slowly. Ultraviolet sunlight kills pathogens; riverbed vegetation eats the nitrogen and traps trash. Concrete channels, on the other hand, usher all these things quickly downstream. The ocean is mainlining urban bacteria.

The people who run the cities of Southern California have long recognized the importance of reducing ocean pollution from runoff, if only because the Environmental Protection Agency was supposed to make them pay if they didn't. (Although at times even the EPA needs a reminder: in 1999, the environmental groups Heal the Bay, Santa Monica Baykeeper, and the Natural Resources Defense Council sued the agency to enforce its own standards at Los Angeles beaches.) Still, the idea of using storm water to significantly reduce the amount of water Southern California imports from the north was once an environmental goal, like gray-water recycling, that you couldn't get utility managers to take seriously.

"Ten years ago, it was like, 'What the hell are you talking about?'" says Rebecca Drayse, the director of TreePeople's Natural Urban Systems Group. "You'd tell people we could use some of this water, and they'd say, 'No thanks, we don't really need it.'"

But that was back when Los Angeles still had a reliable supply of water

coursing down far-away mountains and through the rivers that drain into two gravity-flow aqueducts—before it became apparent that the watersheds from which the city has traditionally taken its water, the Owens River, at the base of the eastern Sierra Nevada, and Mono Lake, fifty miles upriver, could no longer withstand the consequences of those water diversions. The Owens Valley, whose river flows William Mulholland turned southward in 1913, converted to dust-clouded desert; Mono Lake became dangerously depleted and intolerably saline in the absence of the freshwater flows from four of its five feeder creeks, which the DWP diverted in 1941. A second aqueduct, which the utility constructed in 1970, took what was left of the Owens Valley's groundwater. In the 1990s, the EPA identified dry Owens Lake as the single largest source of fugitive dust—small particles that penetrate deep into humans' lungs—in the country.

At full capacity, the Los Angeles Aqueduct system carries 430 million gallons of Sierra snowpack runoff to Los Angeles every day, nearly 500,000 acre-feet a year. When the city's annual water consumption peaked in 1986 at around 700,000 acre-feet, the aqueducts supplied close to 70 percent of the city's water. But three years earlier, the California Supreme Court had already decreed that the "human and environmental uses of Mono Lake—as protected by the public trust doctrine" mattered as much as California's water rights law. As the court explicitly intended, the landmark ruling cleared the way for a long series of decisions that would force the DWP to repair some of the damage done by its water grabs. In 1994, the State Water Resources Control Board ordered the utility to begin restoring flows to Mono Lake's feeder streams, a project that's still in progress. And in December 2006,

after more than a decade of broken promises and foot dragging, the DWP finally began the "rewatering" of the Lower Owens River.

The timing couldn't have been worse for Los Angeles. The ecological restoration orders were followed by the second-worst dry spell in recorded California history. Over the winter of 2006 and 2007, only half the average snowpack accumulated in the mountains; by 2008, key reservoirs around the state were depleted to 60 percent of capacity. That year, the confluence of ecological demands and drought reduced the eastern Sierra portion of L.A.'s water supply to 17 percent.

The utility has compensated by buying more water from the Metropolitan Water District, which delivers water from the reservoirs and aqueducts of the State Water Project, the Colorado River, and various other sources to the twenty-six cities and water districts in its cooperative. But those supplies are threatened, too: in 2007, a federal judge determined that pumping water out of the Sacramento–San Joaquin River Delta, from which California gets roughly half of its drinking water, has been killing the keystone fish species and destroying the Delta's fragile ecology. The court ordered that both federal and state pumps at the mouth of the Delta slow down. Metropolitan General Manager Jeffrey Kightlinger said in a press release that Southern California has "lost the equivalent supply to sustain the water needs of a city the size of Anaheim for more than three years."

Now when I ask Hanna whether displacing imported water with local sources is something people at the city utility are taking seriously, he emphatically answers yes. Not since William Mulholland and then-mayor Fred Eaton first schemed to bring water out of the mountains to make Los Angeles a metropolis have Southern California's aquifers, in particular the San Fernando Basin—which extends across 169,000 acres of land—mattered more.

~ ~ ~

Which brings us back to Sun Valley. By the time Los Angeles County finally scraped up $42 million to build those long-sought storm drains in 1997, Congress had extended the Clean Water Act to include "nonpoint" pollution—dirty water that isn't discharged in one spot by a single offending industry, but drips and flows throughout a watershed. The untreated runoff from the eighty-four coastal and inland cities that share the county's separate storm water and sewer system—along with its permit for discharging that runoff into the ocean—would soon move into the EPA's crosshairs. Another storm drain system would only compound the problem.

So Andy Lipkis, founder of the nonprofit TreePeople, proposed a different idea: he, along with other environmentalists, persuaded the county to drop the storm drain plan and put the money toward building systems that would mimic nature, not battle it. Close to a decade later, the Sun Valley Watershed Stakeholders Group, a coalition of government agencies, business interests, and nonprofits, including the city and county of Los Angeles, unveiled its first significant achievement: Sun Valley Park, a two-acre plot of recreational green space, where storm water collects and percolates into the earth before recharging the groundwater basin with enough water to supply sixty families for a year.

"The soils in Sun Valley are the best in the city for groundwater recharge," Hanna explains as he veers north up Tujunga Avenue—another roadway temporarily reclaimed as a river today by the laws of fluvial geomorphology. "As the water comes out of the mountains, it carries sediment. And as it starts to hit less-steep gradients, the larger particles are left behind.

"In this area we're close to the foothills, so the gravel dropped out. When you get down to Ballona or to Long Beach, anywhere closer to the coast, you have the fine sediments dropping out." If you want to store water in an underground basin and draw it out later, it's best to have a basin filled with big chunks of rock where there's plenty of space for the water to flow through.

"The best place to put water in," Hanna says, "is the best place to take water out."

Those soils have also made Sun Valley a good place to mine aggregate, and the open pits those operations leave behind are excellent for water storage. The DWP and the county have a joint project in the works to turn one, the Strathern pit, into an expansion of Sun Valley Park. The pit will store water under walking trails, a garden, and a couple of soccer fields.

"We look for multibenefit projects," Hanna says. Even a city plan to tear the asphalt off roadway medians and reconfigure them as groundwater-recharging bioswales will provide bird habitat in native vegetation. Hanna admits that trash will collect in those swales. "But that's kind of where you want the trash. Because now someone can go in and pick it up, and it won't end up contributing to that island of garbage in the middle of the Pacific."

"The gyre?" I ask.

Hanna laughs. It's in part due to Captain Charles Moore's discovery of the continent-size garbage patch swirling in the northern Pacific Ocean that the public even knows what people like Hanna are talking about. "That's right," he nods. "The gyre."

"All we hear now is, 'We need every last drop of water we can get our hands on. So how do we do this? Help us do this,'" TreePeople's Drayse says. "There's been a 180-degree shift."

In October 2008, TreePeople agreed to work with the city toward a shared agenda of finding more ways to capture storm water for reuse, including incentives for homeowner-installed cisterns and rain barrels, and retrofitting more Sun Valley gravel pits. Building on work begun by the late Dorothy Green, founder of Heal the Bay and the Los Angeles and San Gabriel Rivers Watershed Council, Drayse and Hanna spent "untold hours," as Drayse puts it, working with seventeen agencies and nonprofits on an exhaustive study of storm water's potential. Published in a report by the Watershed Council, the ten-year study found that the three major watersheds of the Los Angeles region lose an average of 601,000 acre-feet of storm water to the ocean in a year. A new region-wide retainment program could recharge the groundwater with two-thirds of that. Combined with the estimated 194,000 acre-feet that already finds its way into the groundwater each year, that's enough to supply close to four million people with 130 gallons per day for a year. (Considering that DWP customers now use around 146 gallons per person per day, Hanna considers 130 gallons a reasonable conservation goal.)

The shift in the city toward local water supplies isn't simply about hydrologic cycles and court decisions; some of it comes from the lofty water values that H. David Nahai, the DWP's recently displaced general manager, brought with him to the utility. Nahai came from more than a decade on the Regional Water Quality Control Board, where as chairman he presided over a peculiar kind of theater: representatives from inland cities, protesting any restrictions on their storm drains, would deliver emotional presentations worthy of modern tea partiers, and Nahai would struggle to reel in the $300-an-hour lawyers the county had hired to fight clean-water regulations by filibuster.

Nahai was, by most accounts, squeezed out of the DWP job after two years of solid conflicts, among them a fight over stricter water-regulation rules with San Fernando Valley homeowners—the same San Fernando Valley homeowners who in the 1990s launched a campaign against recharging the aquifer with recycled groundwater. (The irony is that Orange County Republicans now own that particular innovation.)

Even with Nahai's departure, though, the conservation rules stay. Gone are the days of washing the driveway with the garden hose or watering the lawn in the middle of the day. Despite a report blaming water rationing for last year's water-main breaks, lawn sprinklers now only have 15 minutes on Mondays and Thursdays to do their work.

The rules are part of Mayor Antonio Villaraigosa's Water Supply Action Plan, a blueprint for obtaining supply for the city's projected annual increase in demand—100,000 acre-feet, or what 200,000 households use every year—from local sources. Also part of the plan is an effort to rehabilitate that San Fernando Aquifer. Industrial contaminants such as hexavalent chromium and trichloroethylene have infiltrated the groundwater; as a result, the entire aquifer has been declared a Superfund site. While the EPA orchestrates the $1 billion cleanup, Jim McDaniel, the DWP's senior assistant general manager in charge of the water system, says the utility "will go after the responsible parties to pay for the groundwater cleanup—the industries responsible for the pollution out there." An EPA report describes how one company, the Burbank-based All Metals Processing Company, allowed chromium, cadmium, and cyanide to run off its site ten feet from a storm drain.

The water-supply angle may give this plan a better chance of succeeding than earlier city measures that placed a higher value on water quality and open space. "It's really hard to quantify water quality," Hanna admits. "If you go into a meeting, and you say, 'The water quality's really going to improve, and we'll have more green space,' it's like, 'Well, that's great, but how much is it going to cost?' But if you walk in saying, 'We're going to capture enough water in this park to supply sixty families of four for a year'"—as Sun Valley Park's basin does—"it's easy to quantify the costs and benefits: we pay money for water."

~ ~ ~

Mark Hanna's first job at the DWP was with the restoration group for the Mono Lake Basin, where for three and a half years he helped figure out how to replenish that region's streams and protect its fragile habitat for fish and other wildlife.

"It's a wonderful place," he says, "a protected ecosystem, an absolutely pristine water supply." When he looked for a place to go next, he thought, "Hey, if there's a place that needs some good improvements to its urban environment, what better place than Los Angeles? I looked at the groundwater group that manages the surface flows in this area, and thought, oh, you know, we've gotta rip up the concrete—we need to get water into the ground by pulling up the concrete.

"Then I saw a spreading ground in operation, and I thought so *that's* how you get water into the ground! Those spreading grounds are operated unbelievably well. They're the mother-ship facilities of our groundwater recharge program."

Spreading grounds are a series of basins diked off by berms; when one basin fills, water flows into the next. Three-thousand acres of spreading grounds currently replenish the Los Angeles region's groundwater basins every year. Since the early 1950s, the DWP has owned the land known as the Tujunga Spreading Grounds adjacent to the Tujunga Wash, where storm flows would naturally converge after pouring out of the steep San Gabriel Mountains. In the modern engineered and flood-controlled landscape, the water is collected first at Big Tujunga Dam, and then metered out to the spreading grounds depending on how much water can safely percolate beneath the soils. Just to the west, water collected behind the Hansen and Pacoima dams is metered out to two other Valley spreading grounds, owned by the county. Until recently, the flows at both the Tujunga and Hansen spreading grounds were literally monitored by hand.

"People would be running around out there, slipping in the mud, pulling boards so the water would gush into the next basin," Hanna says, "and then they'd have to close it off and run over and open the next gate."

Last year, the county, with financial support from the DWP, upgraded the Hansen facility so that all those functions can be controlled by an operator at a computer in a warm, dry office. At the same time, county engineers deepened the basins to store more water, and reduced the number of basins from seventeen to six. "By removing those intermediate levees," Hanna says, "you give yourself more storage capacity."

The Hansen sites currently max out when water in the Tujunga Wash channel starts to flow at a rate of about 1,500 cubic feet per second—the speed and volume of the water that comes down Class III rapids on the American River. After that, they have to pull up the gate that restrains the flows, and let all the water run into the storm channel to the ocean. "If they leave it in the path of the flow," Hanna says, "the gate will start to vibrate so hard it'll rip off its hinges." The final phase of the project will involve installing a rubber inflatable dam, which can be adjusted based on the water level, and withstand the force of the water.

Similar plans have been drawn up to improve the Tujunga Spreading Grounds. With $25 million for design and construction, the city can expand the infiltration rate to capture another 8,000 to 12,000 acre-feet of runoff every year. "It's where our heavy lifting is," Hanna says. But he stresses that spreading grounds don't obviate the need for smaller storm-water capturing technologies dotted around the city.

"I liken it to power plants," he says. "You've got a big—I don't want to say coal-burning—but say a big natural-gas-burning power plant, that's going to give you your mother lode of electricity. But then if people put solar panels on their houses, that's called distributed generation."

In the same way, he says, individual low-impact development projects—rain barrels on single-family homes, swales in parks, permeable median strips—spread the work of storm-water capture through the region.

"You're talking about the most widespread distributed every-drop-counts kind of project," he says. "You can even extend it to whole city blocks."

With the storm still raging, Hanna guides us through yet another inundated street, one that would have been a natural storm channel were it not for its asphalt coating. Hanna looks down a few alleys that have turned into streams—tributaries of the major thoroughfares—with less horror than hope: "By July we should have a re-vised set of standard plans for the city that will include designs for infiltration in alleys," he says. New alleys and those in need of new pavement will be covered with a material that allows water to filter through.

"We're coming up on Elmer Avenue," Hanna says. "Forty acres drain into this one spot." There's a dog in the street. "I hope he can swim."

~ ~ ~

Almost six years ago, a woman named Suzanne Dallman went to work as the manager of storm-water programs for the Los Angeles and San Gabriel Rivers Watershed Council. While working on her PhD in urban planning at UCLA, she set out to find a block in Sun Valley to retrofit, house by house—not just to stop the flooding, although that was a significant part of the plan, but also to involve the residents in a renewal project that educated them about the geology of the place where they lived, in the shadow of a mountain range, in a watershed that drains into a major river, atop a groundwater basin that supplies 11 percent of their city's drinking water.

The outreach was a success. By the time the Watershed Council, with the help of the county, TreePeople, Pomona College, and several other agencies, secured the funding to begin the project, not a single resident of the Elmer Avenue block Dallman had chosen opposed the project. Not even the one who had to sacrifice his brick walkway so workers could install a culvert. As I look out the window of Hanna's car, the bricks of the old walkway lie in pieces on the boulevard, surrounded by street barricades. Orange cones, caution tape, and black tarps border the small front lawns of each tidy house. The street never had sidewalks; storm water flows would have eroded them too fast.

"They tore up the entire street," Hanna says, "then filled it with gravel and put these huge distribution culverts underground so that storm flows will go into that storm drain right there." He points to a cut in the curb. "It will fill up the gravel basin underneath the roadway and percolate it into the groundwater table.

"It's not done yet, obviously. But this is your perfect picture of what a low-impact community would look like. You can see that the driveways have metal grates across them, so flows coming off of people's roofs, off their driveways, will go into those grates."

In a different world, the Elmer Avenue project would have been finished by now, its yards neatly manicured with native vegetation, its curbside rain gardens slowing and sinking the storm flow. But Watershed Council programs manager Edward Belden says that state money from a 2002 water bond was abruptly cut off when the state went nearly bankrupt last fall. "That set us back nine months," he says. This meant that the residents had to cope with a torn-up street from November to July. "They were incredibly understanding of the situation," Belden says. "That was impressive, and it wouldn't have happened just anywhere." Promised funds have only recently begun trickling in again.

For the rest of the city's residents who want to do something to mimic Elmer Avenue, there is still the matter of Los Angeles's city building codes, which have long prohibited retaining water on site for fear—a realistic fear—of accumulated water eroding foundations.

But on January 15, the city's Board of Public Works approved a low-impact development ordinance that, once adopted by the City Council, will require every new or redeveloped property with four or more residential units, and every new commercial property, to capture, infiltrate, or reuse up to the first three-quarters of an inch of every rainstorm. Residents building new single-family homes will get to choose among several options for caching rain, including diverting the spouts that funnel water from the roof into a rain garden, installing a rain barrel, and cutting their concrete driveways with grass strips.

It's part of an effort "to weave nature back into the urban fabric," says Public Works Commissioner Paula Daniels. "Because, as we've learned in the twenty-first century, nature has a pretty impressively elegant way of taking care of problems on the right kind of scale."

Daniels, a lawyer and former Heal the Bay activist who later served on the state Coastal Commission, says the ordinance includes revisions to the city's building codes that Department of Building and Safety "green expert" and engineer Osama Younan drew up with his staff.

There are challenges: Will permeable asphalt stand up to heavy truck traffic? How do you square requirements for accessible sidewalks—the kind you can roll wheelchairs over—with the desire for curbside rain gardens? How will public health officials regard a rain barrel that, poorly managed, can become a breeding ground for West Nile-spreading mosquitoes?

"There are a lot of competing interests," says Daniels, who, after her appointment by Villaraigosa in 2007, put together a Green Streets Committee to encourage collaboration among city, county, and state agencies toward overcoming such obstacles. "Before, there was a lot of thinking about just keeping water away from people." As the explicit mission of the U.S. Army Corps of Engineers, flood-control projects performed only one task: they controlled floods.

The new rules will encourage projects that create open space and habitat, cleanse runoff, and capture rainfall while also protecting places like Sun Valley from floods.

In addition, the rules will streamline what once was a time-consuming trial. "Up until now," Rebecca Drayse says, "everything has been a variance. It's been incredibly difficult to move forward. But things are easing up."

Still, there's nothing yet in Los Angeles to compare with the activity in Santa Monica, which last year redesigned a street to handle the rain of not just a three-quarter-inch storm, but of a Class 5 hurricane. Low-impact development rules have been on the books there since 1992. Los Angeles had to have a water crisis before it began to catch up.

~ ~ ~

"Planning is not progress," says Mark Gold, the executive director of Heal the Bay. "Implementation is progress." And so far, he says, too many of the high-minded ideals of Los Angeles's water planners remain in the larval stage. "That the mayor and David Nahai came out with their water plan for DWP two years ago, a plan that included storm-water capture, recycling, and more conservation—that was great. That was a new day for Los Angeles. But you can't say that progress has been significant until you see what gets built. The city has made tremendous strides in the area where they've always made tremendous strides—conservation." And conservation does not create a supply, it just reduces demand.

Exactly how much of the city's water supply could local sources supply if we started managing our water right? Before it was polluted, the San Fernando Valley aquifer supplied as much as 30 percent of the city's drinking water, and it could rise to that level again. At first, the low-impact development ordinance will net only a tiny fraction of the water

the city imports, but every quarter-acre that comes unpaved has the potential to collect another 100,000 gallons of rain in a year. By 2030, that could add up to 150,000 acre-feet—a year's worth of water for a million conservation-minded people.

Local water could count for even more if Los Angeles would finally embrace what other Southern California cities are exploiting with great success: water recycling. Water from El Segundo's Hyperion Treatment Plant gets recycled for Redondo Beach, Manhattan Beach, and El Segundo in the West Basin Municipal Water District, which for the last five years has supplied recycled water to half of its customers, including the thirsty Chevron Oil refinery nearby. Orange County in 2007 inaugurated a facility to supply a half-million homes with previously used water.

Los Angeles, however, is working on yet another study of the technology. "They're so afraid of going through the 'toilet-to-tap' battle all over again," Gold says. The term was coined by San Fernando Valley Councilmember Joel Wachs, who used the phrase to stop a water-recycling facility that would have supplied water to the East Valley. The project should not have been controversial because it risked no one's health: used water would have been pretreated at Van Nuys's Donald Tillman plant and poured over the Hansen Spreading Ground, where it would have been infiltrated into the Valley's vast basin, cleansed by the same natural process that filters all the water in the world.

But Wachs prevailed, and the Tillman plant still operates as it did in 1985, recycling water for irrigation and local lakes, but nothing more. "It's frankly an embarrassment for the city," Gold says.

"The momentum on water issues slowed to a crawl when Nahai left," Gold observes. Nahai was replaced

in October last year by S. David Freeman, who had run the utility from 1997 to 2001, after serving in the Energy Department under President Carter and greening up the Sacramento Municipal Utility District. As acting general manager for the DWP until he stepped down in April, and deputy mayor for energy and the environment before Nahai resigned, Freeman fixed his sights on getting 40 percent of the city's power from renewable sources by 2020, and hoped to put plans in motion to build a solar farm at Owens Lake.

It's too soon to tell what the appointment of the utility's new interim general manager, Austin Beutner—who agreed to a $1 salary for his initial six-month term—means for the city's water supply. But Beutner, a former Wall Street trader who worked on the city's economic side, is a businessman. And with the cost of imported water from the north—once expensive enough at its pre-Delta crisis rate of around $500 an acre-foot—nearing $1,000 an acre-foot, it may be a good business decision to exploit local sources first.

A low-impact development ordinance isn't enough, Gold argues. "The elephant in the room is retrofits. Nobody is talking right now about requiring anything on existing development." And the city's low-impact development ordinance has not even kicked in—the City Council won't even consider it until summer. Meanwhile, Los Angeles County, which still sends lawyers into hearings to fight regulation, passed a similar ordinance two years ago. It's a more conservative ordinance, with rules adapted to the specific geology of each project site. "But they passed it," Gold says. "The city's is still in progress."

~ ~ ~

Not long after Hanna's rainy-day tour, after weeks of intermittent

poundings by what the Weather Channel calls a "parade of storms," the slopes of the San Gabriels give way in mudslides. Torrents of debris-choked sediment clamber down suburban streets, faithfully depositing more valuable gravel in the Sun Valley basin. Some of the spreading grounds have to be closed when the mud flows carry too much ash from the summer's Station Fire to safely percolate into the basin. They're also getting full: water from the Hansen Spreading Grounds can spill over into the nearby Bradley Landfill—another use for Sun Valley's soils. And at the Tujunga grounds, water can push air through the Sheldon Arleta landfill, pushing methane gas up into neighborhood schools.

Yet high on the spine of the Santa Monica Mountains, at the TreePeople headquarters in a city park on Coldwater Canyon and Mulholland drives, a 216,000-gallon cistern completed two years ago captured enough water last year to irrigate four acres of landscaping, gardens, and trees from March to October. The cistern ran dry just as the first of the winter storms rolled in.

And down the hill toward the Valley, along a stretch of waterway Los Angeles County restored and named the Tujunga Greenway, hawks have begun to return among the riparian sycamores. The water that's redirected from the street to replenish the wash is only a trickle—one to two cubic feet per second, two acre-feet per day.

"But if you do that year round, that's 700 acre-feet," Hanna says. "Enough to supply water to 3,000 people."

A small gain, for sure. But, Hanna insists, "it's significant." When you live in a city looking for water, every drop counts.

As this article went to press, Mark Hanna decided to leave LADWP to join Geosyntec, an independent engineering firm headquartered in Boca Raton, Fla. From the company's Los Angeles office, Hanna will continue working on the restoration of natural systems that replenish aquifers and capture rainwater throughout the Western U.S.

Is there anything that better encompasses the crossroads at which contemporary Los Angeles finds itself than the internal struggles of the Department of Water and Power? Caught between past and future, dark ages and enlightenment, monolith and whimsy, fighting against self-containment, rigid, yet groping toward a new vision.

LIGHT YEARS

A PHOTO ESSAY BY SHANNON DONNELLY

Scattergood Generating Station, 12700 Vista Del Mar, El Segundo

5752 S. Figueroa St., Los Angeles

1394 S. Sepulveda Blvd., Los Angeles

Stone Canyon Water Filtration Plant, Stone Canyon Road, Bel-Air

THE MINX

By Pleasant Gehman

In the late seventies, the Palomino was the nerve center of country music in Los Angeles. The famed San Fernando Valley roadhouse hosted Johnny Cash, Tammy Wynette, Jerry Lee Lewis, and, like, every other country star whose name meant anything. "The Pal," as regulars affectionately called it, might as well have been the West Coast wing of the Grand Ole Opry or Tootsie's Orchid Lounge. That's *jes' how country* it was. The air was always so thick with a haze of cigarette smoke and cheap perfume that it seemed like a gardenia-scented bomb had gone off. It was the type of place where the patrons really did sit at the bar drinkin' doubles and feelin' single. The cocktail waitresses, all genuine Honky Tonk Angels and Buckle Bunnies who'd moved to L.A. from places like Bakersfield or Needles or Kingman, Arizona, had aspirations of being the next Crystal Gayle. Their faces were hard lined and overly made up, and instead of Farrah-dos they had big Nashville hair, teased and sprayed. Stealthy and discreet, with the finesse of thieves, they'd sidle up to tables on the pretense of clearing empty glasses and slip their demo cassettes into the suit pockets of their music-biz clientele.

I frequented the Pal but never really fit in, even though my boyfriend was the lead singer of a popular neorockabilly group, Levi and the Rockats. Whenever I was there, it always felt as if I were on a black-ops mission or doing anthropological research. I was a stranger in a strange land—a clandestine punk-rock refugee trying to pass as an urban cowgirl. In reality, even attired in my vintage 1950s Western wear, I was only fooling myself. With my bleached-white, greased Elvis pomp and chipped, blue-metallic nail polish, I stuck out like a sore thumb among all the embroidered Nudie's rodeo duds and tight, Tanya-Tuckeriffic Spandex jumpsuits.

At least I had company—my favorite partner in crime, The Minx. In our rockabilly phase, The Minx looked like a miniature Italian movie star, circa 1959. But I knew better. It wasn't always that way.

The Minx swears I was the first punk rocker she'd ever met. We first bumped into each other in 1976 at Granny Takes a Trip. The trendy, world-famous, glitter-rock-gone-punk boutique became famous on King's Road in London for dressing the likes of T. Rex's Marc Bolan, the Sweet, and Roxy Music, and had just opened an offshoot on the Sun-

set Strip. Teenagers on leave from suburbia, The Minx and I were both trying to sell the store T-shirts we'd made. Mine had dirty words spray painted all over them; hers had two zippers down the front that could open to expose one's breasts.

Initially I looked upon The Minx as my competition, but her lurid blue eye shadow, breathy voice, and tiny hands enchanted me. Dainty and adorable, with unusually large doe eyes, a perfect, tiny nose, and closely cropped hair, The Minx was the ultimate gamine. If you dressed her in a toga and put a wreath of flowers in her hair, or maybe added a set of gossamer wings, she could be reclining in a Maxfield Parrish print.

Compared to her stature, The Minx's personality was over the top. Smart, brash, and vibrant, she was more like an idealized Japanimation character than a real person. Fun in big, fat, primary-colored Fisher-Price letters with googly eyes and cartoon smiles. Fun like an old-time whorehouse where drunken conventioneers parade about in boxer shorts and fez hats. Fun like the dimly lit backstage of a seedy cabaret in Weimar Berlin.

The Minx was always up for anything, and we became fast friends, seeing each other regularly at the Whisky a Go-Go for Ramones and Blondie shows, at the Masque for Germs

gigs, and at many a drunken party at the Canterbury Arms, a run-down apartment building on Cherokee Avenue, just off Hollywood Boulevard, where lots of punks took up residence.

The place was cheap and it rented to anybody. It was full of junkies and hookers. The manager was running scams with the landlord and probably running drugs. The elevators were tagged with graffiti and constantly out of service. Rigs and beer cans littered the shredded hallway carpet, which probably hadn't been replaced since the McCarthy era.

The apartments themselves were great, or had once been. Big starlet singles from Hollywood's Golden Age, they featured built-in vanities and Murphy beds. Mickey's Big Mouth beer typically fueled Canterbury shindigs. We would blast Clash or Adverts import 45s while people who were too young to legally drink locked themselves in the bathroom to do drugs.

Food fights left the walls of the kitchenettes splattered with day-old Top Ramen or Kraft Macaroni and Cheese. People passed out on ratty sofas salvaged from the trash. The parties usually gave way to drunken pogo dancing and, inevitably, a Murphy bed would come crashing down onto some hapless kid's head.

We would dumpster dive Salvation Army donation box-

es for our clothes and we were always on the guest list for shows. None of us had jobs, because you couldn't get hired if you had dyed your hair pink—or even black, for that matter. Nobody wanted a regular job anyway. It would interfere with our parties. As long as you had enough for cigarettes and beer, you were dandy.

We were wannabe musicians who were also painters, photographers, performance artists, clothing designers, writers, dancers, actors, and smart, disenfranchised teenagers. Then there were the older off-the-wall types who stayed at the Canterbury—refugees from the Midwest and New York, ex-hippies from Haight Ashbury, ex-Beats from North Beach and Greenwich Village, and former Superstars from Andy Warhol's Factory.

Lots of us had come from the glitter rock scene and so were comfortable with multiple partners and bisexuality. Some were openly gay, but also people were into experimentation. We didn't really believe in labels or conventional lives. At the Canterbury we even had a frisky all-female club, or gang (a la *West Side Story*), called the Piranhas. They were rumored to be a bunch of dykes, but were more like raunchy party girls, out for a good time and outrageous fun … and sex with anyone cute.

We had to do something with our time, so we drank a lot, fucked, formed bands, made Xeroxed fanzines, and drank and fucked some more.

Everything trendy in New York or, especially, in London had a huge influence on us. So when English punks started listening to American roots music, getting into Teddy Boy culture—the boys dressing in drape coats and suede "brothel creeper" shoes and the girls in voluminous poodle skirts—we followed suit. It was only a matter of time until it was de rigueur to have a rockabilly paramour.

By 1979, it had become a novelty to stand at the mouth of the stage and see handsome guys in suits and string ties crooning love songs. It was much better than standing at a safe distance from a roiling mosh pit full of boozed-up jocks slam dancing while pasty-skinned, pimply guys covered in spit and beer screamed out one-chord songs about war and the government … *with fake English accents*. Rockabilly was *sexy*. It was about being horny, not about being on the dole. Punk chicks by the dozen were abandoning their Converse Hi-Tops in favor of saddle shoes, trading in their Dead Kennedys T-shirts for bullet bras and tight cashmere sweaters—all to catch the eye of these cool hepcats.

The Minx and I swooped in for the pick of the litter before any other punkettes got hip to the scene. Our boyfriends had migrated from London, via New York's Lower East Side, and were in the hottest, and at that point *only*, nouveau rockabilly band to hit the U.S. They made all the girls in the audience swoon the way they did in those ancient newsreels about "the devil's music."

My boyfriend, Levi, was a bona fide English Ted, a Cockney singer, and The Minx's boyfriend, Dean, the drummer, had a bleached-blond pompadour and a sleepy, Eddie Cochran smile. Plus, Dean grew up in Kentucky before he moved to London, which gave him even more rockabilly cred. Their band was the toast of the town. We were madly in love with them and we became the envy of every girl who hadn't grown out her spiky hair long enough to make a ponytail.

So, of course, The Minx and I were excited and a little tipsy on the night our hepcat beaux were opening for Ray Campi and the Rockabilly Rebels at the Pal. Stand-up bassist Campi was a living legend, a Texan who'd been at it since the early fifties. His singer, Colin Winski, was tall and loose-hipped, with big sideburns and a cool yelping wail. Jerry Sikorski, the lead guitarist, looked like a combination

of slightly walleyed, bleached-blond, teddy bear, and blank-faced Barney Rubble ... but he could do back flips and somersaults with his ax strapped on and not miss a note. Our guys were duly impressed.

The after-party was at Sikorski's place, a neatly kept, post-WWII ranch house in the depths of San Fernando Valley, tract-house suburbia ... where he still lived with his parents. They happened to be gone for the weekend, he said enthusiastically, so it would be possible for the guys to jam together. The Minx and I could barely help rolling our eyes. Even though we were doing our best to be "good girl-friends," these after-parties had become monotonous. We steeled ourselves for a night of listening to the fraternity of drunken Sun Records wannabes warbling out Gene Vincent hits, or sitting there unable to get a word in edgewise while they played the entire collected works of Bill Haley and the Comets–or offshoot band the Jodimars–on scratchy 78s while the guys argued about the bass lines.

The Sikorski house was comfy, homey, and cluttered. Hand-crocheted Afghans were draped over the couch; a pile of *Family Circle*s was stacked neatly on the oversize television set. The supersize fridge was full of beer, and things brightened up considerably when Colin passed

around a joint while everyone plugged in mics and amps.

I was bored by the time they started playing and wandered through the house, impressed by the rampant normalcy, so inviting after staying at a series of punk crash pads. With morbid fascination, I admired the ceramic angelfish figurines floating up the bathroom wall. Then The Minx sauntered in, her crinolines swishing. I took a sip of the cocktail she offered, and then reapplied my Revlon Cherries in the Snow lipstick. It was *the* perfect sex-kitten shade–the ultimate in fifties glamour. I had recently switched from using the punk lipstick of choice, Artmatic's Black Orchid (only 49 cents at Woolworth's), a deep, matte burgundy suitable for extras in *Night of the Living Dead*, Puerto Rican drag queens, or those endless Canterbury parties. The Minx powdered her nose and feigned a yawn as I lit a cigarette. In the den, our boys were murdering the Johnny Burnette Trio's "Butterfingers."

Together we inspected the master bedroom. The double bed had a golden vinyl headboard and a quilted yellow-ochre satin spread. A pair of bifocal reading glasses and a dog-eared *Reader's Digest* sat on the bedside table. I flopped onto the bed to adjust the seams of my hose, and The Minx sat down next to me. Glancing down at my black fishnets, which would've been much

more appropriate for *The Rocky Horror Picture Show* or a spread in a late-1950s pulp detective magazine, everything suddenly became clear to me: all this rockabilly stuff was wearing on my punkette soul.

While the music was great, the teen idol stuff only went so far. Sure, our guys sang about back-seat, drive-in-movie sex and burnin' desires, but all they ever wanted to do in real life was have a couple beers and boast about the rare records they'd found at swap meets and junk stores. The biggest drag was that they were constantly telling you not to mess up their hair, *even during sex*. Carefully sculpting their hair with Murray's Pomade into brand-new *Rebel Without a Cause* duck's-ass dos, these rockabillies would spend hours hogging your bathroom mirror in displays of vanity that would've been off-putting even to Little Richard.

The punk guys, I recalled with newfound nostalgia, would let you dye their hair green, dripping Crazy Color all over their leathers and the kitchen floor. They'd allow you put makeup on them; they'd dress up in your underwear and dance around to Donna Summer disco songs. They wanted to get wasted on hallucinogens and have sex up against a dumpster in an alley ... which might not have been the height of romance, but was a little more exciting than listening

to a bunch of guys in sharkskin suits jabbering away all night about Ersel Hickey.

The Minx and I, it occurred to me, were just as trapped as *real* 1950s women. It was through obligation and loyalty that we found ourselves listening to endless sermons about the early days of Sun Records, dressed in our little Peter Pan-collared blouses, playing Suzi Homemaker, Donna Reed, and June Cleaver rolled into one. On the outside, we were playing Atomic Age arm candy. Inside, we were both secretly pining away for some good old-fashioned debauchery. We didn't want to be prettyprettypretty Peggy Sue, or the virginal Debra Paget, Elvis's love interest in *Loving You*.

What we *really* wanted to be was Priscilla Presley after Elvis turned her into a hooker-looking version of the Bride of Frankenstein, applying gobs of black eyeliner and wearing Bob Mackie gowns and drinking champagne while the King got wasted on Quaaludes and Dilaudid and shot out television sets in a Vegas penthouse suite. Slowly but surely, subversive, black fishnet hose and garters started replacing our bobby sox. Our old punk-rock selves were fighting to reclaim our lost power and individuality.

Ticking like teenage time

bombs, the latent desire for something more decadent was coming to a head. Suddenly, The Minx reached up to my face and gently wiped away a lipstick smudge. The next thing I knew, we were kissing.

It was tentative for a moment, but increasingly wild and passionate. Coming up for air, we shared a brief, charged glance. I reached across her to the nightstand and switched off the lamp. We resumed kissing. I gently pushed her down onto the bed, and, as they say in romance novels, she yielded to me. We writhed around, breathless. Her lips were pillowy; I tasted our recently applied lipstick. She kissed languidly, like a courtesan, and tasted like a divine mixture of cinnamon gum, cigarettes, and vodka. She ran her hands through my hair, and her fifties crystal grandma necklace clattered against my teeth as I covered her neck in love bites. My head was spinning from a combination of cocktails and lust.

The Minx sat up, grabbed my face, and whispered, "I've fantasized about this for so long!" Dumbfounded for a moment, almost expecting her to say she was joking, I stuttered, "Me too!"

She rolled over on top of me, started undressing me slowly. I felt goose bumps covering my entire body as her hands slid up my thighs, lightly snapping the elastic of my vintage garter belt.

We fooled around for a long time, our purses, petticoats, and pumps littering the floor. We squirmed our way through the guys doing Billy Lee Riley's "Flying Saucers Rock 'n' Roll," Jack Scott's "The Way I Walk," Warren Smith's "Ubangi Stomp," and—how utterly appropriate—Buddy Holly's nasty blues about a cheating woman, "Annie's Been Working on the Midnight Shift." We felt an illicit, delicious charge, having sex on a pristine bed, our friend's parents' bed, in a suburban ranch house, knowing that our unsuspecting boyfriends were in the very next room, completely oblivious to what we were doing. It was fabulous, wanton, and dirty as can be.

Finally, we'd been AWOL for too long. I could hear my boyfriend and Colin belting out "Wake Up, Little Susie" by the Everly Brothers, so we took that as a call for reveille. Giggling, we buckled up our push-up, bullet-shaped brassieres and hit the bathroom to comb our hair and fix our lipstick.

The guys barely noticed us as we waltzed into the living room, asking like perky Eisenhower-era housewives if anyone wanted a cocktail. It was as though during our secret encounter we'd slipped into a private *Twilight Zone* of teenage lust ... and our boyfriends had no idea they'd provided the soundtrack!

S

TALES FROM THE TROPICANA MOTEL

BY IRIS BERRY

Just a limo ride or drunken, one-cigarette stumble down La Cienega from the Sunset Strip, the Tropicana Motel was known worldwide during its heyday. Much like other historic addresses of bohemia, 8585 Santa Monica Boulevard was a haven and hideout for actors, artists, writers, poets, directors, sports figures, music producers, film producers, and rock stars. It was the Chelsea Hotel with poolside AstroTurf. Parties sometimes lasted for months and often ended in mayhem. There was a constant parade of groupies, photographers, and drug dealers.

Of course, the clientele also included tourists who innocently happened to share their Hollywood vacations with hookers, pimps, and junkies. Word on the street was that anything you desired—no matter how bizarre, kinky, sleazy, or unsavory—could be had at the Trop, and for an extremely low nightly rate. All just a stone's throw away from the West Hollywood sheriff's station.

In the fifties, the motel was a getaway for Hollywood's better-known character actors. But as Hollywood changed, so did the ownership. In 1963 the motel was sold to its fourth owner, soon-to-be Hall of Famer Sandy Koufax, strikeout artist of the Los Angeles Dodgers. Being a smart businessman, he immediately changed the sign to read "Sandy Koufax's Tropicana Motel," which brought in a whole new clientele. The culture shifted, too, and the movie stars morphed into television stars and rock gods. From 1963 onward, the Trop functioned as a boho playground, pioneered by Jim Morrison of the Doors, who hung around the Palms, a low-rent (and nearly as infamous) dyke bar located directly across the street from the Tropicana. He would drink there all night before stumbling across the street to pass out. Mornings after, he'd write many of the songs that became hits for the Doors. Waves of other musicians arrived and followed the same hit-making formula. The motel was also the site of numerous photo sessions and legendary band interviews, and it served as the location for the Andy Warhol films *Heat* and *Trash*. The party kept going until 1988, when the building was razed and replaced with a Ramada Inn.

Duke's Coffee Shop, underneath the Tropicana, served copious amounts of good, inexpensive food to poor artists and musicians along as well as record and film execs. The seating was family style, which meant that you could be broke enough to consider running out on your check even as you passed the ketchup to someone who could change your life in an instant. Cassettes and scripts were passed across the greasy Formica countertops; romances were kindled over hangovers.

The rooms at the Tropicana looked like Little Richard decorated them with somebody's Midwestern grandma on a lost weekend, and they were continually being trashed. The

Anthony Kiedis
singer for the Red Hot Chili Peppers

Father Knows Best: *My first recollection of the Tropicana was when I was eleven years old, skateboarding down Santa Monica Boulevard and smelling breakfast at Duke's. I first started going to Duke's with my father. Duke's had great character. It felt very cabinlike. It was so tiny and so crowded with people, from punk rockers to ballerinas. I remember seeing Muhammad Ali there once and just being so happy to be close to him. I definitely wasn't going to talk to him or interrupt him from eating his pancakes, or even stare at him too obviously, because I loved him and I respected him, and I just wanted to glean a little bit of his essence by being near him.*

motel's plumbing was iffy at best, which meant flooded rooms were a common occurrence during all-night parties. There were a few private bungalows at the back of the property where Tom Waits and Chuck E. Weiss, among others, took up long-term residence. The kidney-bean-shaped pool was surrounded by AstroTurf and painted black. This was widely assumed to be a choice of function, not fashion: the paint hid the rust stains from the patio furniture that was regularly tossed in the water. Regulars knew better than to dive into the pool—you might have an underwater rendezvous with a chaise lounge, or, worse, a syringe or two. Under the Trop's junglelike foliage there were orgies, murders, suicides, ODs, love triangles, marriages, and drunken brawls on a daily basis. There were even a number of struggling bands living in their cars in the Trop's back parking lot (which the management was fully aware of).

It was not unlikely to see Iggy and the Stooges, Janis Joplin, Van Morrison, Bruce Springsteen, Eddie Cochran, the Beach Boys, Jim McGuinn of the Byrds, Led Zeppelin, Frank Zappa, Elvis Costello, Nick Lowe, Blondie, the Cramps, Johnny Thunders and the Heartbreakers, the Damned, the Clash, the Dead Boys, Johnny Cash, Dennis Hopper, Evel Knievel, Lydia Lunch, Sam Shepard, Levi and the Rockats, legendary photographer Leee Black Childers, Marianne Faithfull, William Burroughs, Nico, Lou Reed and the rest of the Velvet Underground, the New York Dolls, the Ramones, and locals like Rodney Bingenheimer, the Runaways, Van Halen, Guns and Roses, the Motels, the Germs, and the Red Hot Chili Peppers wandering the halls or lounging by the pool.

When the Tropicana Motel's escapades came to a grinding halt in 1988 after three decades, it marked the end of an era ... or two or three. It had stood as bacchanalia central in the time before AIDS and MTV, before demographics and gentrification, and before the Reagan revolution did its damage. While it lasted, though, the Trop was ground zero for some of the best times that the underbelly of L.A. ever saw.

—Iris Berry

I loved Duke's. It was my favorite restaurant. It was my kind of place and the waitresses were cute. It would later become a regular hangout for us: Hillel, Flea, Pete Weiss, Bob Forrest, and that whole little entourage. After a long night of debauchery, drugs, women, smoking, and dancing, we would drag ourselves up to go have coffee at Duke's. We'd scrape together our spare change for food. My favorite thing on the menu was the apple pancakes.

My most memorable and monumental experience at the Tropicana was when I was fifteen years old, which I'm pretty sure was in the spring of 1977. I lived with my father, and we had become more like best friends and partners in crime than father and son. His idea of raising a kid was to expose him to as much as possible and let him sort it out. Whether it was music, drugs, girls, nightlife, or driving the car when I couldn't even really reach the pedals. He was one of the first people I knew who was into the Sex Pistols, and he gave me Blondie's first record, which was my favorite thing ever. She was gorgeous and she talked about sex and sunshine and surfing and rifles and girls and all this fucked-up shit.

One night my dad asks me if I want to go see Blondie at the Whisky. So we go to the Whisky and I watch Blondie and my heart melts a thousand times during the course of the evening. My brain goes all funny and all I can think about is my lust and love and desire and passion to smell and taste and rub up against this heavenly creature of god's finest work, who's singing like an angel. Her voice was so clear and so strong and so girly. After the show, we all kind of mingled about and decided to go down to the Tropicana, where Blondie happened to be staying in one of the poolside rooms. This was a very common experience for my father and me, but the minute I found out we were going there, I started plotting the scheme as to how I was going to get over to Deborah Harry.

Everyone was laughing and drinking, taking Quaaludes and getting blow jobs in the bushes. I was on a mission to marry this girl I had just seen on stage. My moment came later when we were all in her room. I was in the front room and I saw her walking toward me down the hallway. The minute she got in front of me I popped the question. I asked her to marry me. With all my heart, I looked her right in the eyes and said, "Will you please marry me?" I probably only came up to her sternum at the time. She looked at me for a long time, and did not coldly reject my proposal, but kind of put her arm around me and told me how sweet that was. She pointed into the bedroom where I saw some guy sitting on the corner of the bed and she said, "You know, maybe if I wasn't already married we could talk about it, but see that guy in there? That's my husband and we're very much in love." She told me she was sure I'd find the right girl and all that kind of stuff. She let me down easy. That was my most significant night at the Tropicana.

Jerry Stahl
author of **Permanent Midnight**

Stranger in a Shag Land: *The Tropicana was the first place I lived when I moved to L.A. I lived there for a couple of months in 1975. In New York I had a job as a humor editor for Hustler magazine. I wrote something called "Bits and Pieces." Then Larry Flynt decided to move the whole company out to L.A., and the entire Hustler team drove across the country together. I had a friend from high school who at the age of sixteen was already in bands; his name was Mitchell Froom, who now is a big producer. He said the Tropicana was the place to stay when you come to L.A. It was cheap and I could take the bus right down Santa Monica Boulevard to Century City, where the Hustler offices were at the time, and it was full of artists, filmmakers, and bands. Tom Waits and Chuck E. Weiss lived in the back bungalows. I didn't even know who these guys were, I just knew that they were infinitely cooler than I was. I mean every time I had a girl over, which wasn't often, they would make comments—they would whistle and hey, hey, hey. I wasn't sure if it was like, "You're okay," or, "You're a loser." I still don't know.*

Legs McNeil
author of **Please Kill Me: The Uncensored Oral History of Punk**

Turning Punk: *The first time I was in L.A. I stayed at the Tropicana. It was in 1977. I was on an assignment from High Times magazine. I was excited because I wanted to hang out with the Ramones. I remember a lot of parties happening in the rooms at the Tropicana, mostly in the rooms of L.A. punk bands. The guy from the Dickies kept coming around wanting to talk to me, but I didn't want any part of the L.A. punk thing—they just weren't cool. Tom Waits and Chuck E. Weiss were cool.*

Chuck was living in a converted broom closet and it was a disaster. I was messy, but I was really impressed with his mess. I remember once he was looking for a piece of paper from William Morris so he could pick up a check. I said, "Why don't you clean your fuckin' room so we can find this thing, get the money, and buy some beer?" It was some small amount of money, but it seemed like a fortune to us. As he was looking around in this mess he found an old pizza that was shoved into an album cover.

It was around this time that Chuck introduced me to Tom Waits. One day Chuck was trying to teach me how to play craps and he got Tom to come into the room. They seemed really offended that I didn't know how to shoot craps. Tom told me about going to Glen Campbell's house and starting a craps game there and how Glen Campbell wouldn't get down on his knees because he didn't want to wrinkle his pants or

I remember this one time, for some strange reason a bunch of guys from *Hustler*—and only guys, like twenty—all convened in my room one night. I think all of us were doing acid. I'm not a group kind of guy, but anyway we were all on acid. For some reason we were all just sitting like bats in this dark room with the TV on. Legs McNeil came in. I don't remember how I knew who he was. I guess I had heard of *Punk* magazine. Anyway, he was there. Maybe he was doing something for *Hustler*. I don't know what the fuck he was doing, but he had this horrible little hand puppet, like a little Coco the Clown, and he kept sticking it in people's faces. I was like, "Get this asshole out of here, everyone is fucked up, get him out of here." And Legs just kept getting in people's faces, being very creepy. It was bizarre. I knew that he was a guy that I probably wanted to be around, but I couldn't talk very well at the time. And I don't think I ever saw him again until recently.

I used to buy drugs at the Tropicana—speed and pot—from somebody like four doors down. I have no idea who it was. I just remember everybody had a shag and went to the Starwood. I was the only man there without a shag. I felt really less than. It was like shag central. So one of the shags was a drug dealer. I just knew that everybody in every room was having much more sex and fun than I was. But that I was probably doing more drugs.

I remember one night I went across the street to get a massage above that lesbian bar. Loaded out of my mind, I just needed whatever, and this unhappy and possibly laziest woman in the world was woken up by the woman who runs the place and sort of read five minutes of Braille on my spine and took $70 from me. So I sheepishly went back to my room and hated myself until it was time to go to work. Other people probably actually had sex there at the massage parlor. I was just shamed.

I never hung out at the pool at the Tropicana because I don't think I knew it was there. Was there a pool? I had a day job, which I think separated me from everybody else there. I was always working.

There were roaches, I do remember that. They were like big palmetto bugs; they were nice roaches. Not bad, a lot nicer than New York roaches. Honestly, I probably brought them with me from New York in my suitcase, now that I think about it.

The maids were cool. I remember telling the maids not to come for four days, and they'd stay out, and when they did clean they'd leave my joints in the ashtray.

I never went to parties at the Tropicana; I was never invited to anything. I was just some weirdo there. I didn't really know anybody in

L.A. I had won all these literary awards in New York and I was too fucked up to know what to do about it, so I started writing porn and then I ended up at *Hustler*. I think I flew a couple women out from New York, different girls to stay with me at the time, at the Tropicana. They were all suitably unimpressed. They probably wished they were with one of the cool guys, with the shag, four doors down.

Duke's was great. I ate at Duke's every morning and pretty much every night. I saw Sam Shepard eating breakfast there once or twice. I remember I liked the way he was just sitting in the midst of a whole bunch of people, and he would be like a prairie dog coming out of a hole to look around. He seemed very above it, and I wanted to emulate that look. He had so much raw sensitivity and intelligence. He could sort of read what everybody was thinking. But with me it looked like I was just staring at their food.

Even after I moved out, I ate at Duke's all the time. Once in a while I would end up back at the Tropicana. I'd go there to write. I'd lock myself up for a couple of days at the Tropicana and get really fucked up and just write and stumble down to Duke's to eat and stumble back up to my room. It was a great place to write.

When I heard the Tropicana was torn down I felt bummed—I figured I probably still had some drugs hidden in a closet there somewhere.

something. That horrified Tom. I asked Tom if I could interview him and he said yes. We did the interview the next day in the lobby of the Tropicana and it was one of the best interviews I've ever done. He was so good. He talked about his father, who did Spanish voice-overs for the movies, which was great because it was a whole part of the movie industry that you never heard about. I asked him if he ever wrote a cheap paperback novel what would the title be. And he instantly said, and I always loved him for this, *Love Wears Shades*. At this point, a girl comes in who was obviously a junkie. She was saying, "Tom, Tom, I need to talk to you," and he's like, "Wait a minute, honey, I just gotta finish this interview and then we'll talk." She kept interrupting, and then she lifted up her skirt and on her inner thighs were huge open sores, and we both recoiled in horror. She had some weird case of the clap. Tom said in that voice, "Well, honey, you need to go to the

doctor. I don't think I can help you." His voice was so deep. I kept waiting for him to clear his throat, but that was just his voice.

There was a blonde girl from Canada who would knock on my door in the middle of the night. One night I was passed out, so she came in, got in bed with me, and we started fucking. Someone started banging on the door. Turned out it was a guy she had just turned a trick with. He said he just wanted to see if she was all right. I had no idea that she was a prostitute. Then her mother called (she gave my phone number to her mother) screaming, "Where's my daughter?" After all that, I switched rooms. I thought they were gonna come and arrest me after her mother told me her daughter was only fourteen.

We didn't like L.A. punks because they seemed like they just got it and in New York we'd already been doing it for three years. The L.A.

punks lived in nice houses and in New York we were broke on the Bowery. And they had cars. None of us in New York had a car, except for Debbie Harry. Debbie had a Mustang and she would park it in front of CBGB and drive everybody home every night. Now in L.A., it was about anarchy and class warfare, and for me it was about *Gilligan's Island* and the Ramones. For us, it was very fun and very joyous. After the Sex Pistols became famous you suddenly got something different.

I went up to San Francisco to go cover the Sex Pistols show and was in the bathtub with this chick when I heard that the Sex Pistols broke up. That really hit me hard. I thought it was all over. It was only about a week between the time the Pistols had became really huge and then they broke up. I went back to the Tropicana and everybody in the world was a punk now. This was 1978.

1. Joan Jett, Billy Idol, Pleasant Gehman, and Wendy **2.** Stiv Bators of the Dead Boys and Thom Wilson **3.** Kevin Kiely of the Mumps, Pleasant Gehman and Rob Dupré, also of the Mumps. **The** Dickies' Leonard Graves Philips **5.** Johnny Thunders **6.** Poison Ivy Rorschach of the Cramps **7.** Marty Wetherington **8.** Bryon Gregory of the Cramps **9.** Debbie Harry and Pleasant Gehman **10.** Rick Dubov, Paul Body,

Chuck E. Weiss, and Tom Waits **11.** The Cramps—Poison Ivy, Lux Interior, Nick Knox, and Bryon Gregory **12.** Kristian Hoffman of the Mumps **13.** Lux Interior **14.** Cynthia Ross of the B Girls, Stiv Bators and Joan Jett **15.** Cheetah Chrome of the Dead Boys **16.** Billy Klub and Karlos Kaballero of the Dickies. All photography by *Theresa K., Punk Turns 30*; watercolor by *Fred Rochlin*.

Bebe Buell
writer, painter, singer, and mother of Liv Tyler

A Fine Romance ... or Two or Three: *My first real introduction to the Tropicana was when I met Elvis Costello, which was in June of 1978. I was with my girlfriend Pam Turboff the day before Elvis played Hollywood High, and Pam had to drop something off at Elvis's manager's motel. That's when we went to the Tropicana. We had to walk past the pool and all the rooms. I remember thinking that it was a cool little place and Pam was telling me it's a great place if you're a rock 'n' roll band that doesn't have a lot of money. It was the poor man's Sunset Marquis. Rock 'n' roll bands either stayed at the Marquis, the Tropicana, or Le Parc. This was way past the days of the [Hyatt] "Riot House." It's interesting, the ambience and the element of romance and seediness that was entwined with the Tropicana; it just had some sort of wonderful vibe. It had a lot of magic.*

Brendan Mullen
nightclub owner, author, founder of The Masque

The Blind Eye: *I'm originally from Scotland, but I blundered into this town from England with friends in about 1975 thinking there was going to be some wild scene in L.A. But our perception when we got here was that it was absolutely stone dead. Nothing was happening at the Whisky and I couldn't relate to the straight TGIF disco scene, or the action at the Odyssey Club, since I was kind of past my fake bisexual, junkie, rent-boy period—inspired, of course, by Lou Reed's Transformer album. There were no local, street rock 'n' roll bands, except for a few Kim Fowley prefab bands with nowhere to play. Rodney's English Disco was not long for the world, and, besides, I couldn't get the glitter-fairy act or the silver hot pants and Spiders from Mars platforms to work for me.*

There was On the Rocks upstairs at the Roxy. But you couldn't get in there unless you hung out with Harry Nielson, Bernie Taupin, Alice Cooper, Richard Perry, Jack Nicholson, or Harry Dean Stanton, and I knew none of those people, so forget that. Next door to the Roxy, any phony, vaguely limey accent worked like a charm with truckloads of delightfully impressionable wee lasses at the Rainbow Bar & Grill, another cash-and-carry business for Lou Adler and company, where everybody still sat around listening to Bad Company and Led Zeppelin. So our entertainment consisted of gawking at Keith Moon and entourage warming up for the capper of the evening: the destruction of an entire suite at the Continental Hyatt, known as the Continental Riot House, on Sunset Boulevard. Maybe tonight he'd drive another Rolls Royce into the swimming pool? Who knew? Who cared? Everybody cared. Really, there was nothing else to do or talk about.

For the more intellectual boho type, there was no other option but to hang out at the Troubadour, the former folk-rock joint whose time had long, long past. There was never a soul in the place other than the bartender. The highlight of the

I'd met Elvis briefly the night before [when Pam and I went to see the Runaways at the Whisky], but our actual romance began in the parking lot of the Tropicana. When he saw me walk by with Pam he sort of dashed out so that we would see him. I remember it was about 100 degrees outside and he was in a suit and tie and that made me laugh. Pam had this wonderful convertible and she could see he was smitten with me and wanted to hang out. He asked, "Where are you guys going?" Pam said, "I gotta go back to work, but I'll give you guys the car."

So we dropped her at work and we had the convertible for the whole day. That night we went to the Whisky to see Nick Lowe play and then all of us went back to the Tropicana. Elvis was in the Sam Cooke room and was sharing it with his drummer, Pete Thomas. I remember Elvis had the fold-out couch and I warned him that he was going to be crippled the next day because there were always those big lumps in the middle. Elvis and I had our

first kiss standing there, then he dropped dead and passed out. Pam and I were laughing, and we took his shoes off and tucked him in the sofa bed. In March of '79, after Elvis and I had become a couple (we had already been living together for a few months), we stayed at the Tropicana again; it was great.

It was after Elvis and I broke up and I started to hang out with Stiv [Bators] in 1980 that I stayed there again. The Dead Boys had a show at the Whisky the night John Belushi played drums. That was a cosmic night. We were Tropicana babies; we had so much fun in that pool.

I remember one time Stiv and I were in the pool swimming and splashing everybody and George Thorogood walked by. He was wearing snakeskin boots, so Stiv called him a faggot, grabbed him by the leg and pulled him into the pool fully clothed. Now because George Thorogood thought they were scary punk rockers, he tried to act cool

about it and was laughing. And me being an anal neat freak, I was more concerned about the boots than him. I'm like, "OK, let's get the boots off him." We had so much fun in that black pool. I know that the pool was the only way we could get Cheetah Chrome to take a bath. There was enough chlorine in that pool to kill Los Angeles. If you wore a black bathing suit in that pool, when you got out it would be brown.

My fondest memories were those nights when you'd have a few people come and hang out, and everybody would sit around the pool under the palm trees with their doors open and everyone running from room to room. But when I went back in the early eighties to play my own gig in L.A., my band and I stayed there, and it just wasn't the same. The Tropicana was definitely on the outs. The clientele had gone really metal. And punk rock and metal are just different degrees of obnoxious. It was a whole different vibe. I knew the romantic side of the Tropicana.

evening was watching Tom Waits passing out at the bar and being carried back to his bungalow suite at the Tropicana Motel by Chuck E. Weiss, who could barely stand up himself.

The Troubadour was tightly tied in with the denizens of the Tropicana Motel, which at that time included Waits, Chuck E. and Ricki Lee Jones. Ricki wrote the song "Chuck E's in Love" while staying there. Those solo singer-songwriters, the old Geffen mafia, were the only thing left in town at that time. You have to understand that by this time, in 1976, the Roxy had knocked the Troubadour on its ass as the big place to gig.

Fast forward to 1979. I had a couple of clubs called The Masque. The first version was all local punk bands from Hollywood and basically L.A. County. Then I got involved in this other space on Santa Monica and Vine called The Other Masque, and at that point I booked more national acts. I flew the Cramps out from New York, the Dead Kennedys from the Bay Area, the Dead Boys from Cleveland. Then I got a call from Leee Black Childers [famed photographer of early punk and former manager of the

Heartbreakers]. I got all excited, I thought I communicated with heaven or something. He starts giving me a spiel about a rockabilly band, and he goes, "I know your club's punk but, blah blah blah blah blah, but maybe this would be different." I'm going, "Leee it's all right. You don't have to explain what it is." I guess he thought that I was a punk who thought Bowie started rock 'n' roll, you know like a lot of the Masque punks did. So, "blah blah blah, yeah it sounds good." It was wide open, anybody could play, it wasn't closed booking by any chance. So Leee says, "OK, I'm coming."

I pick up the phone at the Masque a few weeks later, and I hear, "Hellooo, it's Leee Black Childers. We're here at LAX." And I go, "Oh, you are?" He hadn't made any prior arrangements. So I scurry around and haul out there with Hal Negro, 'cause he was the rich guy and he had a car. The idea was to get them and to take them to the Tropicana.

So we tool up there, and there were these adorable guys, teenage guys with these beautiful hair cuts, quaffs from the fifties. And the threads—they were a showstopper. Usually, the

first thing a manager says to me is, "So where's the venue? What time is the load in? Where's the hotel? What's our per diem? Where's the equipment?" But the only concern with Levi and the Rockats and Leee Black Childers, especially Leee Black Childers, was, "Where the fuck can we score some Crazy Color?" You know, for Leee to dye his hair blue and pink. So we tool over to Poseur, which was still on Sunset, and fixed them up before heading to the motel.

No arrangements had been made at the Tropicana, and I was thinking that Leee was going to book a whole bunch of rooms. But he goes in and books one room, hiding the band outside. He gets the keys and then they all tiptoe in. I was completely taken by surprise because there were five guys and Leee, and I said, "You're all gonna crash in the one room?" And Leee was like, "Don't worry about it." Levi and the Rockats ended up staying for a couple of months in L.A., six guys in one room at the Tropicana Motel. As it turned out, management tended to look the other way a lot and let bands crash four or five or ten to a room. That's what made the Trop what it became during the punk era—turning a blind eye.

Jimmy Zero
rhythm guitarist for the Dead Boys

Heaven and Hell: L.A. was supposed to the last stop of our American tour in the fall of '77. They checked us into the Hyatt House on Sunset and we hated it! We expected to like it because it was so notorious, and we got there and thought, "Man, this sucks, this is like a glorified Ramada Inn, except there's palm trees." So we bitched about it to Sire Records and they moved us immediately to the Tropicana, where they wisely thought we would feel more at home. We didn't even get our luggage out of our car in the parking lot before we were in complete agreement. We thought, "Now we're talking."

Henry Rollins
writer and singer for Black Flag

Waking Up Into the World: In the summer of 1981 when I joined Black Flag, the police in the South Bay, where Black Flag lived, had run us out of Torrance. So, being homeless upon returning from our tour, we crashed on the floor at that group house that they based the movie Suburbia on, the Oxford House. It wasn't too long before we wore out our welcome, so we got an office space on top of Unicorn Records, which was about fifty paces west of the Tropicana. We were extremely broke, but you could get a very good breakfast of three eggs, potatoes, and sourdough toast and coffee for about $3.50 at Duke's. We were there as many days as we could afford breakfast or dinner. If we did an interview, we would start insinuating that we were starving to the interviewer by saying things like, "Oh and you're a nice girl from UCLA and your dad's a gynecologist and you should take the whole band out to Duke's for dinner."

Because it was so close to where we were staying, we would be around the Tropicana all the time. "Hey, there's that guy Rodney who interviewed us last night, detoxing by the pool."

Whenever you heard a band on *Rodney on the ROQ*, chances were that about an hour after they finished the show you could go to the Tropicana and hang out with them. If you wanted to come to town and, as ZZ Top says, "be low down in the street," the Tropicana would be the place to go. Say you wanted to go meet Nick Cave and the Bad Seeds. Go hang out by the pool at the Trop.

I really liked Duke's as a feature of the Tropicana. It was a great restaurant, and if you were staying at or living in the motel it was so convenient because you go like ten drunken, chemical steps and, boom, you're in the breakfast place. It's a no-brainer if you're fucked up. I never did the drugs, but I watched a lot of people kind of sit over a cup of coffee waking up into the world.

Some of my memorable Tropicana experiences were waiting in the Sunday-morning line to get into Duke's. So one time we

One afternoon I walked out of my room and Nina Hagen was out there sunbathing in a garter belt and stockings, panties and a bra, and sunglasses. I thought, that must make for interesting tan lines. We'd heard a lot about Kim Fowley and Rodney and suddenly these people were there around us in the flesh and blood. It was the coolest thing. We thought it was show biz at its finest and pure L.A. Kim Fowley came over to one of the parties at the Trop and he had his valet or whatever you call them, his "Man Friday," who never left his side. The valet entered the room, clapped his hands and got everyone's attention. He announced "Kim Fowley," and announced all of his gold records and his platinum records, the whole rap sheet. And when he was done, Kim walked in. I'm like

holy shit! You'd never see anything like that anywhere else in the world. It was beautiful.

Not long after, I saw a whole bunch of chicks out in front of Cheetah [Chrome]'s room. They were waiting to get in to have sex with him. That was the first time I ever saw anyone line up outside of a motel room for sex like that. When I went in, he had this ice bucket an inch deep with Quaaludes. As I'm trying to talk to him, he picks up the ice bucket and just dumps like ten Quaaludes all over his bed and all over his face, and about two or three made it in his mouth. It was crazy. There was no talking to him.

One night, I came back to my suite

and found the floor covered literally wall to wall with naked people. I'm not exaggerating. I didn't recognize one single person. It was the ugliest thing I've ever seen in my whole life. It looked like a snake pit. A slice of hell on Earth.

When Nick Lowe got married to Carlene Carter they had their reception at the Tropicana and everybody was there, Johnny Cash, everybody. The people at the Tropicana told Stiv [Bators] that there was no invitation list, but there was a list of people who weren't allowed to attend any of the ceremony, who were to be kept away. And they showed him the list and his name was at the top of it, number one. Stiv was so proud of that. He said, "I'm doing everything right!"

had just driven down from San Francisco playing two sets at the Mabuhay Gardens for Dirk Dirksen. You get in the van, you drive home still in your gig clothes, jeans and a T-shirt. You're aching in pain, 'cause you've slept in a fetal position. I had my face on Chuck Dukowski's back all night. We were like this intensely young, male grunge pit inside this van. So we scrape ourselves off and get out of the van and we had money from the gig. And when we had money our reward was, "We're gonna eat today at Duke's and we're gonna get omelets!" So we've basically just come from driving the Grapevine and we stagger into Duke's after waiting in that line in the blaring sun, our hair is standing up and there's this guy with a scarf around his head eating his food, staring at me. Now I'm really in a bad mood, and believe it or not I was raised to be a very polite person. I say "please" and "thank you." I don't usually look at someone and say, "What the fuck are you looking at?" But that morning I was in a really bad mood. And there's this little guy looking up at me, with his big saucer eyes tripping on me and I say to him, "What the fuck are you looking at?" And he buries his face in his food, starts eating, and gives out a sheepish "Sorry."

Greg Ginn looks over at me, he's like, "Ah, that's Iggy Pop," and I'm thinking, "Oh, fuck," because how much do I worship this guy? I was so bummed. I dissed The Man!

We used to use the phones in front of Duke's with phony credit card numbers that we bought from some guy at Oki Dog. It would be me and Mugger, eyes to the street, looking out for cops because we were sure that the phone company was on to us. We'd call these record stores all over the country asking them if they had Black Flag's new album, *Damaged*, and if not to please order it. We'd do that for hours, and that's where I'd see the endless parade of punk-rock stars walking back and forth in and out of the Tropicana. I'd see Wendy O. a lot. She was so scary looking with her big old intense implants, and her "I've-done-a-lot-of-shit" look on her face. She was a rough woman. The last time I saw Wendy O. Williams alive was at Duke's with all the Plasmatics. They were staying there when they blew up the bus at the Sports Arena and it didn't really work.

I'm tragically attracted to femme fatales, chicks with their hair messed up, their

mascara running, who look dangerous and really hot. I love women like that. I can't help it. You see these women and you know they're gonna break your heart, they're gonna tear you up, they're gonna leave you, and they're gonna laugh like Satan. Yeah, and you'll always remember them. The Tropicana was full of women like that.

The rooms were kind of sleazy. You'd walk in with the attitude, "What's so cool about this place?" Then you realized it was because you could do anything. You could die here and it would be cool. No matter what you did at the Trop, you could not get thrown out. If you ran naked up and down the hallways screaming like a maniac, they would just say, "Oh, I love that guy's record!" You could have eighty people in a room all night and no one was going to care. Me being in Black Flag didn't always get me into all the parties, plus the fact that I don't do drugs, and not only that, but in those days I was very disapproving of that behavior. Whereas nowadays I don't play judge. I just say, "Well I hope you don't die, 'cause I hate going to those funerals."

Chuck E. Weiss
singer for the God Damn Liars

$6 a Night: *I met Tom Waits in Denver, Colorado. We were buddies there and wrote songs together. One day he asked me, "Why don't you move to L.A.? You can stay at my place." At the time he lived on Coronado Street, between Echo Park and Silver Lake. So I moved. Tom knew about this great place for breakfast, which was Duke's, the restaurant at the Tropicana Motel.*

I'd never heard of the Tropicana before in my life, but it had been popular in the sixties because Jim Morrison would hang out there sometimes. Morrison liked to go to the Palms, the gay women's bar across the street.

[Tom and I would] drive to Duke's every day to eat, and every day I'd look at the Tropicana sign that said $6 a night. I thought, instead of driving here every day I should just move in here. And so I did. Then Tom spent so much time coming there to visit me that he decided to get a place there as well. I mean, it was $6 a night, how could you go wrong? Because of Tom's cult following, him living there put the Tropicana on the map, and the legend started. This was in 1975. I ended up living at the Tropicana for about six years, and during that time I stayed in every room they had.

Iris Berry
author, poet, performance artist

What the To-Go Girl Saw: *The first time I went to the Tropicana Motel, at the tender age of seventeen, it was love at first sight, and I would have moved in if I didn't have three older brothers who would have hunted me down and dragged me out by my Chemin de Fers. It was 1977 and I was a bored Valley teenager looking for punk rock and intrigued by Hollywood after dark. One night at 2 a.m., in the Rainbow Bar and Grill parking lot, I met punk-rock prince Gerry Gora, who was the bass player for the New York band Wayne County and the Electric Chairs. We ended up partying at a radio legend's house in Beverly Hills, straight up Coldwater Canyon and amply supplied with Quaaludes and mountains of cocaine, not to mention naked people hot-tub hopping and having sex everywhere. When daylight came, Gerry took me to Duke's Coffee Shop at the Tropicana. I knew the minute we arrived that I'd found a home.*

The line at Duke's was stretched all the way down the block in the blazing hot sun, with people still dressed in the previous night's attire. We fit in perfectly. Once we made it inside, I felt as if I had been transported to another time, in a place I had only read about in Damon Runyon stories. With its East Coast vibe and family-style seating (it could be hell if one were claustrophobic), it was loud and anything but private. People talked over the waiters yelling out food orders and the grinding of multiple milkshake blenders, along with the clamor of plates, the tossing of dishes into bus tubs, the trading of ketchup and hot sauce bottles, the ringing of the cash register and the telephone, and the comforting sounds of the grill sizzling, crackling, and frying food that could stop a heart. Music played from a dust-and-grease-covered transistor radio perched on top of the cash register, which was plastered with band stickers, Polaroid photos, postcards, and bumper stickers. I couldn't make out what the music was, probably Art Laboe's *Golden Oldies*.

Sitting at the same table with us was Lita Ford from the Runaways. Gerry knew Lita, but then Gerry knew everybody.

A few years later I got a job at Duke's as the to-go girl, which meant I had a front-row seat to one of the most exciting scenes in town.

The first night I moved into the Tropicana there was a gunfight between a pimp and his hooker, but I was too high to know what was going on. I was just walking down the corridor talking loud and John Drew Barrymore pushed me out of the way of a bullet. John was a real character. At first he didn't want to have much to do with me. He didn't like me because I was an obnoxious kind of a guy when I got loaded, and I was always asking him to recite his piece from *High School Confidential*, where he talks about Christopher Columbus in a hep, Lord Buckley style. We became good friends later on, though.

The Tropicana was full of people in the middle of their big deals and projects. They were all getting ready to get famous. William Burroughs stayed there a lot. He'd stay for three to four weeks at a time. One time I saw him beat the shit out of a young woman in Duke's; he just slapped her silly, knocked all the glasses off the table, knocked her down, got up, and left.

There were train tracks that ran down the middle of Santa Monica Boulevard. The train would come at 11 at night or 3 in the morning. Waits and I used to hop the train down to the Troubadour. It was pretty weird no one noticed the train. You could come in on the train and people would say, "What, what train?" That's an L.A. thing—people here are oblivious.

When people come to a motel, they're looking for a wild time and they let all their inhibitions drop. I'd say that 90 percent of the reason I even stayed there was because of the wild exploits that I had with the opposite sex. My rent was really cheap and most of the women I got involved with at the Tropicana could supply me with dope, too. One time I was walking down the alley and this French woman was sitting on the toilet. We just started talking, and the next thing I know it's three or four days later.

Another time I was just laying by the pool and this woman comes out of nowhere, invites me in to her room, shuts the drapes and takes off all her clothes. That kind of thing would happen on a daily basis, at that motel. Everything about Hollywood that you could ever imagine happened at the Tropicana.

Every day at around 3 p.m., George Thorogood, who lived at the Tropicana, would arrive with his acoustic guitar and burst into song. I remember thinking, "Who is this guy? And why does he think we want to listen to him?" A few years later he was a superstar.

Chuck E. Weiss was living in the bungalows in the back, and a day didn't go by when he wouldn't come in around 4 p.m. (his breakfast time) and have his usual: a hot bran muffin. "Put it on my tab," he'd always say as he left.

Andy Kaufman came in nearly every morning, ate his breakfast, read the newspaper, went to the bathroom, and didn't return until an hour later. We all thought it was strange, but never questioned it, because, well, he was Andy Kaufman. He was quiet and shy, and very well mannered. Everyone just let him be. When he died, it was a shock to all of us. He never seemed sick.

My dad would randomly come in to check up on me, and one day he sat at the counter right next to Joe Strummer just as I was serving his coffee. I was horrified. Nothing like having your dad show up at a place where you wanted people to think you were cool. Lucky for Dad, he knew Fred, the day manager at Duke's, so he felt like someone was always watching out for me. He also felt free to drop in at any time.

Often James Chance (the Contortions, Teenage Jesus and the Jerks) would sit at Duke's for hours reading books on Nazi Germany while eating his Duke's Hamburger, always ordered rare. The Chili Peppers were always there, too, before they were superstars and just another neighborhood band hanging out at the Tropicana coffee shop and pool.

Legendary session guitarist and keyboardist Al Kooper, who founded Blood, Sweat and Tears and became a producer and A&R icon (he discovered Lynyrd Skynyrd) was another adored regular at the counter. He and I became quite fond of each other in a platonic way, and I looked forward to our humorous banter. He later married my best friend from high school, Vivien. And I truly believe if we hadn't bonded over eggs and one-liners at Duke's that the two of them might have never married.

I also saw a lot of crazy goings-on in the rooms of the Tropicana. The motel was the well-known last stop after a long night of partying and gigs at all the local clubs. It was the perfect place to stay if you were a punk band on tour because of the management's rock 'n' roll–friendly hospitality. Although at a certain point a sign was posted that read, "No hair dyeing in the rooms!" Guests were ruining too many towels and leaving their mess on the bathroom carpets and walls.

When I heard the Tropicana was closing its doors, I wanted to stay one last night for old times' sake. I was with my boyfriend Ratsass, former singer of the notorious Sacramento punk band Tales of Terror and then singer for the band Pirates of Venus. I was in a band called the Lame Flames at the time. We were drunk and ran through the halls knocking on all the doors, screaming at the top of our lungs, "It's the end of an era!" No one seemed to respond or even bother to open their doors. It was just another night at the Tropicana.

We stayed up and watched WWF wrestling and *Movies 'Til Dawn* on Channel 5. When we woke up, we watched *G.L.O.W.: Gorgeous Ladies of Wrestling* and then went down to Duke's for the last meal. After we finished our Monte Cristo, banana pancakes, and coffee, we went to the lobby and sadly payed our tab. The bill came to $30. The management let us keep our room key as a souvenir. Later that day Ratsass complained about catching a voracious case of crabs. "Oh how nice," I thought, "another souvenir." I told Ratsass that they were probably from somebody famous. He wasn't amused.

*"Tales from the Tropicana" is based on interviews **Iris Berry** has done throughout the 2000s; she is compiling the interviews in a book she hopes to publish in 2011.*

THE

HEP-C

GENERATION
BY JOHN ALBERT

The bridge into Tijuana passes over a sea of cars before descending into the bustling chaos of a city in a near-celebratory act of self-destruction. In the past several years, Tijuana's violent narco wars have claimed the lives of three police chiefs and hundreds of civilians, including children. Severed heads have begun turning up around the city like some Aztec-inspired admonition. I walk past a pool of evaporating vomit on the ground and copper-colored blood smears on a graffiti-etched wall.

It's morning and the sun is already frying the pavement. Crossing the bridge with me are tired-looking Mexican families, sun-burnt German tourists, and a handful of solitary men who I assume are seeking the various forms of vice found far easier and cheaper amid the lawless poverty of Mexico.

I pass through a heavy iron turnstile and emerge into a bustling Tijuana plaza. The place is crowded and abuzz with commerce—taco vendors cook up an assortment of meats and cramped storefronts offer cheap souvenirs. Within seconds a taxi pulls to the curb.

"Adelitas?" the driver calls out through the open window, referring to one of the larger Tijuana brothels.

"No, *gracias*," I reply.

"Cheecago Club?" he counters, naming another.

I keep moving. After a few blocks a small guy with a mustache confronts me. I notice that he has a fully formed hand sticking out of his shoulder where his right arm should be.

"Marijuana?" he asks in a high, raspy voice.

I shake my head. He falls in step alongside me. I can't tell if he's twelve or fifty.

"You want girl? Very young, has a tight pussy. Hundred dollars."

"No, thanks."

"What you need, amigo? I get you anything you want."

"I'm just here to see a doctor," I say, and turn back toward the plaza, scanning the horizon for what the receptionist at the William Hitt Center described as a tall building with a red medical sign. On this morning I belong to another sect of frequent visitors—those in search of a miracle. This setting seems an unlikely place to find one, but they say the polluted waters of the River Ganges can heal as well.

My journey into Mexico that morning began almost three decades before in the backroom of a small record store on a boulevard in Pomona lined with Pentecostal churches and vacant lots. The town, thirty miles east of Los Angeles, was once the hub of a thriving citrus industry. It has long since degenerated into one more suburban slum. A gangly ex-radical in his thirties who had glommed on to the local teenage punk scene ran the store. He sold vinyl over the counter and purple tabs of LSD under it. His hippie friend, "Jesus," would drive an old ice-cream truck around the city selling weed and hallucinogens as well as the occasional snow cone. My friend Rozz had recently dropped out of high school and was living with his new boyfriend, Ron, in a back room of the store where the two of them explored sadomasochism. One would periodically hear the sound of a cracking whip followed by a delighted scream. Love was in the air.

They kept a dead cat in the freezer. Ron had brought in the somewhat flattened feline after it had been run over by a slow-moving parade of Chicano lowriders. One night, a biker girl from the neighborhood stumbled into the shop tripping hard on LSD. Someone opened the fridge and handed her the cat. She didn't even flinch, just smiled and began to stroke its icy fur. The cat was eventually defrosted and used in a particularly visceral art performance Rozz and Ron staged for a crowd of punks at a nearby gallery. The members of the fearsome band TSOL arrived that night carrying their homemade "art shields"—medieval-looking things made from cardboard that featured strategic slits through which the band could watch without being splattered with detritus from the "performance."

Next to Pomona is Claremont, where I grew up. With its tree-lined streets and eight private colleges, it resembled an idyllic East Coast college town inexplicably relocated to the sun-scorched sub-

urbs. Toward the end of the seventies, my friends and I abruptly rejected the musty remnants of hippiedom and embraced the new punk culture coming out of England. We cut our hair short, wore thrift-store clothes, and adopted a demeanor of perpetual discontent. Before long, we stopped attending school, and spent our days in unsupervised homes getting drunk, fighting, and listening to records instead. On weekends we would find someone older with a driver's license and head for Hollywood to see our favorite bands play.

I had heard of Ron nearly a year before any of us actually met him when, on a summer day, I was sitting in a van with some mustachioed Black Sabbath types mooching drugs. They mentioned Ron, saying he was "totally queer" but still pretty tough, and always had good pills. When Rozz and I encountered Ron in person, he was wearing tight pants and had strawberry-blond disco hair. The three of us ended up at the local park, where Ron insisted that I chop off his hair with my mom's kitchen scissors. A week later, Rozz and I were in my parents' furnace-like garage rehearsing songs for what would eventually become our band, Christian Death, when we heard someone pounding on the door. We stepped outside to find Ron wearing a black trench coat, and, at a time when a man caught with even a single stud earring could evoke suspicion if not outright hostility, he had an assortment of large wooden crucifixes dangling from both ears. We were, needless to say, impressed.

The following months were an exhilarating but strange time. Everyone seemed in a hurry to grow up and move beyond the relative safety of our not-so-distant childhoods. People were exploring all sorts of exotic avenues musically, sexually, and chemically. My friend Dee, who as a black ex-skateboarder was already deemed a freak by society, took to dressing like a punk witch doctor in dark turtlenecks and bone necklaces. Under Ron's

tutelage, Rozz evolved from an introverted punk with dandruff to an increasingly charismatic figure with his own cadre of oddball disciples. The rest of us traded in our leather jackets and Dead Kennedys records for dark suits and pointy Italian shoes. We started reading William S. Burroughs, J. G. Ballard, and Nietzsche. But nothing proved more efficient at achieving that desperately desired separation from our parents' world than injecting a syringe of ghetto-bought heroin.

And so I found myself in the back room of the record store rolling up my sleeve and holding out an arm. I had just turned sixteen. Ron was next to me, cooking up a spoonful of Mexican heroin, steadying himself on a beam he had been using to suspend and whip a local skate punk who would eventually spend decades in San Quentin. The ominous sounds of Throbbing Gristle warbled on the stereo.

"Are you ready?" Ron asked in a surprisingly gentle voice. I nodded and watched intently as he slid the needle beneath the skin of my arm. He located a vein, pulled the plunger back until it registered a cloud of blood, then shot the mixture into my body. Euphoric warmth engulfed me. For the first time in my life, I was exactly where I wanted to be. It was the beginning of a collective love affair that would very nearly destroy us all.

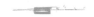

Hepatitis C is the most common blood-borne virus in the United States. An estimated 4.5 million Americans are infected, four times the number of those who are HIV positive. Most are current or former IV drug users, including some who used a syringe just once many years ago. The disease is most prevalent among people born between 1945 and 1965, most of whom became infected during the seventies and eighties. Many of these people have only recently found out they have the virus. Hep

C is a hard disease to track; it can incubate for years, even decades, before symptoms begin to show. A small percentage of those who contract hepatitis C clear it in the first few weeks. Usually, it progresses unnoticed until it's in the chronic stage. Chronic hepatitis C methodically attacks the liver and is the leading cause of cirrhosis and liver cancer. As a result it is also the most common reason for liver transplants. It's estimated that 8,000 to 10,000 died from hepatitis C in the United States last year.

I have the virus. So do nearly all my old friends. My best friend from childhood, who I grew up skateboarding and smoking pot with, is infected. The pink-haired pixie from the San Fernando Valley whom I took to my senior prom has it, as does the formerly homeless, nihilist friend with the cigarette burns on his arms who, as an adult, became a wealthy production designer on blockbuster films. In fact, the majority of the kids I knew in the thriving Los Angeles underground of the late seventies and early eighties—from the slam-dancing kids at the Starwood to the young junkies emulating Johnny Thunders outside the Cathay de Grande—have hep C.

Now, decades later, as so many of us are finally figuring out how to enjoy our lives, this unwanted remnant from the past keeps surfacing all over town like that half-forgotten friend just released from prison who now insists on hanging out and destroying everything.

I first discovered that I was infected with hepatitis C in the late eighties when Blue Cross denied my application for health insurance. When I asked why, I was told my blood tests revealed elevated liver enzymes. At the time, I was just relieved not to have HIV. Hep C was still relatively unknown outside of the medical community, and the diagnosis seemed meaningless. Years later, when I began suffering bouts of debilitating fatigue, I went to see a liver specialist. He informed me that the disease was steadily destroying my liver.

The good news was that it would take decades before I would develop cirrhosis or liver cancer. The bad news is that that was twenty years ago.

After years of neglecting the diagnosis in favor of uneasy denial, I finally went to see a doctor. It had become increasingly hard to overlook the effect the virus was having on my life. Some days I'd be so tired it was all I could do to make it from my bed to the couch. As a result I had become increasingly depressed. There is a psychologically corrosive effect to feeling bad all the time. I felt prematurely old, and the future seemed fraught with uncertainty.

I decided to look into interferon therapy in hopes of eradicating the virus from my body once and for all. Taking interferon is the only medically accepted treatment. It has a 50 percent success rate and comes with a host of unpleasant side effects, including suicidal depression, muscle aches, chronic fatigue, anemia, blindness, thyroid failure, and baldness. I figured with some antidepressants and a toupee I would be fine. A few days after going in for a consultation, I got a message from my doctor telling me to call her back as soon as possible. That's rarely a good sign. When I reached her, she told me the precautionary ultrasound revealed a centimeter-large "spot" on my liver.

"It's still in the early stages," she told me. Early stages of *what*, I wondered after hanging up the phone.

I met with my doctor the following day. The hospital's liver department discussed my case and decided I should proceed with interferon treatment. At the same time, the doctors would try every method available to investigate the spot. "But if it grows at all," she said. "We will have to act quickly."

Ron had been bugging me to do the interferon for at least a year before I finally gave

in. He had recently completed the treatment, and it had been successful. The two of us both got off drugs in the mid-eighties. In my case, legal pressure from multiple theft charges forced me into a rigid custodial treatment center, where I remained for eighteen months. After graduating, I lived in a small apartment with some aging ex-cons before slowly transitioning back to a more creative existence. Ron had stopped drugs only to discover that he was HIV-positive. Back then, the diagnosis was an almost certain death sentence. Yet somehow Ron not only survived, he flourished. A performance art career begun with a flattened cat had morphed into something far more sophisticated, though no less provocative. He achieved worldwide acclaim and notoriety. At one point in the mid-nineties, arch-conservative Senator Jesse Helms propped up a large photo of a seminude Ron on the Senate floor and used him to rail against public arts funding.

And while the two of us managed to survive, many of our old group weren't so lucky. My friend Rozz achieved cult fame as a singer, but succumbed to addiction and depression and eventually hanged himself. Dee shot a man while robbing a bank for drug money. Facing life in prison, he tried to escape from jail by fashioning a rope from bed sheets and climbing out a window. The sheets were wet and he slipped, falling seven stories to the pavement below, where his girlfriend was dutifully waiting with a getaway car. Others had died far less dramatically, quietly overdosing alone after lives of crushing disappointment. Often, it seemed like those of us who lived were left with the virus as a reminder of a shared past that sometimes felt like the prologue to a tenuous future.

The night before injecting myself with the first shot of interferon, I call Ron. The irony of seeking support from the same person who first shot me up with heroin seems strangely perfect. He is brutally honest about what I will face.

"I think you really need to describe it to people as chemotherapy," he tells me. "You need to let people know you're going to be really sick and you might go a bit crazy."

Ron says that while doing the treatment he became so isolated and depressed that he lost many of his friends. "I had a lot of these relationships where people called me 'Daddy' and they would do all their complaining to me. And I finally told them, 'We can't do this anymore.' I didn't want to hear it. I stopped answering the phone and returning calls."

After a few months, the drugs in his system made him feel radioactive. "I was living out in the desert in Palm Springs. The only time I would leave the house would be to walk to the corner store wearing just my boxer shorts and flip-flops. My eye lashes got really dry and then one day they just fell away."

The following morning, I play my final game of baseball for the team of ex-junkies and punk rockers I've been playing with for years, the subject of my book *Wrecking Crew*. I hit a looping single and jog up the baseline. The first baseman, a grizzled ex-minor leaguer, gazes out at the outfield grass.

"It sure is a beautiful day, isn't it?" he says.

"It really is," I reply.

That night, I go into the bathroom with a small vial of interferon and a syringe. The treatment involves taking pills daily and injecting liquid interferon into the stomach or leg muscles three times a week. I slide the syringe into my thigh and push the plunger. Some old Pavlovian reflex has me expecting a euphoric rush, but I feel only a dull ache at the injection site. I take some Tylenol and go to sleep. The following morning I wake up with what feels like the flu. The second day, I start to feel somewhat radioactive, but it isn't bad, just different. As the week progresses, my muscles begin to ache. I have a constant headache and my mouth is dry. I lay out on a slab of sun-heated concrete for hours with my little dog, Wally, sleeping next to me.

Two weeks later, I'm sitting on the couch watching baseball and fighting back tears. Everything has started to make me cry. The only two emotions I can access are intense melancholy and near-homicidal rage. Social invitations have tapered off. The already-strained relationship with my wife is at a breaking point. And then one night, Wally stands and begins to stagger across the floor toward me. She tumbles over and begins to violently shake. Foam comes out of her mouth. I have no idea what is happening and begin to panic. Is it a stroke? I pick up her limp body and carry her to my car.

The following afternoon, Wally is given an MRI and then diagnosed with a brain tumor. She comes home drugged on antiseizure meds. I sleep restlessly on the couch that night, twitchy from my own drug cocktail and traumatized by what I have seen. I keep waking up and looking over at Wally. She seems equally unsettled, peering through the darkness back at me.

When word gets out that I am doing the treatment, it seems like everyone I know has questions. Most want to know if the side effects are as bad as they have heard. Some of my male friends considering the treatment ask if I am losing my hair. A female fashion designer with the virus wants to know if the drug caused me to lose weight. When I tell her it has, she giddily says she might do it after all. Many have been trying "alternative" therapies.

I have lunch with a writer friend and listen as he describes the variety of New Age treatments he has tried: a special sauna installed in his house at the suggestion of one enterprising doctor, an intravenous vitamin C drip that another physician administered at substantial cost. When he begins talking of some healer in San Francisco who can tell when someone last had sex by merely passing her hands over them, I feel a little lost.

I try to hide my skepticism, but my doubts about such treatments seem to put me in the distinct minority among my peers with the virus. Friends who once railed against the silliness of New Age hippies are now ingesting expensive Chinese herbs sold by bearded shaman types, doing acupuncture religiously, drinking expensive holistic potions, and sipping tea doused with homeopathic remedies sold by an aging fashion model. One friend informs me of her plan to fly to Russia for an experimental "stem cell" treatment. When I go online to check the clinic's Web site, I become convinced she will spend her remaining years as an unwilling organ donor for cologne-soaked black marketers. It all reminds me of how sad I felt upon hearing how the supremely cool and confident Steve McQueen spent his last months in Mexico receiving coffee enema treatments for his cancer. The live-fast, die-young bravado of youth inevitably disappears and then one night you're lying awake staring into the darkness, gripped by the realization that you're far closer to the end than the beginning. And at that point you just want more.

The waiting room of the William Hitt Center in Tijuana is decorated with plastic plants and feels like an oven. None of the people sitting there appear to be Mexican. We exchange awkward smiles. A woman in a Bob Dylan T-shirt has circles under her eyes and has lost most of her hair. The receptionist apologizes for the heat and says the air conditioner is broken. I remain standing and survey the framed medical certificates on the wall. I do this in every waiting room or office I enter. The offspring of two college professors, I am, by default, something of an academic snob. The certificates on display here are

from institutions I have never heard of. They also look photocopied. I remind myself to be open-minded.

Dr. Hitt greets me with a smile and a handshake. He is tall, in his seventies, has snowy white hair, and looks remarkably like Sydney Greenstreet from *The Maltese Falcon*. Hitt escorts me around the clinic, passing through a room where several patients recline in plastic chairs with tubes running from their arms to suspended bags of blood. He motions to a container of yellow liquid and tells me that besides the ozone treatments, his clinic offers something called "urine therapy."

Hitt leads me into a converted supply closet cluttered with an assortment of medical supplies. There are some syringes and a bag of blood on the counter. He gestures to the wall and something that looks remarkably like a fuse box with the word "ozone" hand painted on it.

"*That* is our precious ozone machine," he says with a smile.

I first heard about ozone therapy as a treatment for hep C when several members of a hugely successful Los Angeles band started doing it. Though not close friends, they are part of the extended L.A. punk/ex-junkie fraternity, most of whom carry the virus. In the early eighties, we had all frequented the same nightclubs and injected the same drugs in the same bathrooms, sometimes with the same syringes.

Not long after that, I was sitting at Dodger Stadium with another friend from the old days. Chris was one of the seminal, and sometimes violent, Huntington Beach punks who left an indelible mark—slam dancing, buzz cuts, gang fights—on West Coast youth culture. Now he resembles Buddha, if the rotund deity were outfitted head to toe in blue Dodgers regalia. The conversation, as it usually does, eventually turns to our worsening livers. I was surprised when he informed me that his fatigue had all but disappeared and his

tests were apparently improving. He said he had recently started therapy, which I assumed meant interferon. It didn't. Like others, he had gone to Tijuana for the ozone treatments.

Hitt leads me to his office. It is cluttered with magazines and photocopied pamphlets. On his desk is a small microscope of the sort one might use in a high school science class. I inform him that I have hepatitis C and am interested in how ozone treats the virus. He hands me some photocopied articles and launches into a spirited sales pitch, punctuated with all sorts of numbers and statistics. When I mention that I am on interferon, he immediately criticizes the treatment. "As you probably know," he says somberly, "approximately three out of 100 die from the drug itself." This alarms me. Not because I fear for my well-being, but because it seems so obviously untrue. That would mean for every 100,000 people treated with the drug, 3,000 would simply drop dead. No matter how paranoid one might be about so-called "big pharma," no medical treatment that wasn't supervised by Josef Mengele could get away with that high of a mortality rate.

Hitt's theory is that introducing ozonated blood into a person will eradicate all the viruses in his or her body, making hepatitis C a nonfactor. He says that, unlike most physicians, he doesn't use blood tests to verify success but instead examines nasal Pap smears under his microscope.

"I'm interested in looking in that microscope and seeing the total amount of viruses a person has," Hitt explains, gesturing to the microscope on his desk. "And if I can bring their viral population down, then I can keep that person pretty darn safe." He fails to mention that one can't actually *see* viruses with a regular microscope like his. To do so Hitt would need an expensive electron microscope about the size of his desk.

Just then another doctor leans in, apologizing for the interruption. "Don't mean to bother you," he says to Hitt. "But I'm looking for a slide. I think it's a send-in."

"Yes, right," Hitt says thoughtfully. "Could it be in the box? "

"You know, I don't know. It *could* be in the box."

With that Hitt reaches for a box on his desk and pulls the top off. Glass slides of nasal smears tumble out onto the floor. Both doctors bend over and begin picking them up. The other doctor eventually stands, holding a patient's slide between his fingers. He smiles at me. "Found it." The episode reminds me of that scene in the Marx Brothers film *A Day at the Races* where Groucho (aka Dr. Hackenbush), Harpo, and Chico pretend to be doctors.

After his colleague leaves, I ask Hitt about his medical background. He tells me he isn't actually a medical doctor but has PhDs in immunology and microbiology. His medical degree is honorary, awarded to him by a Mexican medical school. "The university president gave me one so I could lecture there," he admits with a shrug. He holds up a finger dramatically and adds, "But at the highest levels, I give lectures. I'm a member of the Mexican Psychiatric Association, the American Psychiatric Association, and the Canadian Psychiatric Association—because of the work I've done in drugs."

Back home in Los Angeles, I do some research. I discover that in the eighties, at the height of the AIDS crisis, Hitt was sued by the state of Texas for fraudulent practices and for making false claims about his qualifications. He was prohibited from representing himself as a doctor.

Later, I speak on the phone with a Dr. Robert Baratz from the National Council Against Health Fraud. He systematically debunks Hitt's ozone therapy, saying, among other things, that the premise of our bodies being loaded with viruses is

just not true. "The body is *not* loaded with viruses," he explains. "Our body has something called the immune system and T-cells, which kill viruses. Sure, some viruses, like HIV, can hide inside cells so they can't be killed by our immune system. But since the ozone isn't getting inside the cells, it can't kill those viruses either."

I ask him about many of the alternative remedies my friends are trying. For each one he explains the fundamental flaws. In the end he tells me, "Look, 'alternative medicine' is really a misnomer because it is not an alternative to medicine. It's a marketing tool. A true alternative is a scenario where you can take United Airlines or American Airlines, but you'll get there either way. The more accurate term for all this is just quackery. They're pumping these people full of hope and telling them they will feel better and so some of them do, which is a placebo effect. Until you do a clinical test, you can't claim anything."

The following week, as my forty-first birthday nears, I'm in the basement of a hospital in Hollywood. A half hour before, a technician removed some of my blood, mixed it with radioactive material, and injected it back into my body. Now I'm lying on my back and a large box is circling my body like a hyperinquisitive robot. The department is called nuclear medicine and the doctors are using the procedure in an attempt to see the spot on my liver. When they're done, the technician tells me that when I piss I should flush the toilet several times and wash my hands thoroughly.

That night, I make the mistake of going online and reading all about liver cancer. I almost throw up. Death is common. A survival of five years is considered success. Because I was raised by godless intellectuals, there is no heaven waiting. Death simply means nothingness—forever. As a child my mother tried to soothe my anxiety by explaining that we live on in the memories of those who love us. It didn't work.

My doctor calls the next morning and tells me to come in. When I arrive she isn't smiling and looks tired. We have become friendly over the last few months and her demeanor alarms me. She informs me that the spot has grown.

"I was upset by this news," she says. "But then I was thinking about it, and there *is* hope. We have caught this early, which makes a difference."

I understand what she is saying, but I feel nothing. It's as if the whole thing is happening to someone else on a TV show I am watching from my couch. She says I have an appointment with a surgeon in two hours.

I call my brother and ask him to meet me at the surgeon's office. He has always been more pragmatic than me, and I have come to rely on him in situations such as this. The surgeon is a tanned man in his late sixties with a reassuring confidence. He wants to go in and cut out the part of my liver with the spot. The other option is to wait and see what happens.

"What would you suggest if I were a member of your family?" I ask. It's a question I had always planned on using if faced with a moment like this.

"It's a safe operation," he says matter-of-factly.

I look over at my brother, who nods.

"Let's do it," I tell the surgeon.

The surgeon reaches for a leather day planner and lazily flips through pages. There is something comforting about him scheduling my operation around golf games.

"How about tomorrow afternoon?" he asks.

"Too soon," I respond.

"Okay, how about in two weeks then?"

"Sure."

I'm driving through the vast, sprawling Los Angeles Harbor district to meet an old friend. His name is Manny and he works as a longshoreman. He used to be a punk rocker. I park my car near a huge, gray cargo ship. Manny eventually arrives at a small doughnut shop situated near the docks. He's an enormous Hispanic biker with a black beard, slicked-back hair, and heavy boots. I have come here because Manny is the only person I know who has had a liver transplant. As strange as it once seemed, it's now something I might have to confront.

A few years back, Manny's liver began to shut down because of hepatitis C. He began pissing and vomiting blood and his legs became swollen. Manny's doctors immediately put him on the list for a new liver. After waiting for more than a year, the call finally came. "I was bringing the trash in and my wife came out and said, 'Your liver's ready.' I just waved and told her I would be right in. I thought she said, 'Your dinner is ready.' When she told me I was suddenly scared."

I ask him what the surgery was like. I have never had any kind of operation, and the thought of going under terrifies me. "It was supposed to be a five-hour operation, but it lasted thirteen because my liver was so swollen," he says. "I wake up and there are tubes in me and I was hallucinating. I gained 110 pounds from all the liquids. My nuts were swollen up like baseballs." Manny tells me he went home after two weeks.

"They said I wouldn't work for a year. But I went back to work in a couple of months. They said I wouldn't drive, but I started riding my motorcycle pretty soon after that." He tells me that as bad as the surgery was, the prospect of not getting a liver had been far more frightening.

"I've known people who are thinking

of getting them on the black market now, they're so desperate," he says.

Unfortunately, the virus is still in Manny's system and is now attacking his new liver, a common occurrence. As a result he must go back on interferon. We sit there for a while talking about old times and old friends. "Punk rock came and my life changed," he says. "It was a scene where anybody could do anything. Those nights in Hollywood were some of the best times of my life." As the conversation continues, it seems like so many of our old compatriots from that period are now dead. We do a casual count and come up with more than twenty names. Most of those who survived now have hep C.

The night before my surgery, I make the mistake of once again going online. This time my research involves the unnerving phenomenon of people waking up during the operation. The first account I read is of a woman who regained consciousness during an operation that involved removing one of her eyes. Turns out the procedure requires a lot more "torque" than one might imagine. The woman won a lawsuit but remains understandably traumatized. This pretty much sets the tone for the night. By the time I'm done viewing a documentary on people committing suicide by jumping off the Golden Gate Bridge, the alarm goes off and it's time to go.

The surgery is merely an absence of time. I hear later that after making a long incision in my stomach, the doctors removed my organs and placed them in a bowl resting on my chest. At that point, the surgeon carved off a chunk of my liver, and then everything was replaced and the incision stapled shut. The real fun begins afterward.

At some point they tell me that I don't have cancer. It's a testament to the sheer agony I am in that I couldn't care less.

I stay in the hospital for five days. The cancer ward is not a particularly joyful place. There are screams and the sound of people crying. My roommate is an older Chinese man with lung cancer. The nurses encourage the two of us to fart, which in any other situation would make me happy. It's harder than you might think with one's organs still resettling. When I finally manage a short, tuba-like burst, my Chinese friend applauds enthusiastically. Later, I pass a mirror and notice that my beard has turned white.

It takes months to recover. The incision gets infected and I have to stuff the wound with gauze every few hours. It's one of the most painful sensations I've experienced. At one point, I am shuffling around with a pink discharge dripping from the open cut in my stomach when my friend "Pig," a hulking ex-con with survivalist tendencies, walks in. He immediately goes to his jalopy pickup truck, retrieves a medical kit, and proceeds to expertly clean and bandage my wound. He does it several more times in the following weeks. Where and why he learned to dress gaping gut wounds is something best left a mystery.

The interferon treatment lasts eighteen months. During this time, I experience a parade of physical and psychological side effects. For a while I'm covered with a violent red rash. I suffer from blinding headaches and near-crippling fatigue. There is a constant sensation of heat emanating from within my body and my mouth is perpetually dry, the inside of it covered with sores. But it is by far the psychological effects that prove the most insidious.

I gradually fall into a depression like nothing I have ever experienced. I almost stop working altogether. The most I can muster is an occasional record review. I give the new album by aging hair band Whitesnake a rave suitable for *Sgt. Pepper's*. I also start to obsess on things and spend hours watching online videos of Eu-

ropean football hooligans rioting. Soon, I am reading hooligan message boards and conversing with them in English slang. At my worst, I attempt to arrange a massive battle between two rival English hooligan gangs. The plan fails when I am discovered as an impostor. I begin watching reality television relentlessly and weep during episodes of *Star Trek*. My only joy comes from attending Dodgers games.

For the entire time I am on the treatment my blood tests show that the virus has disappeared. A month after finishing, it comes back. Everything that happened—the surgery, the interferon— was of no real physical benefit. Besides a ten-inch scar across my stomach, the experience left me with little more than a sustained depression and some sort of consolation from knowing I tried. One morning, I try to think of something, anything really, that would make me happy. Nothing comes to mind. I eventually start taking antidepressants, but by then my marriage is over and I am virtually homeless, living on a friend's couch.

My dog, Wally, continues to have seizures, but thanks to medication she is still alive today. So are many of my old friends. We still discuss our livers at Dodgers games and while hiking through the hills above Hollywood. For the most part, I just try to focus on enjoying the individual moments of my life. Some days I'm so fatigued, I sleep up to 20 hours and still wake up tired. Other days, I feel relatively normal. Years ago, when I was a nihilistic teenage junkie, I never imagined I would live to see anything even resembling middle age. Back then the idea didn't appeal to me in the slightest. Now I want more life. My doctor recently informed me there is a new interferon treatment on the horizon that promises to be more effective with fewer side effects. I'll probably give it a shot.

S

Glue

By Joe Donnelly

Broken like what?
A still day?
A rippled night?
Wings,
water,
windows?
A banished tooth in a deer's leg?
Like syntax,
Innocent, illegal and knowing,
That's been knocked onto the floor
To be swept up later?

Broken beyond what?
Money, conversation, messages, white couches on
beige carpet, discovery, case studies,
journals—personal and peer-reviewed,
UN missions, Aristotle, Newton,
the Antarctic, art, cable,
the reach of helicopters and a rope ladder?
Belief?
Glue?

Broken into what?
Frames?
A part,
a piece,
a puzzle?
A growth industry
An attendee
Dues?
Something to see
To hold
To crush?
A moment,
A monument
An atom,
The blues?

But what of
being held hostage
at the summit
by a great owl atop a cypress
Rendered in royal, black silhouette
And bearing a likeness
To the Mona Lisa hanging
on a fading, orange horizon
smiling in conspiracy
at the full moon rising

The day breaks into twilight
Treasures flow from its cracks
This spell will be broken
Its time will eventually lapse
But until then just linger
And listen to its gasps

Night comes at last
Whispering its call
To the words, the mirrors, the bones
The trees, the planes, the halls
Everything that can
And will be broken
In front of gods
Great and small
Carried by the dark
to the river
spilling over the falls

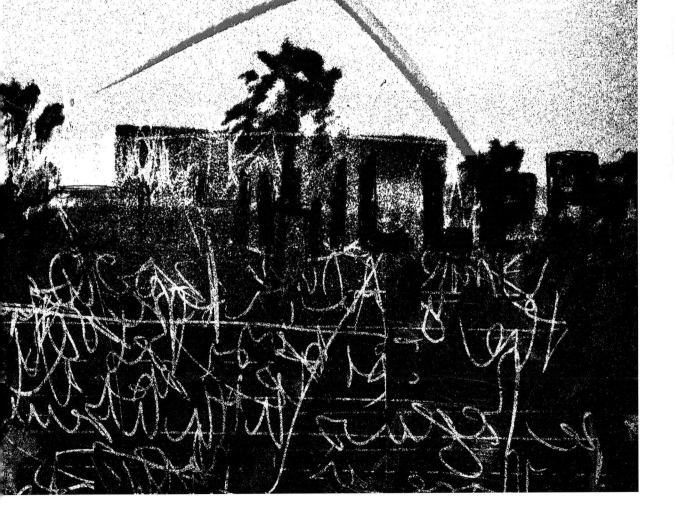

BABY KILLER

FICTION BY RICHARD LANGE

Power Lines by **Sandow Birk**

Puppet shooting that baby comes into my head again, like a match flaring in the dark, this time while I'm wiping down the steam tables after the breakfast rush at the hospital.

Julio steps up behind me with a vat of scrambled eggs, and I flinch like he's some kind of monster.

"*Que pasa?*" he asks as he squeezes by me to drop the vat into its slot.

"Nothing, *guapo*. You startled me is all."

I was coming back from the park and saw it all. Someone yelled something stupid from a passing car, Puppet pulled a gun and fired. The bullet missed the car and hit little Antonio instead, two years old, playing on the steps of the apartment building where he lived with his parents. Puppet tossed the gun to one of his homies, Cheeks, and took off running. He shot that baby, and now he's going to get away with it, you watch.

Dr. Wu slides her tray over and asks for pancakes. She looks at me funny through her thick glasses. These days everybody can tell what I'm thinking. My heart is pounding, and my hand is cold when I raise it to my forehead.

"How's your family, Blanca?" Dr. Wu asks.

"Fine, Doctor, fine," I say. I straighten up and wipe my face with a towel, give her a big smile. "Angela graduated from Northridge in June and is working at an insurance company, Manuel is still selling cars, and Lorena is staying with me for a while, her and her daughter, Brianna. We're all doing great."

"You're lucky to have your children close by," Dr. Wu says.

"I sure am," I reply.

I walk back into the kitchen. It's so hot in there, you start sweating as soon as the doors swing shut behind you. Josefina is flirting with the cooks again. That girl spends half her shift back here when she should be up front, working the line. She's fresh from Guatemala, barely speaks English, but still she reminds me of myself when I was young, more than my daughters ever did. It's the old-fashioned jokes she tells, the way she blushes when the doctors or security guards talk to her.

"Josefina," I say. "Maple was looking for you. *Andale* if you don't want to get in trouble."

"*Gracias, señora,*" she replies. She grabs a tray of hash browns and pushes through the doors into the cafeteria.

"*Que buena percha,*" says one of the cooks, watching her go.

"Hey, *payaso,*" I say, "is that how you talk about ladies?"

"*Lo siento, Mamá.*"

Lots of the boys who work here call me *Mamá*. Many of them are far from home, and I do my best to teach them a little about how it goes in this country, to show them some kindness.

At 12 I clock out and walk to the bus stop with Irma, a Filipina I've known forever. Me and Manuel Senior went to Vegas with her and her husband once, and when Manuel died she stayed with me for a few days, cooking and cleaning up after the visitors. Now her own Ray isn't doing too good. Diabetes.

"What's this heat?" she says, fanning herself with a newspaper.

"It's supposed to last another week."

"It makes me so lazy."

Irma and I share the shade from her umbrella. There's a bench under the bus shelter, but a crazy man dressed in rags is sprawled on it, spitting nonsense.

"They're talking about taking off Ray's leg," Irma says.

"Oh, honey," I say.

"Next month, looks like."

"I'll pray for you."

I like Ray. Lots of men won't dance, but he will. Every year at the hospital Christmas party he asks me at least once. "Ready to rock 'n' roll?" he says.

My eyes sting from all the crap in the air. A frazzled pigeon lands and pecks at a smear in the gutter. Another swoops down to join it, then three or four smaller birds. The bus almost hits them when it pulls up. Irma and I get a seat in front. The driver has a fan that blows right on us.

"I heard about the baby that got killed near you yesterday," Irma says.

I'm staring up at a commercial for a new type of mop on the bus's TV, thinking about how to reply. I want to tell Irma what I saw, share the fear and sorrow that have been dogging me, but I can't. I've got to keep it to myself.

"Wasn't that awful?" I say.

"And they haven't caught who did it yet?" Irma asks.

I shake my head. No.

I'm not the only one who knows it was Puppet, but everybody's scared to say because Puppet's in Temple Street, and if you piss off Temple Street, your house gets burned down or your car gets stolen or you get jumped walking to the store. When it comes to the gangs, you take care of yours and let others take care of theirs.

There's no forgiveness for that, for none of us coming forward, but I hope—I think we all hope—that if God really does watch everything, he'll understand and have mercy on us.

Walking home from my stop, I pass where little Antonio was shot. The news is there filming the candles and flowers and stuffed animals laid out on the steps of the building, and there's a poster of the baby, too, with "RIP Our Little Angel" written on it. The pretty girl holding the microphone says something about grief-stricken parents as I go by, but she doesn't look like she's been sad a day in her life.

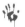

This was a pretty nice block when we first moved onto it. Half apartments, half houses, families mostly. A plumber lived across the street, a fireman, a couple of teachers. The gangs were here, too, but they were just little punks back then, and nobody was too afraid of them. One stole Manuel Junior's bike once, and his parents made him bring it back and mow our lawn all summer.

But then the good people started buying newer, bigger houses in the suburbs, and the bad people took over. Dopers and gangsters and thieves. We heard gunshots at night, and police helicopters hovered overhead with their searchlights on. There was graffiti everywhere, even on the tree trunks.

Manuel was thinking about us going somewhere quieter right before he died, and now Manuel Junior is always trying to get me to move out to Lancaster, where he and Trina and the kids live. He worries about me being alone. But I'm not going to leave.

This is my little place. Three bedrooms, two bathrooms, a nice, big backyard. It's plain to look at, but all my memories are here. We added the dining room and patio ourselves, we laid the tile, we planted the fruit trees and watched them grow. I stand in the kitchen sometimes, and twenty-five years will fall away like nothing as I think of my babies' kisses, my husband's touch. No, I'm not going to go. "Just bury me out back when I keel over," I tell Manuel Junior.

Brianna is on the couch watching TV when I come in, two fans going and all the windows open. This is how she spends her days now that school's out. She's wearing hardly anything. Hoochie-mama shorts and a tank top I can see her titties through. She's fourteen, and everything Grandma says makes her roll her eyes or giggle into her hand. All of a sudden I'm stupid to her.

"You have to get air conditioning," she whines. "I'm dying."

"It's not that bad," I say. "I'll make some lemonade."

I head into the kitchen.

"Where's your mom?" I ask.

"Shopping," Brianna says without looking away from the TV. Some music and dancing show.

"Oh, yeah? How's she shopping with no money?"

"Why don't you ask her?" Brianna snaps.

The two of them have been staying with me ever since Lorena's husband, Charlie, walked out on her a few months ago. Lorena is supposed to be saving money and looking for a job, but all she's doing is partying with old high school friends—most of them divorced now, too—and playing around on her computer, sending notes to men she's never met.

I drop my purse on the kitchen table and get a Diet Coke from the refrigerator. The back door is wide open. This gets my attention because I always keep it locked since we got robbed last time.

"Why's the door like this?" I call into the living room.

There's a short pause, then Brianna says, "Because it's hot in here."

I notice a cigarette smoldering on the back step. And what's that on the grass? A Budweiser can, enough beer to slosh still in it. Somebody's been up to something.

I carry the cigarette and beer can into the living room. Lorena doesn't want me hollering at Brianna anymore, so I keep my cool when I say, "Your boyfriend left something behind."

Brianna makes a face like I'm crazy. "What are you talking about?"

I shake the beer can at her. "Nobody's supposed to be over here unless me or your mom are around."

"Nobody was."

"So this garbage is yours then? You're smoking? Drinking?"

Brianna doesn't answer.

"He barely got away, right?" I say. "You guys heard me coming, and off he went."

"Leave me alone," Brianna says. She buries her face in a pillow.

"I don't care how old you are, I'm calling a babysitter tomorrow," I say. I can't have her disrespecting my house. Disrespecting me.

"Please," Brianna yells. "Just shut up."

I yell back. I can't help it. "Get in your room," I say. "And I don't want to see you again until you can talk right to me."

Brianna runs to the bedroom that she and her mom have been sharing. She slams the door. The house is suddenly quiet, even with the TV on, even with the windows open. The cigarette is still burning, so I stub it in the kitchen sink. The truth is, I'm more afraid for Brianna than mad at her. These young girls fall so deeply in love, they sometimes drown in it.

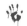

I change out of my work clothes into a housedress, put on my flip-flops. Out back, I water the garden, then get the sprinkler going on the grass. Rudolfo, my neighbor, is working in the shop behind his house. The screech of his saw rips into the stillness of the afternoon, and I smile when I think of his rough hands and emerald eyes. There's nothing wrong with that. Manuel has been gone for three years.

I make myself a tuna sandwich and one for Brianna, plus the lemonade I promised. She's asleep when I take the snack to the bedroom. Probably faking it, but I'm done fighting for today. I eat in front of the TV, put on one of my cooking shows.

A knock at the front door startles me. I go over and press my eye to the peephole. There on the porch is a fat white man with a sweaty, bald head and a walrus mustache. When I ask who he is, he backs up, looks right at the hole and says, "Detective Rayburn, LAPD." I should have known, that coat and tie in this heat.

I get a little nervous. No cop ever brought good news. The detective smiles when I open the door.

"Good afternoon," he says. "I'm sorry to bother you, but I'm here about the boy who was killed Sunday, down at 1238?"

His eyes meet mine, and he tries to read me. I keep my face blank. At least I hope I keep it blank.

"Can you believe that?" I say.

"Breaks your heart."

"It sure does."

The detective tugs his mustache and says, "Well, what I'm doing is going door to door and asking if anybody saw something that might help us catch whoever did it. Were you at home when the shooting occurred?"

"I was here," I say, "but I didn't see anything."

"Nothing?" He knows I'm lying. "All that commotion?"

"I heard the sirens afterward, and that's when I came out. Someone told me what happened, and I went right back inside. I don't need to be around that kind of stuff."

The detective nods thoughtfully, but he's looking past me into the house.

"Maybe someone else then," he says. "Someone in your family?"

"Nobody saw anything."

"You're sure?"

Like I'm stupid. Like all he has to do is ask twice.

"I'm sure," I say.

He's disgusted with me, and, to tell the truth, I'm disgusted with myself. But I can't get involved, especially not with Lorena and Brianna staying here. A motorcycle drives by with those exhaust pipes that rattle your bones. The detective turns to watch it pass, then reaches into his pocket and hands me a business card with his name and number on it.

"If you hear something, I'd appreciate it if you give me a call," he says. "You can do it confidentially. You don't even have to leave your name."

"I hope you catch him," I say.

"That's up to your neighborhood here. The only way that baby is going to get any justice is if a witness comes forward. Broad daylight, Sunday afternoon. Someone saw something, and they're just as bad as the killer if they don't step up."

Tough talk, but he doesn't live here. No cops do.

He pulls out a handkerchief and mops the sweat off his head as he walks away, turns up the street toward Rudolfo's place.

My heart is racing. I lie on the couch and let the fans blow on me. The ice cream truck drives by, playing its little song, and I close my eyes for a minute. Just for a minute.

A noise. Someone coming in the front door. I sit up lost, then scared. The TV remote is clutched in my fist like I'm going to throw it. I put it down before Lorena sees me. I must have dozed off.

"What's wrong?" she says.

"Where have you been?" I reply, going from startled to irritated in a hot second.

"Out," she says.

Best to leave it there, I can tell from her look. She's my oldest, thirty-five now, and we've been butting heads since she was twelve. If you ask her, I don't know anything about anything. She's raising Brianna differently than I raised her. They're more like friends than mother and daughter. They giggle over boys together, wear each other's clothes. I don't

think it's right, but we didn't call each other for six months when I made a crack about it once, so now I bite my tongue.

I have to tell her what happened with Brianna though. I keep my voice calm so she can't accuse me of being hysterical; I stick to the facts, A, B, C, D. The questions she asks, however, and the way she asks them, make it clear that she's looking for a way to get mad at me instead of at her daughter.

"What do you mean the back door was open?"

"She acted guilty? How?"

"Did you actually see a boy?"

It's like talking to a lawyer. I'm all worn out by the time I finish the story and she goes back to the bedroom. Maybe starting dinner will make me feel better. We're having spaghetti. I brown some hamburger, some onions and garlic, add a can of tomato sauce, and set it to simmer so it cooks down nice and slow.

Lorena and Brianna come into the kitchen while I'm chopping lettuce for a salad. They look like they've just stopped laughing about something. I feel myself getting angry. What's there to joke about?

"I'm sorry, Grandma," Brianna says.

She wraps her arms around me, and I give her a quick hug back, not even bothering to put down the knife in my hand.

"That's okay, *mija*."

"From now on, if she wants to have friends over, she'll ask first," Lorena says.

"And no beer or smoking," I say.

"She knows," Lorena says.

No, she doesn't. She's fourteen years old. She doesn't know a goddamn thing. Brianna sniffs the sauce bubbling on the stove and wrinkles her nose. "Are there onions in here?" she asks.

"You can pick them out," I say.

She does this walk sometimes, stiff arms swinging, legs straight, toes pointed. Something she learned in ballet. That's how she leaves the kitchen. A second later I hear the TV come on in the living room, too loud.

"So who was he?" I whisper to Lorena.

"A boy from school. He rode the bus all the way over here to see her."

She says this like it's something sweet. I wipe down the counter so I don't have to look at her.

"She's that age," I say. "You've got to keep an eye on her."

"I know," Lorena says. "I was that age once too."

"So was I."

"Yeah, but girls today are smarter than we were."

I move over to the stove, wipe that too. Here we go again.

"Still, you have to set boundaries," I say.

"Like you did with me?"

"That's right."

"And like Grandma did with you?" Lorena says. "'Cause that worked out real good."

We end up here every time. There's no sense even responding.

Lorena got pregnant when she was sixteen and had an abortion. Somehow that makes me a bad mother, but I haven't figured out yet how she means to hurt me when she brings it up. Was I too strict, or not strict enough?

As for myself, the boys went kind of nuts for me when I turned fourteen. I wasn't a tease or anything; they just decided that I was the one to get with. That happens sometimes. I was the oldest girl in my family, the first one to put my parents through all that. My dad would sit on the porch and glare at the guys who drove past hoping to catch me outside, and my mom walked me to school every day. I got a little leeway after my *quinceañera*, but not much.

Manuel was five years older than me. I met him at a party at my cousin's when I was fifteen. He'd only been in the U.S. for a few years, and his idea of dressing up was still boots and a cowboy hat. Not my type at all. I was into lowriders, *pendejos* with hot cars. But Manuel was so sweet to me, and polite in a way the East L.A. boys weren't. He bought me flowers, called twice a day. And after my parents met him, forget it. He went to Mass, he could

rebuild the engine in any car, and he was already working at the brewery, making real money: they practically handed me over to him right there.

Our plan was that we'd marry when I graduated, but I ended up pregnant at the end of my junior year. Everything got moved up then, and I never went back to school. My parents were upset, but they couldn't say much because the same thing had happened to them. It all worked out fine though. Manuel was a good husband, our kids were healthy, and we had a nice life together. Sometimes you get lucky.

I do the dishes after dinner, then join the girls in the living room. The TV is going, but nobody's paying attention. Lorena is on her laptop and Brianna is texting on her phone. They don't look up from punching buttons when I sit in my recliner. I watch a woman try to win a million dollars. The audience groans when she gives the wrong answer.

I can't sit still. My brain won't slow down, thinking about Antonio and Puppet, thinking about Lorena and Brianna, so I decide to make my rounds a little early. I can't get to sleep if I haven't checked the lock on the garage door, latched the gate, and watered my flowers. Manuel called it "walking the perimeter."

"Sarge is walking the perimeter," he'd say.

The heat has broken when I step out into the front yard. The sun is low in the sky, and little birds chase each other from palm tree to palm tree, twittering excitedly. Usually you can't hear them over the kids playing, but since the shooting, everybody is keeping their children inside.

I drag the hose over to the roses growing next to the chain-link fence that separates the yard from the sidewalk. They're blooming like mad in this heat. The white ones, the yellow, the red. I lay the hose at the base of the bushes and turn the water on low, so the roots get a good soaking.

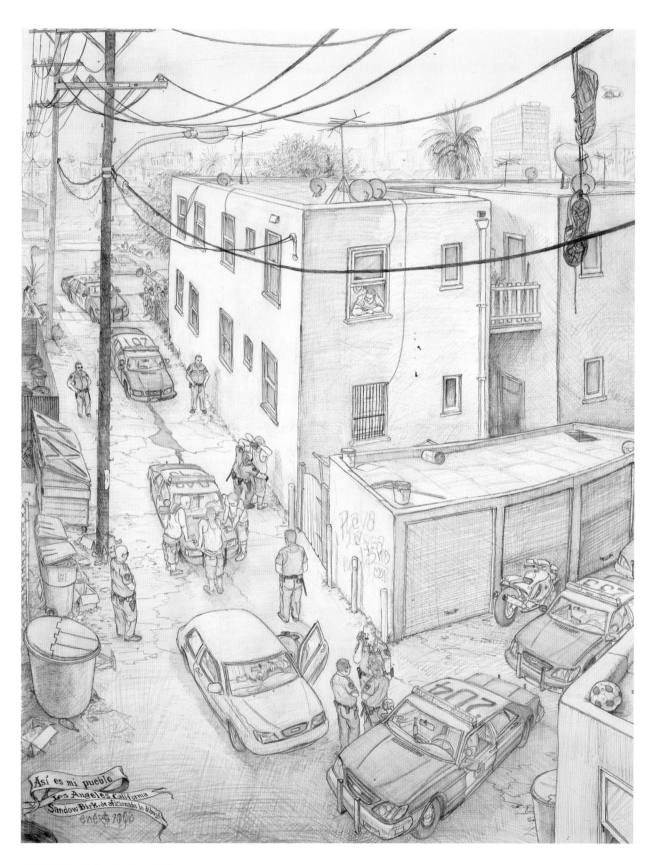

Así Es Mi Pueblo by **Sandow Birk**

Rudolfo is still at work in his shop. His saw whines, and then comes the BANG BANG BANG of a hammer. I haven't been over to see him in a while. Maybe I'll take him some spaghetti.

I wash my face and put on a little makeup. Lipstick, eyeliner, nothing fancy. Perfume. I change out of my housedress into jeans and a nice top. My stomach does a flip as I'm dressing. I guess you could say I've got a thing for Rudolfo, but I think he likes me, too, the way he smiles. And for my birthday last year he gave me a jewelry box that he made. Back in the kitchen I dig out some good Tupperware to carry the spaghetti in.

Rudolfo's dog, Oso, a big shaggy mutt, barks as I come down the driveway.

"*Cállate, hombre*," Rudolfo says.

I walk to the door of the shop and stand there silently, watching Rudolfo sand a rough board smooth. He makes furniture—simple, sturdy tables, chairs, and wardrobes—and sells it to rich people from Pasadena and Beverly Hills. The furniture is nice, but awfully plain. I'd think a rich woman would want something fancier than a table that looks like it belongs in a farmhouse.

"Knock, knock," I finally say.

Rudolfo grins when he looks up and sees me standing there.

"*Hola*, Blanca."

I move into the doorway but still don't step through. Some men are funny. You're intruding if you're not invited.

"Come in, come in," Rudolfo says. He takes off his glasses and cleans them with a red bandanna. He's from El Salvador, and so handsome with that Indian nose and his silver hair combed straight back. "Sorry for sawing so late, but I'm finishing an order," he says. "That was the last little piece."

"I just came by to bring you some spaghetti," I say. "I made too much again."

"Oh, hey, *gracias. Pasale.*"

He motions for me to enter and wipes the sawdust off a stool with his bandanna. I sit and look around the shop. It's so organized, the lum-ber stacked neatly by size, the tools in their special places. This used to crack Manuel up. He called Rudolfo "the Librarian." The two of them got along fine but were never really friends. Too busy, I guess, both working all the time.

Rudolfo takes the spaghetti from me and says, "Did that cop stop by your house today?"

"The bald one? Yeah," I reply.

"He told me he's sure someone saw who killed that baby."

Someone who's just as bad as the killer. I know. I run my finger over the blade of a saw sitting on the workbench. If this is what he wants to talk about, I'm going to leave.

"Are things getting crazier?" Rudolfo continues. "Or does it just seem that way?"

"I ask myself that all the time," I reply.

"I'm starting to think more like *mi abuelo* every day," he says. "You know what he'd say about what happened to that baby? 'Bring me the rope, and I'll hang the bastard who did it myself.'"

I stand and brush off my pants.

"Enjoy your spaghetti," I say. "I've got to get back."

"So soon?"

"I wake up at 2:30 to be at the hospital by 4."

"Let me walk you out."

I wave away the offer. "No, no, finish what you were doing."

Puppet and his homies are hanging on the corner when I get out to the street. Puppet is leaning on a car that's blasting music, that BOOM BOOM FUCK FUCK crap. He is wearing a white T-shirt, baggy black shorts that hang past his knees, white socks pulled all the way up and a pair of corduroy house shoes. The same stuff *vatos* have been wearing since I was a kid. His head is shaved, and there's a tattoo on the side of it, Temple Street.

I knew his mom before she went to prison; I even babysat him a couple times when he was young. He went bad at ten or eleven, though, stopped listening to the grandma who was raising him and started running with thugs. The boys around here slip away like that again and again. He stares at me now, like, "What do you have to say?" Like he's reminding me to be scared of him.

"Baby killer," I should shout back. "You ain't shit." I should have shut the door in that detective's face, too. I've got to be smarter from now on.

I haven't been sleeping very well. It's the heat, sure, but I've also been dreaming of little Antonio. He comes tonight as an angel, floating above my bed, up near the ceiling. He makes his own light, a golden glow that shows everything for what it is. But I don't want to see. I swat at him once, twice, knock him to the floor. His light flickers, and the darkness comes rushing back.

My pillow is soaked with sweat when I wake up. It's guilt that gives you dreams like that. Prisoners go crazy, rattle the doors of their cells and scream out confessions. Anything, anything to get some peace. I look at the clock, and it's past midnight. The sound of a train whistle drifts over from the tracks downtown. I have to be up in two hours.

I pull on my robe to go into the kitchen for a glass of milk. Lorena is snoring quietly, and I close her door as I pass by. Then there's another sound. Whispers. Coming from the living room. The girls left something unlocked, and now we're being robbed. That's my first thought, and it stops the blood in my veins. But then there's a familiar giggle, and I peek around the corner to see Brianna standing in front of a window, her arms reaching through the bars to touch someone—it's too dark to say who—out in the yard.

I step into the room and snap on the light. Brianna turns, startled, and the shadow outside disappears. I hurry to the front door, open it, but there's no one out there now except a bum pushing a grocery cart filled with cans and newspapers down the middle of the street. Brianna is in tears when I go

back inside, and I'm shaking all over, I'm so angry.

"So that talk today was for nothing?" I say.

My yelling wakes Lorena, and she finds me standing over Brianna, who is cowering on the couch.

"Let her up," Lorena says.

She won't listen as I try to explain what happened, how frightened I was when I heard those voices in the dark. She just grabs Brianna and drags her back to their room.

I wind up drinking coffee at the kitchen table until it is time to get ready for work. Lorena comes out as I'm about to leave for the bus. She said that the boy from Brianna's school came to see her again, and she was right in the middle of telling him to go away when I came in. She says we're going to forget the whole incident, let it lie.

"That's the best way to handle it," she says. "I want to show that I trust her."

"Okay," I say.

"Just treat her like normal."

"I will."

"She's a good girl, Mom."

"I know."

They've beaten the fire out of me. If all they want is a cook and a cleaning lady, fine.

My stomach hurts during the ride to work the next morning, and I feel feverish, too. Resting my forehead against the cool glass of the window, I take deep breaths and tell myself it's nothing, just too much coffee. It's still dark outside, the streets empty, the stores locked tight. Like everyone gave up and ran away and I'm the last to know. I smell smoke when I get off at the hospital. Sirens shriek in the distance.

Irma is fixing her hair in the locker room.

"You don't look so good," she says.

"Maybe it's something I ate," I reply. She gives me a Pepto Bismol tablet from her purse, and we tie our aprons and walk to the kitchen. One of the boys has cornered a mouse in there, back by the pantry, and pinned it to the floor with a broom. Everybody moves in close, chattering excitedly.

"Step on it," somebody says.

"Drown it," someone else suggests.

"¡No! ¡No mate el pobrecito!" Josefina wails, trembling fingers raised to her lips. Don't kill the poor little thing! She's about to burst into tears.

The boy with the broom glances at her, then tells one of the dishwashers to bring a bucket. He and the dishwasher turn the bucket upside down and manage to trap the mouse beneath it. They slide a scrap of cardboard across the opening and flip the bucket over. The mouse cowers in the bottom, shitting all over itself. The boys free it on the construction site next door, and we get to work.

I do okay until about 8, until the room starts spinning and I almost pass out in the middle of serving Dr. Alvarez his oatmeal. My stomach cramps, my mouth fills with spit, and I whisper to Irma to take my place on the line before I run to the bathroom and throw up.

Maple, our supervisor, is waiting when I return to the cafeteria. She's a twitchy black lady with a bad temper.

"Go home," she says.

"I'm okay," I reply. "I feel better."

"You hang around, you're just going to infect everybody else. Go home."

It's frustrating. I've only called in sick three times in my twenty-seven years here. Maple won't budge though. I take off my gloves and apron, get my purse from my locker.

My stomach bucks again at the bus stop, and I vomit into the gutter. A bunch of kids driving by honk their horn and laugh at me. The ride home takes forever. The traffic signals are messed up for blocks, blinking red, and the skyscrapers shimmer in the heat like I'm dreaming them.

I stop at the store for bread and milk when I get off the bus. Not the Smart & Final, but the little *tienda* on the corner. The Sanchezes owned it forever, but now it's Koreans. They're nice enough. The old lady at the register always smiles and says gracias when she gives me my change. Her son is out front painting over fresh graffiti. Temple Street tags the place every night, and he cleans it up every day.

A girl carrying a baby blocks my path. She holds out her hand and asks me in Spanish for money, her voice a raspy whisper. The baby is sick, she says, needs medicine. She's not much older than Brianna and won't look me in the eye.

"Whatever you can spare, she says. Please."

"Where do you live?" I ask.

She glances nervously over her shoulder. A boy a little older than her pokes his head out from behind a tree, watching us. Maria, from two blocks over, told me the other day how a girl with a baby came to her door, asking for money. The girl said she was going to faint, so Maria let her inside to rest on the couch while she went to the bathroom to get some Huggies her daughter had left behind. When she came back, the girl was gone, and so was Maria's purse.

My chest feels like a bird is loose inside it.

"I don't have anything, I say. I'm sorry."

"My baby is going to die," the girl says. "Please, a dollar. Two."

I push past her and hurry away. When I reach the corner, I look back and see her and the boy staring at me with hard faces.

The sidewalk on my street has buckled from all the tree roots pushing up underneath it. The slabs tilt at odd angles, and I go over them faster than I should while carrying groceries. If I'm not careful, I'm going to fall and break my neck. I'm going to get exactly what I deserve.

Brianna's eyes open wide when I step through the door. A boy is lying on top of her on the couch. Puppet.

"Get away from her," I yell, and I mean it to be a roar, but it comes out like an old woman's dying gasp.

Standing quickly, he pulls up his pants and grabs his shirt off the floor. Brianna yanks a blanket over her naked body. As he walks out, Puppet sneers at me. He's so close I can feel heat coming off him. I slam the door and twist the deadbolt.

It was one month after my fifteenth birthday, and all everybody was talking about was a party some kid was throwing at his house while his parents were in Mexico for a funeral. Carmen and Cindy said, "You've got to go. We'll sneak out together." Stupid stuff, teenagers being teenagers. "You tell your mom that you're staying at my house, and I'll tell mine I'm staying at yours." We were actually shocked that it worked, to find ourselves out on the streets on a Saturday night.

The crowd at the party was a little older than we were, a little rougher. Lots of gangbangers and their girlfriends, kids who didn't go to our school. Carmen and Cindy were meeting boys there and soon disappeared, leaving me standing by myself in the kitchen.

One of the *vatos* came up and started talking to me. He said his name was Smiley and that he was in White Fence, the gang in that neighborhood. Boys were always claiming to be down with this clique or that, and most of them were full of it. Smiley seemed like he was full of it. He was so tiny and so cute.

Things move fast when you're that age, when you're drinking rum and you've never drunk rum before, when you're smoking weed and you've never smoked weed before. Pretty soon we were kissing right there in front of everybody, me sitting on the counter, Smiley standing between my legs. I was so high I got his tongue mixed up with mine. Someone laughed, and it bounced around inside my head like a rubber ball.

Following Smiley into the bedroom was my mistake. I should have said no. Lying down on the mattress, letting him peel off my T-shirt, letting him put his hand inside my pants—I take the blame for all that, too. But everything else is on him and the others. Forever, like a brand. I was barely fifteen years old, for God's sake. I was drunk. I was stupid.

"Stop," I hissed, but Smiley kept going.

I tried to sit up, and he forced me back down. He put his hand on my throat and squeezed.

"Just fucking relax," he said.

I let myself go limp. I gave in because I thought he'd kill me if I didn't. He seemed that crazy, choking me, pulling my hair. Two of his homies came in while he was going at it. I hoped for half a second that they were there to save me. Instead, when Smiley was finished, they did their thing, too, took turns grinding away on a scared little girl, murdering some part of her that she mourns to this day.

Afterward they made me wash my face and get dressed. I wasn't even crying anymore. I was numb, in shock.

"White Fence," Smiley said right before he walked back out into the party, into the music and laughter. "Don't you forget." A warning pure and simple. An ugly threat.

I never told my friends what happened, never told my family, never told my husband. What could they possibly have said or done that would've helped? Nothing. Not a goddamn thing. The sooner you learn it, the better: some loads you carry on your own.

They make a big show of it when they come for Puppet. Must be six cop cars, a helicopter, TV cameras. That detective wasn't lying: all it took was an anonymous phone call. "I saw who killed the baby."

One minute Puppet is preening on the corner with his homies, acting like he owns the street, the next he's face-down on the hot asphalt, hands cuffed tight behind his back.

I run outside as soon as I hear the commotion. I want to see. Lorena and Brianna come, too, whispering, "Oh my God, what's happening?"

"It's the bastard who shot little Antonio," says an old man carrying a bottle in a bag.

We stand at the fence and watch with the rest of the neighborhood as they lift Puppet off the ground and slam him against a police car. Then, suddenly, Brianna is crying. "No," she moans and opens the gate like she's going to run to him. "No." Lorena grabs her arm and yanks her back into the yard.

"José," Brianna yells. His real name.

He can't hear her, though, not with all the shouting and sirens and the CHOP CHOP CHOP of the helicopter circling overhead. And I'm glad. He doesn't deserve her tears, her reckless love. Instead, I hope the last thing he sees before they drive him off is my satisfied smile and the hatred in my eyes, and I hope it burns him like fire, night and day, for as long as he fouls this earth.

It's Friday evening, and what a week. The freezer at work broke down, Maple changed the rules on vacation time, and one of the boys cut his finger to the bone, chopping onions. There was some good news, too: looks like Puppet isn't going to be back. As soon as they picked him up, his boy Cheeks flipped on him and told the cops everything. A few punks still hang out on the corner and stare the neighborhood down, but none of them know that it's me who took out their homie.

I fall asleep on the couch when I get home and don't wake up until a few hours later, but that's okay, because I'm off tomorrow, so I can go to bed whenever I want tonight and sleep in. I couldn't do that when Lorena and Brianna were here. They'd be banging around in the kitchen or blasting the TV every time I tried to rest. Or I'd be cooking for them or doing their laundry.

I love them, but I wasn't sad to see them go when they moved out last week. They're in Alhambra now, living with a fireman Lorena met on the computer. He's really great, she says, with a big house, a swimming pool, and an RV. And so good with Brianna. I was thinking she should ask him about his ex-wife, find out why she's not around anymore, but I kept it to myself.

When I get up, I finish watering the garden and pick a bunch of tomatoes. The sun has just set, leaving the sky a pretty blue, but it's going to be one of those nights when it doesn't cool down until past midnight. The kids used to sleep out in the yard when it was like this. Manuel would cut up a watermelon he'd kept on ice all day, and the juice would run down their faces and drip onto the grass.

I sit on the back porch and watch the stars come out. There's a little moon up there, too, a little silver smile in the sky. Oso barks next door, and another dog answers. Music floats over from Rudolfo's shop, old ranchero stuff, and I think, You know, I'll never eat all these tomatoes myself.

Rudolfo looks up from the newspaper he's reading as I come down the driveway, trailed by Oso.

"Blanca," he says. "*Buenas noches.*"

He reaches out and turns down the radio down a bit. He's drinking a beer, and a cigar smolders in an ashtray on the workbench. Picking up the ashtray, he moves to carry it outside.

"Go ahead and smoke," I say.

"You're sure?"

"No problem."

He lived next door for years before I found out that he had a wife and son back in El Salvador. He got in trouble with the government there and had to leave. The plan was that he'd go to the U.S. and get settled, then his family would join him. But a few years later, when it was time, his wife decided that she was happy where she was and refused to move north. I remember he told this like it had happened to another person, but I could see in his eyes how it hurt him.

"I brought you some tomatoes," I say, setting the bag on the workbench. "I've got them coming out of my ears."

"You want a beer?" he asks.

"Sure," I say and lower myself onto a stool.

He reaches into a cooler and lifts out a Tecate, uses his bandanna to wipe the can dry.

"I'm sorry I don't have any lime," he says as he passes it to me.

"It's good like this," I reply.

He lifts his can and says, "*Salud.*"

I take a sip, and, boy, does it go down easy. Oso presses his cold nose against my leg and makes me jump. I'm wearing a new skirt. A new blouse, too.

"Another wild Friday night, huh?" I say.

Rudolfo laughs. He runs his fingers slowly through his hair and shakes his head. "I might have a few more in me," he says. "But I'm saving them up for when I really need them."

He asks about Lorena and Brianna, how they're doing at the new place, and wonders if I'm lonely now that they're gone. I admit that I'm not.

"You get used to being by yourself," I say.

"Yeah, but that's not the same as enjoying it," he replies, something sad in his voice.

I like the way we talk to each other. It feels honest. Things were different with Manuel. One of us always had to win. Husbands and wives do that, worry more about being right

than being truthful. What goes on between Rudolfo and me is what I always imagined flirting would be like. It's kind of a game. We hint at what's inside us, each hoping the other picks up on the clues.

I didn't learn to flirt when I was young. I didn't have time. One year after that party I was engaged to Manuel, and the last thing I wanted him to know were my secrets.

A moth flutters against the bare light bulb suspended above us, its wings tapping urgent messages on the thin glass. Rudolfo tells me about something funny that happened to him at Home Depot, how this guy swiped his shopping cart. It's his story I'm laughing at when he finishes, but I'm also just happy to be here with this handsome man, drinking this beer, listening to this music. It feels like there are bubbles in my blood.

A song my mom used to play comes on the radio.

"Hey," I say. "Let's dance."

"I don't know, it's been years," Rudolfo replies.

"Come on." I stand and wiggle my hips, reach out for him.

He puts down his beer and wraps his arms around me. I pull him close and whisper the lyrics to the song in his ear as we sway so smoothly together. You forget what that feels like. It seems impossible, but you do.

"Blanca," he says.

"Mmmmmm?" I reply.

"I'm seeing a lady in Pacoima."

"Shhh," I say.

"I've been seeing her for years."

"Shhh."

I lay my head on his chest, listen to his heart. Sawdust and smoke swirl around us. *Que bonita amor*, goes the song, *que bonita cielo*, *que bonita luna*, *que bonita sol*. God wants to see me cry. He must have his reasons. But for now, Lord, please, give me just one more minute. One more minute of this.

S

DREAM of a SUNDAY AFTERNOON in BOYLE HEIGHTS
BY Matt Fleischer

In a dark room with tin walls, on the second floor of an anonymous storage facility in Long Beach, seventy-five identical cardboard boxes are stacked on top of each other, coated in dust and stewing in a rather dank, unpleasant musk. No one has set foot in this room for more than a year, but not because the contents of the boxes lack value or intrigue. Each one contains a small, contentious piece of Los Angeles's history: the infamous Hollenbeck mural—a nearly $200,000 piece of art commissioned by the city that has never seen the light of day.

The creation of Long Beach artist Sandow Birk and his wife, Elyse Pignolet, the work is composed of more than 4,000 tiles depicting scenes from a day in the life of Boyle Heights. It was set to run the length of a football field when installed outside the neighborhood's new Hollenbeck Community Police Station. Rather famously, it never made it. In 2008, the mural set off a quintessential California identity-politics battle and became a target for pissed-off residents of the predominantly Latino neighborhood to take a stand against what some regarded as cultural imperialism. In short, they wondered, why was a white boy from Long Beach given stewardship over such an important cultural landmark?

Birk is a provocative, ambitious artist, and no stranger to controversy. His most recent large project in a career full of them is a literal transcription of the Koran, done in graffiti-style script. A scene from contemporary American life illustrates each chapter. He has set Dante's Divine Comedy in Los Angeles with a South Bay slacker as the hero, waged a satirical war between Northern and Southern California, and taken on the moral lapses of the Iraq War. He has painted the cruel banality of infamous L.A. episodes, such as the O. J. saga, the bashing of Reginald Denny, and the Rampart disgrace in mock-heroic tones that both elevate and deflate the subject matter.

For the Hollenbeck project, Birk studied the grand muralists of Mexico, including David Alfaro Siqueiros and José Clemente Orozco. His mural drew especially from Diego Rivera's Dream of a Sunday Afternoon in Alameda Park. The hand-made tiles were designed in the blue and yellow scheme that's a hallmark of Portuguese and South American mural traditions.

But seeking inspiration from past masters was the least of his prep work. After he was selected from a pool of statewide applicants to create the mural, Birk spent years doing research in Boyle Heights with precinct police officers and many enthusiastic (at the time, anyway) community members, soaking up the history and atmosphere of the neighborhood.

During the conceptual stages of the piece, criticism was polite and Birk accommodated suggestions. The community requested a man in a zoot suit replace one with a leaf blower. All told, the project took five years. It went through many appraisals and was eventually approved by the police, the Los Angeles Department of Cultural Affairs, and the community. A team of twenty artists, a good number of them from Boyle Heights, painted the tiles.

Then something happened that Birk still doesn't fully understand. The Hollenbeck station's construction was delayed a couple years. During that lag, the cultural affairs department got a new chief and the work was completed and deemed ready to install. Birk and Pignolet went on vacation and, though there was no legal reason to do so, the mural was shown to the community again in March 2008. That's when the trouble started.

At this meeting, according to the artist, a new set of community members who had just gotten wind of the project -- and were stoked by rumors about the mural's content—showed up and protested the work. A second meeting was called, and it went worse than the first, culminating in cries to have the mural destroyed and veiled threats against Birk showing his face in Boyle Heights. The early supporters were all but missing in action.

"Anyone that had anything positive to say was in the minority and pretty much hissed at," says gallerist Greg Escalante, a friend of Birk who attended the meeting.

The city shelved plans to install the mural and so, for the past two years, Birk has paid seventy-five bucks a month to keep it locked in this bleak, air-conditionless storage room, trying to figure out what to do with arguably the most ambitious project of his life.

Birk himself can be a difficult read. He's given to surfer dude argot when he's relaxed or excited about something, but he is also an intellectually curious autodidact, an avid travel, a reader. He is shy and reserved until he warms up and then is prone to dry, understated humor and a sly grin. Intense, almost feral eyes belie Birk's laid-back, beach-boyish appearance.

Sitting at his laptop in the open dining room of his airy Long Beach loft, splotches of paint stuck to his arms from a project he's working on, Birk scans the Internet to find the critiques of his mural. He looks tired—a porkpie hat pulled low on his head to help shade the circles under his eyes. That most likely has to do with the fact he has a newborn at home—a baby girl who doesn't sleep more than two hours at a time—but the situation with the mural can't be helping.

For such a controversial work, the mural is shockingly apolitical. It depicts scenes from Boyle Heights's history—from its origins as a Jewish neighborhood to its more recent incarnation as L.A.'s "Latino Mayberry." But some residents claimed the mural contains hurtful stereotypes—illegal yard sales, fat women with braids, piñatas, and, well, dogs without leashes.

"The woman with the braid I borrowed from the Diego Rivera mural," he says. "People have complained she's having an illegal yard sale, and that she stuck a bunch of clothes in the bushes—but she's clearly displaying them on a fence. People say she's fat, too, but I think that's completely subjective. As far as dogs without leashes … I said I could put [the leashes] in somehow."

Police, too, were critical of the mural, saying it made them look menacing—in one scene a cop appears to be arresting someone.

Birk says he never would have predicted negative reaction from the police considering the efforts he made to meet LAPD's concerns. He spent hundreds of hours doing research, talking to people, and touring the community. At the behest of the LAPD, he included images of Jack's bar and police boxing trainer Rudy de Leon and his Olympic protégé, Paul Gonzalez. Birk sketched a scene from Mariachi Plaza and the man in a zoot suit at the request of community members. He included the Broad Street Temple in deference to the neighborhood's origins as a Jewish community. Other figures, using his artistic discretion, he borrowed from Rivera.

Birk is sure that people would embrace the mural if they just saw it in person. He and his wife, Elyse, haven't even seen it installed. No one has. And that, says Birk, is the real problem. Without seeing the mural, it's impossible for people to separate fact from fiction.

"At this point, we just want to see it go up," he says. "It almost doesn't matter where. We want people to actually see it and then make their judgments."

But figuring out what to do with the mural isn't easy.

Aside from being site specific and the length of a football field, it is caught in legal limbo. The city of Los Angeles has paid Birk nearly $180,000 for the piece, giving it a substantial claim to ownership. However the city still owes Birk nearly $20,000—and his contract won't be fulfilled until the piece is installed outside the Hollenbeck police station. Until the work is up, and Birk is paid the remainder of his fee, he still has a reasonable claim to partial ownership.

That said, he can't sell it without the city's consent for fear of legal reprisal. It's too big to install in most galleries and the galleries that are big enough don't want it because it isn't for sale. The cultural affairs department wants to take possession of the mural and store it so Birk doesn't have to. But that prospect leaves Birk cold.

"It'll wind up in a basement somewhere and never be seen again," he says.

About a year ago, Birk fired off a letter to the cultural affairs department, trying to get some resolution on how to handle the situation. He never heard back. "We're not sue-ers," Birk says. "That's not how we want to resolve this. We'd like to work with the city again. But we want to see this mural go up."

Outside the Hollenbeck police station, rows of bright orange flowers do their best to distract from the dull, lifeless wall where Birk's mural would be. Nice as they are, the flowers can't mask the void behind them. The garden is empty—a dead space coffined in beige concrete. The nearest soul is a man in a wheelchair across the street in a pocket park.

The real action is farther up the block, at a taco truck parked on the street underneath a large, shady, oak tree. It's lunchtime, and several patrons sit straddling plastic crates on the sidewalk in front of the truck. Women with strollers roam the block, waving left and right to people they know. Three nurses pass by on their way to a fruit cart at the end of the street.

About five blocks away, yes, a yard sale is underway. A woman and her three small children have set up shop in the front yard—clothes, toys, and knickknacks on display behind a silver chain-link fence. If anything is out of the ordinary, no one seems to be letting on. These scenes aren't dissimilar from Birk's mural.

Strangely enough, the city of Los Angeles agrees, in so many words.

"I think Sandow did more research and gathered more community input for this project than just about any artist we've ever worked with," says Felicia Filer, public art director for the L.A. Department of Cultural Affairs. "We wanted to throw in our support for this mural. But 95 percent of the people we heard from in the community were against it. The mural's supporters never showed. So our hands were tied."

Given the relatively superficial nature of the critiques, the underlying subtext of the complaints against the mural seem to be that if someone is going to make a mural depicting Boyle Heights, it should be someone from Boyle Heights. And considering the neighborhood is 95 percent Latino, the racial/ethnic undertones of that position are hard to ignore.

"Content aside," wrote one commenter on an LA Eastside blog post covering the contentious final meeting, "I think it's bullshit that they couldn't hire one of the hundreds of muralists from Boyle Heights. I like Birk myself, but stop wasting money on rich-ass white boys with no roots in the community."

"The city has never done things like that," replies Filer when asked about hiring an artist from Boyle Heights. "We have an open bidding policy. You can't just solicit bids for a public project from one neighborhood. We chose the project we thought was best."

Which leaves open the question of the mural's fate.

Filer insists the city will find it a suitable site. "The way this situation has been handled hasn't been fair to Sandow," she says. "We fully intend to pay him the remainder of the money he's owed. We'll get this sorted out."

Whatever resolution is reached, it will not include Birk's mural being installed at Hollenbeck. "Community members in Boyle Heights have already expressed interest in getting a new piece of art in that location," Filer explains.

As for the blank wall at Hollenbeck, Filer says that with L.A.'s perennial budget concerns, finding funding for a second, grand new mural at Hollenbeck isn't likely to fall high on the agenda.

"It's sad," Birk says. "They're going to wind up with a bunch of children's handprints, or something like that."

—*John Stephens contributed to this story.*

S

WATTS FIRE 64
BY ROBERT SOBUL

I found the bench at the front doors of the Los Angeles Fire Department's Station 64, 108th and Main streets, just a few days after beginning my ride-alongs. During the four months that I shot footage of the station's "A" Platoon for the documentary Watts Fire 64, I sat on that bench for hours. It became my refuge from the hot interiors and the intensity of the rescue calls. Sometimes, as the offshore breezes kicked up, I'd watch the patrol cars come in and out of the Los Angeles Police Department's South Division across the street or chat with neighborhood kids who had dropped by for help with their homework. Out front with me were Rescue 64 and Rescue 864. The 1950s-era firehouse (replaced last summer with a spacious new seven-bay station) was too small to house all the crew's vehicles, so these units were always parked outside on the sidewalk

When I used to think of dangerous places, I didn't imagine this. Fruit trees in full bloom across a sprawling concrete landscape. The streets filled with children playing catch or riding bikes, the sorts of things I no longer saw in other parts of the city. Kids stayed out long after dark, their laughter and voices everywhere, hanging onto an innocence that's quickly lost in South Los Angeles.

LAFD Station 64 is one of the three busiest companies in the department. In 2005, the year that I shot the film, Station 64 covered a 5.1-square-mile district (the department average was 4.7 square miles; the average U.S. suburban station covers 2 square miles). Station 64's area included four freeways, three housing projects, and Los Angeles International Airport. That year, the station responded to forty-nine or fifty calls in a typical day. Remarkably, fire was the least of it. "We have fire-prevented ourselves out of a job," goes one of the jokes I heard around the LAFD. In South Los Angeles, the fire department, ERs, and trauma centers are how most people access the healthcare system.

My idea was to follow members of Fire 64's "A" Platoon on the job and at home, a tale of two families. The plan was to ride with them for two weeks, see what they did, and shoot a sizzle reel. I met Captain Armando "Mondo" Hogan over dinner, and he invited me to 64 for an audition. If his crew approved, I would be given entry to their work environment and home life. I stayed with them for four months. "Basically the job comes down to three things," Captain Hogan told me.

"To pay the ladies and gentlemen when they come to work in the morning, to feed them, and, most important, to send them home safely to see their families. What I try to instill in the people I work with is the fact that I feel personally responsible for their safety. Their well-being. We're not allowed to pick and choose what calls to respond to. If someone calls the 911 system and it's in this area, we're going to respond. It won't always be a sterile environment and there will be some confrontation, but my job is to ensure that none of my members are injured while performing their duties More important, I'm very proud to be put in that situation because every day when we make relief in the morning I know I've done my job one more day and I look forward to the next time I'll be able perform those tasks."

Around 2 in the morning, there would often be a lull in the action and I'd rest on the bench, my Panasonic DVX strung across my lap as passenger jets circled in the sky above, waiting to descend into LAX. The smell of fire and soot was long ago weeded into my borrowed brush jacket, another reminder of the years the jacket's owner, firefighter Eric Thompson, spent putting cold on hot, as they say. I grew to love that jacket. The smell. My clothes covered in all kinds of liquids. My boots soaked through with whatever might have been on the ground. There, alone, I thought about what I had seen that day or what I might see later on that shift . . .

The house of a "pack ratter."

Car fire on the 110: "Is that your chicken?" asks a firefighter. "Yeah, yeah," the driver says. "But you guys can have it. I just want to grab a cab and go home."

Ped vs. Auto: Light Force plus Rescue 64 pull into a housing project. Kids are everywhere. Hogan talks with the lead police officer. A car ran a stop sign and hit a young boy on his way home from a Little League game. The boy's cries fill the courtyard. .

4th of July

Captain Hogan believes that the firehouse is a community building. The doors are always open and not metaphorically.

The Flopper: A gang member caught in a foot chase by the LAPD appears to go into a seizure. But his vital signs are strong. The patient may or may not be a "flopper" faking his symptoms, but the firefighters can't take a chance. He is treated like anyone else and transported to the nearest trauma center.

Rush hour on the 105.

House of Worship: Task Force. Structure Fire.

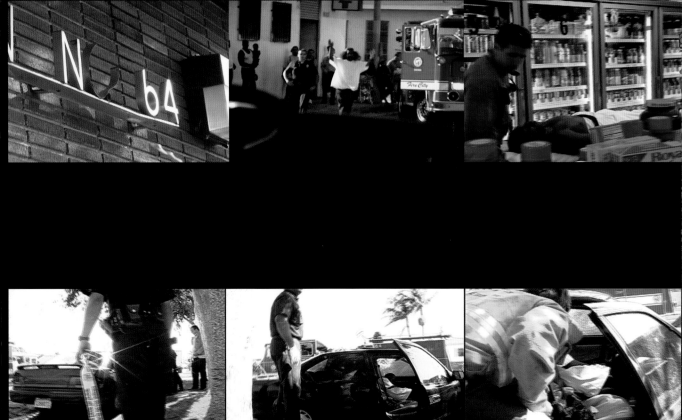
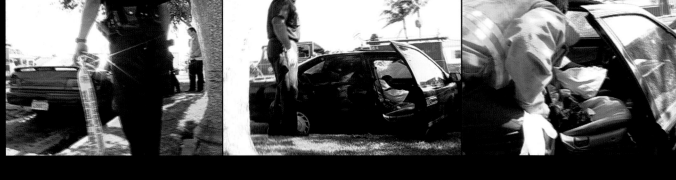
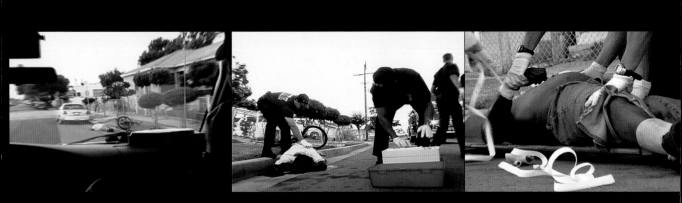

Shooting: A man hides in a liquor store after he and a friend are shot while walking down the street. His friend didn't make it.

*Memorial Day Drive-By: The victim started his car and then was shot
multiple times as his foot rested on the gas pedal, sending the car crashing ahead.
The front tires were shot out, the rims dug into the concrete.*

*Bike Wreck: He was drunk. He crashed his bike into the curb. Under the O2 mask on the way to hospital he mumbles,
"My Bike, man -- where's my bike?" After they clean up the scene, members of Engine 64 bring his bike to the hospital.*

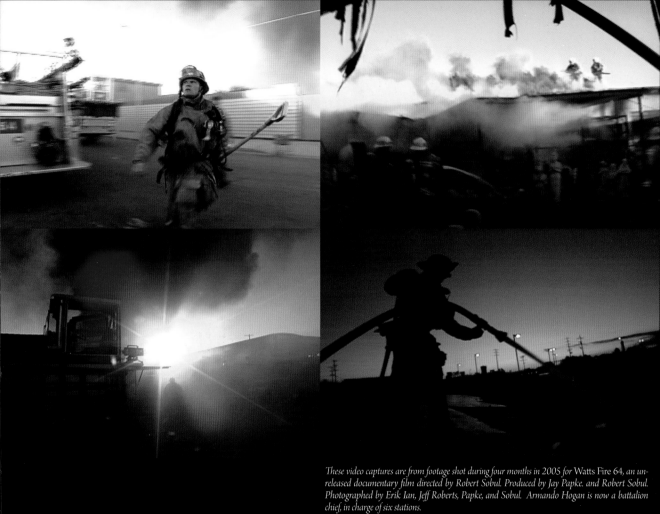

These video captures are from footage shot during four months in 2005 for Watts Fire 64, an un-released documentary film directed by Robert Sobul. Produced by Jay Papke. and Robert Sobul. Photographed by Erik Ian, Jeff Roberts, Papke, and Sobul. Armando Hogan is now a battalion chief, in charge of six stations.

SHIFT CHANGE

A large woman in a muumuu catches the evil eye for not tipping. An Asian girl looking out of place plays songs nervously on the jukebox. Old men sit next to each other without speaking and I sit at the end of the bar alone as always, drinking my Maker's and trying not to stare at the bartender. She looks tired. Maybe it's from all the shots she's done with me or maybe it's from something else. Everyone except me seems to have a reason to be tired, like they work a lot, or have kids, or have a job they can't stand so that they can do the stuff they really aspire to. I wish I aspired to something. I try to remember if I ever did, but I can't remember wanting to do anything except drink. Settlement or not, I'd probably be sitting on this same barstool in this same bar, in the same hazy light of day, drunk.

The bartender bends down to wash the glasses and her breasts sway from side to side like pom-poms.

"Excuse me…"
She looks up.
"Can I get another?"
"Sure."

I don't really want another but I can't bear to watch her clean. She should be in the movies or on TV. Isn't that what everyone here wants? Everyone except me 'cause I look like a hangdog extraordinaire. The last time I saw a photo of myself it was hard to believe that was what people saw when they looked at my face. For a year, the mirror in the bathroom down the hall has been cracked, and before that it was so stained you could be that guy from *Mask* and think you were good-looking.

FICTION BY DEBORAH STOLL

She hands me the glass. It's a heavy pour.

"Thanks."

"That one's on me. You're the only one with manners."

"Yeah," I say.

"Yeah," she replies.

She's no conversationalist but I don't need someone who talks a lot. I'd feel like I had to keep up and I don't have anything to say.

The shift change happens but I don't notice until the new bartender gives me a glass of water. He doesn't like me. She'd never give me a glass of water. She'd only give me booze, shots, and now this guy is insinuating it's time I went home. Well, fuck him!

Now the doorman is dragging me out. Maybe I forget my credit card. Maybe my pack of cigarettes gets left behind. But there's no arguing with the doorman and anyways, I respect him. Fucking bartender though. Who does he think he is?

"Hey." A girl is staring at me.

"Yeah?"

"What happened?"

Her eyes are huge like saucers. Like she's looking at something terrible. I peer down at myself to see if I'm bleeding but I'm not.

"Shift change," I say.

"You all right?"

"Yeah. You?"

"I was just going in to get a drink."

"Well…" I say, and then I don't know what to say and smile stupidly. She turns and disappears inside. I watch through the windows as she makes her way to Mister Shift Change. He kisses her on the mouth, and I think that if someone loved me, I could be a bartender too.

THE RESURRECTION OF HENRY GRIM

BY HANK CHERRY

It's a cold January Friday afternoon in Manhattan. Henry Grimes and his wife, the writer and music promoter Margaret Davis-Grimes, have assembled a pickup quintet for a jam session in a cozy walk-up overlooking West Twenty-second Street in Chelsea. The apartment has high ceilings, and portraits of jazz musicians hang on the wall.

A sparse afterthought of a beard hangs around his chin, and Grimes is bald on top. His face, though, bears the same expression of intent it did some forty years ago when he could be seen in magazines, heard on records, and caught onstage alongside Ornette Coleman, Albert Ayler, Cecil Taylor, John Coltrane, and other giants of the 1960s free-jazz movement. But that was before he died.

This afternoon, Grimes huddles with a borrowed bass in the corner, inspecting the instrument the way a horse trainer inspects a Triple Crown contender. He's not being modest, though he is unassuming; he's simply found the best spot to project his bass lines out into the room and hear the sound of the other musicians bouncing back onto him.

A brief round of introductions are made. Andrew Lamb is on reeds, Giuseppi Logan on alto sax, Claire Daly on baritone sax, and Connie Crothers on piano. Then the music starts.

Though he controls the session, Grimes is no taskmaster. Dressed in a bright blue Hawaiian shirt speckled with Escher-like geckos, black snow pants, and his trademark sweatband, Grimes exudes the kind of calm that often accompanies greatness.

When his fingers slide down the strings and return effortlessly, drawing a bow across the strings, the sound in the room flutters an instant. Where nimble fingers glided on top of the collapsing melody of saxophones and piano just a moment before, the bowed bass now flaps an altered tone, changing the tempo, beat, and vibration of the room instantaneously. Everyone is in a trance. Even the radiator hisses in approval. The message seems to be clear: no time to waste. Get up, get down, and blow.

Grimes pulls the upright bass's neck in close and sucks the rest of us into his sound as he blisters through a gymnastic pizzicato run. Lamb and Crothers follow but a nanosecond behind. Then, Daly's baritone collides with the rest of them. Notes bounce from window pane to wall sconce, now drowning out the radiator, jostling a picture of John Coltrane, the patron saint of free jazz, framed on the wall.

Lamb rests a moment and closes his eyes. Logan, a wiry seventy-five-year-old with shocks of white hair, replaces Crothers on piano. Grimes switches to violin. And then they're galloping off again. You can feel the music as it cascades around the room. The Holy Spirit as song. This time around, it's about the love. Henry Grimes is enjoying his afterlife.

Henry Grimes died in 1984.

At least that's what jazzbo bible *Cadence* magazine reported in 1986. It wasn't alone. Rumors of Grimes's demise had been circulating for years by then, fueled by his mysterious disappearance from the New York scene in which he'd played such a prominent role. In the second edition of her book *As Serious As Your Life: The Story of the New Jazz*, noted jazz historian Valerie Wilmer wrote at the end of her preface, "although details have never emerged, it is generally believed that Henry Grimes died in California in the 1970s."

Grimes left New York for California in 1968. Or maybe it was 1969. Whenever it was, it was a long time ago. Or, as he says, "It's all sort of buried back there in the past."

He had his reasons for skipping town. The tail end of the sixties was unkind to free jazz, the form named after the Ornette Coleman recording of the same name and pioneered by Coleman, Taylor, Coltrane, Ayler, Sun Ra, Charles Mingus, and others. Looking to release the music from the rigidity of bebop, hard bop, and modal jazz of the forties and fifties, free jazz, sometimes called liberation music, took its cues from the snaky, polyphonic rhythms of New Orleans.

The name fits. The music blossoms so peculiarly to the untrained ear that it seems free of any skeletal underpinnings. Angular, visceral, versatile, it feels right in a living room, on a stage, or in a studio. But by the late sixties, club owners stopped booking free jazzers in favor of more commercially viable forms.

Had he stayed in New York, Grimes would have witnessed cohorts like Dewey Redman, Rashied Ali, and Sam Rivers retiring from clubs that had once paid handsomely and instead plying their trade in once-vacant SoHo lofts that became a haven for free jazz practitioners when the clubs abandoned them. There, they put on shows and made records themselves, all the while expanding informally upon the sound Grimes had helped define.

As it was, Grimes missed the entire loft jazz movement. At the time, he believed the West Coast offered more opportunity for the music he heard in his head. Tales from poets back from the beatnik haven of San Francisco suggested the Golden Gate would provide a friendly place for an itinerant bassist of Grimes's skill and credentials. Not to mention his own budding interest in free-verse poetry. But by the time Grimes got there, the Bay Area was buzzing with the 4/4, acid-blues beats of the Grateful Dead, Jefferson Airplane, and Big Brother and the Holding Company. The jazz hideouts of North Beach were all but chained.

Grimes moved on to Los Angeles. There, like many artists before him, he quickly seemed to vanish, losing touch with everything that mattered to him—family, friends, and otherwise. In November 1970, soon after Grimes disappeared, the body of his friend and musical ally Albert Ayler was found floating in the East River near Congress Pier in Brooklyn. With Ayler dead and Grimes disappearing into the California ether, it's not surprising that rumors began to overtake friends and fans.

In truth, Grimes was down, but not out.

♩

Henry Grimes was born in a working-class section of South Philly he describes as "semi-rough." South Philly has spawned enough great musicians to warrant its own hall of fame. There's Grimes's high school mate, noted trumpeter Wilmer Wise, as well as trumpeters Ted Curson and the legendary Lee Morgan, who was shot dead in 1972 between sets at Slugs' in the East Village. He was just thirty-three. Grimes and Morgan attended Mastbaum Area Vocational High School, known for a hyperintensive music program that required students to master five instruments upon graduation. Grimes's first instrument was the violin. He added English horn, tympani, tuba, and double bass to his repertoire.

During his senior year in high school, Juilliard invited Grimes to audition. The Conservatory was still located in Morningside Heights, a step away from Columbia University and, more important, adjacent to a Harlem that was still shimmering in the light of its renaissance. Grimes auditioned for the school's board of directors on bass, and they liked what they heard. He did two years at Juilliard. "I would have liked to swallow everything they taught whole," he says of that time.

When Grimes hit the professional jazz circuit, he hit it hard. From September to December 1957, he played on six different sessions. A year later, he played the Newport Jazz Festival with Thelonious Monk and was featured with the pianist in *Jazz on a Summer's Day*, a weird but beautiful film that captures the festival, interspersing footage of the musicians with shots of that year's America's Cup sailing race.

Grimes discovered he fit easily into the New York world, establishing himself as double bassist nonpareil, gigging with giants Monk, Coltrane, and Miles Davis, and bebop pianist Bud Powell, who also died too early at the age of forty-one. Grimes ably shifted from working with the jazz elite to the purveyors of free

jazz, playing with Coleman, Sonny Rollins, Sunny Murray, and Charles Tyler. But he was more than that. In impromptu jam sessions, recordings, and international tours he became a confidante and co-creator, his voice helping to shape the style and progression of free jazz. During the early sixties, his talents lured fabled bassist Charles Mingus, who quickly added Grimes to a date when he needed a willing improviser with strong bowing skills. When Mingus decided to delve into the more experimental sound and employ an extra bassist, Henry Grimes got the job.

From 1957 to 1966, Grimes recorded more than sixty sessions. At the same time, he witnessed a new African American unity as black radicalism took shape. Grimes formed strong bonds with two of post-renaissance Harlem's most daring intellectuals, avant-garde pianist Cecil Taylor and LeRoi Jones, the poet, playwright, and sometime music critic who urged Grimes to continue writing his own poetry. Black Panther groups spread out of the Bay Area, with offshoots taking root in African American neighborhoods of cities like Baltimore, Chicago, and Cleveland. The Panthers organized a group in Harlem in 1966. Less than a year later, LeRoi Jones became militant writer Amiri Baraka. Grimes backed him at Harlem readings. The April 1968 issue of *The Liberator* features a stunning half-silhouette portrait of Grimes captioned with the words *black music*.

Poet Al Young wrote in his poem "Dance of the Infidels" (dedicated to Bud Powell), "Genius does not grow on trees." And yet, over the course of the sixties, genius blossomed with a frequency never again rivaled in the New York jazz scene. Reviews of Grimes's performances from that

era talk of his "revelatory playing" and "feverish runs." Critics refer to Grimes's exploratory compositions as "spiritual."

At one New Year's Eve performance, Grimes shared the stage with Coltrane, Ayler, Taylor, and Eric Dolphy.

"That was really a beautiful gig," says Grimes.

That Grimes would be in such demand is no surprise when you listen to any records on which he's featured. He plays the bass like he's giving an incantation—sometimes frantic, sometimes hallucinatory, always magical.

Despite the accolades of critics, peers, and fans, Grimes needed to get his own sound out. Free jazz opened his mind, allowed him to incorporate his razor-sharp technique with his poetic sensibilities. In the mid-sixties, Grimes got a deal with Bernard Stollman's ESP-Disk, an avant-garde label that featured him as a sideman to Ayler, Tyler, Frank Wright and Burton Greene.

The Call, made with Perry Robinson on clarinet and Tom Price on drums, is a frenetic, adventurous, and beautiful debut that remains a seminal free jazz recording. Sadly, this is the sole recording Grimes made as a bandleader before disappearing into the West. Ayler and Grimes recorded their final date together in the winter of 1966, producing the much-lauded *In Greenwich Village*. Ayler was dead by 1970. Grimes would not record again for thirty-seven years.

Henry and Margaret, who live in the Yorkville neighborhood on Manhattan's Upper East Side, keep a busy schedule. During the several days I spend with them, we attend a screen-

ing of Charlie Chaplin's *The Kid* at Merkin Concert Hall, where their friend, jazz guitarist (and early Tom Waits collaborator) Marc Ribot, performs the score he wrote for the film. Another evening it's down to Abrons Arts Center on the Lower East Side for a Festival of New Trumpet tribute to Grimes's high school buddy Wilmer Wise. There's a trip to the Harlem branch of the New York Public Library for a talk by former Sun Ra Arkestra member Craig Harris.

I notice throughout that Grimes is calm, well mannered, and slyly humorous. One day, walking past Lincoln Center, we notice a Julliard student practicing his bass. It prompts me to ask about Jimmy Knepper, Mingus's fabulous trombonist and musical transcriber.

"I had to get away from him," Grimes says, his mouth forming the trace of a smile.

"Why?" I ask.

"He was always calling me to baby-sit."

During a break in the action, as we grab a meal and talk at a diner, Margaret shows me Henry's résumé from his lost years in L.A. It lists janitorial skills, floor-treatment techniques, punctuality. Nowhere does it mention his sublime arco bass playing, or that he played with Sonny Rollins and Pharoah Sanders.

The Los Angeles that Grimes arrived in was hardly a friendly place. To make headway in the music biz, you needed to know someone. Grimes called on LaMont Johnson, an East Coast transplant like Grimes and something of a free-jazz hanger-on. He'd run a small record label and recording studio back in New York. Johnson offered Grimes a place in the house he shared with a few other musicians. Right off, Grimes noticed something strange. Turns out John-

son and the other musicians sharing the house were all Scientologists. Every chance they got they tried to enlist Grimes.

"They sort of sprung it on me after we had a rehearsal one time. We'd practiced playing jazz, then ..." Grimes trails off.

"I didn't go for it," he says, finally. "I just said I'd had it, I got to go."

Only he had nowhere to go. So he grabbed his bass, broken and battered from traveling, packed up his few belongings, and found his way to a pawnshop. Grimes hocked his bass. The money wasn't much, and he used some of it to get to the Mission on Skid Row. "I started working there, for food and clothes," says Grimes.

Los Angeles once had a thriving jazz scene. Storied musicians and vital clubs had been supported by eager promoters and willing record labels. By the time Grimes made it to L.A., both the Central Avenue scene of Charles Mingus and Eric Dolphy and the West Coast jazz scene of Stan Getz and Dave Brubeck had wound down.

But Grimes would have been hard to find even if the scene hadn't been dead. By the late seventies, he was living in the Huntington Hotel, an SRO on Seventh and Main. The Huntington is a flophouse to this day, full of dope fiends, hustlers, and thieves. It's hard to picture Grimes, well dressed and impeccably polite, in this milieu, and despite his circumstances he managed to steer clear of the booze, drugs, and crime all around him. Instead, he worked—at a bowling alley in Long Beach, as a custodian at the Sinai Temple in Westwood, and at other menial jobs.

Grimes kept his jazz-musician past under wraps, and with this he probably did himself no favors. But he had his reasons. "They stole your shoes," he says of the people he lived with, and it's clear he's sharing a memory and not a metaphor.

His only salvation was poetry. He compiled ninety notebooks' worth. "I wasn't okay with not playing the bass, but I compensated with poetry," he says with characteristic understatement.

His poems avoid the familiar hard-boiled diatribes that often romanticize the L.A. underworld in which he lived. His free verse rumbles with a well-patterned cadence. Contemporary events mark his progress into obscurity, the Olympics of '82, the Greyhound bus drivers strike of '83. He was, like so many here, anonymous and searching for some connective tissue.

December 2002 was rolling along for Grimes much like December 2001 had gone by, and all the Los Angeles Decembers Grimes could remember. Then one day, the Huntington's manager knocked on his door. "You got a phone call," he said. Grimes didn't ask who it was, thinking maybe it was about a job. He followed the manager down to the office. An unfamiliar voice greeted him on the other end of the line.

"Is this Henry Grimes?"

"Yes."

"The Henry Grimes that was active on the jazz scene in New York in the sixties?"

"Yes."

The call was from Marshall Marotte, a social worker, part-time bass player, and full-time music fan. He was taken with the sounds of Henry Grimes. "My marriage was falling apart, so I was able to focus my energies," Marotte tells me via e-mail. "In reality, I became obsessed with the whole process of research. I was listening to his recordings for hours on end. I would stay after work was done, brew up a pot of coffee, put on some music, and search online for whatever I could find. In years past, I had only been able to gather a handful of mostly wrong info about him. He died in the eighties in Los Angeles. He became a preacher. Finally I came up with some good data and made a call to the SRO."

A week later, Marotte was at the Huntington interviewing Grimes. That winter, an article based on Marotte's interview appeared in the music quarterly *Signal to Noise*. Eventually, word got out that Grimes was alive and bassless in Los Angeles. Then the news reached renowned double bassist, poet, and composer William Parker. Parker happened to have an extra bass lying about. He called the stained-green instrument Olive Oil. Parker enlisted the help of David Gage String Instruments in New York and got the bass shipped to California.

"For years one of the most-asked questions was, 'Where is Henry Grimes?'" Parker tells me by e-mail. "What happened to him? No one knew, just rumors about his death, or him dyeing his hair green and moving to California. When I read that Henry was found, it was a great day for the music world."

Grimes says that when the big, wooden crate arrived, it looked like Dracula's coffin. "They pried it open with crowbars. The bass inside was like a big ray of hope."

Grimes lugged it up to his room and immediately started practicing. After gigging around Los Angeles a bit, he found the opportunities here lacking. A few months later, through the support of his extended musical family, Grimes had a plane ticket to New York. As he left the SRO that had been his home for decades, he

saw the crate still sitting in the lobby. Not long after that, the few remaining jazz clubs he played in L.A. had closed.

Before Ayler's death, Grimes appeared on four massively important recordings with the saxophonist, his bass bribing the implied rhythm, his bellowing runs serving as a counterpoint to Ayler's snake-charmer horn, navigating the deconstruction of structure, using his alchemy to turn it to memory, implication, a ghost spirit for the music's freedom. Lost in L.A., Grimes missed Ayler's funeral. In fact, he didn't know of Ayler's death until 2003, when he asked Marotte about his old friend. It's only coincidence that Grimes stopped playing right around the same time Ayler died.

That Grimes would all but vanish after he pawned his bass, though, is not a coincidence. During the jam session on that last day of my visit, as Logan delicately honks his way down the lines Lamb and Grimes stretch out for him, one thing is clear: the only way you'll ever really get to know Henry Grimes is through his music.

A drum set sits quiet and empty in the corner, but it doesn't matter. Grimes hits the drum beats on the strings of his bass while simultaneously careening past melody, harmony, and pace into the ether of skronk. Logan wants to play some songs in the session, to liberate them perhaps. Up comes the meditative opening of "My Favorite Things." It's just the two elder jazzbos going at it.

Logan has a story, too. Every misstep Grimes avoided, Logan took. He explains before the session starts that he's been away for some thirty years. He mentions jail, he mentions a woman, he mentions drugs. What he doesn't mention is the two mind-numbingly expressive recordings he also did for ESP-Disk in the sixties, before life forced him to fade from the scene altogether.

When Logan and Grimes begin to play, a tapestry spun from the fibers of their past covers the music with unexpected warmth. For each of them to have their instruments back in their hands is for them to be able to speak again. To have a partner as worthy as the other is to have conversation restored. What they coax from their instruments is a refusal to settle for the more ordinary renditions of the song. They deconstruct it, then refashion it with stutters and blurts that bond with the song so totally that you think it always sounds as such.

This is free jazz, what Wynton Marsalis referred to as formless noise. Marsalis was wrong. In Logan's and Grimes's hands the music is dynamic and riveting. All of us in that room are swept up in it. Lamb sets down his can of beer, Connie Crothers (Max Roach, Lennie Tristano) moves to the couch. She's up at the edge of her seat cushion as the music finally stops. The room gives way to applause. Then, like attending to a snap of the fingers, Logan bellows the opening of "Summertime," and everyone goes silent.

Grimes comes in a half step behind, but steering the song as the two men lock onto the stately old haunt, originally composed by George Gershwin for Porgy and Bess. Crothers moves to the keyboard, Lamb picks up his sax. The whole band rustles to life. Each member steps in as if opening a door, and each one exacts precisely the right information, the right instinct. And they cook for a few minutes. Until, just at the moment where any more would be too much, Logan releases the blues, and Grimes adds one final comment, sending the song shimmering to an end. The musicians are all quiet now, but the song is still tangible. It reverberates, an energetic buzz whispering long after the cord has been pulled.

I ask Lamb afterward how often he'd played with Logan and Daly. "This is my first time," he says nonchalantly. Lamb and Grimes do have a history, however. The saxophonist was a member of the Grimes-led trio voted best in New York by the New York Press a couple years back. The first time he played with Grimes, "We got on the bandstand to do a sound check and everything came together as if we'd been playing for a hundred years."

Grimes has that effect on the players this day, too. The ease with which each musician melds to the song while continuing to support Grimes, all the while retaining his or her individuality, reinforces my belief that free jazz promotes conversation. It relies on it. You can't have expression without individuality in the highly improvised style. And you can't improvise without a full understanding of modes and keys and shifts and changes and scales. It's language. Lamb explains it succinctly, "If you're really listening, then it allows you to communicate."

After more than thirty years, Grimes has returned and claimed this language as his own. Some might have shrunk from the challenge, unwilling to create a future from so distant a past. Grimes didn't. Experiencing him perform, led by his ears, is to know that as much as his time was back in the sixties, his time is also right now. As Crothers puts it, "It's like being in heaven, playing with Henry."

And everyone knows heaven is timeless.

S

THE SEEKER
BY STEVEN KOTLER

In 1968, Michael Backes was thirteen years old and not feeling very well. His muscle coordination seemed off. Plus, he'd been dizzy for a few days, his peripheral vision kept disappearing, and that ringing in his ears just wouldn't quit. Then came the pain, an excruciating explosion in his head. Followed by nausea, vomiting, and a weird pins-and-needles sensation that started in his leg–which first went completely numb and then refused to respond to his commands–and moved to his arm, his shoulder, and finally his face. His lips stopped working, his tongue felt like a dead fish. Suddenly, Backes went mute. He was terrified.

By the next morning he was fine. A few weeks later, though, it happened again. He went to doctors, to specialists. He was diagnosed as having hemiplegic migraine–which is a rare form of migraine that induces numbness and paralysis–but the condition is not well understood. Back then neurology was still a nascent field and migraines were considered a woman's condition. No one knew why a thirteen-year-old boy was having them or what to do about it.

The migraines continued to plague Backes on and off. There were drugs, of course, but not very good ones. He spent a long time taking Ergotamine, a powerful vasoconstrictor, but the side effects were almost as bad as the headaches. Sometimes there was nothing to do except head to the emergency room for a shot of Demerol and a quiet place to wait it out. Those ER visits weren't cheap, though, and this would eventually become a problem that led Backes to seek out his own solutions.

Michael Backes was born in Illinois in 1955. His mother was a happy housewife, his father a peripatetic professor. Following his father's career trajectory from university job to university job, Backes had lived in every state beginning with "I"—Illinois, Iowa, Indiana, Idaho—by the age of fourteen. Then the family moved to Tucson, where Backes started high school. This was 1969 and Tucson, being both a university town and close to the Mexican border, was abundant with high-quality marijuana.

Like everyone else back then—except, perhaps, President Clinton—Backes inhaled. He liked smoking pot in high school. He thought he was going to like smoking pot in college, but then he went to Indiana University. Bloomington might be a university town, but it's nowhere close to the Mexican border. The weed was terrible.

"Dirt weed," says Backes, shaking his head at the memory. "Awful, hurt the lungs, hurt the head, the high was much closer to a low."

So Backes quit smoking pot for twenty years. But he did graduate IU with a degree in biology and an interest in technology. He was all set to work in the sciences, but fate intervened in the form of a girl he followed out to Los Angeles. At a party one night, a movie producer offered Backes a job, and he soon found himself working for the dream factory.

Backes's Hollywood résumé runs the gamut, but he first came to prominence as a screenwriter (he co-wrote *Rising Sun* with Michael Crichton) and then as head of a small studio. Mainly, though, he worked as a technical consultant, designing the control room set for *Jurassic Park*, among other things.

Always something of an egghead, Backes made his way to Silicon Valley during the PC revolution. There, he spent the 1990s building cutting-edge 3-D imaging software and accruing stock options. But when the dot-com bubble burst in 2000, he went from paper millionaire to flat broke. Along the way, he lost his health insurance and his ability to afford the medical costs of dealing with his migraines.

Not knowing what else to do, Backes went looking for alternative treatments. A friend suggested marijuana. Backes hadn't smoked pot since high school, but did a little research and quickly discovered a boatload of anecdotal evidence about cannabis's efficacy in treating migraines and other ailments.

Cannabis has been used as a healing herb for millennia. Its first recorded medical use was roughly 5,000 years ago in China, where the plant was put into service treating malaria, constipation, absent-mindedness, and menstrual pain. In India, it was favored as an appetite stimulant and fever reducer. In Africa, it treated snakebite and eased the pain of childbirth.

It didn't arrive as a treatment in the West until the mid-nineteenth century, when the Irish physician W. B. O'Shaughnessy popularized it as an analgesic and an anticonvulsant. Between 1840 and 1900, more than 100 papers on the medicinal uses of cannabis appeared, enhancing its reputation as a cure-all.

By the end of the nineteenth century, cannabis was being used to treat tetanus, neuralgia, dysmenorrhea, convulsions, epilepsy, insomnia, ulcers, rheumatism, asthma, postpartum depression, depression, psychosis, gonorrhea, chronic bronchitis, and reduced appetite, and in all forms of pain relief.

Dr. J. B. Mattison, an early advocate, saw cannabis as a more healthful option than the overreliance by young physicians on "that modern mischief maker" opium. Writing in the *St. Louis Medical Surgical Journal* in 1891, Mattison also recommended it for "that opprobrium of the healing art—migraine."

So a century or so later, Backes tried it for just that opprobrium. The results were spectacular.

"Not only did it block the pain and the paralysis," he says, "it even blocked the auras [the technical term for the sensory distortion that precedes a migraine]. All I have to do is smoke high-quality cannabis twice a week, and it has a completely prophylactic effect."

The problem, though, was where to get high-quality can-

nabis. There is no standardization when it comes to medical marijuana and thus no predictability in its effectiveness. So, around 2004, Backes became a marijuana detective. He started going to dispensaries, trying all the strains he could find, and writing detailed reviews for Web sites. Not finding exactly what he was looking for, he decided to take matters into his own hands. He opened the Cornerstone Research Collective and embarked on a serious mission: to take one of the most effective medicines the world has ever known and make it better.

The Cornerstone Research Collective sits on the bottom floor of an old Craftsman home in Eagle Rock. Unlike the hippie vibe found in many Los Angeles dispensaries—Bob Marley posters on the wall, surfboards propped into corners—Cornerstone looks like a mid-eighties oxygen bar or a mid-nineties sushi joint, like the kind of place where you'd have to wait to get a table.

"What can I say," explains Backes. "I'm just not a huggy guy."

Instead, he's something of an anomaly, the curmudgeon in the middle of the burgeoning medical marijuana drum circle. For example, a few years ago, when most of the other Los Angeles dispensaries embarked on blitzkrieg marketing campaigns, doing everything in their power to lure fresh business, Backes decided to cap his membership at around 2,000.

"I really think there are certain people who shouldn't smoke pot," he says one morning over breakfast at Auntie Em's in Eagle Rock. "I'm not interested in promoting stupidity. When the 'Dude, I hear you've got tasty buds for cheap' crowd started showing up, I'd seen enough."

Now, prospective members must pass an IQ test of sorts to join.

"Our membership is closed, but if you really want to become a member, then you can become a member," he adds. "The IQ test is trying to figure out how."

Backes is a tall man with a bald head and a penchant for wearing ties. He takes pride in the fact that he's probably the only weed dealer in Los Angeles who wears one to work. But this isn't the only thing that sets him apart from many of his colleagues. For someone in the pot biz, Backes is not really much of a pothead—he is definitely not a stoner. But he is a cannabis geek.

"A stoner," says Backes, explaining the difference, "wants to smoke as much pot as possible to get as high as possible. A cannabis geek wants to smoke as little as possible and get the exact desired effect they want."

His quest for the exact desired effect led Backes to his recent decision to expand Cornerstone. Sometime in the next few months, in accordance with new Los Angeles zoning restrictions on dispensary locations, he will move to a building large enough to house a small research wing and a gas chromatograph–mass spectrometer, a machine that is just about as whiz-bang as it sounds.

A GC-MS is an extremely expensive and specialized piece of equipment used for forensic substance identification. Bomb disposal teams like them for identifying explosives, environmental engineers for tracking pollutants, and food and beverage analysts for detecting spoilage. A couple of these machines have already left the planet. One tagged along on a Voyager mission to analyze the atmosphere of Venus, another to study the soil on Saturn's moon Titan. Backes has more prosaic hopes for his GC-MS—to explore marijuana's medicinal potential.

With some 900 dispensaries in Los Angeles and some 300,000 people with prescriptions, you might think marijuana's medical potential has been comprehensively explored. After all, researchers have declared it one of the most successful palliatives in the medicine chest, already known to be beneficial in the treatment of pain, nausea, vomiting, PMS, lack of appetite, migraines, fibromyalgia, cancer, depression, ADHD, Parkinson's disease, Huntington's disease, Lyme disease, OCD, and Tourette's syndrome as well as the aforementioned ailments. The list goes on.

"Really," says Backes, "there's nothing in our current pharmacopoeia that comes close. And it's this helpful without the benefit of human intervention. Yet we've only figured out how to grow marijuana that gets people higher; we haven't even started to figure out how to grow marijuana that makes people healthier. That's why I got into this game. That's the real frontier."

In an arena rife with entrepreneurial opportunists, Backes's Cornerstone Collective is one of the few (the Steep Hill Collective in Oakland is another) seriously exploring that frontier. Unfortunately, that frontier is a ways away. Right now, without the top-down supervision of a governmental body, quality control is something of a crapshoot. Pot shows up at dispensaries coated in fertilizers, pesticides, and heavy metals (leached out of the ground water). Mold is another concern. Analyzing samples with a GC-MS, along with a few other tests, should solve this purity problem—but it's merely the beginning.

After purity has been addressed, standardization is the next goal. "Standardization is the mainstay of modern medicine," says Backes. "If I get a prescription for Vicodin, I not only know that the pills contain only hydrocodone, I know exactly how much hydrocodone they contain."

Marijuana, though, is a fairly complicated plant, made up of some 400 different chemicals. How much of each of these chemicals exist in, say, a given strain of the Northern Lights brand, is not known. Worse, the chemical content from one batch of Northern Lights to the next can also vary significantly—so even buying a "brand name" isn't a guarantee of anything.

Figuring out the exact chemical content of each strain has two benefits. One is that it will finally allow dispensary owners to know which strains are most effective for which conditions, but even better, it's the foundation for future improvement—and this is Backes's real goal, the frontier he's aching to explore.

One of the challenges is that modern medicine is built on a reductionist formula. If pharmaceutical companies want to turn a plant into a medicine, they usually do it by isolating the most active ingredient and making what's known as a "single-compound drug." Morphine, for example, is really just the chemical core of the poppy plant. Aspirin developed from isolating salicin, a compound found in willow bark.

This, too, has been tried with marijuana, with less success. Out of the 400 chemicals in marijuana, eighty of them belong to a class called "cannabinoids." Of those eighty cannabinoids, a number of big pharmaceutical companies have tried reducing marijuana to only one, tetrahydrocannabinol (THC), but the results did not produce the desired effects.

"There are certain cases," says Rick Doblin, president of the Multidisciplinary Association for Psychedelic Research, a nonprofit that has been actively involved in the medical marijuana debate since the eighties, "where the single-compound formula works wonders. But it's just not true in every case. When you reduce cannabis to just THC, you lose efficacy and gain side effects. Marinol [the approved brand name for pure THC extract] is less effective in treating chronic pain, less effective for nausea, and can make users extremely tired and really paranoid."

Not to mention, you're going to have to pay through the nose to get less-effective, federally approved (or, if you prefer, big-pharma-produced) THC.

"If we say the main medicine in marijuana is THC, then if you buy that medicine at Cornerstone, you're paying $80 a gram," explains Backes. "But if you go to Canada and buy synthesized THC [with a little bit of another chemical called cannabidiol, or CBD], well, that drug is made by GW Pharmaceuticals, is called Sativex, and retails for about $800 gram. It's worse in America. Here, in generic form, pure THC is $1,600 a gram, but if you want the top-shelf brand, Marinol, it's $2,300 a gram."

Backes, though, wants to go in the opposite direction. Instead of reduction, he thinks the best medicine could come from

learning more about the exact relationship between the cannabinoids and "terpenes"—which are marijuana's aromatic essential oils—and ultimately tinkering with the percentage levels of both of those compounds. The results, he believes, could make marijuana even more medicinally potent that it is today.

Sounds like a win-win. Oddly though, what Backes is doing is technically illegal thanks to a series of Kafkaesque drug policy decisions. Not the least of them is the Controlled Substances Act of 1970, whereby the DEA added cannabis to Schedule 1, the most restrictive placement, ostensibly reserved for drugs with no known medicinal value and a high potential for abuse. Also found on Schedule 1 are cocaine and heroin.

So, for the past forty-two years, when American researchers have wanted to study marijuana, the only marijuana they've been allowed to study has come from Elsohly Labs (named for the lab's founder, Mohammed Elsohly) at the University of Mississippi, which is administered by the National Institute of Drug Abuse (NIDA). Unfortunately, NIDA was established to prevent drug abuse and has never been much interested in doing pro-pot research.

"If you want to study the negatives of marijuana," says Doblin, "like, does cannabis cause lung cancer, NIDA is happy to supply it. But if you want to find out if marijuana is effective against lupus, NIDA will turn you down."

Or, as Nora Volkow, the institute's director, told *The Boston Globe* in 2006, "It's not NIDA's mission to study the medicinal uses of marijuana or to advocate for the establishment of facilities to support this research."

And even when researchers have managed to wade through this morass and obtain NIDA pot, they've been confronted with the problem that NIDA grows shitty pot.

To illustrate, the THC content of standard, street cannabis is 12.5 percent and high-grade medical stuff can get into the low 20s, but NIDA pot can be as low as 3.5 percent and the highest anyone has ever found it is 8 percent. Patients who have enrolled in NIDA studies complain of getting prerolled joints packed with stems and seeds. Others have repeatedly dropped out of studies because they had to smoke endless quantities of NIDA pot for the same relief they used to get from a few hits of regular, street-bought cannabis.

Many researchers have pointed out that the U.S. government is operating a monopoly on research pot. In a 2001 attempt to end this practice, Doblin, alongside University of Massachusetts agronomist Lyle Cracker, applied to the DEA (which, again because of these Kafkaesque laws, oversees the NIDA monopoly) for permission to establish a second growing facility.

The case went before an administrative law judge, who ruled in their favor, but that ruling is not legally binding, so the DEA has refused their license and the case is now moving toward federal court.

The reason Doblin and Cracker are going this route is because they want to make marijuana a legitimate, FDA-approved medicine—a process that requires extensive testing on legally sanctioned pot. Backes is not so patient.

"Fuck the FDA," says Backes. "My interest is in learning more and helping my patients. I don't need to go through official channels for that."

A glimmer of hope on the horizon—and the reason he's willing to shell out a bundle of cash for a GC-MS—is the Obama administration's decision to defer to local jurisdictions over medical marijuana dispensaries. Backes sees this as a green light for research.

"This is the route we need to go," says Backes. "We made a mistake. We demonized a nontoxic plant and ignored a great medicine," he says. "It was just stupid. The only way to rectify that mistake is intelligently applied passion. We need more folks like me: obsessive autodidacts. Seriously, that's what makes marijuana research so great: it's the last bastion of the amateur scientist."

⟨S⟩

ARTICHOKE

BY ERICA ZORA WRIGHTSON

There is the light coming through the bone-white blinds in the morning. There are the hot baths, Constant Comment tea, Laura Nyro songs, and chocolate-dipped honeycomb. After the radiation, when you can no longer walk, your appetite narrows—a sudden decrescendo as the body accelerates toward an end.

It is no surprise. In the final year of your cancer, the limbs slow, but the mind does not. Thin bouquets of hair stay behind on your pillowcase. The body nudges the skeleton into the foreground, becoming more subject, less frame.

In the side yard, plums ripen and sparrows place bets on the crop. You have never had this much time in your house; you were always working. You try to cook, navigating the square corners of your kitchen in your wheelchair. On your lap, you rest a small wooden cutting board, and with a paring knife slice plum tomatoes from your garden, the translucent juice running onto numb legs. Friends bring food to fill the house with the scent of comfort: meatloaf, quiche, minestrone soup. These are not unlike meals you made once every day, but they are not yours. There is less to prepare, but you would rather think about lasagna than death. You would love to make summer salads and in the mornings bake scones for the kids; you would love to walk to the stove on strong legs and boil a pot of water for tea.

In illness, the appetite hovers. It is the ghost of hunger, desire transposed into need. It is impractical. A slice of coffeecake that was once the center of your perfect breakfast is grainy and brown; it is a wedge of sand and sugar. Toward the end, there are artichokes. Like you, they are time's material—a rationing of leaves. Artichokes make sense when you move through days in a body, just fifty-three years old, that has aged decades in a year. Busy dishes are difficult to digest. An artichoke is reliable symmetry, edible geometry. You find comfort in its layered chamber of leaves and the final pleasure of its heart.

On Saturday mornings your daughter goes to the farmers market alone; it is too difficult for her to maneuver you in your chair through the crowd now, and the uneven pavement makes your back sore for days. The spring artichokes are huge. You watch your child trim the pointy tips. Her technique is uneven, but you will not correct her. You are learning to let go.

You sit with her on the porch, eating with your hands. The men are out. It is Friday night and the sun takes its time to set. It is hot, but you like the fresh air and prefer to witness the sunlight deepen on the large oaks of Mar Vista Avenue. You watch the squirrels bicker over acorns in the street; young couples push their children in strollers. You sit beside your daughter, plucking dark green leaves, dipping them in a mixture of plain yogurt and mayonnaise, dragging them between your teeth. One artichoke is all you eat. You undress the thistle, anticipating the heart. Your daughter gives you the larger half, scooping out the lavender center.

In a few months, on a Sunday afternoon, the street will be crowded with everyone you know. The neighbors will climb ladders to hang paper lanterns from the oaks and the camphors. Your son will write a song that he and your daughter will play with a jazz quartet right there on the lawn. Your friends will pot succulents in your memory; a Jewish chaplain and a Unitarian priest will say words. The man you have loved since you were fifteen will read the Ferlinghetti poem that you quoted on your wedding invitation, the one from *Pictures of the Gone World* that starts, "Fortune has its cookies to give out"

A week later, there will be traces. A crow will catch its leg on a forgotten lantern cord still draped over an oak branch. The meals will continue to arrive. Your family will not gather the plums, and the sparrows will peck at the windfall. Artichokes will enter and exit seasons, obeying the map of their own private harvests.

The Extravagance Of Loss

By Luke Davies

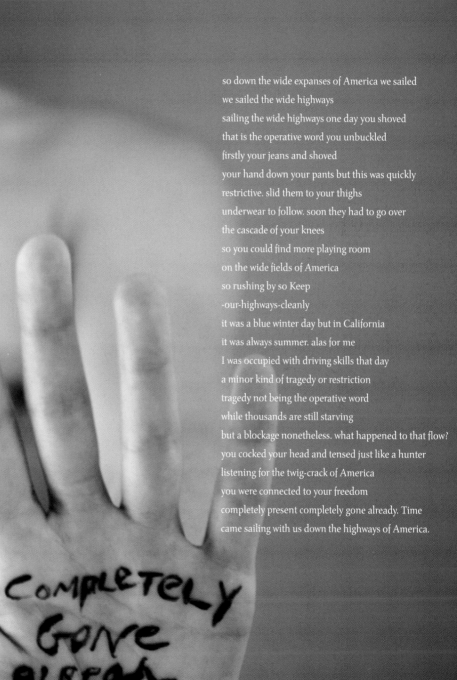

so down the wide expanses of America we sailed

we sailed the wide highways

sailing the wide highways one day you shoved

that is the operative word you unbuckled

firstly your jeans and shoved

your hand down your pants but this was quickly

restrictive. slid them to your thighs

underwear to follow. soon they had to go over

the cascade of your knees

so you could find more playing room

on the wide fields of America

so rushing by so Keep

-our-highways-cleanly

it was a blue winter day but in California

it was always summer. alas for me

I was occupied with driving skills that day

a minor kind of tragedy or restriction

tragedy not being the operative word

while thousands are still starving

but a blockage nonetheless. what happened to that flow?

you cocked your head and tensed just like a hunter

listening for the twig-crack of America

you were connected to your freedom

completely present completely gone already. Time

came sailing with us down the highways of America.

John Albert, a native Angeleno, has written for the *Los Angeles Times*, the *L.A. Weekly*, *Fader*, and *Hustler* among others, winning national awards for sports and music writing. Albert's essays have appeared in several anthologies and the film rights to his book *Wrecking Crew*, about the true-life adventures of his amateur baseball team composed of drug addicts, transvestites, and washed-up rock stars, have been optioned most recently by the actor Philip Seymour Hoffman.

Alex Bacon and **Dan Peterka** are the co-founders of **GAMA** (Guerilla Arts Movement of America) in Los Angeles, which can be found online at gamafunction.com.

Iris Berry is a writer, actress, musician, and native Angeleno. She has written several books and recorded two collections of her poetry and spoken-word pieces, *Life on the Edge in Stilettos and Collect Calls*. In the 1980s she was a singer for the punk rock band the Lame Flames, and later the Ringling Sisters. Berry just completed a book of prose, *The Daughters of Bastards* and she is working on a short-story collection, *Punk Hostage*.

Jamie Brisick has written two books: *We Approach Our Martinis with Such High Expectations* and *Have Board, Will Travel: The Definitive History of Surf, Skate, and Snow*. His writings have appeared in *The New York Times*, the *Guardian*, *Details*, and *The Surfer's Journal*. In 2008 he was awarded a Fulbright Scholarship. He lives in New York City with his wife and 5'10" Channel Islands Pod, and is working on a memoir.

Sandow Birk is a Los Angeles artist whose work has dealt with contemporary life in its entirety. His past themes have included inner-city violence, graffiti, various political issues, travel, prisons, surfing, skateboarding, Dante, and the war in Iraq. He is the recipient of many awards and has exhibited extensively.

Hank Cherry is a writer, editor, filmmaker, and tennis fan. For now, Los Angeles is home.

Mark Z. Danielewski was born in New York City and now lives in Los Angeles. He is the best-selling author of the novels *House of Leaves* and *Only Revolutions*, the latter of which was a finalist for the 2006 National Book Award for Fiction.

Luke Davies is a film critic, essayist and the author of three novels, including the cult best seller *Candy*, and four volumes of poetry, including *Totem*, which won The Age Book of the Year Award. He won the Australian Film Institute's Best Screenplay Award for his adaptation of *Candy*. His short film *Air* screened at the Festival des Antipodes in St. Tropez. His first children's book, *Magpie*, will be released in 2010.

Ray DiPalma's recent books include *Pensieri* (Echo Park Press, 2009), *The Ancient Use of Stone* (Seismicity Editions, 2009) and *Further Apocrypha* (Pie in the Sky Press, 2009). His writings have been translated in Italian, Spanish, Chinese, French, Danish, and Portuguese. DiPalma teaches in the Humanities Department at the School of Visual Arts in New York and has recently been a visiting writer at Otis College of Art and Design.

Shannon Donnelly's passion for photography started during a fondue mishap, cheese of course being her first love. Discovering that she could not make a career of eating cheese, Donnelly turned to her second passion: travel. Drifting aimlessly around the world turned out to be not much of a great career builder, either, so she tried something even more ludicrous and picked up a camera. Donnelly is now, surprisingly, an award-winning photographer based in Los Angeles, but is still looking for a job.

Anne Fishbein is a Los Angeles photographer whose work is collected in many museums, including the Museum of Modern Art, Los Angeles County Museum of Art, and the National Gallery of Canada. Her monograph, *On the Way Home*, was published by Perceval Press.

Kelly Fajack was raised in Manhattan Beach, California. His photography career began at 13 when he sold an image to *Surfing* magazine. Since then, has traveled to more than 40 countries on six continents to shoot for such clients as AOL, Fiat, and Fujitsu Siemens. Fajack's work has been published in magazines *Le Figaro*, *Time* and *Grazia*.

Matt Fleischer is a former staff writer at the *L.A. Weekly* and senior editor of *L.A. City Beat* who writes for the *Los Angeles Times Magazine*, among other publications. Says Matt, "You've heard that nobody walks in L.A. Not true. Any number of schizophrenics walk in L.A. Crackheads, too. And when I'm not writing, I wander, usually by foot."

Craig Gaines is a freelance copy editor who maintains a blog about writing at thewritingguide.wordpress.com. He lives in Los Feliz.

Pleasant Gehman is a writer, dancer, actor, painter, and musician. She has written for *Rolling Stone*, the *L.A. Weekly*, *Spin*, and *Los Angeles Magazine*. She is the author and/or editor of six books, including the acclaimed memoir *Escape from Houdini Mountain* and *The Underground Guide to Los Angeles*, which spent nine weeks on the Los Angeles Times best sellers list. She lives in Hollywood.

Polly Geller grew up in Rome and left at 17 to attend Dartmouth College. Her poetry has been published in *The Strip*; her prose has been published by NameCalling.org and 32WordStories.com. She recently earned an MFA from Otis College of Art and Design. Her thesis, a translation of Adriano Spatola's only novel, *L'oblo*, (The Porthole), will be published by Otis Seismicity Editions/Agincourt in the fall.

Jonathan Gold, restaurant critic for the *L.A. Weekly* and author of *Counter Intelligence: Where to Eat in the Real Los Angeles*, is the first food writer to win the Pulitzer Prize for criticism. In addition to his writing for *Gourmet*, *Saveur*, and other food and travel magazines, Gold has a shady past as a composer and performance artist, spent time as the rap and heavy-metal correspondent for the *Los Angeles Times*, was the *L.A. Weekly*'s music editor, and wrote for *Spin* and *Rolling Stone*.

Jacob Heilbrunn is a senior editor at *The National Interest* and author of *They Knew They Were Right: The Rise of the Neocons*.

Daniel Hernandez is a journalist based in Mexico City working on a book to be published by Scribner. He was staff writer at the *Los Angeles Times* and then the *L.A. Weekly*, where he wrote about art, politics, culture, and the 2006 presidential election in Mexico. He does commentary and journalism in English and Spanish for various media. His blog, Intersections, is featured on La Plaza, the Latin America news blog at LATimes.com. His work has appeared in *The New York Times*, the *Guardian*, and more.

Michelle Huneven's most recent novel, *Blame*, was nominated for a National Book Critics Circle Award and named a finalist for a Los Angeles Times Book Prize. Her first and second novels, *Round Rock* and *Jamesland*, were New York Times notable books. She teaches creative writing at UCLA and lives with her husband in Altadena, California, where she was born.

Theresa Kereakes grew up in Southern California and studied at UCLA. Theresa photographs raw and candid images of artists who are now household names: Debbie Harry, Chrissie Hynde, Joan Jett, The Sex Pistols and more.

Steven Kotler is a New Mexico-based writer and author of the forthcoming *A Small, Furry Prayer: Dog Rescue and the Meaning of Life*; *West of Jesus: Surfing, Science and the Origins of Belief*, was a 2006 PEN West Finalist. His articles have appeared in *The New York Times Magazine*, *GQ*, *Wired*, *Popular Science*, and *Outside*.

Richard Lange is the author of the short story collection *Dead Boys* and the novel *This Wicked World*. He received the Rosenthal Family Foundation Award for Literature from the American Academy of Arts and Letters, was a finalist for the William Saroyan International Prize for Writing, and is a Guggenheim Fellow in fiction.

Judith Lewis Mernit writes about natural resources, Western politics, and the great outdoors from Venice, California. Her work has appeared in the *L.A. Weekly*, *Mother Jones*, *Sierra*, *Utne*, the *Los Angeles Times*, and *High Country News*, where she is a contributing editor.

Arty Nelson has written for the *L.A. Weekly*, *Bikini*, *Raygun*, *Arena*, *Interview*, *Black Book*, *Frank*, *Vogue*, and numerous art catalogs. He is the author of the novel *Technicolor Pulp* and is a writer on HBO's *How to Make It in America*.

Geoff Nicholson is the author of numerous books, most recently *The Lost Art of Walking* and *Gravity's Volkswagen*. He lives on the lower slopes of the Hollywood Hills.

John Powers is a contributing editor at *Vogue*, where he writes about film and politics, and is critic at large for NPR's *Fresh Air with Terry Gross*. He was film critic at the *L.A. Weekly* from 1985 to 1993, and returned in 2001 to write a weekly media/politics column, "On," until 2005. He is the author of *Sore Winners (and the Rest of Us) in George Bush's America*. He and his wife, Sandi Tan, live in Pasadena.

Fred Rochlin's first two jobs—working for Frank Lloyd Wright's son, Lloyd Wright, and for Charles and Rae Eames—were as inspiring as he'd hoped. But when his firm, Rochlin & Baran, got the Tropicana Motel project, the developer insisted on details he considered ugly—the kidney-bean-shaped pool—and Rochlin wanted to forget the job. Still, right before the Trop was torn down, the late architect parked himself across the street, painted a watercolor of the landmark.

David Schneider was born and raised in San Francisco. He has worked in commercials, film, television, and theater since moving to Los Angeles in 2002. He would like to thank Mom, Dad, Jeffrey, Matthew, Michael, Jenny, C. J., Dana, Michael, Adam, Emily, Nana, Oliver, and Christine.

Robert Sobul is a filmmaker who lives in Los Angeles with his wife and son.

Jerry Stahl is the author of six books, including *Permanent Midnight*; *I, Fatty*; and *Pain Killers*. "Sammy Talks Frank" is taken from his upcoming novel, *Jumping from the H*.

C. R. Stecyk is an artist based in Ocean Park, California. His work has been exhibited internationally and is included in a number of public collections. A surfboard he built and painted is in the permanent archive of the Smithsonian Institution. He has been profiled in several films, including in *Dogtown and Z Boys*.

Deborah Stoll is a native New Yorker who enjoys living in Los Angeles. She contributes to *The Economist*'s online literary magazine, *More Intelligent Life*, and writes cocktail-inspired stories for the *L.A. Weekly*. Her TV show *The Foundry* was a semifinalist at Slamdance. You can find more information and tawdry tales at bubbemaisse.com.

Jervey Tervalon is the author of five novels including *Understand This*, for which he won the Quality Paper Book Club's New Voices Award. He was awarded a key to the city of New Orleans for his bestselling novel *Dead Above Ground*. He was selected as a Disney Screenwriting Fellow. He teaches creative writing at USC.

John Tottenham has dedicated himself to the lucrative, fast-paced world of poetry for the past decade, a morbid addiction that he is now trying to quit. His work has appeared in *Artillery*, *The Southern Humanities Review*, *Dialectical Anthropology*, and other publications. The musician Matt Johnson (otherwise known as The The) is working on a multimedia interpretation of Tottenham's book, *The Inertia Variations*.

Dave White is the author of the memoir *Exile in Guyville* and is featured in the anthology *Love Is a Four Letter Word*. He writes about film, TV, and pop culture for Movies.com, MSNBC.com, and QueerSighted.com.

Erica Zora Wrightson is a Pasadena native who writes about proximities, distances, and the ingredients of place. Her nonfiction can be found in the *L.A. Weekly*. She resides in Angeleno Heights.

Editors and Co-founders

Joe Donnelly is an award-winning journalist who was the deputy editor of the *L.A. Weekly* from 2002 to 2008. Before that, he was the arts editor of *New Times Los Angeles* and editor in chief of the seminal Los Angeles pop-culture magazine *Bikini*. Donnelly earned a master's degree in journalism from UC Berkeley. Donnelly started dreaming up *Slake* several years ago when he asked himself a simple question: why doesn't a city as cool and interesting as Los Angeles have a publication as cool and interesting as the city?

Laurie Ochoa led the *L.A. Weekly* to more national journalism awards than any other alternative newspaper in the country during her eight years as editor in chief. She was the executive editor of *Gourmet* from 1999 to 2001, and spent ten years as a reporter and editor at the *Los Angeles Times*, including five years as editor of the food section. She wrote *Nancy Silverton's Breads from the La Brea Bakery*, which was nominated for James Beard and Julia Child cookbook awards.

slake\
v. (slāk) to allay or make
(thirst, desire, etc.) less
active or intense by satis
fying; assuage; satisfy